CHINESE JADE

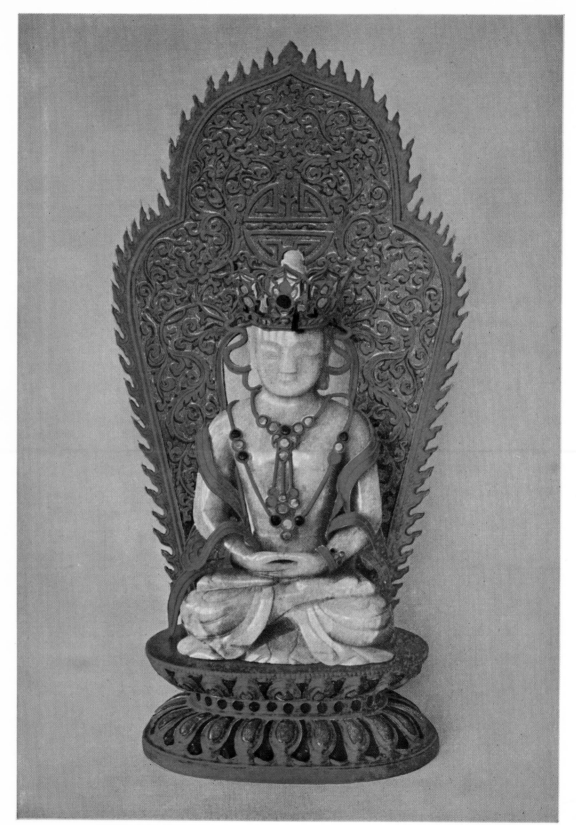

JEWELLED BUDDHA IN JADE ON ENAMELLED LOTUS THRONE
COLOUR: Pale Celadon. Sino-Tibetan, 17th century.
(*In the Collection of Her Majesty Queen Mary and included by Her Majesty's gracious permission.*)

CHINESE JADE

THROUGHOUT THE AGES

A Review of its
Characteristics, Decoration,
Folklore, and Symbolism

by

STANLEY CHARLES NOTT

CHARLES E. TUTTLE COMPANY
Rutland, Vermont & Tokyo, Japan

European Representatives
Continent: BOXERBOOKS, INC., Zurich
British Isles: PRENTICE-HALL INTERNATIONAL, INC., London

*Published by the Charles E. Tuttle Company
of Rutland, Vermont & Tokyo, Japan
with editorial offices at
15 Edogawa-cho, Bunkyo-ku, Tokyo, Japan*

*Copyright in Japan, 1962, by
Charles E. Tuttle Co.
All Rights Reserved*

Library of Congress Catalog Card No. 62–8839

*1st edition published 1936 by B.T. Batsford, Ltd., London
2nd edition published 1962 by Charles E. Tuttle Co.
(This 2nd edition is a complete
photographic reprint of the original,
with the plates slightly rearranged.)
2nd printing, 1964*

PRINTED IN JAPAN

TRANSLATION OF THE CHINESE TRIBUTE TO JADE PRINTED ON THE OPPOSITE PAGE.

Chian: Quan: Chien: Yu: (Jade).

Jade is a certain kind of fine stone possessing five qualities:

(1) It is moist and glossy, possessing the characteristics of " Jen." (Kind and loving.)

(2) Upon examining its exterior, its interior is revealed to those who understand the stone, for it resembles the character of " Yi." (Perfect understanding and good treatment.)

(3) Its sound is musical and far-reaching, like the character of " Tsi." (Intelligent.)

(4) Although it may be cut, it retains to itself completeness, thereby displaying an inherent characteristic of self-defence like unto the character " Yung." (Brave.)

(5) It is without blemish when clear, similar to the character " Chieh." (Pure.)

Its written symbol is formed by the combination of three Jades.

Copied from the " Shuo Wên," the first lexicon of the Chinese language, circa A.D. 100, and brush-written in Chinese script, by Hsiao Yi when staying in London in the year Nineteen Hundred and Thirty-Six.

璿璂瓈瓘瑿

說文解玉曰玉石之美有
五德潤澤以溫仁之方也
鰓理自外可以知中義之
方也其聲舒揚專以遠聞
智之方也不撓而折勇之方
也銳廉而不忮絜之方也
眾三五之連其貴也

蕭遠題 一九三元年 特爲編敬

INTRODUCTION

BY

SIR CECIL HARCOURT-SMITH, k.c.v.o., d. litt.

ANY excursion into the realms of Chinese Art is apt to be something of an adventure; even to-day, when in the inexorable march of " progress " the barriers which so long hedged the Celestial Empire are crumbling, and the " Son of Heaven " is an empty title, China is in many respects as much an undiscovered country as it was to Marco Polo or the Jesuit missionaries of the 17th century; the oldest continuous civilisation in the world, immemorial, inscrutable.

There is always an element of rashness in attempts to evaluate the spiritual and intellectual as distinct from the purely æsthetic appeal in works of art. We are confronted with this danger especially to-day, when the apostles and prophets of a new creed claim some mysterious inner virtue as the excuse for ugliness and crudity in their manifestations. In order to acquire even a glimmering of the basic significance underlying much of the art of China, we must not be wholly ignorant of the intimate relation it bore to the age-long traditions of religion and its kindred superstitions : we can trace the dawning of spiritual ideas and their gradual cultivation into the flower of artistic form, always instinct with the ruling motive of the National faith in self-control and contemplation. There is something here so remote in its super-mundane tranquillity, in its subtle and philosophic calm from our bustling *journalier* and journalistic work-a-day life, that one feels one must approach the sanctuary reverently and, as it were, with our shoes put off. I wonder how many of us had this sensation among the curious crowds at Burlington House ? For months the names of Chinese dynasties, Ming, Sung and T'ang were bandied about Piccadilly like a broken peal of exotic and inharmonious bells.

And of all the products of Chinese Art, there is perhaps none like jade for typifying its inherent characteristic. From the earliest times it seems to have been credited with medicinal qualities : the *pietra di Hijada* or " colic stone " of the Spanish adventurers is the " nephrite " of the mineralogist : in its ritual character it was believed to have qualities of the solar light, and so to have relationship with the powers of heaven : naturally it was thus appropriate to the Son of Heaven, the Emperor, and a royal attribute. To the artist-craftsman it appealed, not only in its range of exquisite colours, but in the hardness which to him was a symbol of eternity : he had the artistic impulse so to master this hardness as to give the effect of natural fluency : and could this

sensation be more aptly or more practically expressed than in the delicious term applied by the Chinese to one kind of jade " Moss entangled in melting snow " ?

To the Western mind there is a bewildering but attractive quality in the symbolism which permeates so much of Chinese Art. One example of this which Mr. Nott mentions I find peculiarly characteristic and suggestive. Among the " literary symbols " worked in jade is the *Wên chan shan tou*, which being interpreted is " Scholarship equal to the Hills and the Great Bear." The polar constellation is in Chinese thought the abode of the god of literature, so that the scholar who has achieved this has far transcended even Parnassus ; but he is spared the toilsome hill-climb, for this Pegasus is a friendly fish-dragon.

One of the most intriguing figures in the Chinese theogony is that of Kuan-Yin, who during the Sung Dynasty began to change his sex and, assimilating the attributes of female divinities, became a gracious divine Mother-type, protectress of children and giver of sons. Mr. Nott has given us a lucid and interesting account of her evolution.

The author is I believe something of a new-comer into the ranks of writers on art. It has given me great pleasure to be permitted to offer him this *envoi* on his journey. The pages that follow bear abundant testimony to the wide and diligent research which he has devoted to the work, not only in the vast field of both European and Chinese sources, but also in the selection of the beautiful illustrations, both from public and private collections, which cannot fail to enhance its value.

CHINESE JADE

CHAPTER I.

CHARACTERISTICS AND OCCURRENCE OF JADE.

WHEN Sir Walter Raleigh returned to England from Spanish America, he brought with him the magic *"pietra di hijada,"* the ' stone of the loins,' which was reputed to possess unique curative medicinal powers.[1] Thus was introduced to Britain a mineral believed to embody the quintessence of creation, accredited with having been forged from the rainbow into thunderbolts for the use of the storm god, and having been eaten as food[2] by the Taoist genii ; for such would appear to be the romantic inheritance of Jade.

The Chinese classify this material under three headings :—

(1) *Yü*—its general name.

(2) *Pi Yü*—the dark green variety, similar in character to serpentine obtained mainly from Barkul, Manas in Sungaria, the country surrounding Lake Baikal and the mountain slopes of Western Yunnan.

(3) *Fei-ts'ui*—an emerald green variety first obtained from Lan-t'ien on the borders of the province of Shensi, and later imported from Burma.[3]

This latter variety owes its Chinese name to its remarkable similarity in colour to the brilliant plumage of the kingfisher,[4] and originally referred only to the pieces of emerald green ; to-day it embodies all varieties of Jadeite with the exception of the opaque dark green.

The colours most venerated by the Chinese are perhaps best described by a Manchu author,[5] who, writing in A.D. 1777, says :—

> " There is a river in Yarkand in which are found Jade pebbles. The largest are as big as round fruit dishes, or square peck measures, the smallest are the size of a fist or chestnut, and some of the boulders weigh more than five hundred pounds. There are many different colours, among which snow white, kingfisher green, beeswax yellow, cinnabar red, and ink black, are all considered valuable ; but the most difficult to find are pieces of pure mutton fat texture with vermilion spots, and others of bright spinach green flecked with shining points of gold, so that these two varieties rank as the rarest and most precious of jades."

Lavender Jadeite is another colour greatly prized and appreciated in China, and very few fine examples of this are at present in European hands. An exceptionally beautiful pair of Tea Bowls in this material, which are perhaps unequalled in any Collection in Europe, are those in the Collection of Her Majesty Queen Mary, here illustrated in PLATE I.

This exquisitely coloured Lavender Jadeite chiefly comes from Burma, where it is found in small quantities in the headwaters of the Chindwin and Mogaung tributaries of the Irrawaddy river. The emerald

[1] *Journal Royal Society of Arts*, 7th February, 1936, p. 339, and A. Mangin, *Earth and its Treasures*, p. 102.

[2] Compare Laufer, *Jade*, p. 297, and Chavannes, *Le T'ai Chan*, p. 425. De Groot, *The Religious System of China*, Vol. I, p. 272, and Mayers, *Chinese Readers Manual*, Part 1, pp. 303-304.

[3] Bauer, " Precious Stones," pp. 468-470.

[4] *T'ao shua*, trans. Dr. Bushell, 1910, p. 44.

[5] *Hsi Yü Wên Chien Lu*, a description of Chinese Turkestan, published, A.D. 1777.

green variety also is derived from these waters and mined by wild Kachins in the surrounding hills.

Hua hsueh tai tsao ("moss entangled in melting snow") is another variety of Jadeite which comes from Burma, and its appearance reminds one of melted snow, frozen, veined with clouds of shaded green.

In China jade is valued according to its colour, sonorousness and freedom from cracks. It should have a soft, "greasy" appearance when polished; specimens which do not possess this oily feel when handled are described as "dry" and regarded as inferior.

The chief visual characteristics of Jadeite and Nephrite are as follows :

JADEITE is generally brighter and more vivid in colour than Nephrite. Its body is usually more translucent, and it is sometimes partially crystallised. Its basic colourings would seem to be lavender and bright apple green. White, streaked with emerald green, or brilliant emerald green, is the most valuable; this latter colouring is due to chromium, the element which gives its colour to the true emerald.

NEPHRITE is usually of some shade of green, deepening as the proportion of iron present increases. These may be sea green, grey green, celadon, lettuce green, grass green, and spinach green. Other colourings found in Nephrite are : Grey, blue grey, reddish grey, and greenish grey ; yellow ; black containing chromic iron ; cream ; and lastly the pure limpid white often compared to mutton fat. A typical example of the latter variety is shown in PLATE LXIV.

Most of the Nephrite carved in China comes from the regions of Khotan and Yarkand in Eastern Turkestan, the Jade mountains in Belurtag on the upper waters of the Tisnab River about 80 miles from Yarkand being probably the most notable source of supply.[1]

The Hsi Yü Wên Chien Lu tells us that the precipitous mountain sides are there entirely made of jade, and narrates how the Mohammedan natives on yaks penetrate beyond the snow limit, light fires to split the rock, and then roll the boulders over the precipice into the valley below.

The river boulders, as opposed to the mined rock, are chiefly found in the upper waters of the Yarkand Daria, and in the Yurungkash (white jade) and Karakash (black jade) Rivers of Khotan, where natives were, and still are, employed to "fish" for the precious jade.

The principal methods adopted by the Chinese in working jade, based upon observations made in the workshops at Peking have been well-described by Dr. Bushell[2] as follows :—

"The Chinese lapidary has all the tools of his art, an art which may be traced back to ancient Chaldæa and Susiana, from which it seems to have spread at some unknown period westwards to Europe, southwards to India, and eastwards to China. The modern lapidary has invented no new tools. The European craftsman only adds to the power of the old tools by the use of a continuous lathe and increasing

[1] Pope-Hennessy, *Early Chinese Jades*, p. 5, and Bushell, *Chinese Art*, Vol. I, p. 129.
[2] Bushell, *Chinese Art*, Vol. I, pp. 135-136.

its rapidity of revolution by means of steam and electricity ; the Chinese craftsman does the same by patient industry, as he sits alone for long days beside his table, working a reciprocal treadle with his feet so as to have his hands free for glyptic work.

" The tools of the craft are many, but as the Chinese say, they all owe their efficiency to the biting power of the abrasives with which they are anointed. These abrasives are prepared by various preliminary processes of pounding, grinding, and sifting, and are made into pastes with water ready for use. Four kinds are used in Peking, increasing in power, being—(1) ' yellow sand,' quartz crystals ; (2) ' red sand,' garnets or almadin, used with the circular saws ; (3) ' black sand,' a kind of emery, used with the lap wheels, etc. ; and (4) ' jewel dust,' ruby crystals from Yunnan and Tibet, with which the leather wheel is smeared which gives the final polish to the jade.

" The crude block of jade is first sawn round with a four-handed toothless iron saw worked by two men, to ' strip off the peel.' It is next roughly shaped with one of the circular saws, a graduated series of round discs of iron with sharp cutting edge, fitted to be mounted on the wooden axle of the treadle and put by it into vertical revolution. The prominent angles left by the saw are ground down and the piece is further shaped by a set of small solid iron rings mounted in turn on the end of the same horizontal spindle, after which the striated marks of the grinding are removed by a set of little polishing wheels worked in similar fashion by the rocking pedals. The object is now shaped ready to be carved in artistic relief with the lap wheels, or to be pierced through and through with the diamond drill and subsequently cut in open fretwork designs with the wire saw, the wire being inserted into holes pierced by the drill for the purpose.

" The lap wheels, which are little iron discs like small flat-headed nails, and are consequently called ' nails ' by the Chinese lapidary, are hammered into the hollow end of a light iron spindle which is kept in motion by a leather strap worked by the treadles. The diamond drill is worked by hand and is kept in revolution by the usual string-bow wielded by the right hand of the operator, while he holds the jade in his left ; the cup-shaped head-piece of the drill is fixed above to a horizontal bar, on which a heavy stone weight is hung as a counterpoise to give the necessary pressure. Another phase of the diamond drill is exhibited in the boring of smaller objects, which are floated upon boat-shaped supports in a bamboo tub of water while they are being bored ; the cup-shaped headpiece of the drill now rests in the left palm of the craftsman, who keeps it pressed down as he works the string bow with his right hand.

" Another instrument used by the jade worker for hollowing out the interior of small vases and the like is the tubular drill, a very ancient instrument in all parts of the world. In China it consists of a short iron tube, grooved in two or three places to hold emery paste, which is mounted on the same light iron spindle as the lap wheels. As it works it leaves behind a core, which has to be dug out by little gouges, and a

number of other instruments of varied shape are provided to be worked on the same lathe, for a further scooping out of the interior of a vase that has been previously bored by the tubular drill.

" The fabric of the piece of jade has now been fashioned and carved with relief designs and openwork decoration, but it still requires a prolonged polishing of the surface to bring out the intrinsic merit of the material. The harder the jade the more it will repay the patient handiwork of the craftsman, who must carefully rub down all scratches and angles left by wheel or saw, as he follows every curve and intricacy of a complicated carving. He must go over the ground again and again to attain in hard stone the fluent lines and delusive softness of the perfect piece, which should seem to have been modelled by the most delicate touch in some soft and plastic substance. The Chinese connoisseur likens a finished work in white jade to liquescent mutton fat, or to congealed lard, shaped as it were by the fire. The polishing tools are made of fine-grained wood, dried gourd skin, and ox leather, and are charged with the ruby-dust paste, the hardest of all. For polishing the surface there is a graduated series of revolving wooden wheels, from fifteen inches in diameter downwards, which are mounted upon a wooden spindle and worked upon the reciprocal treadle lathe. For searching out the deeper interstices of the carved work there is a selection of wooden plugs and cylinders of varied size and shape fitted to hold the abrasive, down to the smallest points, which are cut out of the rind of the bottle gourd. The revolving wheels which give the final polish are bound round with ox leather stitched together with hempen thread."

An interesting illustration of a jade carver's workshop is shown in PLATE II.[1]

The carvings developed from the early spear heads and weapons to ritual tokens, and thence to the imperial emblems and the fixed Ritual of the Chou dynasty,[2] and passing on through the succeeding centuries jade became the principal medium through which a vast and mighty people expressed their pietistic beliefs.

Some idea of the extensive use and importance of jade can be gathered from the following list of the contents of the *Ku-yü t'ou p'u*, " Illustrated Description of Ancient Jade," in 100 books, of the collection belonging to the second Emperor of the Southern Sung dynasty, printed in the year A.D. 1176 :

1. State Treasures, Insignia of Bank, Sacrificial Symbols, Imperial Seals. Books 1-42.
2. Taoist Amulets, Talismans, Charms. Books 43-46.
3. Chariot Ornaments, Official Costume Pendants. Books 47-66.
4. Apparatus for Study, Ink Palettes, Brush-handles and Receptacles, *Ju-i* Sceptres, etc. Books 67-76.
5. Censers for burning incense and fragrant woods. Books 77-81.
6. Wine Ewers, Libation Cups and Drinking Cups. Books 82-90.
7. Sacrificial Vessels and Dishes. Books 91-93.

[1] Copied from an old Chinese print reproduced in the Catalogue of the Bishop Collection.
[2] Wylie, *Notes on Chinese Literature*, p. 4.

4

INTRODUCTION

BY

SIR CECIL HARCOURT-SMITH, K.C.V.O., D. LITT.

ANY excursion into the realms of Chinese Art is apt to be something of an adventure ; even to-day, when in the inexorable march of " progress " the barriers which so long hedged the Celestial Empire are crumbling, and the " Son of Heaven " is an empty title, China is in many respects as much an undiscovered country as it was to Marco Polo or the Jesuit missionaries of the 17th century ; the oldest continuous civilisation in the world, immemorial, inscrutable.

There is always an element of rashness in attempts to evaluate the spiritual and intellectual as distinct from the purely æsthetic appeal in works of art. We are confronted with this danger especially to-day, when the apostles and prophets of a new creed claim some mysterious inner virtue as the excuse for ugliness and crudity in their manifestations. In order to acquire even a glimmering of the basic significance underlying much of the art of China, we must not be wholly ignorant of the intimate relation it bore to the age-long traditions of religion and its kindred superstitions : we can trace the dawning of spiritual ideas and their gradual cultivation into the flower of artistic form, always instinct with the ruling motive of the National faith in self-control and contemplation. There is something here so remote in its super-mundane tranquillity, in its subtle and philosophic calm from our bustling *journalier* and journalistic work-a-day life, that one feels one must approach the sanctuary reverently and, as it were, with our shoes put off. I wonder how many of us had this sensation among the curious crowds at Burlington House ? For months the names of Chinese dynasties, Ming, Sung and T'ang were bandied about Piccadilly like a broken peal of exotic and inharmonious bells.

And of all the products of Chinese Art, there is perhaps none like jade for typifying its inherent characteristic. From the earliest times it seems to have been credited with medicinal qualities : the *pietra di Hijada* or " colic stone " of the Spanish adventurers is the " nephrite " of the mineralogist : in its ritual character it was believed to have qualities of the solar light, and so to have relationship with the powers of heaven : naturally it was thus appropriate to the Son of Heaven, the Emperor, and a royal attribute. To the artist-craftsman it appealed, not only in its range of exquisite colours, but in the hardness which to him was a symbol of eternity : he had the artistic impulse so to master this hardness as to give the effect of natural fluency : and could this

sensation be more aptly or more practically expressed than in the delicious term applied by the Chinese to one kind of jade " Moss entangled in melting snow " ?

To the Western mind there is a bewildering but attractive quality in the symbolism which permeates so much of Chinese Art. One example of this which Mr. Nott mentions I find peculiarly characteristic and suggestive. Among the " literary symbols " worked in jade is the *Wên chan shan tou*, which being interpreted is " Scholarship equal to the Hills and the Great Bear." The polar constellation is in Chinese thought the abode of the god of literature, so that the scholar who has achieved this has far transcended even Parnassus ; but he is spared the toilsome hill-climb, for this Pegasus is a friendly fish-dragon.

One of the most intriguing figures in the Chinese theogony is that of Kuan-Yin, who during the Sung Dynasty began to change his sex and, assimilating the attributes of female divinities, became a gracious divine Mother-type, protectress of children and giver of sons. Mr. Nott has given us a lucid and interesting account of her evolution.

The author is I believe something of a new-comer into the ranks of writers on art. It has given me great pleasure to be permitted to offer him this *envoi* on his journey. The pages that follow bear abundant testimony to the wide and diligent research which he has devoted to the work, not only in the vast field of both European and Chinese sources, but also in the selection of the beautiful illustrations, both from public and private collections, which cannot fail to enhance its value.

CHINESE JADE

CHAPTER I.

CHARACTERISTICS AND OCCURRENCE OF JADE.

WHEN Sir Walter Raleigh returned to England from Spanish America, he brought with him the magic *"pietra di hijada,"* the ' stone of the loins,' which was reputed to possess unique curative medicinal powers.[1] Thus was introduced to Britain a mineral believed to embody the quintessence of creation, accredited with having been forged from the rainbow into thunderbolts for the use of the storm god, and having been eaten as food[2] by the Taoist genii ; for such would appear to be the romantic inheritance of Jade.

The Chinese classify this material under three headings :—

(1) *Yü*—its general name.

(2) *Pi Yü*—the dark green variety, similar in character to serpentine obtained mainly from Barkul, Manas in Sungaria, the country surrounding Lake Baikal and the mountain slopes of Western Yunnan.

(3) *Fei-ts'ui*—an emerald green variety first obtained from Lan-t'ien on the borders of the province of Shensi, and later imported from Burma.[3]

This latter variety owes its Chinese name to its remarkable similarity in colour to the brilliant plumage of the kingfisher,[4] and originally referred only to the pieces of emerald green ; to-day it embodies all varieties of Jadeite with the exception of the opaque dark green.

The colours most venerated by the Chinese are perhaps best described by a Manchu author,[5] who, writing in A.D. 1777, says :—

> " There is a river in Yarkand in which are found Jade pebbles. The largest are as big as round fruit dishes, or square peck measures, the smallest are the size of a fist or chestnut, and some of the boulders weigh more than five hundred pounds. There are many different colours, among which snow white, kingfisher green, beeswax yellow, cinnabar red, and ink black, are all considered valuable ; but the most difficult to find are pieces of pure mutton fat texture with vermilion spots, and others of bright spinach green flecked with shining points of gold, so that these two varieties rank as the rarest and most precious of jades."

Lavender Jadeite is another colour greatly prized and appreciated in China, and very few fine examples of this are at present in European hands. An exceptionally beautiful pair of Tea Bowls in this material, which are perhaps unequalled in any Collection in Europe, are those in the Collection of Her Majesty Queen Mary, here illustrated in PLATE I.

This exquisitely coloured Lavender Jadeite chiefly comes from Burma, where it is found in small quantities in the headwaters of the Chindwin and Mogaung tributaries of the Irrawaddy river. The emerald

[1] *Journal Royal Society of Arts*, 7th February, 1936, p. 339, and A. Mangin, *Earth and its Treasures*, p. 102.

[2] Compare Laufer, *Jade*, p. 297, and Chavannes, *Le T'ai Chan*, p. 425. De Groot, *The Religious System of China*, Vol. I, p. 272, and Mayers, *Chinese Readers Manual*, Part 1, pp. 303-304.

[3] Bauer, " *Precious Stones*," pp. 468-470.

[4] *T'ao shua*, trans. Dr. Bushell, 1910, p. 44.

[5] *Hsi Yü Wên Chien Lu*, a description of Chinese Turkestan, published, A.D. 1777.

1

green variety also is derived from these waters and mined by wild Kachins in the surrounding hills.

Hua hsueh tai tsao (" moss entangled in melting snow ") is another variety of Jadeite which comes from Burma, and its appearance reminds one of melted snow, frozen, veined with clouds of shaded green.

In China jade is valued according to its colour, sonorousness and freedom from cracks. It should have a soft, " greasy " appearance when polished ; specimens which do not possess this oily feel when handled are described as " dry " and regarded as inferior.

The chief visual characteristics of Jadeite and Nephrite are as follows :

JADEITE is generally brighter and more vivid in colour than Nephrite. Its body is usually more translucent, and it is sometimes partially crystallised. Its basic colourings would seem to be lavender and bright apple green. White, streaked with emerald green, or brilliant emerald green, is the most valuable ; this latter colouring is due to chromium, the element which gives its colour to the true emerald.

NEPHRITE is usually of some shade of green, deepening as the proportion of iron present increases. These may be sea green, grey green, celadon, lettuce green, grass green, and spinach green. Other colourings found in Nephrite are : Grey, blue grey, reddish grey, and greenish grey ; yellow ; black containing chromic iron ; cream ; and lastly the pure limpid white often compared to mutton fat. A typical example of the latter variety is shown in PLATE LXIV.

Most of the Nephrite carved in China comes from the regions of Khotan and Yarkand in Eastern Turkestan, the Jade mountains in Belurtag on the upper waters of the Tisnab River about 80 miles from Yarkand being probably the most notable source of supply.[1]

The Hsi Yü Wên Chien Lu tells us that the precipitous mountain sides are there entirely made of jade, and narrates how the Mohammedan natives on yaks penetrate beyond the snow limit, light fires to split the rock, and then roll the boulders over the precipice into the valley below.

The river boulders, as opposed to the mined rock, are chiefly found in the upper waters of the Yarkand Daria, and in the Yurungkash (white jade) and Karakash (black jade) Rivers of Khotan, where natives were, and still are, employed to " fish " for the precious jade.

The principal methods adopted by the Chinese in working jade, based upon observations made in the workshops at Peking have been well-described by Dr. Bushell[2] as follows :—

" The Chinese lapidary has all the tools of his art, an art which may be traced back to ancient Chaldæa and Susiana, from which it seems to have spread at some unknown period westwards to Europe, southwards to India, and eastwards to China. The modern lapidary has invented no new tools. The European craftsman only adds to the power of the old tools by the use of a continuous lathe and increasing

[1] Pope-Hennessy, *Early Chinese Jades*, p. 5, and Bushell, *Chinese Art*, Vol. I, p. 129.
[2] Bushell, *Chinese Art*, Vol. I, pp. 135-136.

its rapidity of revolution by means of steam and electricity ; the Chinese craftsman does the same by patient industry, as he sits alone for long days beside his table, working a reciprocal treadle with his feet so as to have his hands free for glyptic work.

" The tools of the craft are many, but as the Chinese say, they all owe their efficiency to the biting power of the abrasives with which they are anointed. These abrasives are prepared by various preliminary processes of pounding, grinding, and sifting, and are made into pastes with water ready for use. Four kinds are used in Peking, increasing in power, being—(1) ' yellow sand,' quartz crystals ; (2) ' red sand,' garnets or almadin, used with the circular saws ; (3) ' black sand,' a kind of emery, used with the lap wheels, etc. ; and (4) ' jewel dust,' ruby crystals from Yunnan and Tibet, with which the leather wheel is smeared which gives the final polish to the jade.

" The crude block of jade is first sawn round with a four-handed toothless iron saw worked by two men, to ' strip off the peel.' It is next roughly shaped with one of the circular saws, a graduated series of round discs of iron with sharp cutting edge, fitted to be mounted on the wooden axle of the treadle and put by it into vertical revolution. The prominent angles left by the saw are ground down and the piece is further shaped by a set of small solid iron rings mounted in turn on the end of the same horizontal spindle, after which the striated marks of the grinding are removed by a set of little polishing wheels worked in similar fashion by the rocking pedals. The object is now shaped ready to be carved in artistic relief with the lap wheels, or to be pierced through and through with the diamond drill and subsequently cut in open fretwork designs with the wire saw, the wire being inserted into holes pierced by the drill for the purpose.

" The lap wheels, which are little iron discs like small flat-headed nails, and are consequently called ' nails ' by the Chinese lapidary, are hammered into the hollow end of a light iron spindle which is kept in motion by a leather strap worked by the treadles. The diamond drill is worked by hand and is kept in revolution by the usual string-bow wielded by the right hand of the operator, while he holds the jade in his left ; the cup-shaped head-piece of the drill is fixed above to a horizontal bar, on which a heavy stone weight is hung as a counterpoise to give the necessary pressure. Another phase of the diamond drill is exhibited in the boring of smaller objects, which are floated upon boat-shaped supports in a bamboo tub of water while they are being bored ; the cup-shaped headpiece of the drill now rests in the left palm of the craftsman, who keeps it pressed down as he works the string bow with his right hand.

" Another instrument used by the jade worker for hollowing out the interior of small vases and the like is the tubular drill, a very ancient instrument in all parts of the world. In China it consists of a short iron tube, grooved in two or three places to hold emery paste, which is mounted on the same light iron spindle as the lap wheels. As it works it leaves behind a core, which has to be dug out by little gouges, and a

number of other instruments of varied shape are provided to be worked on the same lathe, for a further scooping out of the interior of a vase that has been previously bored by the tubular drill.

" The fabric of the piece of jade has now been fashioned and carved with relief designs and openwork decoration, but it still requires a prolonged polishing of the surface to bring out the intrinsic merit of the material. The harder the jade the more it will repay the patient handiwork of the craftsman, who must carefully rub down all scratches and angles left by wheel or saw, as he follows every curve and intricacy of a complicated carving. He must go over the ground again and again to attain in hard stone the fluent lines and delusive softness of the perfect piece, which should seem to have been modelled by the most delicate touch in some soft and plastic substance. The Chinese connoisseur likens a finished work in white jade to liquescent mutton fat, or to congealed lard, shaped as it were by the fire. The polishing tools are made of fine-grained wood, dried gourd skin, and ox leather, and are charged with the ruby-dust paste, the hardest of all. For polishing the surface there is a graduated series of revolving wooden wheels, from fifteen inches in diameter downwards, which are mounted upon a wooden spindle and worked upon the reciprocal treadle lathe. For searching out the deeper interstices of the carved work there is a selection of wooden plugs and cylinders of varied size and shape fitted to hold the abrasive, down to the smallest points, which are cut out of the rind of the bottle gourd. The revolving wheels which give the final polish are bound round with ox leather stitched together with hempen thread."

An interesting illustration of a jade carver's workshop is shown in PLATE II.[1]

The carvings developed from the early spear heads and weapons to ritual tokens, and thence to the imperial emblems and the fixed Ritual of the Chou dynasty,[2] and passing on through the succeeding centuries jade became the principal medium through which a vast and mighty people expressed their pietistic beliefs.

Some idea of the extensive use and importance of jade can be gathered from the following list of the contents of the *Ku-yü t'ou p'u,* " Illustrated Description of Ancient Jade," in 100 books, of the collection belonging to the second Emperor of the Southern Sung dynasty, printed in the year A.D. 1176:

1. State Treasures, Insignia of Bank, Sacrificial Symbols, Imperial Seals. Books 1-42.
2. Taoist Amulets, Talismans, Charms. Books 43-46.
3. Chariot Ornaments, Official Costume Pendants. Books 47-66.
4. Apparatus for Study, Ink Palettes, Brush-handles and Receptacles, *Ju-i* Sceptres, etc. Books 67-76.
5. Censers for burning incense and fragrant woods. Books 77-81.
6. Wine Ewers, Libation Cups and Drinking Cups. Books 82-90.
7. Sacrificial Vessels and Dishes. Books 91-93.

[1] Copied from an old Chinese print reproduced in the Catalogue of the Bishop Collection.
[2] Wylie, *Notes on Chinese Literature*, p. 4.

4

8. Musical Instruments. Books 94-96.
9. Furniture, Jade Pillows, Screen Pictures, etc., including a large upright bowl 4½ feet high, holding twenty gallons of wine, of white jade marbled with shaded greens, carved with scrolled and three-clawed dragons. Books 97-100.

Further confirmation of the importance attached to jade by the Chinese is afforded by the inscription on the stone slab[1] of the Han dynasty found in the Tombs of the Wu Family, in the neighbourhood of the City of Chia-hsiang-hsien in the Province of Shantung,[2] which details the " Felicitous omens that herald the rule of a virtuous sovereign,"[3] as follows :—

The Well of Pure Water that appears mysteriously without boring.
The Tripod capable of cooking food without heat.
The Spotted Unicorn called *Ch'i-lin*.
The Dragon of the Yellow River.
The Marvellous Plant capable of indicating the day of the month.
The Six-legged Monster.
The White Tiger of Jade.
The Jade Horse.
The Jade Rock growing in marvellous manner from the ground.
The Red Bear.
The Twin Tree with two trunks united above.
The Gem (*pi-lui-li*) disc shaped with round hole in the middle.
The deep green Tablet of Jade (*hsüan kuei*) an ancient badge of rank.
The Two-headed Quadruplets, birds and fishes.
The White Carp that appeared to Wu Wang, the founder of the Chou dynasty.
The White Deer used by foreign envoys when visiting the court of the Emperor Huang Ti.
The Silver Wine Jar (*yin wêng*).
And lastly the Jade symbol of victory (*yü shêug*) the form of which resembled that of a weaver's spindle, or two discs united by a central bar.

The uses of the various creations in jade are ably described by a native writer, quoted by Dr. Bushell,[4] who after referring to many ancient jade objects, historical seals, insignia of rank, girdle buckles and other details of a mandarin's costume, continues his theme in a summary of 18th and 19th century carvings as follows :—

" Among the large things carved in Jade, we have all kinds of ornamental vases and receptacles for flowers, large round dishes for fruit, wide mouthed bowls, and cisterns ; among smaller objects, pendants for the girdle, hairpins and rings. For the banquet table there are bowls, cups (see PLATE III), and ewers for wine ; as congratulatory gifts a variety of round medallions and oblong talismans with inscriptions. Beakers and vases are provided to be frequently replenished at wine parties, a wine pot with its prescribed set of three cups for bridal ceremonies. There is a statuette of Buddha of long life to pray to for length of days, a screen carved with the eight immortal genii for Taoist worship (see PLATE CXXXV). *Ju-i* sceptres and fretwork mirror-stands are highly valued for betrothal gifts ; hairpins, earrings, studs for the

[1] A rubbing of this slab was exhibited in the Oriental Congress Exhibition, Berlin, 1881.
[2] Chavannes, *La Sculpture sur Pierre en Chine au temps des deux Dynasties Han*, Paris, 1893.
[3] Bushell, *Oriental Ceramic Art*, p. 560.
[4] Bushell, *Chinese Art*, Vol. I, p. 138.

PLATE I

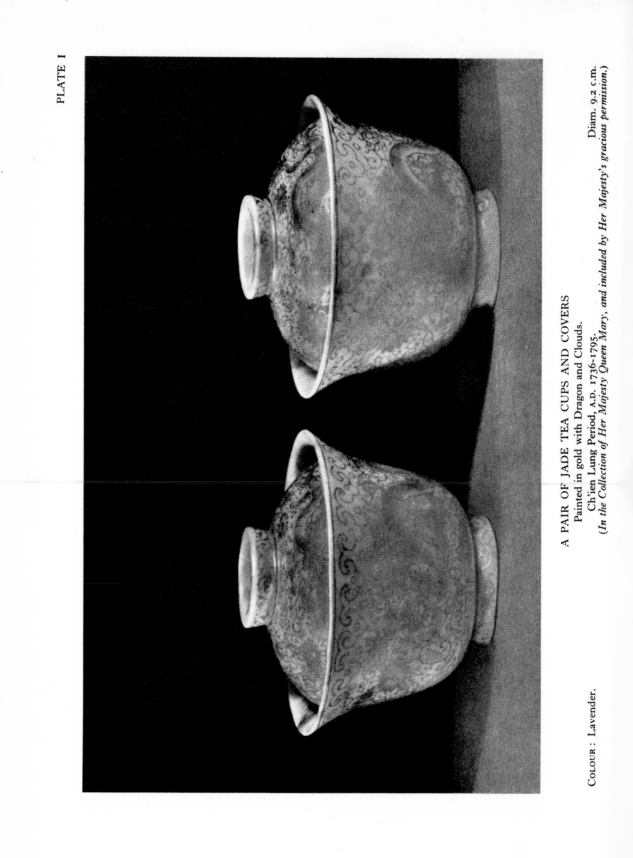

A PAIR OF JADE TEA CUPS AND COVERS
Painted in gold with Dragon and Clouds.
Ch'ien Lung Period, A.D. 1736-1795. Diam. 9.2 c.m.
(In the Collection of Her Majesty Queen Mary, and included by Her Majesty's gracious permission.)

COLOUR: Lavender.

PLATE II

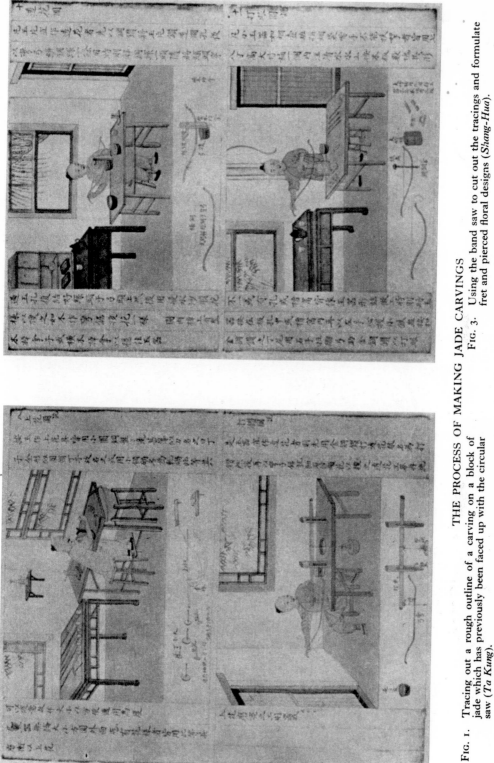

THE PROCESS OF MAKING JADE CARVINGS

Fig. 1. Tracing out a rough outline of a carving on a block of jade which has previously been faced up with the circular saw (*Ta Kung*).

Fig. 2. Drilling holes in the tracing with a weighted diamond drill (*Ta-Yen*).

Fig. 3. Using the band saw to cut out the tracings and formulate fret and pierced floral designs (*Shang-Hua*).

Fig. 4. Drilling miniature carvings in a bamboo tub of water, showing hand diamond drill used for this purpose.

forehead, and bracelets for personal adornment. For the scholar's study the set of three (*san shih*), tripod, vase, and box, is at hand for burning incense, for more luxurious halls sculptured flowers of jade and jewels in jade pots are arranged in pairs, displaying flowers appropriate to the current season of the year. Combs of jade are used to dress the black tresses of beauty at dawn, pillows of jade for the divan to snatch a dream of elegance at noon. Rests for the writer's wrist lie beside the ink pallet, weights are made for the tongue of the dead laid out for the funeral. Rouge pots and powder boxes provide the damsel with the bloom of the peach, brush pots and ink rests hold the weapons of the scholar in his window. The eight precious emblems of good fortune—the wheel of the law, conch-shell, umbrella, canopy, lotus-flower, jar, pair of fish, and endless knot—adorn the altar of the Buddhist shrine : pomegranates bursting open to display the seeds, sacred peaches, and Buddha's hand citrons, appear as symbols of the three all-prayed-for abundances—of sons, of years, of happiness. Linked chains of jade are tokens of lasting friendship, jade seals attest the authenticity of important documents. There are beads for the rosary to number the invocations of Buddha, paper-weights for the writing table of the scholar, tassel ornaments for the fan screen hiding the face of the coquette, and keyless locks of jade for clasping round the necks of children. And lastly mortars and pestles for pounding drugs, thumb-rings for protecting the hand of the archer from the recoil of the bowstring ; jade mouthpieces for the pipes of tobacco smokers, and jade chopsticks for gourmands."

A large jade bowl, or cistern, rivalling in size the one referred to in the *Ku-yü t'ou p'u*,[1] stands in one of the courtyards of the imperial palace at Peking. It is noticed in the travels of the celebrated friar Oderic, who commenced his long journeys through Asia in April, 1318, as related in Yule's *Cathay and the Way Thither* :[2]—

" The palace in which the great Khan dwells at Cambaluk (Peking) is of great size and splendour. In the midst of the palace is a certain great jar, more than two paces in height, entirely formed of a certain precious stone called *Merdacas*, and so fine, that I was told its price exceeded the value of four great towns. It is all hooped round with gold, and in every corner thereof is a dragon, represented as in act to strike most fiercely, and this jar has also fringes of network of great pearls hanging therefrom, and these fringes are a span in breadth. Into this vessel drink is conveyed by certain conduits from the court of the palace ; and beside it are many golden goblets from which those drink who list."

At the fall of the Mongol dynasty, this jar,[3] so lavishly mounted with gold and pearls, disappeared and was stripped of its ornaments. In the 18th century it was found again in the kitchen of a Buddhist temple in the vicinity, where the ignorant monks were using it as a receptacle for salted vegetables. The emperor Ch'ien Lung bought it of them for a few hundred ounces of silver, and composed, to be engraved inside the bowl, an ode in its honour, in which he narrates its

1 Book 98.
2 Vol. I, p. 130.
3 Bushell, *Chinese Art*, Vol. I, pp. 132-133.

PLATE III

A PAIR OF TEA BOWLS AND SAUCER-COVERS, AND AN OPEN BOWL IN FINE
TRANSLUCENT EGGSHELL THICKNESS JADEITE

COLOUR : Pale Green splashed Emerald. Ch'ien Lung Period, A.D. 1736-1795.

TEA BOWLS BOWL

Diam. 11.3 c.m. H. 7.8 c.m. Diam. 13.8 c.m. H. 5.5 c.m.

(In the Collection of J. H. Smyth-Pigott, Esq.)

history. It is a tall bowl, with flat bottom and upright sides, shaped like one of the large pottery fish-bowls, called *yü kang*,[1] which the Chinese use in their gardens for gold fish or lotus flowers, and is boldly carved upon the exterior with grotesque monsters and winged horses disporting in sea-waves.

The Mongol emperors of Hindustan were also lovers of jade, and it is well known that beautiful carvings in white and sage-green nephrites were produced under their patronage ; these were often incrusted with rubies, emeralds and other precious stones, for which the soft tints of the jade afford a most effective background. The varieties of jade, from which they were carved, were originally imported into India from Eastern Turkestan, and were derived probably from the same districts from which the Chinese obtained their supplies of crude jade. After the Chinese conquest of Eastern Turkestan, many of these Indian carvings were imported into Peking, and it is not uncommon to find in a European collection such a piece of characteristically delicate and graceful Indian work (see PLATE IV), incised with a Chinese inscription in verse attesting its origin, and with the imperial seals of Ch'ien Lung attached. Much of the finest work in jade was executed in the palace at Peking during his reign, and we are told that the imperial workshops of the period included a special branch called *Hsi Fan Tso*, or " Indian School," which was devoted to the reproduction of Indian works. An exceptionally fine example of this type of work is the jewelled Buddha in the Collection of Her Majesty Queen Mary, reproduced as frontispiece to this volume.

The jewelled jades of China, which are occasionally met with, date for the most part from this period, and were perhaps mainly inspired from the same source. They are usually flat plates, intended to be mounted as small screen pictures, carved out of white jade, incrusted with figure scenes or other details, inlaid with rubies, amethysts, lapis lazuli and emerald-green jadeite, they are cut in thin slices or set *en cabochon*, and are etched with gilded lines to complete the designs. The soft looking jade ground makes an inimitable foil for the brilliant colouring and flashing sheen of the inlaid jewels.

The Chinese term for Jade, *Yü*, covers a large range of stones including the Agate, Quartz, and Fluor families, in contrast to the accepted mineralogical classification of the present day European scientist, who confines the term Jade to three varieties, Nephrite, Jadeite and Chloromelanite : it is of the carvings executed by the Chinese in these last-named stones only that this book will treat. Nephrite is composed mainly of Silica and Magnesia, and is dependant for its green colour upon the amount of iron present, whereas Jadeite is composed mainly of Silica and Alumina, also obtaining its fine green colour from the presence of iron. Although both of these minerals are known as Jade, their individuality can easily be proved by the simple specific gravity test—Nephrite (sp. g. about 3.0) floating in a liquid of

[1] Legge, *Li Ki*, Vol. II, p. 12, and Couvreur, *Li Ki*, Vol. I, p. 698. Note " *Yü Ku Kuan*, Fishbone Jars."

PLATE IV

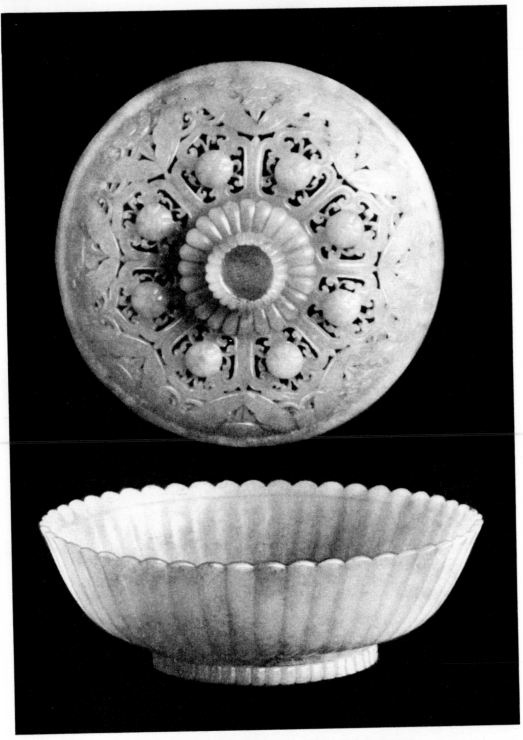

A TRANSLUCENT NEPHRITE BOWL AND COVER
With pierced floral and fluted decoration.
COLOUR: White and Green. Ch'ien Lung Period, A.D. 1736-1795. H. 8.5 c.m. Diam. 11.5 c.m.
(*In the Victoria and Albert Museum.*)

PLATE V

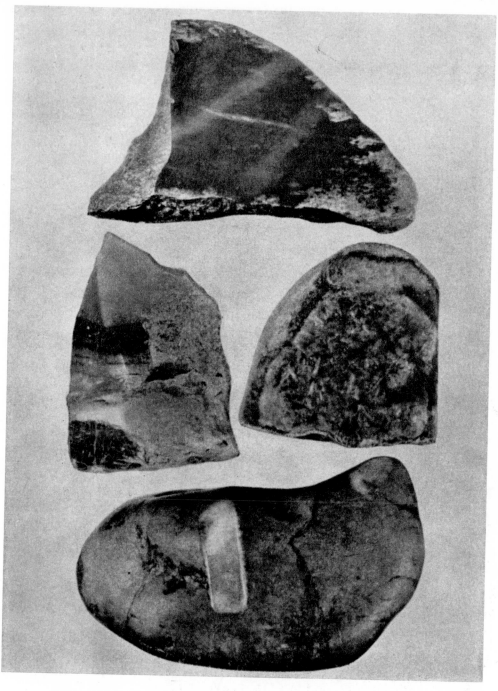

SPECIMENS OF ROUGH JADE IN THE GEOLOGICAL MUSEUM,
SOUTH KENSINGTON, LONDON.

1. NEW ZEALAND JADE (NEPHRITE). Part of a boulder of translucent green nephrite. The polished face shows brown marks at the edges due to weathering along the schistosity.
2. JADEITE-ALBITE ROCK. From the Jade mine, Uru River, Burma. Banded white and green jadeite and felspar.
3. BOULDER OF JADEITE, BURMA, polished. Very coarse felted crystals of grey-green Jadeite. Weathered at the outside, forming a crust of brown jade.
4. A TYPICAL BOULDER OF JADEITE, CHINA (or possibly imported from Burma). The white mark has been cut by a polishing wheel, to show the interior of white and green jade.

Reproduced from photographs supplied by the Director of the Geological Survey, by permission of the Controller of His Majesty's Stationery Office. (Crown Copyright.)

intermediate density, Jadeite (sp. g. about 3.33) sinking easily in the same liquid. Another test, unfortunately of a destructive character—though only a minute filing is necessary for its performance, is to note the behaviour of the minerals under heat. Nephrite becomes white and cloudy and fuses with difficulty to a grey slag ; Jadeite fuses easily even in an ordinary candle flame, colouring the flame a bright yellow, through the presence of sodium, which it contains in generous proportions.

A further and more definite test with a filing of the minerals may be made with the mineralogical microscope ; with this instrument the structural difference between Nephrite and Jadeite is quite apparent. For those interested in mineralogical research into the properties of Jade, reference to the works of Damour (1863) and of Dr. Max Bauer (1904) will supply useful information of fundamental importance. From these writings the following interesting analyses and data respecting the comparative hardness of the mineral are derived.

JADE
(Nephritoids)

Group		Group	
Amphibole		Pyroxene	
	Nephrite ($CaO.3MgO.4SiO_2$)	Jadeite ($Na_2O.Al_2O_3.4SiO_2$)	Chloromelanite
	per cent.	per cent.	per cent.
Silica	58.00	58.24	56.12
Alumina	1.30	24.77	14.96
Magnesia	24.18	0.45	2.79
Soda	1.28	14.70	10.99
Ferrous Oxide	2.07	—	6.54
Ferric Oxide	—	1.01	3.34
Lime	13.24	0.69	5.17
Potash	—	1.55	trace
Manganese Oxide	—	—	.47
Titanium Dioxide	—	—	.19
	100.07	101.41	100.57

The various hardness of different minerals is based on the comparative hardness between themselves and the scale known as Moh's Hardness Scale, which latter gives the following values for certain minerals :

1. Talc.
2. Gypsum.
3. Calcite.
4. Flourite.
5. Apatite.
6. Felspar.
7. Quartz.
8. Topaz.
9. Corundum (ruby, etc.).
10. Diamond.

Nephrite and Jadeite are relatively known as $5\frac{3}{4}$ and $6\frac{3}{4}$, and it is therefore clear that many writers have erred in referring to jade as being very hard. This mistake has probably arisen owing to the toughness of jade, and the consequent difficulty of carving it. It is best described as being very finely fibrous to compact aggregates, and to this fine uniform texture its wonderful tenacity is mainly due.

CHLOROMELANITE.

(Sp. g. 3.4. Hardness $6\frac{1}{2}$-7)

A black variety of Jadeite, obtained to-day in Burma, would appear to belong to the class to which Damour in 1865 gave the name "Chloromelanite." Recent research suggests that many black carvings dating from remote antiquity also come under this heading, and the reader is therefore referred to the analysis given here, from which it will be seen at once that there is a close relationship between this mineral and Jadeite ; Silica, Alumina and Soda being equally prominent in each. In fact it is a ferruginous and heavy variety of Jadeite. The discovery of an axehead in France first led to the introduction of this name, and interesting matter relative to this mineral will be found in standard books on Mineralogy. The exact situation of the mines or quarries from which the Chinese obtained this rock are unknown, but their use of the mineral is proved by several of the Black Jade carvings still extant.

LOCALITIES IN WHICH JADE IS FOUND

NEPHRITE.

Chinese Empire :

Eastern Turkestan.
Zillerthal in the Tyrol.
Transbaikalia.
New Zealand.
Jordansmuhl in the Zobten Mountains.

1. Little Bucharia.
2. In the region of Yarkand and Khotan.
3. On the slopes of the Kuen-Lun Mountains.
4. In the Nan Shan Mountains.

JADEITE.

Asia :

Upper Burma
Tawmaw
Uru Valley

{ Many specimens from here are included under the term " *Yü.*" }

Bhamo.
Gulbashen.
Kaskem Valley (Jadeite was quarried here by the Chinese prior to invasion, when they were driven out of Yarkand).

Canton was a great centre for jade from Burma and large quantities were also carved in Shanghai and Peking.

Notwithstanding their chemical differences, Nephrite, Jadeite and Chloromelanite are equally prized by the Chinese. They are esteemed among the most valuable of all jewels and are believed to embody qualities of solar light, and to communicate directly with heavenly powers by means of transcendental properties.

There are many works in jade which have descended from remote antiquity, while, on account of its inimitable decorative quality, it holds to-day a proud place among the precious stones of the world, and is often mounted in rich settings, even of diamonds.

In ancient times the Chinese Emperors announced their succession to the throne on five tablets of jade offered up on the altar of the great nature deities of Heaven and Earth.[1]

The idea that death is merely a protracted sleep and that the corpse may come to life was possibly the origin of one of the earliest Chinese rites, that of filling the mouths of the dead with jade, which stone was believed to be imbued with the vital energy of the *Yang* principle, and thus facilitated revival and retarded decomposition.[2] Koh Hung[3] says, " If there be jade in its nine openings, a corpse will not putrefy." Both the *Chou Li* and the *Li Ki* contain many references which confirm the importance of the use of jade in funeral rites.[4]

The Chinese believed that jade ornaments, worn on the person, induced good health. If they turned dull or broke, the person wearing them would meet with some misfortune, while children were safe-guarded from sudden shock by jade bracelets and anklets.

This veneration and esteem of the Chinese for jade is well expressed in the following quotation from their own immortal classic," The *Li Ki* ":—

> " Benevolence lies in its gleaming surface,
> Knowledge in its luminous quality,
> Uprightness in its unyieldingness,
> Power in its harmlessness,
> Purity of soul in its rarity and spotlessness,
> Eternity in its durability,
> Moral leading in the fact that it goes from hand to hand without being sullied."

In the *She King* (Book of Poetry)[5] one reads :—

> " Be cautious of what you say ;
> Be reasonably careful of your outward demeanour ;
> In all things be mild and correct.
> A flaw in a piece of white jade may be ground away ;
> But for a flaw in speech nothing can be done."

A Chinese proverb reads :—

> " If jade is not polished it cannot be made worth anything.
> If man does not suffer trials he cannot be perfected."

According to Chinese Mythology[6] the Unicorn appeared to the mother of Confucius, knelt before her and cast from its mouth a piece of jade, upon which was the inscription—" the son of the essence of water shall succeed to the withering Chou, and be a throneless king."[7] Thus we find jade used as the medium to convey the message of the gods.

[1] Laufer, *Fine Arts Journal*, June 1915 ; Chavannes, *Le T'ai Chan*, p. 22, et seq., ibid. p. 173.
[2] De Groot, *Religious Systems of China*, Vol. I, p. 269, 273, 274.
[3] An Alchemistic Author of the 4th century.
[4] *Li Ki*, Book XVIII, Beh-Ki, Part 1, p. 2, No. 31.
[5] *She King* (*Book of Poetry*), trans. Legge, Bk. III, Ode II, p. 513.
[6] *Annals of the Bamboo Books*, Legge's translation, p. 109.
[7] Doré, *Researches into Chinese Superstitions*, p. 672, and Legge, *Biography of Confucius*, Vol. I, p. 59, Note 5.

In the Mythological records we find, too, that the sacred stone was used for purposes other than art. In *Researches into Chinese Superstitions* by Doré, reference is made to the following story:

"About the year 314 B.C. K'üh-yuen,[1] also known by the name K'üh-p'ing, was Privy Councillor to Prince Hwai-wang, of the State of Ch'u, with whom he stood in high favour until ousted from his position by a jealous rival named Kin-shang who unjustly denounced him to the Sovereign. The disgraced minister found solace in composing the poem *Li-sao*,[2] by which he sought to reinstate himself into the prince's favour. Failing, however, to achieve his object, he resolved to end his miserable existence, and betook himself to the bank of the River Mih-lo,[3] where clasping a pebble of jade to his breast, he plunged into the stream. This suicide was enacted on the fifth day of the fifth Moon, and has been commemorated by the Chinese in the 'Dragon Boat' Festival."

Another story, which is recorded in the *Elucidation of Historic Annals*, also confirms the Chinese esteem for jade, and refers to jade amulets of animal and bird form as existing under the later Han dynasty (A.D. 58-76).[4]

Prince Liu-ying, younger brother of the Emperor Ming-ti, discovered that his fortune was enhanced by wearing jade amulets, in the form of cranes, of these he had many made both in gold and in jade, together with golden images of tortoises. Good fortune attended him until growing avaricious, he rose in rebellion against the ruler, was captured, stripped of all his worldly belongings, and banished. He committed suicide at Sia-tan yuan, in Ning-kwoh-fu on his way into exile.[5]

It is curious to note that Chinese carving in jade developed gradually from the purely mythological type, used in religious ceremonies, to a grotesquely symbolical type, derived from many influences, and similar in design to art-forms already existing in other parts of the world until, becoming utilitarian, it finally reached, during the Ch'ien Lung period, a high degree of decorative perfection.

It must neither be believed, nor imagined, that the only type of carving done by the Chinese in prehistoric days was in connection with the rite of burial. De Groot[6] states that: "The Emperor Wen-ti (179-156 B.C.) acquired a drinking cup of Jade, bearing the following inscription carved thereon: 'Master of Mankind, may thy life be prolonged to the great delight of this world.'"[7] Many similar references to still earlier dates are made by other authorities, notably Doré,[8] who has covered a wide field and produced a valuable book of reference on the Spiritual Beliefs of the Chinese.

1 *Writings by K'üh-yuen*, published in 17 Vols. in 1883.
2 Text, *Zottoli, Cursus Litteraturae Sinicae*, Vol. IV, p. 209.
3 A. Tschepe, *Histoire du Royaume de Tch'ou*, p. 322 (Note: *Variétés Sinologiques*, No. 22.)
4 See Legge, *The Chinese Classics*, Vol. V.
5 Doré, *Researches into Chinese Superstitions*, Vol. V, p. 706.
6 *The Religious System of China*, Vol. I, p. 272.
7 Compare Laufer, *Jade*, p. 297.
8 *Researches into Chinese Superstitions*.

In order to classify the carvings of different periods it is helpful to group the respective types under separate headings. For instance, those made primarily for use in the period of evolution must be distinguished from those which are merely copies of earlier designs. Again, the mythological products of any period must be distinguished from the purely æsthetic ; and these headings must be further subdivided. By so doing we shall be able to appreciate the subtle differences of technique between the works of each period. To assist us in this, reference, whenever possible, should be made to actual specimens, as well as to illustrations in order to effect a comparison of styles.

It is curious that the jade craftsman unfailingly allows some individual inbred artistry to reveal itself, and a mode, or characteristic trait, of his period is usually manifest in the work he creates. It is of course extremely difficult to discern exactly where any one particular dynasty merges into another, as there is no definite or sudden change of type ; differences in style, however, are discernible, as the author hopes will be apparent in the following chapters.

CHAPTER II.

ARCHAIC CARVINGS IN JADE.

FOR convenience the carvings of archaic type may be grouped into two main divisions : (1) those made prior to the Han Dynasty (206 B.C.); (2) those which followed immediately thereafter, up to the commencement of the Ming Dynasty (A.D. 1368).

The productions of the first division may be classified into four groups, viz. :—(a) Jade weapons and implements which may probably belong to an early " Stone Age." (b) Jades for Burial Ritual. (c) Jades for Court and Sacrificial purposes. (d) Jades serving as charms, tokens, or ornaments.

The dating of the pieces of the first main division presents considerable difficulty owing to the almost complete absence of archæological knowledge concerning them. In considering their chronology it is therefore necessary to accept some assistance from mythology ; to have due regard to the evidence afforded by modern geographical and mineralogical research,[1] and to study with minute care such significant characteristics as those of texture, surface and colour, as well as the form of the carvings themselves.

The jade used for the archaic carving was of two kinds, (a) that found in river boulders, and (b) that from rock-like formations which had not been affected by water for any length of time before being worked.[2] In certain cases it would seem that after carving, specimens were subjected to the action of heat or fire.[3]

It would appear that the Chinese from the earliest times were conservative in their choice of raw material for their carvings, and it may be significant that in many instances mineralogical classification agrees fairly closely with logical chronological classification.

Nephrite from different localities usually differs in colour. This feature taken in conjunction with the microscopic and chemical composition serves to determine the locality from which any particular specimen has come. The colour of nephrite depends upon the amount of iron present ; it is usually of some shade of green, brighter or paler according to the amount of iron present. In rare cases the mineral is practically colourless, but various tints of green are met with, including grey green, leek green, grass green and emerald green, also yellow, brown and grey, splashed with a bluish, reddish or greenish tinge.[4] According to recent mineralogical research it is possible to divide nephrite into three

[1] Dr. Bushell says, " It may be taken for granted that the jade used in prehistoric carvings in this material was generally obtained from local sources." *Chinese Art*, Vol. I, p. 138.

[2] " In the Pamir region jadeite occurs *in situ* in the valley of Tunga, a tributary on the left bank of the Raskem Daria. The quarries are situated about thirty or forty versts from the nephrite quarries in the Kasem valley. This deposit was at one time worked by the Chinese, but since the latter were driven from Yarkand the quarries have been abandoned." In the nephrite mines at Gulbashén, in the Karakash valley, jadeite has been found intermingled with nephrite. Mines of jadeite are situated in Mogoung near the river Uru, and in the form of rounded boulders or pebbles, it is also found in the debris of the Uru River ; but above Sabka on this river, it is entirely absent. (*Precious Stones*, Bauer, p. 468, par. 4.)

[3] *Investigations and Studies in Jade*, Bishop, Vol. II, p. 240.

[4] *Precious Stones*, Bauer, pp. 459-460.

divisions—(1) material quarried out of primary deposits; (2) material carried down from inaccessible heights by glaciers; (3) water-worn boulders from the ancient glacial deposits or from the later alluvial deposits of rivers.

It was on account of its toughness and durability that jade first attracted the attention of the Chinese carver, and it may be that the Neolithic discoveries in Ssu Ch'uan by Professor D. S. Dye,[1] whose collection is now preserved in the Union University Museum, Cheng-tu, will partially uphold a theory that a Palæolithic Age existed in China[2]— an assumption which may well lead us to conclude that the crudely formed spear-heads and weapons[3] usually assigned to the Chou Dynasty were of a much earlier epoch (see PLATE VI).

Carvings of a Spiritual or Religious character have been found in caves in the Valley of the Upper Yellow River and in excavations at the foot of the Kansu Hills,[4] whence there are specimens, in the form of large flat rings, suggesting a connection with the Six Sacrificial objects (the *Pi, Ts'ung, Kuei, Chang, Hu* and *Huang*)[5] which have been tentatively identified on evidence contained in the *Chou Li*.[6]

It would seem probable, therefore, although so far we have no definite proof thereof, that at some period following the Palæolithic Age a more advanced and cultivated race found in jade a substance fitted for the embodiment of their Spiritual beliefs, possibly on account of its apparent perpetuity and the appeal of its wonderful range of colours. This would explain the presence among sacrificial objects of certain elementary geometrical forms inspired possibly by the Astronomers,[7] to which belong the six sacrificial objects referred to on pp. 15 and 31.

Following such carvings as these, one would expect to find a more developed type of ritual symbol, and in this connection the *Ta Ts'ung*[8] (see PLATE VII) would seem to take its natural place. It is perhaps the first composite form found in jade and embodies the earliest fundamental religious beliefs of the Chinese. It took the form of a plain square prism enclosing a hollow cylinder, probably a combination of the circular *pi* and another form which may have been the *Chang*,[9] and was perhaps connected with the fertility deities of early Ancestor Worship.[10]

A peculiar feature noticeable in the *Ts'ung* is the imperfect drilling of its centre which, through its dual arrangement and opposition (charac-

[1] *Chinese Art*, by A. Silcock, p. 26.

[2] Dr. Laufer states that "the Chinese have never passed through an epoch which for other culture-regions has been designated as a stone age" (*Jade*, p. 29), but the evidence he produces by no means suffices to substantiate this statement. Cf. Dr. Cheng.

[3] Prehistoric axes and celts of jade have been found in both jadeite and nephrite. They are known as *yao chan*, or "medicine spades," and are supposed to be relics of the Taoist herbalists of mythological days. *Chinese Art*, Bushell, Vol. I, p. 138.

[4] *Preliminary Report on Archæological Research in Hansu.*

[5] Page 31 in this book.

[6] Biot, *Le Tcheou li.*

[7] Pope-Hennessy in *Chinese Art*, edited by Leigh Ashton, p. 92.

[8] Incorrectly described in the *Ku yü t'ou p'u* as wheel hubs of ancient jade chariots. Laufer, *Jade*, p. 125.

[9] Dame Una Pope-Hennessy, referring to the *Chang* says, "its shape as known to-day admittedly only comes from the 3rd century B.C." (*Chinese Art*, edited by Leigh Ashton, p. 92.)

[10] See article on the *Ts'ung* by Professor Karlgren, "Some Fecundity Symbols in Ancient China": in the *Bulletin* of the Museum of Far Eastern Antiquities, Stockholm.

teristic of heavenly bodies when 180 degrees apart), is undoubtedly of great symbolic importance, embodying an attempt to portray the *yin* and *yang* principle of creation. Considering the skill displayed in the drilling and decoration of many jades assigned to the Chou Dynasty, it would appear that the plain Huang *Ts'ung* originated at a much earlier date (PLATE IX). If we accept this latter theory, we shall be able to understand how it was that during the Shang Yin Dynasty the carver was able to produce examples of the *Ts'ung* ornamented with the *Pa Kua*, or eight trigrams, a device said to have been introduced by the mythical Emperor Fu Hsi, 2953 B.C.,[1] also the flat type of animal and bird representation, of which perhaps the Tiger[2] and the Dragon were the first.

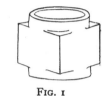

FIG. 1 shows an example of the plain *Ts'ung* of the Shang Yin or an earlier period, reproduced from Wu Ta Ch'êng's book,[3] and described therein as " a *Huang Ts'ung*, 18.9 c.m. high ; carved in a Yellow Jade bearing red spots."

FIG. I

FIG. 2 shows the decorated type of *Ts'ung* of the Chou Dynasty, described by Wu Ta Ch'êng as a *T'su-ts'ung* 11.5 c.m. high, carved in " White Jade bearing black veining."

FIG. 2

Burial jades may have originated at the time of the Chou Dynasty. They are referred to in the *Chou Li*[4] as follows : " The steward of the treasury was entrusted with looking after these interesting pieces. . . . He fastens silken cords through the apertures with which these pieces are perforated. These are the *Kuei*, the half *Kuei*, or *Chang*, the circular disc *Pi*, the jade tube *Ts'ung*, the tablet in shape of a tiger *Hu*, and the tablet in shape of a half circle *Huang*. The Steward removes the circular disc *Pi* from the tube *Ts'ung*. The objects are thus arranged to be deposited with the corpse and when the body is placed in the coffin, the *Kuei* is to the left, the half *Kuei* is at the head. The tablet in the shape of a *tiger* is to the right. The tablet in shape of a half circle is at the feet. The circle disc is under the back. The jade tube *Ts'ung* is on the abdomen. In this way, one figures a representation of the *Fang-Ming* or brilliant cube which serves as an emblem in the sacrifices. The circular disc *Pi* and the octagonal tablet *Ts'ung* are by their separation, symbolical of Heaven and Earth."

According to the Chinese philosophical belief[5] " the universe is a compound of an infinite number of *Kwei* (the material soul) and *Shen* (the superior soul) continuously infused into men and animals. In ancient times, the Chinese knew but the *Kwei*; the *Shen* came later. The *Kwei* emanated from the earth, and returned thereto after death, remaining with the body in the grave. The *Shen*, or superior soul, emanated from the ethereal part of the cosmos and constituted the

[1] Legge, *The Great Plan*, p. 323.
[2] Laufer, *Archaic Jades in the Bahr Collection*, p. 37.
[3] Ku yü t'u k'ao, *Illustrated Study of Ancient Jades*, published 1889.
[4] Biot, Vol. I, p. 490.
[5] De Groot, *Religious System of China*, Vol. IV, p. 5. (The Soul in Philosophy.)

15

great *Yang* principle. It was made manifest by the *K'i* or breath. After death ' the superior soul ' ascends to the higher regions, there to live on as lucid matter, *Shen-ming*. The *hwun* is the energy of the *Shen*."

Does not this learned explanation throw light on the animal, bird, fish and figure representations as distinct from the burial jades ? It may well be that the conception of the former was partly due to this interpretation of life and death : the carver evolving, from the dictates of a diviner, his various forms for burial with the body. If we can accept the importance of the various animals and birds, as recorded in Mythological writings, it seems probable that the forms of the jade carvings conform strictly to the traditional characters of the different creatures. Beal[1] tells us the Chinese believe that a person who, a short while after the death of any one, examining carefully that part of the body which remains warm the longest, can divine what character and form the spirit just departed will occupy in its next incarnation. This reasoning supplies a partial explanation of the highly stylised character given to the human form in many jade carvings (see PLATE XI) : the suggestion being that the deceased who is there imaged will return to Earth as a god, hence his portrayal in a form largely devoid of human characteristics.

Mr. W. A. Thorpe when dealing with this subject in an admirable article on the Jades in the Rutherston Collection in the South Kensington Museum,[2] writes that " worship, being emotionally[3] grounded, required a concrete apparatus. Thus the logical bias passed from astronomy, through worship, into the design of ritual objects, and thence to pure decoration."

Dame Una Pope-Hennessy says that " One dynasty destroyed the art of another in China and it is supposed that many Shang-Yin objects were broken up in Chou days, but the great bugbear of the student of early Chinese jades is Shih Huang Ch'in or Ch'in Shih, the Napoleonic character thrown up in the 3rd century B.C. by the most influential of the states of the Chou Empire, the Duchy of Ch'in."[4] This in fact refers to the period of the Warring States and marks the commencement of a new era in the study of Archaic Jades.

[1] Beal, *A Catena of Buddhist Scripture from the Chinese*, p. 41.
[2] *Burlington Magazine*, Vol. LV, No. CCCXX, November 1929.
[3] Cf. *Li Chi*, ed. Couvreur I, 58.
[4] *Jades*, p. 92-93, *Chinese Art*, edited by Leigh Ashton.

PLATE VI

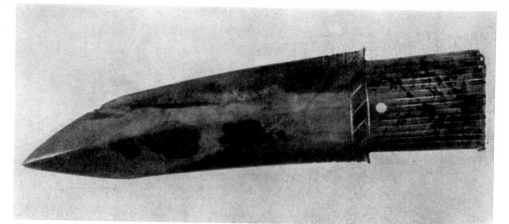

A JADE RITUAL KNIFE

Colour: Light Green, speckled Black. Shang-Yin Dynasty, 1766-1122 B.C. L. 35 c.m.
(In the Eumorfopoulos Collection, British Museum.)

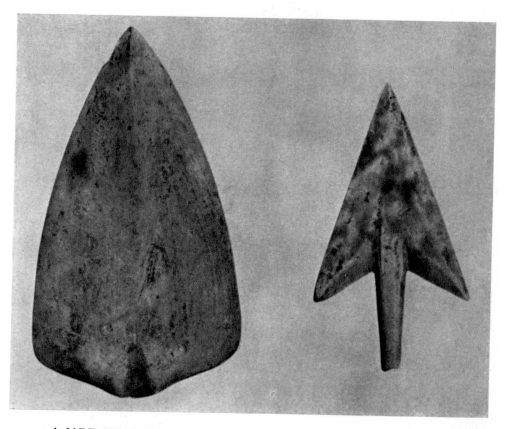

A JADE SPEAR HEAD

Colour: Grey Green speckled Black.
Period of the Spring and Autumn Annals.
722-481 B.C. L. 10.5 c.m.
(In the Collection of Chang Nai-Chi, Esq.)

A JADE ARROW HEAD

Colour: Grey Green with light and
dark shadings. L. 8.3 c.m.
Han Dynasty, 206 B.C.-A.D. 220.
(In the Collection of Chang Nai-Chi, Esq.)

PLATE VII

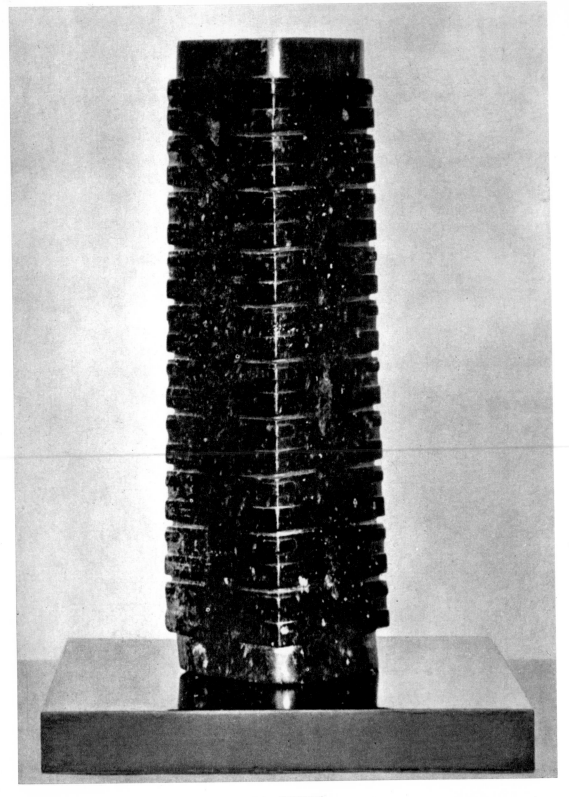

TA TS'UNG

Decorated across the four corners with ten separate rectangular fields of relief carvings with ornamentation of three horizontal bands close together, two circles above them and a shorter band above the circles. In several of the short bands traces of a design of groups of alternately horizontal and vertical lines are faintly visible. Down the centre of each side runs a 1.20 c.m. wide flat groove. Chou Dynasty, 1122-249 B.C.

COLOUR: Dark green speckled with dark and light brown marking. H. 29.25 c.m.

(In the Collection of D. Abbes, Esq., Greenwich, Conn., U.S.A.)

PLATE VIII

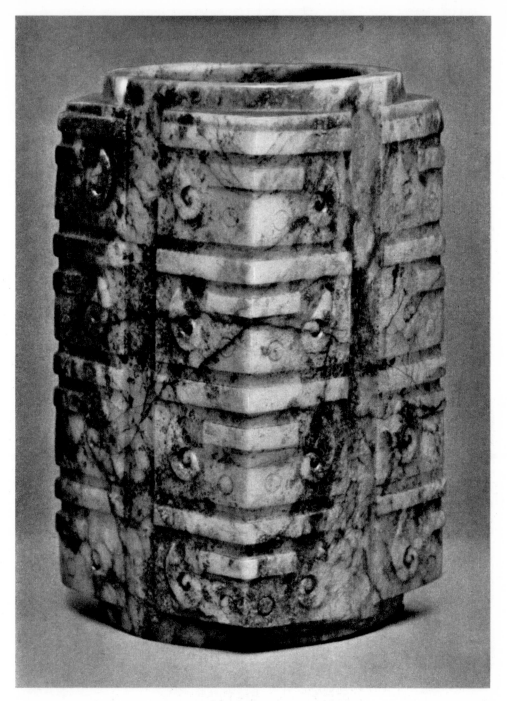

A JADE *TS'UNG* RITUAL EMBLEM

Colour : Green, splashed Brown and Black markings. H. 14.5 c.m. W. 7.5 c.m.
Chou Dynasty, 1122-249 B.C.
(*In the Eumorfopoulos Collection, Victoria and Albert Museum.*)

PLATE IX

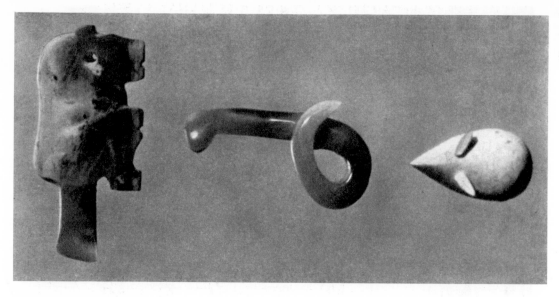

A JADE CARVING OF
THE MONKEY

COLOUR: Green, splashed bone
shadings. L. 5.2 c.m.
Chou Dynasty, 1122-249 B.C.

A JADE CARVING OF THE SNAKE

COLOUR : Pale Green and Brown. L. 4.3 c.m.
Sung Dynasty, A.D. 1127-1279.

A JADE CARVING OF
THE RAT

COLOUR : Bone. L. 2.6 c.m.
Chou Dynasty, 1122-249 B.C.

(All in a Private Collection, U.S.A.)

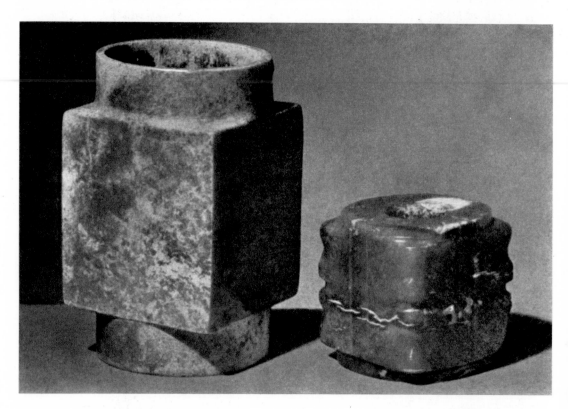

A JADE *HUANG TS'UNG*

COLOUR : Pale Green covered with a Bluish sheen and
earth markings. H. 6.9 c.m. W. 4 c.m.
Early Chou Dynasty, 1122-722 B.C.

A JADE *TSU-TS'UNG*

COLOUR : Pale Green splashed Reddish Brown
and Grey weathering. H. 3.5 c.m. W. 3.2 c.m.
Late Han Dynasty, A.D. 25-220.

(Both in the Collection of A. W. Bahr, Esq.)

PLATE X

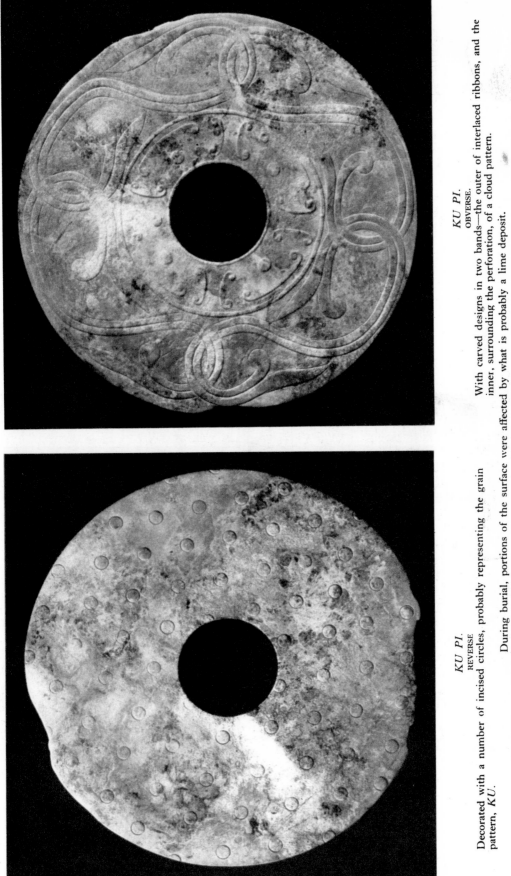

KU PI.
REVERSE

Decorated with a number of incised circles, probably representing the grain pattern, *KU*.

KU PI.
OBVERSE.

With carved designs in two bands—the outer of interlaced ribbons, and the inner, surrounding the perforation, of a cloud pattern.

During burial, portions of the surface were affected by what is probably a lime deposit.

COLOUR : Greyish blue. Chou Dynasty 1122-249 B.C. Diam. 34.20 c.m. Diam. of perforation, 8.40 c.m.

(*In the Collection of D. Abbes, Esq., Greenwich, Conn., U.S.A.*)

PLATE XI

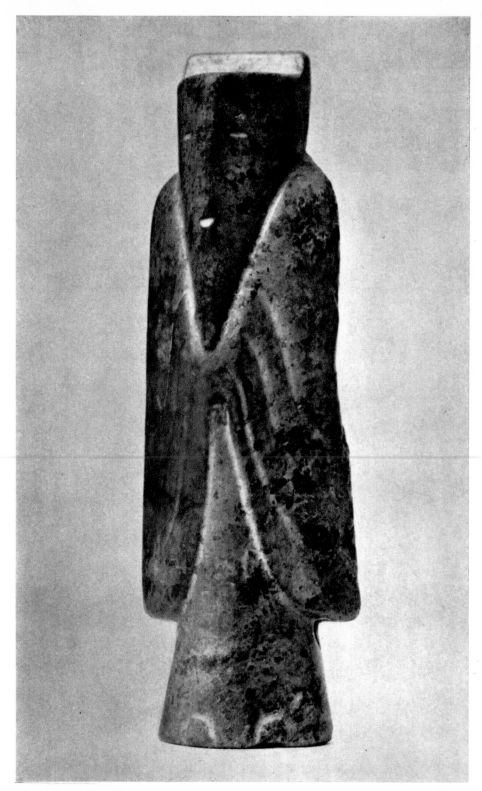

A HIGHLY STYLISED HUMAN FIGURE IN NEPHRITE

COLOUR : Grey Green, mottled Black and Brown. H. 16.5 c.m.
Early (Western) Chou Period, 1122-722 B.C.
(*In the Eumorfopoulos Collection, British Museum.*)

CHAPTER III.

ARCHAIC RITUAL SYMBOLS AND IMPERIAL EMBLEMS UP TO THE HAN DYNASTY.

IT may assist the reader to a fuller understanding of the meaning and significance of the various designs met with in archaic jades if we briefly consider, in the light of recent research, certain specimens illustrated in the Chinese work *Investigations into Ancient Jades*,[1] by General Wu Ta Ch'êng. The author of this remarkable book was a military officer of high rank in the Chinese army, who had made a lifelong study of jade carvings of which he possessed many examples, a number of which, after his death, were acquired by the Field Museum in Chicago[2] and by various private collectors. The most outstanding specimens in his collection are illustrated in his book, in a series of woodcut engravings which bear evidence of having been prepared with minute care. It is from these engravings that the figures included in this chapter have been reproduced, mostly to a reduced scale.

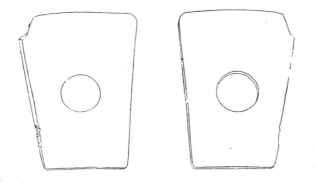

FIG. 3

JADE HAMMER SHAPED RITUAL SYMBOL
Dark Green Jade mottled in various colours.
H. 23.5 c.m.

This specimen, FIG. 3, is identified by Wu through the medium of the *Chou Li*,[3] where a similar form is described as " a tablet of the Son of Heaven with a *pi* in the centre." Wu, however, is of the opinion that it is actually the *Chên Kuei*, the symbol of imperial sovereignty. Dr. Laufer agrees with this opinion, suggesting that its form may be derived from a ceremonial axe. I prefer to accept the interpretation of the

[1] Published in Peking in 1889 and now extremely scarce. The personal copy of Wu Ta Ch'êng's book has been used for reference during the compilation of this book, all quotations and reproductions of drawings having been made therefrom.

[2] The Collection of Archaic Jades in the Field Museum may be considered to be in two distinct parts :
 (a) Those acquired from Mr. A. W. Bahr and tabulated " Bahr Collection."
 (b) Those acquired from various sources unnamed.
Unless otherwise stated reference made to archaic Jades in the possession of this Museum throughout this book refer to specimens under catagory (a).

[3] Biot, Vol. II, p. 522.

Chou Li, as this would seem to fit in more logically with its character. This view is partially supported by De Groot,[1] who refers to a symbol of similar type being used in early solar worship.

Wu's specimen appears to combine both ritual and martial characteristics, derived possibly from a stone weapon[2] and a ritual *pi*, its religious significance being suggested by the malformation of the chamfered upper left corner, a peculiarity which may be of significance parallel to the imperfect drilling of the *Ts'ung*,[3] the example thus forming a connecting link between the productions of an early Palæolithic Age and those of a highly cultivated ritualistic people of a later period prior to the Chou Dynasty.[4] In fact it may well be the symbol from which the *Ts'ung* was later evolved. I have discussed with Mr. A. W. Bahr the possible explanation of the defacement noticeable in many early ritual jades, and he is in agreement with me in thinking that this had a religious significance. It is of interest to note that the black jade ritual-knife of the Chou Dynasty, possessed by Mr. Bahr, which is perhaps one of the finest of its kind in European hands, is definitely and deliberately defaced. (See PLATE XIII.) An example possessing similar characteristics is found in the Eumorfopoulos Collection (see PLATE XII).

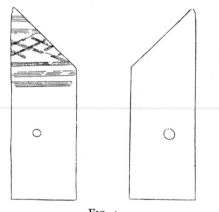

FIG. 4
JADE TABLET *CHANG* ?
Green Jade with russet spots.

This specimen (FIG. 4) is considered by Wu to be the *Chang*.[5] Dr. Laufer says that it may be the *Pien Chang*.[6] Its form and character would rather suggest the *kuei*, which is described by Pan Ku in the *Po hu*

[1] De Groot, *Religious System of China*, Vol. VI, p. 1172.
[2] Cf. *Archaic Jades in the Bahr Collection*, Plate VIII, No. 2.
[3] See p. 32.
[4] Compare the Chou Chisel illustrated in Plate VIII, of *Archaic Jades in the Bahr Collection*.
[5] "The *Chang*" according to early Chinese records is a tablet of Jade emblematic of Imperial power divided into four types : the *Ta Chang* 9 inches long, the *Chung Chang* 9 inches long, the *Pien Chang* 7 inches long, and the *Ya Chang* bearing a tooth-like protrusion. See *Chou Li*, Vol. II, p. 527. *Biot and She King* (ed. Legge, Vol. II, p. 306).
[6] "The *Pien Chang*" according to the *Chou Li* was the emblem used by the Emperor in the Public Worship to the Mountains and Rivers during the third or Autumn Sacrifice. See Bushell, *Oriental Ceramic Art*, p. 120 ; p. 5, "A set of 16 of different sizes and thicknesses form the *Pien Ch'ing*, or 'Stone Chime.'" Did Dr. Laufer unconsciously connect this specimen with this very ancient musical instrument ?

t'ung as a " tablet pointed above and angular below, the tapering part signifying the male principle *Yang*, and the lower portion (or oblong part) the female principle *Yin*."[1] The hole in the centre of the lower rectangular section, points to the same ritual significance as that of the *pi*. The decoration on the " male " or pointed end is suggestive of the trigrams,[2] which are themselves fundamentally related to the *Yang* and *Yin* principle. This decorated object has a similar imperfection on the left side of its pointed end. These peculiarities which have obvious connections with early Chinese ritual lead one to conclude that this carving was a very early rendering of the *Kuei*, for in the *Chou Li*, Chapter XVIII, we read " with the yellow jade tube *ts'ung*, he does homage to Earth. With the green tablet *Kuei*, he rendered homage to the region of the East."[3] In an intensive search through several collections of Archaic Jades, I have been unable to find but few similar specimens.[4]

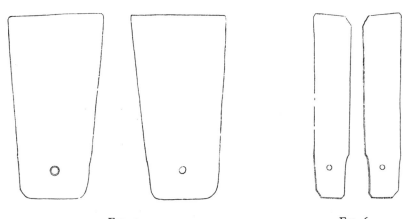

FIG. 5

TS'ING KUEI?
Dark or Green Jade.
H. 29.8 c.m.

FIG. 6

TA KUEI
Dark Green and Black Jade.
H. 25.8 c.m.

Wu gives no explanation of the significance of the specimen illustrated in FIG. 5. Dr. Laufer suggests that it may be the *Ts'ing kuei* which derived its form from the axe.[5] I am of opinion that the specimen is more probably the *Ta kuei*, which has been described by Biot[6] as a large tablet with hammer-shaped head, three feet long,[7] used exclusively by the Emperor, and carried by him attached to his girdle. A comparison of FIG. 5 with FIG. 6 suggests that this type later became modified to conform more closely with the accepted description of the

[1] Laufer also quotes *Pan Ku*, p. 99.
[2] Mayer's *Chinese Reader's Manual*, p. 333, and Legge's *Yi King in Sacred Books of the East*, Vol. XVI (Oxford 1882).
[3] Biot, Vol. I, pp. 434-435.
[4] An unadorned example of this form is in the Collection of M. Vignier, Paris. It is 20.5 c.m. in length and reputed to be of the Chou Dynasty. See *Chinesische Kunst*, No. 163.
[5] Laufer, *Jade*, p. 96.
[6] Biot, Vol. I, p. 484, and Vol. II, p. 522.
[7] Laufer, *Jade*, p. 91, where he upholds Wu as to the length of the symbol, and tells us that the old measure compared with the measure of to-day is as 1 to 3 in units.

kuei as given in the *Chou Li* (see PLATE XIII), where we read " the green tablet *kuei* was used to render homage to the region of the East " and was " pointed like a lance head." The absence of decoration on these specimens would certainly uphold the assumption that they were used in a ritual manner.[1]

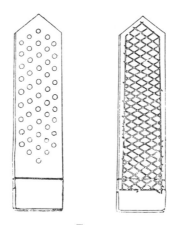

FIG. 7
KU KUEI
Green Jade with Black spots.
H. 13.5 c.m.

Wu identifies this specimen (FIG. 7) with the *Ku kuei*, which is described as a " tablet of grains,"[2] seven inches long ; given by the emperor as a talisman to his bride.[3]

Dr. Laufer expresses the opinion that it derived its form from a spear, and attempts to establish further Wu's deductions.[4] The general form and decoration of the specimen which bears a strong resemblance in design and character to the *Fang Sheng*[5] would certainly lead one to imagine that it is inspired both by the Jade *Chang* (FIG. 4) and the *Ta kuei* (FIG. 6). The presence of decoration and the absence of a hole suggests that the object was not associated with ritual or worn emblems.[6]

The specimen shown in FIG. 8 is not commented upon by Wu. Dr. Laufer suggests that it derives its form from a knife-shaped implement[7] probably dating from the Shang Dynasty.

The example bears a strong resemblance to that shown in FIG. 10. The hole, however, is not placed in the central or ritual position, which would suggest that it is the earlier form of the later *Chên kuei* (FIG. 9),

[1] Legge, Vol. I, p. 400. Couvreur, Vol. I, the *Li Ki*, p. 549. " Acts of the greatest reverence admit of no decoration."
[2] (a) Bushell, *Oriental Ceramic Art*, p. 110. " *Feng Mi* " grains of rice, often represented on pierced medallions of ancient jade, the earliest tokens of value in China. (b) *La Céramique Chinoise* by Grandidier, Pl. 11, 7.
[3] Biot, Vol. II, p. 525.
[4] Laufer, *Jade*, pp. 97-99.
[5] Bushell, *Oriental Ceramic Art*, p. 120.
[6] Legge, Vol. I, p. 400.
[7] Laufer, *Jade*, p. 99.

20

which both Wu and Laufer consider to be of the Chou Dynasty. It is perhaps the ritual symbol transformed for the first time into an Imperial emblem, which later took the form shown in FIG. 9. Its

FIG. 8

FIG. 9
CHEN KUEI
Dark Green Jade

previous connection with religion being indicated by the presence of the upper left defaced corner. The imperfect drilling of the hole in the earlier form is all significant.

Wu identifies the specimens in FIGS. 9, 10 and 11 as *Chên kuei*, but Laufer considers this classification premature, owing to the lack of the

FIG. 10
CHÊN KUEI
Dark Green with Black
spots.

FIG. 11
CHÊN KUEI
Red.

former implement characteristics and also to the absence of the large central hole. These peculiarities, however, would appear to confirm Wu's classification, for the examples are no longer purely ritual symbols but emblems associated with the Emperor, the imperfect drilling[1] and defaced surface[2] of FIG. 10, and the defaced corner in

[1] Symbolising the *Yin* and *Yang* principle.
[2] Significant of human faults and failings.

21

FIG. 11, being reminiscent of their former ritual significance. Biot[1] tells us that the *Chên kuei* is a tablet of power, measuring one foot two inches long, the use of which is confined solely to the Emperor, who carried it in his hands on ceremonial occasions.[2] It will be noticed that both pieces are unadorned, which suggests some connection with ritual. The orange-coloured jade *kuei* belonging to Mrs. E. Sonnenschein, shown at the recent Exhibition of Chinese Art[3] at Burlington House, is of similar character (PLATE XIII).

FIG. 12	FIG. 13
CHANG ?	*YEN KUEI.*
(Possibly the Yen kuei)	Colour Black.

Wu does not express any opinion concerning this specimen (FIG. 12). Dr. Laufer, however, suggests that it may be derived from some earlier form of implement, and dates possibly from the Shang-Yin Dynasty. He further attempts to connect it with the *Chang*[4] through the medium of Chang Pang-ki's book, the *Mo chuang man lu*.[5] If we compare the *Yen kuei* (FIG. 13) identified by Wu, with the *Chang* (FIG. 12) established by Laufer, a most noticeable development of form is apparent, and I believe this type of *Chang* is probably the earliest form of the later *Yen kuei*, described by Biot[6] as a pointed tablet which possesses the virtue of changing conduct or destroying depravity. It was sent by the Emperor (by messenger) as an emblem of warning, or token of disfavour, to a feudal prince suspected of wrong doing. An excellent example of the *Yen kuei* which was found during excavations at Yu-Lin-Fu (border of Honan Province) is shown in PLATE XVI.

Wu identifies the specimens depicted in FIGS. 14 and 15 as *Yüan kuei*, described by Biot[7] as " a rounded tablet nine inches long, fastened by

[1] Biot, Vol. I, p. 484.
[2] Legge, Vol. I, p. 400.
[3] Specimen 297, *Chinese Art Exhibition Catalogue*, p. 10.
[4] Laufer, *Jade*, p. 100.
[5] Published *circa* A.D. 1230 and containing 10 chapters, revised and reprinted A.D. 1800 as part of the *Shua Ling*, 30 Vols.
[6] Biot, Vol. I, p. 491, and Vol. II, p. 524.
[7] Biot, Vol. II, p. 523, Vol. I, p. 491. *Chou Li*, p. 83.

a silken band, used to regulate virtue." These emblems were used by the emperor as a token of esteem and reward to worthy princes.

FIG. 14
Dark Green.
30.4 c.m.

YÜAN KUEI

FIG. 15
Dark Green with earth
spots.
30.0 c.m.

FIG. 16. This specimen is identified by Wu with the piece referred to in the *Chou Li* as the *Ya-Chang*,[1] " a tablet with a tooth which serves to mobilise troops and to administer the military posts."

In my opinion it would appear more likely to be one of the five tablets of jade used ceremoniously by the Chinese Emperors in announcing their succession to the throne.

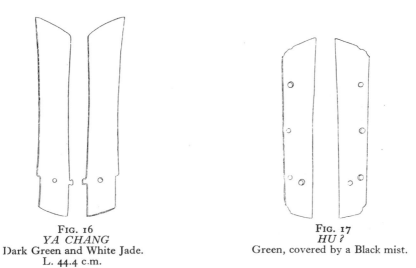

FIG. 16
YA CHANG
Dark Green and White Jade.
L. 44.4 c.m.

FIG. 17
HU ?
Green, covered by a Black mist.

FIG. 17 described by Wu Ta Ch'êng as being carved in " Green Jade covered by a black mist," and dated by him as from the Chou Dynasty. It has been considered by some authorities to be an Imperial writing Tablet (*Hu*), and has therefore been erroneously connected with the

[1] Biot, Vol. II, p. 527.

23

equipment of the Scribe. This emblem[1], an exceptional example of which is in the Collection of Mr. A. W. Bahr, is illustrated in PLATE XIII, would seem more likely to be another type of the five tablets in jade just referred to, and, considered in this light, conforms fairly closely to the reference to these objects in the *Li Ki*.[2]

FIG. 18 is described by Wu Ta Ch'êng as being carved in " A yellow Jade with carnelian markings." A similar excellent example is in the Collection of H.R.H. The Crown Prince of Sweden, illustrated in PLATE XII. This type appears to conform with the description of the Ancient Dance Axe[3] referred to in the *Li Ki* (Ming Tang Wei 9)[4] and used by the Emperor during the ritual to Chou-Kung in the royal temple.

FIG. 18

IMPERIAL INVESTITURE TABLETS

Biot[5] tells us that special workmen called " Jade men " were employed by the Emperor to carve the Imperial tablets and, further, that the Imperial symbol was regulated in design, dimensions and colour,[6] corresponding to the rank of its bearer, thus, that used by the Emperor was of white jade and the others of various distinguishing colours. The characteristics and purpose of the tablets are as follows :

FIG. 19 FIG. 20 FIG. 21

A *Mao Kuei* : a short cube of jade, each side four inches long with an arched shaped section cut out on the lower face,[7] used by the Emperor at an investiture in the same manner as a capping sword.

[1] Compare *Chinese Exhibition Catalogue* (London), No. 288.

[2] During the Han Dynasty this emblem seems to have been supplemented by the *Hwuh* (Plates XIV and XV), a tablet three feet long, held before the breast by courtiers during their audience with the Emperor. A practice which continued up to the close of the Ming Dynasty.

[3] Compare Laufer, *Archaic Jades in the Bahr Collection*, Plate IX, No. 1.

[4] " The Emperor took a red lance and a Jade Axe " (see page 42).

[5] Biot, Vol. II, p. 519, Vol. I, p. 483.

[6] Biot, Vol. II, p. 521.

[7] *Ibid*, p. 520, and *Ku ming*, 23rd ed. Couvreur, p. 356.

Huan kuei :	a " pillar tablet," nine inches long, used as an investiture tablet for a feudal prince of the first rank[1] (see FIG. 19).
Sin kuei :	a narrow pillar tablet, seven inches long, used as an investiture tablet for a feudal prince of the second rank (see FIG. 20).
Kung kuei :	a curved tablet seven inches long, used as an investiture tablet for a feudal prince of the third rank (see FIG. 21).
Pi :	a perforated circular disc with grain pattern, used as an investiture tablet for a feudal prince of the fourth rank (see FIG. 22).
Nan ·	a jade disc, ornamented with the emblem of rushes, used as an investiture tablet for a feudal prince of the fifth rank (see FIG. 23).

FIG. 22 FIG. 23

FIGS. 22 and 23 are reproduced from the *Li Ki* and appear somewhat flamboyant in character. The reason for this may possibly be explained by the commentator having based his drawing upon the original inspiration of the decoration of these discs, rather than from an actual jade emblem. The *Li Ki* states that female plants of Hemp were offered to the Gods[2] during the ritual sacrifices, and as most of these emblems appear to have been evolved from previous ritual objects, it seems feasible that those bearing decoration should have had their decoration inspired from the same source. Under these circumstances the *Pi* investiture tablet of the feudal princes of the fourth rank is most likely similar in character to the gray jade disc in the Collection of Mr. H. Hardt, Berlin,[3] and the *Nan* investiture tablet of the feudal princes of the fifth rank is similar to the jade disc in the Field Museum,[4] the decoration thereon suggesting the bark of the Hemp-palm embodied in the archaic rendering of the thunder symbol. FIG. 24 represents a similar type of carving described by Wu Ta Ch'êng as covered " with earth coloured markings," the decoration being described by Laufer as the " sleeping Silkworm Cocoon Pattern."

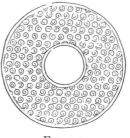

FIG. 24

[1] Laufer, *Jade*, p. 84.
[2] Page 42 in this book.
[3] *Chinesische Kunst*, No. 154.
[4] Laufer, *Archaic Jades in the Bahr Collection*, Plate XII.

25

PLATE XII

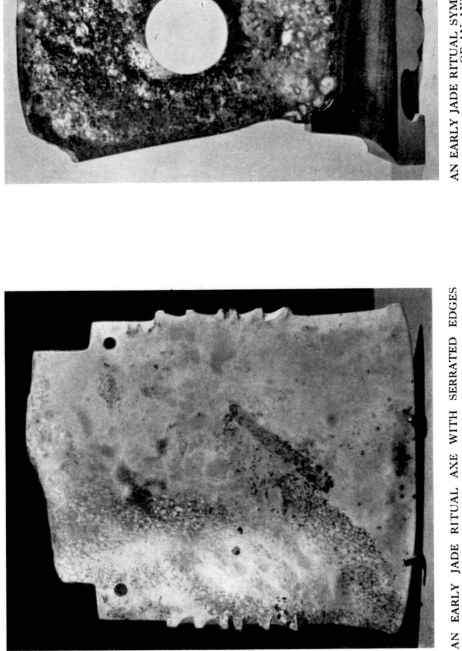

AN EARLY JADE RITUAL SYMBOL IN THE FORM
OF AN AXE

COLOUR: Dark Green with Black and Grey shadings.
Early Chou Dynasty, 1122–722 B.C. H. 24 c.m. W. 17.6 c.m.
(In the Eumorfopoulos Collection, British Museum.)

AN EARLY JADE RITUAL AXE WITH SERRATED EDGES

COLOUR: Grey Green, mottled Black and Brown markings.
Early Chou Dynasty, 1122–722 B.C. H. 14.6 c.m. W. 12.3 c.m.
(In the Collection of H.R.H. The Crown Prince of Sweden,
and included by the permission of His Royal Highness.)

PLATE XIII

A JADE *KUEI*, SYMBOL OF AUTHORITY

COLOUR : Orange, shaded Green and Black. L. 30.5 c.m. W. 7.2 c.m.

Early Chou Dynasty, 1122-722 B.C.

(In the Collection of Mr. and Mrs. Edward Sonnenschein.)

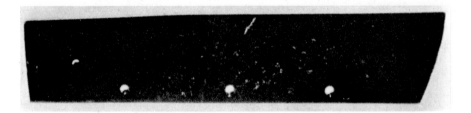

AN EARLY JADE KNIFE

COLOUR : Black. L. 43.2 c.m. W. 9.5 c.m.

Early Chou Dynasty, 1122-722 B.C.

(In the Collection of A. W. Bahr, Esq.)

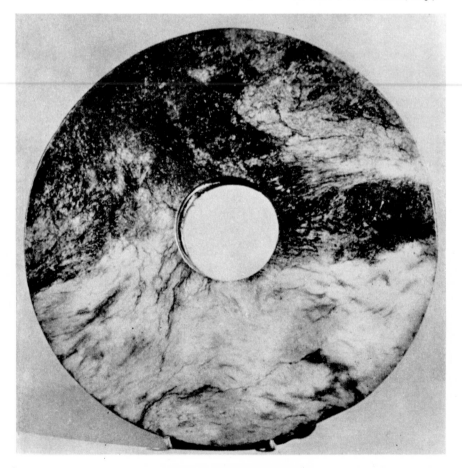

A JADE *PI* OR RITUAL DISC

COLOUR : Black and Green. Diam. 21.8 c.m.

Shang Yin Dynasty, 1766-1122 B.C.

(In the Eumorfopoulos Collection, British Museum.)

PLATE XIV

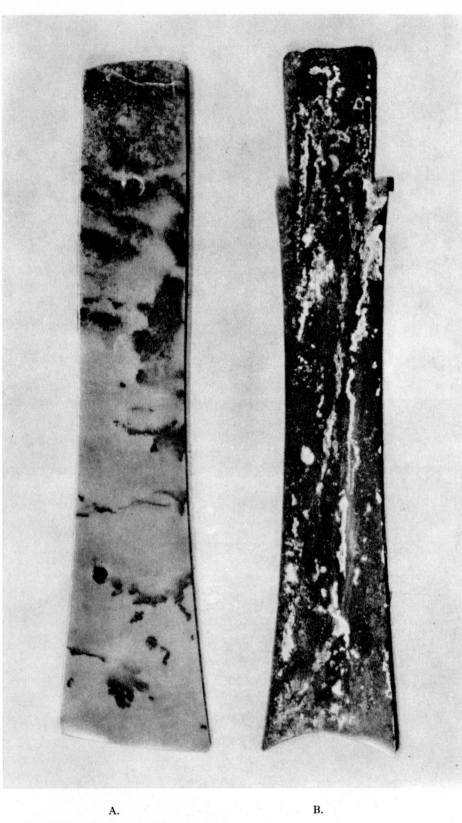

A. B.

A. A JADE *HWUH*, carved in Cloud Jade.
 COLOUR: Pinkish Grey Green, mottled Black and dark Green shadings.
 Han Dynasty, 206 B.C.-A.D. 220. L. 31.7 c.m.

B. AN EARLY JADE *YA-CHANG*. Found during excavations at Yu-Lin-Fu in Honan
 Province.
 COLOUR: Sage Green covered with earth markings. Chou Dynasty 1122-249 B.C.
 L. 32.1 c.m.

(*Both in the Collection of A. W. Bahr, Esq.*)

PLATE XV

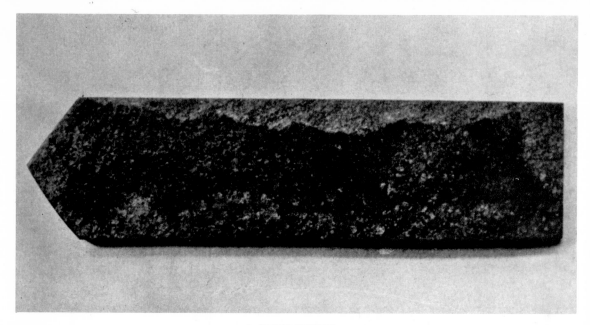

A JADE *HWUH*
Bearing symbolical gash defacement.
COLOUR : Grey Green, flecked and streaked with Black, Grey, Fawn, Orange and Brown.
Han Dynasty, 206 B.C.-A.D. 220. L. 24 c.m. W. 6.7 c.m.
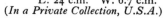
(*In a Private Collection, U.S.A.*)

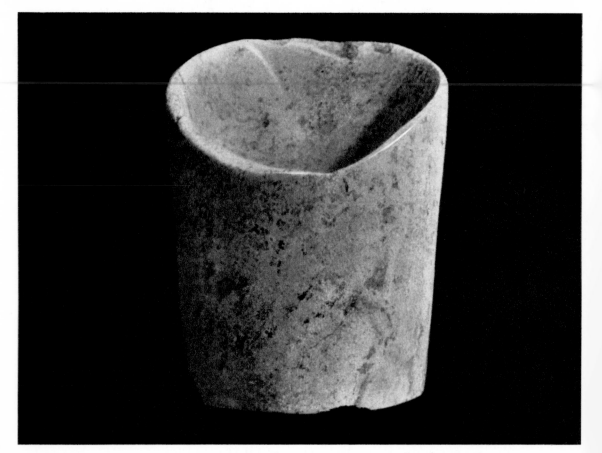

AN EARLY JADE SACRIFICIAL GRAIN-SCOUP (*TIAO-TSUAN*)
Probably used to scoup up the corn for the offerings made to the God of Agriculture during the Spring and Winter
Festivals.
COLOUR : Bone with Earth markings. H. 9.5 c.m. W. 7.7 c.m. Breadth 5.3 c.m.
 Chou Dynasty, 1122-249 B.C.
(*In the Collection of A. W. Bahr, Esq.*)

PLATE XVI

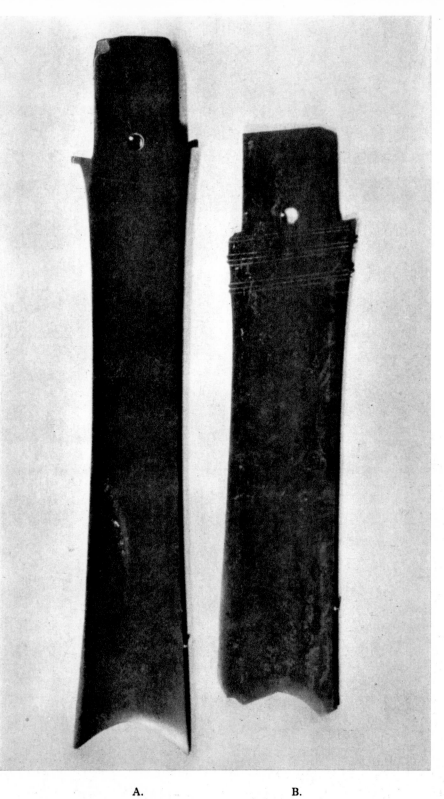

A. B.

A. A JADE *YA-CHANG.*

 COLOUR : Black. Han Dynasty, 206 B.C.-A.D. 220. L. 37.1 c.m.

B. A JADE *YEN KUEI.*

 Excavated at Yu-Lin-Fu in Honan Province.
 COLOUR : Sage Green with dark Green shadings.
 Han Dynasty, 206 B.C.-A.D. 220. L. 30.4 c.m,

 (Both in a Private Collection, U.S.A.)

PLATE XVII

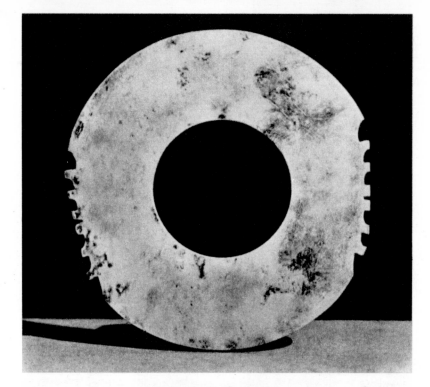

A SERRATED JADE DISC

Carved on opposite edges with seven notches.

COLOUR: Ivory. Early Chou Dynasty, 1122-722 B.C. Diam. 12.7 c.m.

(*In the Collection of Mr. and Mrs. Edward Sonnenschein.*)

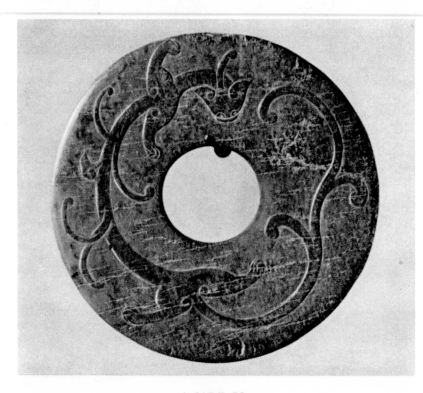

A JADE *PI*

A Ritual Emblem, decorated with Dragon.

COLOUR: Green. Chou Dynasty, 1122-249 B.C. Diam. 12 c.m.

(*In the Eumorfopoulos Collection, Victoria and Albert Museum.*)

PLATE XVIII

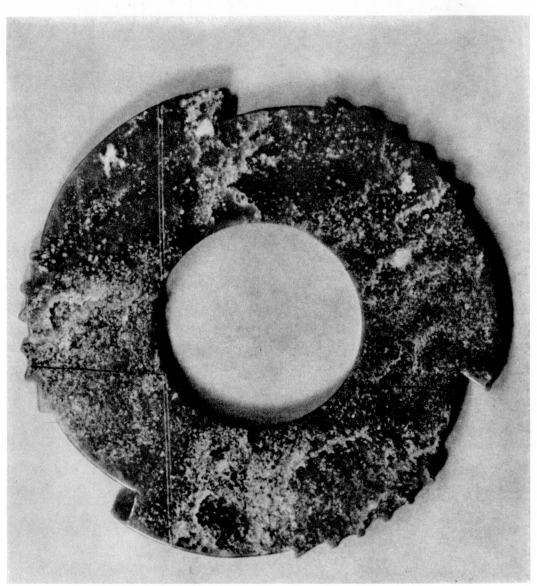

A JADE *SUAN-KI*

Showing division into four sections by lines.

COLOUR : Pale Grey Green covered with a Bluish sheen, splashed Fawn speckled markings.
Han Dynasty, 206 B.C.-A.D. 220. Diam. 13.6 c.m. Internal hole diam. 6.4 c.m.
(In the Collection of A. W. Bahr, Esq.)

PLATE XIX

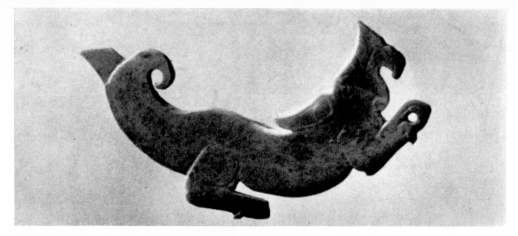

A JADE GIRDLE ORNAMENT (*HENG*)

COLOUR : Pale Green. Early Chou Dynasty, 1122-722 B.C. L. 9.4 c.m.
(In the Collection of Alfred H. Pillsbury, Esq., Minneapolis, U.S.A.)

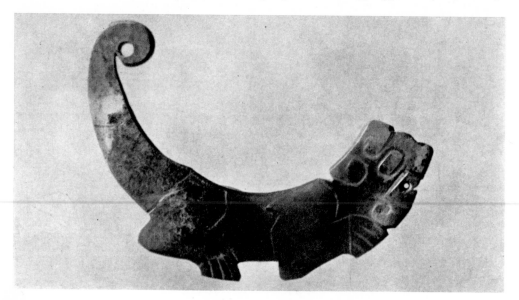

A JADE GIRDLE ORNAMENT (*HENG*)

COLOUR : Pale Green. Early Chou Dynasty, 1122-722 B.C. L. 9.7 c.m.
(In the Collection of Alfred H. Pillsbury, Esq., Minneapolis, U.S.A.)

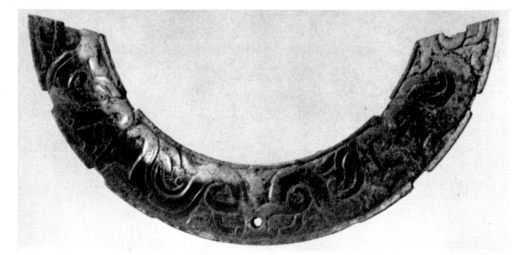

ONE OF A PAIR OF JADE PENDANTS (*HUANG*)

COLOUR : Grey Green, speckled Brown, and light and dark shadings. W. 13 c.m.
Period of the Warring States, 481-221 B.C.
(In the Collection of Chang Nai-Chi, Esq. Shanghai.)

CHAPTER IV

ARCHAIC JADE CARVINGS POSSESSING ASTRONOMICAL CHARACTERISTICS.

TO attain a better understanding of the carvings in jade to-day believed to represent some type of astronomical instrument, it will be necessary to appreciate not only the involved and interwoven ideas of the Chinese concerning Astrology, Astronomy and Divination, but also the affiliated philosophical beliefs of this remarkable people. These beliefs embodied the thought that the Gods communicated their knowledge to the world, through oracles, dreams, signs, omens and portents. Thus the symbols used to convey the messages might take the form of the stars of heaven, the semblance of earth, ether or water, or that of animals, birds, and sometimes of the human form. Such, then, was the material at hand for the use of the early diviners of China. Of the presence of diviners in China at very early times, there is ample evidence.[1] The *Li Ki* records that divination preceded the Border Sacrifice.[2]

During the Shang-Yin Dynasty we read that diviners were consulted by the Emperor P'an-kêng prior to his removal of the capital to the North of the Yellow River.[3] In the *Chou Li* is recorded[4] the classification and names of the various State Diviners of the Chou Dynasty. In studying the records of the methods used by these early Diviners, we find that the formula of the " Eight Diagrams," various " Rods," and information gleaned from the " starry heavens," played an important part. It is recorded[5] of K'u that " He observed the Sun and the Moon in order to receive them and to accompany them." Another record tells us[6] that the Emperor Shun " made use of Jade, in order to verify the accord between the seven governments." This would suggest that jade was utilised in this connection possibly in the form of a divining rod. The *Chou Li* records that a piece of jade, one foot, five inches long, was used " to determine the point where the sun comes, and to measure the earth." This rod may conceivably have formed part of a jade instrument derived from " the invention about 2400 B.C. of the gnomon which displaced the use of the Lunar Zodiac for dating the summer solstice, determined by the shadow of a vertical rod,"[7] used in conjunction with another form at present unidentified. If we consider the specimen illustrated in Wu Ta Ch'êng's book, shown here in FIG. 26, it will be seen that this carving (claimed by Wu to be a jade astronomical instrument, the *Süan Ki*, now preserved in

[1] (a) *Sacred Books of the East*, Vol. XVI, Oxford 1882, p. 40.
 (b) *Yih-King*, Appendix III, p. 374, para. 34 (Legge's translation).
 (c) *Li Ki*, Book I, K'ü-li.
 (d) *Shu-King*, chapter Hung-fan, " The Great Plan."
[2] Book IX, p. 428.
[3] *Book of Records*, Legge's translation, p. 222.
[4] The Ritual of the Chou Dynasty.
[5] *Ma Ts'ien Mém. Hist.*, Vol. I, p. 40.
[6] *Ibid.* Vol. III, p. 415.
[7] Pope-Hennessy, *Jade*, p. 14.

FIG. 25
Peking Astronomical Instruments, 17th Century.

FIG. 26 *Süan-Ki.*

28

the Field Museum, Chicago)[1] is divided into four segments by vertical lines. Another similar specimen of the Han Dynasty in the Collection of Mr. A. W. Bahr is shown in PLATE XVIII. Comparing this object with the drawing, FIG. 25, of the Peking Astronomical Instruments,[2] an extraordinary similarity of constructional form is apparent, in fact, a carving of the type depicted in Wu's drawing might well have been the inspiration and model for the larger instrument portrayed. At any rate the remarkable similarity lends strong support to the theory that this type of carving had some connection with astronomy.

It has been suggested by some authorities that the serration of the edges of carvings of this character into a number of divisions may also have had some primitive and remote association with divination by the stars and other heavenly bodies (see PLATE XVII, top). These serrations, eighteen in number, are divided into four groups, actually presented in four segments through the introduction on the carving of facial lines. The total of eighteen suggests a connection with the Eighteen Arhats or Arhans, and following this line of thought, an interpretation of the meaning or significance of the carving as a whole becomes apparent. The pair of segments below the double dividing line each contain six serrations denoting, in opposition, the twelve animals of the Duodenary Circle,[3] these most probably being inspired by the twelve divisions of the Ecliptic. The pair of segments above the double line divide the serrations into groups of five and one. Taoist philosophical beliefs embodied the idea that the five elements : Water, Metal, Earth, Wood and Fire, were absorbed in the Heavenly sphere as the five planets : Mercury, Venus, Saturn, Jupiter and Mars,[4] whereas the Polar Star or " Mystic Pearl " was the star of Confucius (*K'üh*) and emblematic of the Emperor.[5] It would appear reasonable to assume therefore that the carving under consideration actually was an early ritual charm inspired by the stars, the Sun's disc being represented by the central hole. Dr. Laufer, commenting upon Wu's specimen, put forward the unlikely explanation that the apparent division of the circle by lines into four parts of different size may have been caused by saw-marks in the cutting out of the disc from the solid stone, but such a theory seems untenable considering the defined character, intricacy, and excellent finish of the carving as a whole.

It seems feasible, too, that the colour of the stone chosen for this carving may be significant. Wu describes it as " white jade interspersed with russet spots," which at once suggests a connection with early Chinese Charms. One of the most potent of these, employed by the Taoists, represents the Sun, the Moon and Light. The stellar gods, and the constellations in which they are located, are represented by spots or dots linked together in groups or clusters; thus we have the four stars in the bowl of the Dipper, the six stars in the constellation of the South pole (the six influences of Heaven), *Nan-teu luh-sing*,[6] the

[1] Another specimen is in the H. Hardt Collection, Berlin.
[2] Bushell, *Chinese Art*, Vol. I, Fig. 65.
[3] See page 32.
[4] Compare Laufer, *Jade*, p. 106, and Edkins, *Religion in China*, p. 106.
[5] See page 42.
[6] Depicting the Six Gods of the Ministry of Exorcism. Doré, Vol. III, p. 261.

seven in that of the Great Bear, the thirty-six stars in the Dipper, and seventy-two maleficent stars hostile to man (*Ti-shah*).[1]

The institution of Charms[2] first came under Imperial control during the Han Dynasty and it may be assumed that the jade carver of that period was inspired by the recently introduced circular mirrors of bronze, the backs of which were frequently ornamented with designs of an astrological character, including the ritual *pi* embellished with a mystic representation of the Stellar gods.

According to Dr. Bushell, " The Chinese are supposed to have derived their knowledge of the division of the periods of the moon's diurnal path among the stars into weeks of seven days, about the eighth century, when they obtained also the animal cycles, which had been previously unknown to them. Their knowledge of the twenty-eight lunar mansions is, however, far more ancient, and long discussions have taken place as to whether they were invented in Chaldea, India, or China, or derived from some common source in central Asia."[3] Professor W. D. Whitney[4] says " considering the concordances existing among the three systems of the Chinese, Hindus, and Arabians, it can enter into the mind of no man to doubt that all have a common origin, and are but different forms of one and the same system."

From the foregoing brief survey it will be apparent that, although Astrology or Astronomy was definitely associated with early Chinese mythology, there is at present insufficient evidence to state positively that the jade carver actually produced an astronomical instrument prior to the Han Dynasty ; on the other hand it is probable that charms of an astronomical character were produced at an earlier date, and it is possible that the mysterious notched discs in jade, such as those depicted in Wu's drawings, were in reality diviner's instruments of an astrological character belonging to a dim and remote past.

FIG. 27

The specimen shown in FIG. 27 is described by Wu as of " yellow colour like gold and translucent like amber." He considers that it pre-dates the Chou period, and he connects jade of which it is made with that found in " The Sacred Mountains," *Hua Shan*. He is further of the opinion that it was inspired by an emblem first used by the ancient Tribes, called " *I*." His suggestion that this specimen pre-dates the *Süan-Ki*, shown in FIG. 26, is well-founded and, judging by its form, seems obviously to have been inspired by the ritual *Pi*. The irregularity of design and absence of lined divisions further suggests that it is an imperfect and primitive conception.

[1] De Groot, *The Religious System of China*, Vol. VI, p. 1043.
[2] *Ibid*, Vol. VI, chap. xii, p. 1025.
[3] Bushell, *Oriental Ceramic Art*, p. 561.
[4] Professor W. D. Whitney, *Studies on the Indian Makshatras, or Lunar Stations*.

CHAPTER V

ARCHAIC JADE SYMBOLS OF WORSHIP

THE *Yao Tien*,[1] probably the oldest calendar in existence, and reputed to be derived from the astrological formula of the Chinese Emperor Yao, dating from at least 2800 B.C., was used by early students for the interpretation of the lunar zodiac, as distinct from the solar calendar. "The lunar zodiac, which was instrumental in predicting the arrival of the full moons that heralded the feasts of the spring and autumn equinoxes, was itself displaced by a type of sundial about the year 2400 B.C."[2] We may believe, however, that even after its introduction, the people of China continued to revere the older method of divination used to forecast the weather for the coming seasons, and, although no ancient script establishes the supposition, it may well be that at this time the Chinese commenced to study the Moon astrologically. The *Li Ki* states that, during the Chou Dynasty, the Sun and Moon were worshipped by the people.[3]

To the jade collector the character and significance of the symbols found on carvings used in sacrifices to the Moon Goddess, will be of interest. Of these symbols, the *kuei*, which are round above and angular below,[4] and which date from the Shang-Yin Dynasty, are the earliest found in jade.

Laufer refers to an unperforated disc, with one *kuei* at the upper end, which may have been used in the sacrifices of the Sun, the Moon, the Planets and Constellations.

The six sacrificial objects mentioned in the *Chou Li* comprise :—

		Shape.
The *Pi*	Symbolical of Heaven and in colour Blue-green.	Flat circle with hole in centre.
The *Ts'ung*	Symbolical of Earth and in colour Yellow.	Tube open at each end in the form of a circle within a square.
The *Kuei*	Symbolical of Wood and in colour Green.	Flat one end tapering to a point.
The *Chang*	Symbolical of Fire and in colour Red.	Rod with jointed end.
The *Hu*	Symbolical of Metal and in colour White.	In the form of a Tiger.
The *Huang*	Symbolical of Water and in colour Black.	Semi-circular.

We read that these symbols were made under the supervision of the

[1] Pope-Hennessy, *Jade*, p. 13.
[2] *Ibid.*, p. 14.
[3] *Li Ki*, Book XX, The Law of Sacrifices, para. 3.

埋 少 牢, 王 宮 祭 日 也 ; 夜 明 祭 月 也.
Mai, Chao-Lao, Wang-Kung Tsi Peh Yeh ; Yeh-Ming Tsi Yueh Yeh.
Worship was offered to the sun, moon and stars ; in the sacrifice mentioned here : " For these being benefactors of mankind were entitled to worship."
[4] *Shuo Wên.*

31

Master of the Sacred Ceremonies (*Ta Ts'ung Pe*) for use in sacrifices in the following tabulated manner :[1]

A Round *Pi*	in homage to Heaven
A *Ts'ung*	,, ,, ,, Earth
A Long *Kuei*	,, ,, ,, The East
A *Chang*	,, ,, ,, The South
A *Hu*, resembling a Tiger	,, ,, ,, The West
A *Huang*	,, ,, ,, The North

These six symbols form the subject matter of several writings on Chinese art ; it is, therefore, unnecessary to refer here in detail to their types and uses. It will suffice to mention that the later jade creations appear to have derived their inspiration from these early sacrificial carvings. It is, however, necessary to record that recent research suggests that the symbolical importance of Heaven and Earth as ascribed to the *Pi* and *Ts'ung* respectively by writers of the 2nd century A.D. is now not entirely acceptable ; "recent investigations suggest that these very important Archaic jade structures were more likely instrumental emblems used in the ritual of early Chinese Ancestral Worship, and therefore they may possibly signify, in a manner as yet not determined, the ancient fertility deities."[2] The symbols were certainly used in the Chou (and probably Shang-Yin) ritual, to typify the points of the compass.

Among the early composite carvings which remain, are many figures of mythological animals, such as the Three-Legged Toad, the Hare, the Rabbit, etc., and it will therefore be necessary to refer briefly to certain mythological legends associated with these creatures (see PLATES XX and LXIX).

It is recorded that *Ch'ang Ngo*, the wife of Hou I (2357 B.C.), after stealing from her husband the drug of Immortality given to him by Hsi Wang Mu, fled to the moon. She is said to have been turned into a three-legged toad (*chou chu*) for her sins. This reptile is thought to be the essence of the life of the moon.[3]

In the *Si king tsa ki* we read that " The King of Kuang-ch'uan[4] (during the Han period) opened the grave mound of Duke Ling of Tsin[5] (620-607 B.C.) and found there a striped toad of Jade (*yü chou chu*) of the size of a fist, and hollow inside."

Here it is important to note that the toad, symbolical of the moon, is a three-legged reptile, and not a four-legged one. The toad has been represented repeatedly by the jade carver along with the god, *Liu Hai*,[6] another inhabitant of the moon. The *cassia* (a tropical plant) is believed to grow in the moon. The hare, which is also associated with the moon, having been transported there as a reward for having

1 Pope-Hennessy, *Jade*, p. 28.
2 Compare *Journal of the Royal Society of Arts*, Vol. LXXXIV, p. 343 ; Jade by Oscar Raphael.
3 Plopper, *Chinese Religion seen through the Proverb*, pp. 38 and 39.
4 Chavannes, *Se-Ma Ts'ien*, Vol. II, p. 497 ; Vol. III, p. 99.
5 Chavannes, *L.C.*, Vol. IV, pp. 311-316.
6 " A minister of state of the 10th century A.D. and a student of Taoist Magic." *Outlines of Chinese Symbolism and Art Motives*, Williams, p. 399.

offered himself as food for the Buddha, is often depicted pounding the "*elixir vitæ*." Mayers[1] tells us that " This animal is reputed as deriving its origin from the vital essence of the Moon, and is thereby subject to lunary influences." Chang Ssü Wei writes : " The black hare is more uncommon than the white hare. It comes from the North Pole, bringing greetings from the Moon Goddess, and is auspicious of a successful reign. Now may the magic medicine be pounded with a jade pestle and the divine nectar be prepared in a crystal cup."

It would seem that the Hare and Moon legends which abound in Chinese writings, owe their origin to India.

Previously to the Han period the Hare is referred to as inhabiting the face of the Moon, later Taoist stories depict it as a messenger of the Moon Goddess.

The Hare, the three-legged Crow, and the Toad, are all found in jade statuettes of about the Han period. The figures of these creatures in flat tablet form would appear to belong to Chou tradition.[2]

As we review the creations of the jade worker from the T'ang period to the Ming, we shall be struck by the fact that the tradition of the moon and the animals of the zodiac exerted great influence upon the jade artists, who introduced them frequently in the decoration of their masterpieces.

THE TWELVE ANIMALS OF THE DUODENARY CIRCLE

These comprise the Ox, the Horse, the Rat, the Goat, the Dog, the Cock, the Tiger, the Serpent, the Dragon, the Hare, the Monkey and the Pig (or Hog).

They were considered by the diviner as mutually opposed, in the sequence quoted, and among other attributes, were believed to exercise an influence, over the hour, day or year to which through the duodenary cycle of symbols they respectively appertain. Their usage is of foreign origin and has been traced to the Tartars. The first explicit mention of denoting years by the names of animals is found in the *History of the T'ang*, where it is recorded that " the Nation of the Kirghiz spoke of events occurring in the year of the hare or the horse." Not until the Mongol ascendency did the system become universally popular. According to *Chao Yih* there were traces in Chinese literature of a knowledge of this system as far back as the Han period, but the writer is of opinion that it was introduced at the time of the Tartar emigration. There is no doubt that the Duodenary cycle was primarily inaugurated in the remote ages, when there existed a closer intimacy and sympathy between man and the lower animals, and was obviously inspired by the primitive worship both of stars and animals.

ARCHAIC JADE FORMS PRODUCED AS CHARMS

In the *Chou Li*, *Li Ki* and *Shu King*, reference is made to the exist-ence of Charms (*Chuh*) during the Chou and ensuing Dynasties. It

[1] *Chinese Reader's Manual*, Pt. 1, p. 724.
[2] Compare Laufer, *Jade*, p. 168.

would appear from these records that the *Chuh* possessed potent powers of good and evil, and considering the intricate nature of early Chinese religious beliefs it is not surprising to find that jade, which in those early times was revered as possessing mystic attributes, was the material used for the making of these talismans.

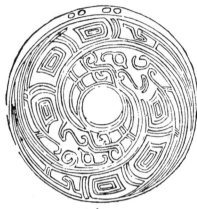 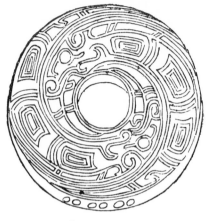

a obverse *b* reverse

FIG. 28

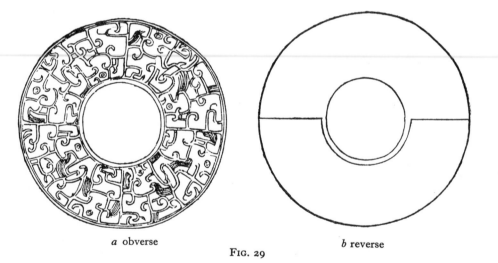

a obverse *b* reverse

FIG. 29

Wu Ta Ch'êng, in his book, illustrates several specimens from his collection which undoubtedly belong to this class. Two of these are here reproduced. FIG. 28 is described as follows : " ' *Shi pi* '[1] colour green and white bearing a heavy earth marking, in the top is pierced two pairs of holes, in the bottom three pairs of holes." FIG. 29. " ' *Shi pi* ' colour green with slight earth markings." Wu then proceeds

[1] Meaning, Charm of Jade or Charm made of Jade in the form of *pi*.

34

to connect these carvings through the Shuo Wên[1] explaining the alteration of the radical 口 (*K'eu*, mouth) and *Yen* 言 (words) for *shi* 示 (religious objects), thereby translating an ancient quotation in the *Li Ki* as meaning that these " *Shi pi* " were the pendant charms worn on each breast, supported by a string or ribbon, by the high officials of State during the periods preceding the Chou, and possibly from the time of the Three Dynasties.

If we pursue this line of thought, it assists us to refer certain small symbolic carvings to a definite period and to understand the origin of those archaic animal and ritualistic miniature carvings, which, on account of their size and form, cannot be included in the Burial ritual or Court and Sacrificial classes of jade. These objects belong to the category of archaic carvings worn as charms, tokens, or ornaments,

FIG. 30 FIG. 31

and may conveniently be classed under separate divisions as follows :—

(1) Exorcising Charms, or those worn to keep away evil spirits ; referred to in ancient writings by the radical *Shi* (示). The charms were the most potent used in ancient times, and would appear to have been inspired in design by the various ritual Symbols.[2]

(2) Charms of Good Omen, those worn in the hope that their possessor may achieve happiness and long life. To this category belong various animal and bird forms, believed to possess these inherent qualities.

(3) Cosmic and mythological types conceived from the early ideas of Astrology, Astronomy and Physiognomy, and embodying the power of bestowing on their owners the blessings of long life, riches, health and honours. Into this class obviously belong the animals of the Duodenary Cycle and other types possessing astrological and astronomical characteristics as well as those bearing various hieroglyphic or conventional ritual signs.[3]

(4) Imperial Charms ; in the form of the Dragon and Phœnix.

(5) Charms belonging to the Literati, such as those in the forms of the Tortoise, Fish, etc.

It will be apparent that these main divisions can be further sub-divided *ad infinitum*.

[1] The Chinese Dictionary often used by Wu Ta Ch'êng.
[2] Page 31 in this book.
[3] FIG. 30, of button form included in Wu's book and described as white jade bearing a black sheen with 3 holes similar to an elephant's tusk in form underneath.
 FIG. 31. A green jade with two holes. These specimens obviously were made as charms and were probably sewn on the garments of their owners. It is a type, I believe, of a later date than those shown in FIGS. 28 and 29, though possibly belonging to the Chou Dynasty.

35

FIG. 32 shows an animal charm depicted by Wu and described by him as of white jade. It corresponds to several illustrations in the *Ku yü t'u p'u*[1] some of which bear the figure of the *Hu* (tiger) on their underside. Dr. Laufer attempts to connect this type of carving with the tiger-jades buried on the right-hand side of a corpse.[2] His reasoning for this supposition, though certainly subtle, is not convincing. I prefer to accept the records in the *Ku yü t'u p'u* which describe twelve similar specimens of various colours, and having carefully considered

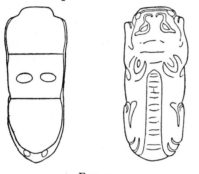

FIG. 32

the text of the *Chou Li*, which details the types used for burial (see PLATE XXI), I am convinced that the forms are not related. The figure under discussion would seem more consistently to belong to the Charm category.[3] The character *Hu*, inscribed upon some specimens, partially supports this theory :[4] furthermore, the fact that so many are recorded in the *Ku yü t'u p'u* supports this argument, as does that of their being carved from jades of various colours, for it is definitely stated in the *Chou Li* that the burial jades were only to be formed " in purest white." The drilling of the underside of these charms is demonstrative of their having been threaded with a cord or ribbon, and is similar to the drillings of those specimens shown in FIGS. 30 and 31. It is recorded that early Taoist monks practised strict mortification, thereby to prolong the life of the body. The Seven Immortals of the Brahmans (*Ts'ih-sien*) personified in the seven " Bright stars of the Heavens," three of which form Orion's belt, were derived from these early religious beliefs. If momentarily we consider the carving shown in FIG. 32, it will be seen that it conforms in rough outline to the Orion, and is belted on its underside, which confirms to some extent the suggestion made by some authorities that the Ancient Chinese saw in the Orion the Tiger, where we see the Hunter, further support is afforded by the fact that the later " Black Tiger Charms " (*Heh-hu*) which were used almost exclusively by Taoist Priests, are only for use by them when appealing to the God of Wealth (*Ts'ai Shen*) whose accepted associates are the Dragon and Tiger of the Heavens. Moreover this Tiger Jade would appear to belong to the living rather than to the dead since its form is round and not tablet shaped.

[1] Chapters 22 and 23.

[2] Laufer, *Jade*, pp. 177-180.

[3] Compare De Groot, *Religious System of China*, Vol. VI, p. 955, and *Fung Su T'ung* (chap. 8), by Ying Shao, *circa* A.D. 260.

[4] *Hu* 虎 derived from the radical *hu* 虍 and the form *jên* 儿 representing the tiger's stripes.

Shi 示 religious objects in early times was written 呪 or 説

Kwei 鬼 disembodied soul.

Hu 兕 the manner in which it is sometimes written in early script.

The symbol representing *Hu* on the jades mentioned in the *Ku Yü t'u p'u* would appear to be a combination of the early representation of the radical *Shi* and *Hu* meaning, *Tiger Charm* rather than *tiger animals*.

PLATE XX

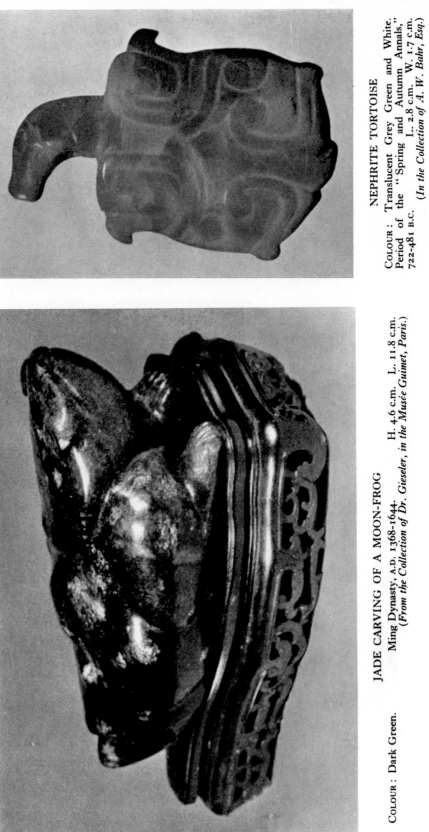

JADE CARVING OF A MOON-FROG

Ming Dynasty, A.D. 1368-1644. H. 4.6 c.m. L. 11.8 c.m.
(From the Collection of Dr. Gieseler, in the Musée Guimet, Paris.)

COLOUR : Dark Green.

NEPHRITE TORTOISE

COLOUR : Translucent Grey Green and White.
Period of the "Spring and Autumn Annals,"
722-481 B.C. L. 2.8 c.m. W. 1.7 c.m.
(In the Collection of A. W. Bahr, Esq.)

PLATE XXI

A JADE FIGURE OF A CROUCHING PIG
Used as a Burial Charm and placed in the arm-pits of the deceased.

COLOUR : Light Green with Yellow and Grey White markings. L. 11.3 c.m. H. 2.7 c.m. W. 2.5 c.m.
Han Dynasty, 206 B.C.-A.D. 220.

(*In a Private Chinese Collection*)

A JADE CEREMONIAL STAFF HEAD
COLOUR : Pale Grey Green with mottled markings and streaks of Brown and Red. Han Dynasty, 206 B.C.-A.D. 220
L. 8.4 c.m. H. 4.9 c.m.
(*In a Private Chinese Collection*)

PLATE XXII

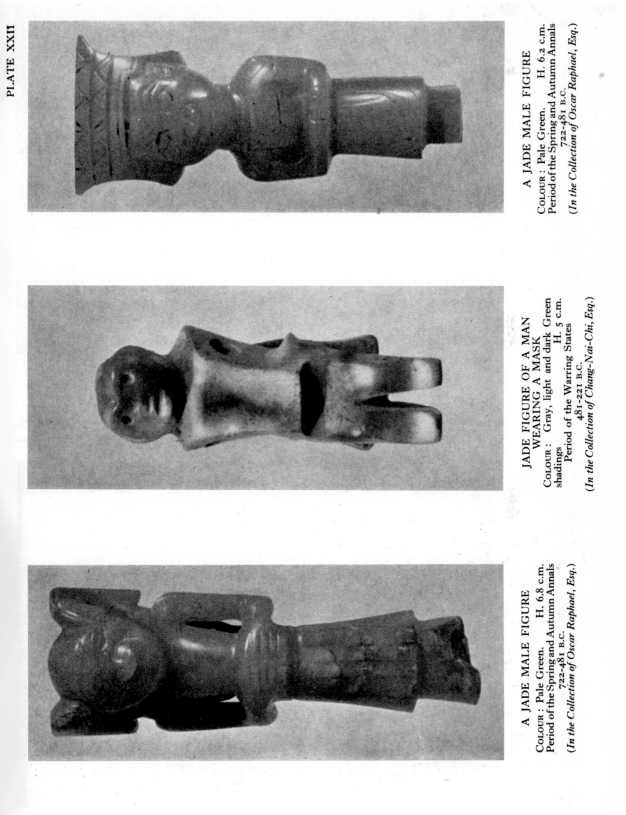

A JADE MALE FIGURE
COLOUR: Pale Green. H. 6.2 c.m.
Period of the Spring and Autumn Annals
722–481 B.C.
(*In the Collection of Oscar Raphael, Esq.*)

JADE FIGURE OF A MAN
WEARING A MASK
COLOUR: Gray, light and dark Green
shadings H. 5 c.m.
Period of the Warring States
481–221 B.C.
(*In the Collection of Chang-Nai-Chi, Esq.*)

A JADE MALE FIGURE
COLOUR: Pale Green. H. 6.8 c.m.
Period of the Spring and Autumn Annals
722–481 B.C.
(*In the Collection of Oscar Raphael, Esq.*)

PLATE XXIII

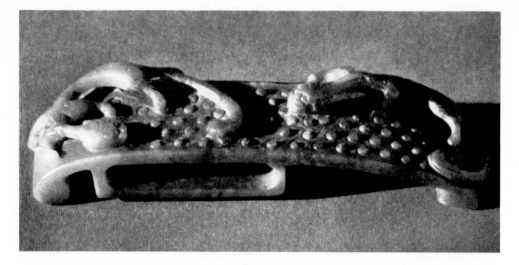

NEPHRITE DRAGON BUCKLE CARVING ORNAMENTED WITH GRAIN PATTERN

COLOUR : Grey Green, mottled Rust Brown. L. 15.5 c.m. H. 3 c.m.

T'ang Dynasty, A.D. 618-906.

(*In the Collection of A. W. Bahr, Esq.*)

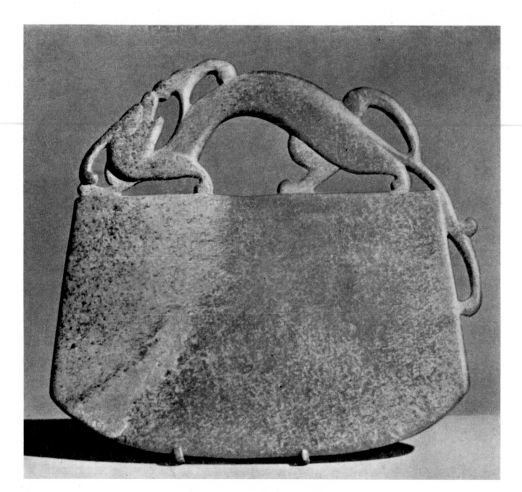

A JADE CEREMONIAL AXE, WITH DRAGON HANDLE

COLOUR : Grey Green, splashed Brown. H. 17.2 c.m. W. 17.7 c.m.

Han Dynasty, 206 B.C.-A.D. 220.

(*In the Eumorfopoulos Collection, British Museum.*)

PLATE XXIV

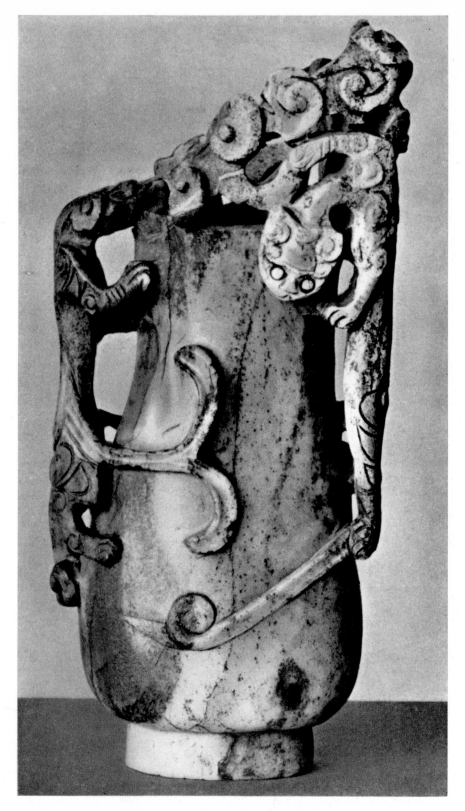

AN EARLY NEPHRITE CARVING IN THE FORM OF A DRAGON-HANDLED LIBATION CUP

COLOUR : Bone White, mottled Grey-Green and flecked with Black. H. 26 c.m.
Northern Sung Dynasty, A.D. 960-1127.
(In the Aston Collection, Victoria and Albert Museum.)

PLATE XXV

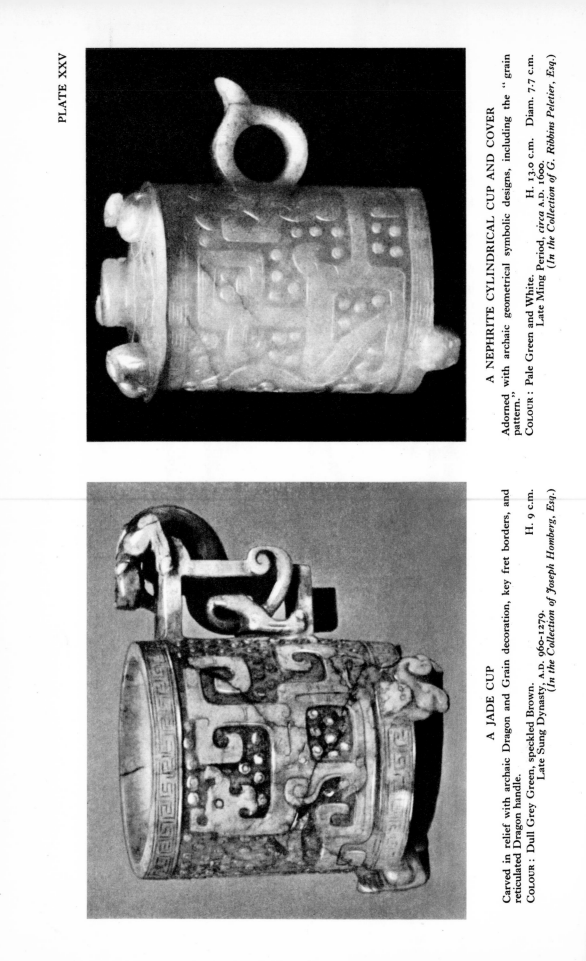

A NEPHRITE CYLINDRICAL CUP AND COVER

Adorned with archaic geometrical symbolic designs, including the "grain pattern."

COLOUR: Pale Green and White.　　H. 13.0 c.m.　Diam. 7.7 c.m.

Late Ming Period, *circa* A.D. 1600.

(In the Collection of G. Ribbins Peletier, Esq.)

A JADE CUP

Carved in relief with archaic Dragon and Grain decoration, key fret borders, and reticulated Dragon handle.

COLOUR: Dull Grey Green, speckled Brown.　　H. 9 c.m.

Late Sung Dynasty, A.D. 960-1279.

(In the Collection of Joseph Homberg, Esq.)

PLATE XXVI

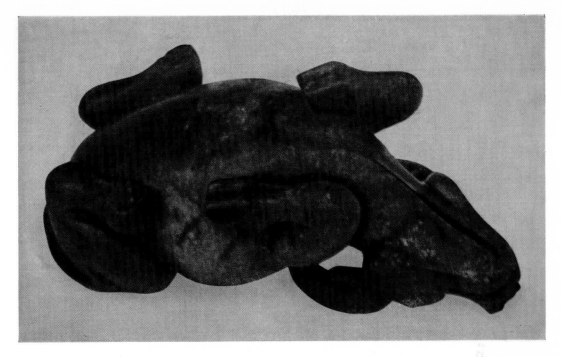

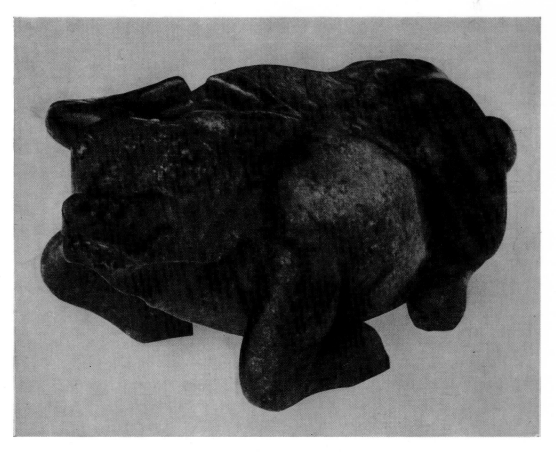

TWO VIEWS OF A JADE CARVING OF A RECLINING BUFFALO

COLOUR : Dark Reddish Brown and Black, splashed Yellow and Green.　　H. 8.9 c.m.　L. 19.1 c.m.

T'ang Dynasty, A.D. 618-906.

(*In the Collection of A. W. Bahr, Esq.*)

PLATE XXVII

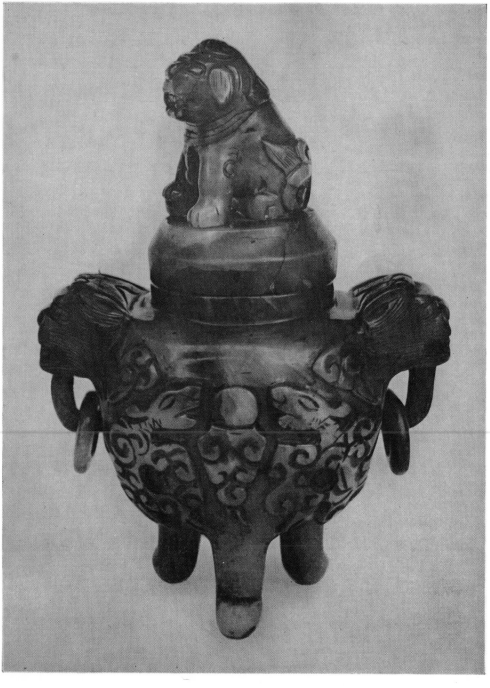

JADE INCENSE BURNER

Grotesquely carved in bold relief with archaic dragon emerging from clouds ; two Hydra
(*chih-lung*) supporting an Ogre head (T'ao T'ieh), two monster masks at sides holding well-
positioned loose ring handles : a Buddhist lion surmounts the cover ; the whole supported
on three curved feet.

COLOUR : Rust Brown, splashed Grey, Black and Green. H. 21 c.m. W. 15 c.m.

Yüan Dynasty, A.D. 1260-1368.

(In the Collection of Frank H. Fulford, Esq.)

CHAPTER VI

ARCHAIC JADE CARVINGS FROM THE HAN TO MING DYNASTIES

(206 B.C.-A.D. 1368)

WITH the advent of the Han Dynasty the real history of China begins, substantiated by inscriptions and other written records, and supported by archæological research.[1] During the first part of this period, the jade carver used, almost exclusively, nephrite obtained from Honan, a distinctive type of a fine green colour, but which has often been oxidized to a rich brownish red. Certain rust-coloured carvings claimed to be of the Han period, yet of quite modern production, derive their name from the colour of the nephrite in general use at the commencement of the Han Dynasty. These pseudo-Han pieces are usually of " weathered " jade, derived from the outer crust of the jade boulders, and when scratched with a knife, the decayed surface is easily distinguishable, even if the carving has been buried for a considerable time. Any such specimen having an archaic appearance should be viewed with suspicion, especially if the carved surface has not been substantially defaced through the process of weathering.

During the Han period the jade craftsman largely concentrated his labours upon producing a somewhat heavy, though lifelike, statuette type of carving, in contrast to the more formal ritual emblems and vessels made by his ancestors ; and it is thought that some of the first carvings of horses in jade were produced during this dynasty. Ornamentation, which previously had been almost solely of a symbolic character, from this time displayed an intricate decorative style, obviously inspired by the bronze worker's craft of the Chou Dynasty, and it would seem that for the first time the jade worker attempted to combine in his art the qualities both of life and rhythmic line. An excellent example of this type is illustrated in PLATE XXIII.

The draped human forms, which occur at this period, possess definite Western style, and contrast vividly with the earlier highly stylised human figures (see PLATES XI and XXII). Towards the close of the Han Dynasty we find the carver using a different type of jade, a translucent green nephrite, probably obtained from Turkestan[2] in place of the opaque variety found in Honan. Here it may be of interest to record that I have had the opportunity, thanks to the assistance of several collectors, of analysing several pieces of this period, some of which are

De Morant, *Chinese Art*, p. 72.

[2] In the region south of Yarkand and Khotan, are situated the Konakan and Karala nephrite quarries. The colour of the nephrite is generally paler than that found elsewhere. Another source of the nephrite used in ancient times is in the Kar angu-Tag hills on the Khotan Daria above Khotan, where only secondary deposits of the mineral remain. It would appear that these and the deposits at Shanut, in the basin of the Tisnab, and at Lishei in the district of the Kira Daria, also those of the famous Mount Mirdshai on the upper reaches of the Asgensal, have not been worked since the revolt of the Mahometans and the expulsion of the Chinese. All the primary deposits of nephrite are in high mountain regions, many, indeed, above the line of perpetual snow. From these situations a quantity has been carried down to the valleys by the agency of running water and glaciers. It is not improbable that the ranges of the Kuen-lun and the Nan-Shan actually supplied the Chinese with a large proportion of the stone they call " yu." (Bauer, *Precious Stones*, p. 462.)

not carved in nephrite, but in a variety of Avanturine (Quartz) a material which would appear to have been highly esteemed in China. Dr. Bauer tells us : " It is one of the stones referred to as ' *yü* ' and is distinguished from the others as the imperial *yü-stone*." He further informs us that the imperial seal is said to be made of this material, which is far more highly esteemed than nephrite. The locality whence the Chinese obtained the stone is not known.[1] Dr. Cheng states : " This Jade ultimately fell into the hands of Chin when it succeeded in absorbing the Empire of Chou and ended the Period of Warring States (221 B.C.) and it was this Jade that was made into the Grand Seal of the State Chin by order of the First Emperor."[2]

Another innovation in the jade craft which would appear to belong to the Han period is the resonant stone carvings, or musical jades,[3] due possibly to the custom, established at that time, of the Emperor wearing a jade hat with nine strings of beads.[4] The swinging of these hanging jades creating various notes when knocking one against another. It is recorded that regulations were introduced during the T'ang Dynasty respecting the use of a musical stone called the *K'ing* in connection with the worship of the deities of Heaven and Earth.[5] These musical stones were extensively copied during the Ch'ien Lung period (see Plate LIII, Laufer, *Jade*).

An impressive mastery of line and grouping was attained by the Han carver, an excellent example of which is seen in the Ceremonial Axe with dragon handle (see PLATE XXIII). The statuettes produced at this time give the impression of being primitive, but display a wondrous degree of motion. This quality points to a definite break with tradition,[6] and marks the passing of the purely symbolic ritual and religious type of carving produced during the previous dynasties.

With the advent of the T'ang Dynasty it becomes apparent that the carver · has acquired a freedom of line much in advance of the carvers of the Han period. The appearance of heaviness has gone, and in its place a sense of buoyancy appears to dominate the art. The jade Buffalo (PLATE XXVI) is an outstanding example of this development, displaying a perfect representation of " living movement " from whatever position the carving is viewed. The sweeping forms, buoyant lines and simple vigour of many of the productions of this period are most impressive. In the *Ku Yü T'u*,[7] will be found an interesting note, following the description of a reclining " Piebald of Black jade, a type of horse of the T'ang dynasty." This note records the modelling in jade from life of five cavalry horses, and would appear to be the first record of such sculptural work executed in this stone. Another exceptional example of animal sculpture of

[1] Dr. Max Bauer, *Precious Stones*, p. 503, para. 3.
[2] *Civilization and Art of China*, p. 25.
[3] Bishop *Collection*, Vol. II, p. 107.
[4] *Li Ki*, Vol. I, p. 400.
[5] Couvreur, Vol. I, p. 549, and Biot, Vol. II, p. 235.
[6] Laufer, p. 233.
[7] Chapter 2.

this period is that of the six horses that dance at the tomb of T'ai Tsung (died A.D. 649), being a representation of his six favourite mounts.[1]

The vases and cups in jade of this time impress us by their similarity of form to those of the Neolithic age, the decoration being of a powerful yet highly refined type. In comparison the T'ang and the Sung Dynasties appear to have been periods of reproduction, in which the jade carver revived many of the forms and designs of the past, particularly those of the Bronze workers of the Chou period. The Sung craftsmen appear to have attempted to create pieces which might in reality be of that earlier time.[2] An innovation of the Sung period was the introduction of high undercut relief and pierced carving, similar in character to the designs produced by the Han bronze worker. The Bronze Censer (*Po shan lu*) of the Han Dynasty, in the Collection of Mrs. Christian R. Holmes,[3] suggests the prototype of this kind of carving.

The predominating colour of the rock used by the Sung carvers seems to have been white, though black jade was also used, as can be seen from the jade horse in the Raphael Collection (PLATE LV). A comparison of the latter with the Buffalo of the T'ang Dynasty in the Bahr Collection (PLATE XXVI) shows interesting differences of design and form in the work of the two periods. The carvings of the Sung Dynasty are delicate and graceful in form, but lacking in the life and vibrancy of the pieces of the T'ang period.

[1] *A History of Chinese Art*, by G. S. De Morant, p. 156.
[2] Dr. Bauer in *Precious Stones*, p. 469, says : " Good specimens of Jadeite are to be found, though rarely, in the red, clayey weathered product called laterite, which occurs in the Uru valley. These stones have a colourless nucleus enclosed in a red crust of a certain thickness. This red crust produces the effect of a fine sheen, and is due to the penetration of iron oxide from the clay in which the pebbles are embedded. Such stones, the colouring of which is quite permanent, are distinguished as ' red Jadeite ' and are much esteemed by the Chinese." It would appear to have been this type of rock which was used by the Sung carvers in their reproductions of earlier types.
[3] *Chinese Exhibition Catalogue*, London, No. 394.

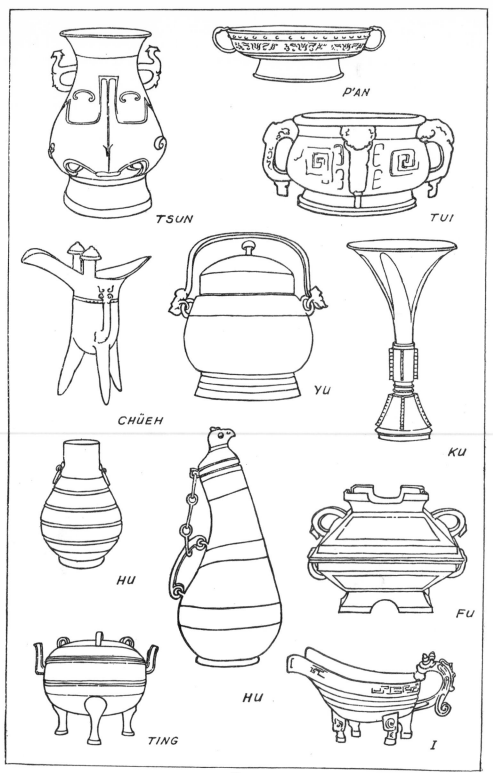

TSUN

P'AN

TUI

CHÜEH

YU

KU

HU

HU

FU

TING

I

FIG. 33
ARCHAIC VESSEL FORMS

CHAPTER VII

ARCHAIC VESSEL FORMS IN JADE FROM THE CHOU TO THE MING DYNASTY

IT is stated in the *Li Ki* that the vessels used in ritual worship were of three kinds ; those made of Bronze, those made of Jade, and those made of Wood. The forms produced by the early bronze workers, the chief types of which are shown in FIG. 33, obviously exercised considerable influence upon the art of the jade carver, many of whose productions are almost identical in shape and decoration with those created by the earlier craftsmen in bronze. Of the vessels made of wood little is known, few having survived the ravages of time and decay.

In addition to their use in connection with the various rituals and sacrificial services, jade drinking vessels were also used at imperial banquets and conferences, as well as in the houses of the wealthy Chinese.

Much interesting information relating to the early ritual vessels is to be found in the ancient Chinese writings[1] as well as in those of later European and American authors,[2] and it is from these combined sources that the following brief particulars, having special relevance to the forms and uses of these vessels, have been condensed.

The most important of the ancient writings is perhaps the *Li Ki*[3] wherein are described the vessels used in the ancestral Temple for the ritual in honour of Chou-Kung,[4] of which the following is a literal translation :

" In June, the later summer, great sacrifice was offered to *Chou-kung* in the Royal Temple.

" ' *Pai-Mu* '[5] was sacrificed.

" Wines were offered in ' *Hsi*,'[6] ' *Hsiang*,'[7] and ' *Shan-Lei*.'[8]

" Wines were offered in ' *Hwang-Mu*.'[9] Wines were offered in ' *Yu-Tsan* '[10] which had a large jade handle.

[1] The *Po-Ku l'on*, A.D. 1119-1125 ; *T'ao Shuo*, A.D. 1774 ; The *Li Ki* ; *Chou Li* ; *Ching tê-chen T'ao lu*, A.D. 1815 ; *Ku Yu tu k'ao* ; *Ku yü t'u p'u*, etc.

[2] Dr. Bushell, Laufer, Pope-Hennessy, G. Soulie de Morant, Arnold Silcock, etc.

[3] Chapter 31, folio 6 versa, 7 recta (15, 2, 20 c/a). See Plate XXVIII.

[4] Bushell, *Oriental Ceramic Art*, folio 107 to 108.

[5] " *Pai-Mu* ": It is recorded that this creature, a white male animal (not unlike a sheep) was only used in the Shang Dynasty ; mention of it here therefore emphasises the importance of the Ceremonial honour bestowed on Chou-Kung.

[6] " *Hsi* ": a type of *Tsun*. In the *T'ao Shuo* (Chapter 1) the *Hsi* is referred to as one of the five sacrificial vessels (*Wu Kung*) used in the ceremonial worship of the Emperor at the *T'ai Miao* (the Ancestral Temple in the prohibited City at Peking). These vessels were shaped in the form of a rhinoceros.

[7] The " *Hsiang* " is referred to in the *T'ao Shuo* and described as being shaped like an Elephant.

[8] " *Shan-Lei* ": another type of *Tsun*, only used during the Hsia Dynasty. The form of this vessel has been traced by Wu Ta Ch'êng and is shown in FIG. 34.

[9] " *Hwang mu* ": In the ancient writings the Radicals are often interchanged, and in the *Li Ki* it seems most probable that the symbol *Hwang* (yellow) qualifies an involved adjectival representation meaning wood (*mu*). Thus the literal meaning of this sentence would seem to be : " The mellowed wine was offered in the container (*Tsun*) which vessel was the ' *Hwang Mu*,' " expressing the further involved meaning that the wine became mellowed to a yellow colour through storage in this wooden container. It would appear therefore that *Hwang Mu* is in fact a type of wooden cask. Partial support to this interpretation of this part of the text is contained in this further reference in the *Li Ki* to the general description of the Temple ritual-vessels : " Of vessels used they are of three kinds, those made of Bronze, those made of Jade, those made of wood."

[10] (A) The text of the *Li Ki* is very definite in the description of this vessel ; explaining its general characteristics as follows : " *Tsan*: its form like *p'an*, its capacity 5 *san* ; the handle called *Ta Kuei*." (B) " *Tsan*: its form like *p'an*, its capacity 5 *san*. If possessing a jade handle, this handle is called *Ta kuei*." (*Continued in footnotes on p.* 42.)

" Wines and female plants of hemp were offered in ' *Yu-Tou* '[1] and ' *Tiao-Tsuan*.'[2]

" Wines were offered in carved ' *Yu-Tsan*.'[3]

" In the second service of ' *Chi-Hsa* '[4] wines were offered in ' *Pi-San* '[5] and ' *Pi-Chüeh*.'[6] Wines were offered in ' *Huan* '[7] and ' *Chüeh*.'[8]

" Then the musicians entered the Hall of the Temple, and sang ' *Ching-Mao*.'[9] '*Hsiang* ' was played down the hall. The Emperor took a red lance and a jade Axe and wore a crown, dancing and singing ' *Ta Wu* '[10] " The Emperor also wore a fur conical cap and white robe and danced to the music of ' *Ta-Hsia*.'[11] Although ' *Mei* ' was the music of the Eastern Savages, and ' *Jen* ' was the music of the Southern Savages. The Emperor still accepted and played such barbarian music in the big Temple ; which showed that he recognised that all the people in the world were akin."

To assist in understanding the literal translation of the *Li Ki* given above, it will be necessary to detail the recorded description of Ancient Ancestral Ritual Worship (*Chi-hsa*) which was performed in the Royal Temple each year at the beginning of Spring and Winter.

The Service was conducted in duplicate, first for the Emperor and his family, secondly for the Feudal Princes and Officials who represented the general populace. This latter service was known as *Ja*. These services were divided into two parts (*Quong*) and (*Tsin*). During the

(*Continuation of footnote* (10), *page* 41.)

It would appear from the rendering of the text that the commentator does not mean to imply that the form of the handle is actually that of a *Kuei*, but rather that when possessing a handle, that handle gives the vessel symbolical importance in the same manner as the *kuei* ; thus the vessel is primarily for imperial sacrificial purpose, used as a ladle : as distinct from similar vessels without handles, which were used as imperial banquet wine cups.

See (*ming t'ang wei*, 20) where this vessel is ascribed to the Chou Dynasty. In the *Records of Liang-Chou* it is mentioned that in the second year of the period Hien ning (A.D. 276) a " *Tsan* " carved from white Jade, was obtained from the Tomb of Chang Kiün.

The name of " *pa pei* " (literally " handled cup ") is applied in China to the tazza-shaped cups used for tea or wine, just as the " *pa wan* " are the tazza-shaped rice bowls, with high cylindrical stems. Cups with handles at the sides like our teacups are even now rarely seen in China : they were quite unknown in early times. (Bushell : *Oriental Ceramic Art*, p. 171).

(A) Dr. Laufer (*Jade*, p. 315) translates this passage as " with a handle in the shape of the great jade tablet *kuei*."

(B) Dame Una Pope-Hennessy (*Jade*, p. 98), quoting from Biot's translation of the *Li Ki*, Vol. II, p. 522, says : " and the handle is a *kuei* of jade." It will be apparent from the Chinese characters in the original text that the description refers to the general characteristics of the vessel rather than to this concise rendering of an individual part.

1 " *Yu-Tou* " : A Tazza-shaped vessel in Jade having a solid stem (see Plate XXXII). In some ancient writings described as of cauldron shape. This vessel was used only by the Emperor as a cup to hold the mellowed sacred wine drawn from the *Hwang-Mu*, which wine was consumed by him whilst the female hemp plants were being offered to the Gods on the bronze vessels (*Tiao-Tsuan*), by the officiating priests.

2 *Tiao-Tsuan* : a shallow vessel in bronze or jade recorded to have first been used during the Hsia Dynasty ; described as similar in form to the scoop and later as of *P'an* form. See Plate XV.

3 " *Yu-Tsan*," used by the Emperor during the latter part of the service (*Tsin*) : A Jade Cup similar to the *Chüeh*, deriving its form from the Bronze vessel of that name, first used in the Hsia Dynasty ; and known during the Shang Dynasty as the " *Huan*."

4 " *Chi-Hsa* " : Ancestral Ritual Worship in the Royal Temple.

5 " *Pi-San* " : The wine cup used by the feudal princes during the first part of the ritual service (*Quong*), made of wood or horn and adorned with jade, similar in form to the " *Tou*."

6 " *Pi-Chüeh* " : The wine cup used by the feudal Princes during the second part of the service (*Tsin*), made of Bamboo like the *Li* and decorated with jade.

7 " *Huan* " : The name given to a vessel deriving its form from the *Tsan* of the Shang Dynasty, made of wood or pottery, or wood adorned with precious stones (excluding jade) used during the (*Quong*).

8 " *Chüeh* " : A vessel made of wood or pottery, or wood adorned with semi-precious stones (excluding jade). Used by the public officials during the (*Tsin*) ceremony.

9, 10, and 11, Index figures, see Chinese Glossary in Appendix II at end of this book.

Quong or first part, an animal (*Pai-mu*) was sacrificed, followed by offerings, including female plants of hemp, being made to the gods; at the same time were drunk measures of the sacred mellowed sacrificial wine (*Yueh*) ladled from its container (*Hwang mu*) by the Officiating Priest using the sacred imperial handled ladle (*Ta-Qua Yu-Tsan*). The drinking vessels used during this part of the service were known by the general term (*Tsun*) which comprised the *Yu Tou* used by the Emperor, the *Pi-San* used by the Feudal Princes and the *Huan* used by the Public Officials. The vessels used by the Officiating Priests in both parts of the ceremony were of a different type and known as *Hsi*, *Hsiang* and *Shan-lei*.

During the second part of the service, which was known as the *Tsin*, praise was offered to the Ancestors and universal Gods and ordinary wine was consumed by the Emperor from a vessel described as a *Yu-Tsan* and by the Feudal Princes from another vessel known as the *pi-Chüeh*. The Public Officials drank from a *Chüeh*; the ceremony concluded with the congregation joining in a pious demonstration of religious contentment. The vessels used during the second part of the ritual were known by the general name (*Chan*).

From this very important reference to the vessels used during the Chou Dynasty, certain forms in jade appear to correspond with the detailed descriptions of similar vessels in other Chinese writings, notably those of Wu Ta Ch'êng and in the *T'ao Shuo*.

THE *TSUN*.

Wu Ta Ch'êng, in his book on Jade, gives an illustration of this vessel which is here reproduced in FIG. 34. He describes its form and uses in the following terms :

" This jade is the *Tsun*, it is bigger than the *Chan*.

" Its capacity is the same as that of five ' *san*,' a measurement based on the unit of the capacity of the *Tsan*.

" In the *yueh ling*[1] of the *Li Ki*[2] it is recorded that the *Tsun* was used in the ritual performed in which animals were sacrificed[3] (to ' Heaven and Earth' by the Emperor).

" The *Li Ki* also describes the capacity of the Jade *Tsun* as follows : ' it will hold the combined contents of 2 *Tou*, 1 *Pien*[4], 4 *Chan* ; 1 *Kio* 1 *San*,' it is said that the capacity of a *Tou* is the same as the *Tsan*.

FIG. 34

| Pien | .. | .. | Two Tsan | Kio | .. | .. | Four Tsan |
| Chan | .. | .. | Three Tsan | Tsun | .. | .. | Five Tsan |

[1] Monthly proceedings of the Government (Legge's translation, Vol. I, p. 253).
[2] Or *Record of Rites*, Book IV.
[3] Doolittle : *Social Life of the Chinese*, Vol. II, p. 22 and p. 187.
[4] See description of sacrificial vessels used in the Ancestral Temple " twelve *pien* on the right of the altar, twelve *tou* on the left." Bushell, *Oriental Ceramic Art*, p. 491.

43

"The *Li Ki* also records that a *pi-San* and a *pi-kio* or (*Pi-Chüeh*) is stored in all ancient ancestral halls, for use in ancestral ritual worship.

"The ancient description of the *San* and *Kio* (or *Pi-Chüeh*) is that they are vessels bordered around with (*pi*) ' A certain type of Jade.' "[1]

Wu relates that he possesses one of these vessels, and that he is of the opinion that the ancients also possessed *Yü San* and *yü Kio*.

Continuing our translation of Wu Ta-Ch'êng, we read :

"The *Li Ki* (*yueh ling*) says 'in the Royal Hunting Time, the vessel *Tsun* was used for the supply of the drinking wine ; this pot was adorned externally with faceted square protrusions, in the same manner as the ritual pots of the ancients.'

"This *Tsun* is therefore like the *pien* which also bears these faceted protrusions." Wu further makes the important statement that : "This *Tsun* reminds us of the reference in the *Li Ki* (*yueh ling*) to a vessel called *Lung* which is described in the *Shuo wên*[2] as a type of jade vessel used for ' wishing ' or praying for rain."

He continues : "Lung Ta-yuan[3] in his writing *Yao Chu Chi* (The life of the family Yao) says ' The emperor Yao appointed special commissioners (*Ch'un-Ying*) to go to *Ching* (a small suburb) to present there his vessels *Lung pien*[4] to *Ying-ch'un* (" Welcome the Spring ")."[5] Wu considers that this story may be considered authenticated by the *Shuo wên* description of the *Lung*.

It would appear from Wu's able summary that *Tsun* vessels in jade were made during the Chou Dynasty and were used as containers for the sacrificial wine in the ritual to the "god of Soil and Grain, or the god of Agriculture." This may well be one of the earliest references to the *Ch'un-niu* ;[6] the ceremony of the Sacrifice of the Spring Ox, during which, even to-day, the weather for the ensuing year is foretold.[7]

FIG. 35

CHAN.

The *Li Ki* (ming t'ang wei, 9) refers to the *chan* in jade during the Chou Dynasty :

"As drinking-cup they used the jade cup *chan* carved in the usual manner." Wu Ta-Ch'êng suggests that the specimen (here repro-

[1] Legge, " There were also the plain cups and those of horn, adorned with round pieces of jade." Couvreur : " Les coupes additionelles étaient le san et la corne, dont le bord était orné de jade." Laufer : *Jade*, p. 315, " both made of the jade called pi."

[2] The Chinese dictionary often used by Wu Ta-Ch'êng.

[3] The *Ku yü t'u p'u* compiled under the guidance of Lung Ta-yuan.

[4] Compare *Lung-kang* (dragon bowls) made under the imperial order of Shun-chih (1654). Bushell, *Oriental Ceramic Art*, p. 294.

[5] *Li Ki*, Book 4 (Legge's translation, Vol. I, p. 253). " In early times, the Son of Heaven, accompanied by his high officials and the Feudal princes, went out to meet the Spring in the Eastern suburb."

[6] Compare *Li Ki*, Book IV, Monthly Proceedings of the Government, Yueh-ling (Legge's Translation, Vol. I, p. 253).

[7] If white predominates, there will be a superabundance of floods and rain ; red portends fire ; blue, strong winds and storms ; black, sickness and yellow, a plentiful year. *China Review*, Vol. I, p. 62.

duced as FIG. 35) is one of these vessels. He, however, only tells us that his example is of white jade bearing cornelian markings. He also refers to its capacity as smaller in comparison to the *Tui*, inferring therefrom that it must be the cup into which the wine contained in the *Tui* is poured. Wu does not ascribe a date to his piece, but its material and design suggest a Han reproduction.[1] There is no doubt that from Han times onward this type of design[2] was much used by the jade carver (see PLATE XXXI).

<center>THE P'AN.</center>

The archaic jade *P'an* was probably the type of vessel which Wu Ta-Ch'êng illustrated in his drawing (FIG. 36).

<center>FIG. 36</center>

This he describes as " of white jade, the bottom rim or (foot), both inside and out, bearing earth marks . . . undoubtedly a very rare and precious work of the three Dynasties—the Hsia, Shang and Chou. . . ."[3]

In the Artificers Section of the *Chou Li* reference is made to the *Chüeh-p'an* and another type of vessel, the *Chüeh t'ieh*, as being used during the Chou Dynasty at the banquets which preceded the conferences held with his feudal Princes by the Emperor. (PLATE XXIX.)

The ancient Chinese writer Tze-luo states that jade *p'an* (*yü-p'an*), were provided at these Conferences for the use of the Emperor and each of the Princes and that, when any decision was reached, the Princes signified their approval by pouring the blood[4] from their vessel into that of the Emperor or, if they disagreed, on to the ground. A representation of what would appear to be the developed form of the *p'an* is shown in PLATE XXX.

When describing the Sacrificial vessels of later times, the *T'ao Shuo* associated the *p'an* with the radical *min*, meaning dishes, and distinction

[1] Compare Pope-Hennessy, *Jade*, p. 97, where the author quoting from T'ao Shuo, says, " The cups (*chan*) of the ancient Hsia Dynasty were made of carved Jade."

[2] The Tao Chuo (Bushell : *Description of Chinese Pottery*, p. 96), refers to vessels called *chan*.

[3] Cf., *Li Ki*, Book XXIX, para. 52.

[4] The blood contained in these vessels was obtained from an animal sacrificed before the conference and denoted the sanctity of the oaths pledged during these meetings.

<center>45</center>

PLATE XXVIII

LI-KI, Chapter XXXI, folio 6 versa, 7 recto (15, 2, 20, c /a).

(Reproduced from the volume in the British Museum.)

PLATE XXIX

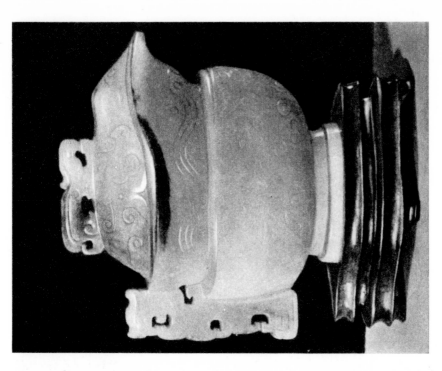

A JADE CUP AND COVER IN THE FORM OF THE
BRONZE *I* VESSEL

COLOUR : Grey, splashed Brown and Black. H. 8.4 c.m. W. 9 c.m.
Early Ch'ien Lung Period, A.D. 1736-1795.
(Formerly in the Collection of Sir Dudley Myers.)

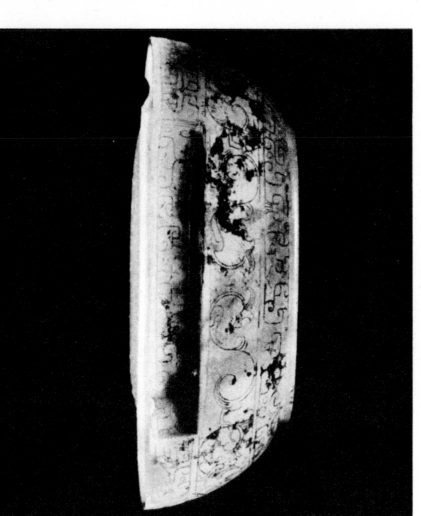

A TRANSLUCENT OVAL JADE *TIEH*
Used during Imperial Conferences.

COLOUR : Mottled Grey White with Yellowish Brown and Reddish Brown markings covered by
earth marks. W. 10.4 c.m. L. 12.85 c.m. H. 3.8 c.m.
Period of the Warring States, 481-221 B.C.
(In the Collection of A. W. Bahr, Esq.)

is made between large and small kinds; those measuring over six inches being termed *p'an*, those of smaller size *tieh*.[1]

This type of *p'an*, when carved in jade, took the form of a plain or fluted plate, obviously inspired by ceramic models. In its plain form it was probably first introduced during the Yuan Dynasty, the fluted type being developed during the Ming. This fluted type was sometimes of Rose Mallow design and was used as a sacrificial vessel in private houses. Another form of the Ch'ien Lung period which is a type of Bowl is illustrated in PLATE XXX.

<div align="center">THE TUI.</div>

Wu Ta Ch'êng is of the opinion that this vessel was evolved from the bronze vessels *Tsun* and *I* of the Shang and Chou periods. The specimen which he depicts, here shown in FIG. 37, is stated to be of " pure red colour, the lip of the vessel bearing earth markings, and is toned slightly yellow. Its decoration is of the finest execution."

He further tells us the jade *tui* was a covenant vessel, and that the bronze *tui* was used for sacrificial purposes.

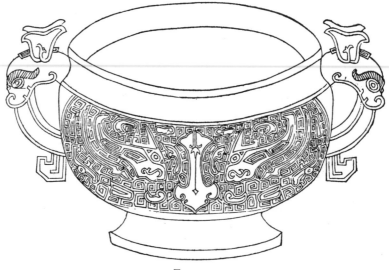

<div align="center">FIG. 37</div>

After the Han Dynasty the jade *tui* became an incense urn for use on the altar. An excellent example of this type is shown in PLATE XXX (lower subject).

Another example of the *tui* in jade, found during excavations in

[1] Bushell: *Oriental Ceramic Art*, pp. 53 and 475.

<div align="center">46</div>

Fêng-siang fu in Shensi province, is shown in FIG. 38. It is described by Wu Ta Ch'êng as " of pure white colour comparable with the elephants teeth (ivory)."

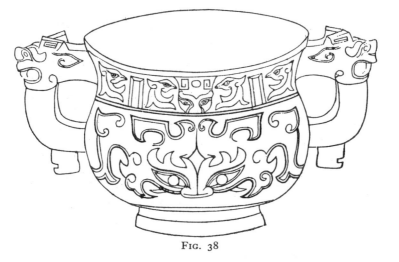

FIG. 38

From the general characteristics and form of this piece one would be disposed to assign it to a period not earlier than the Han Dynasty.

THE *TOU* OR *TENG*.

This is a type of Tazza shaped vessel having a solid stem and spreading feet.[1] It probably was first made in jade during the Shang Dynasty, although according to the *Li Ki*[2] such vessels " were devised for the house of Yin " (1401-1191 B.C.). The *Tou* is referred to in the *Li Ki*[3] as one of the sacrificial vessels used in the special ceremony performed in the ancestral temple in honour of Chou-kung, and is described as made of jade (*yü tou*). An excellent example of this type of vessel, of the Ming Dynasty, is in the Collection of Major-General Sir Neill Malcolm and is illustrated in PLATE XXXII.

In the *Chou Li* it is also stated that the *Tou* was used during the Chou Dynasty whilst the offerings were being presented to the Gods. *T'ao Shuo* records that in the ceremonial worship of the Emperor at the *T'ai Miao* (the Ancestral Temple in the Prohibited City of Peking), twelve Tou were placed on the left of the sacrificial table, containing all kinds of cooked dishes, sturgeon and minced carp, deer's sinews, minced hare and minced deer, sweet-bread, pickled pork, etc., with cakes of different sorts, and fruit, including hazelnuts, the prickly water-lily, jujubes, and chestnuts.[4]

This infers that the *Tou*, primarily an imperial Ritual wine cup, was now a type of ritual dish. This alteration became manifest during

[1] *Chinese Exhibition Catalogue*, No. 94, for bronze prototype. Laufer : *Han Pottery*, pp. 188, 189, for illustrations.
[2] *Ming t'ang wei*, 28
[3] *Ming t'ang wei*, 9.
[4] Compare Bushell : *Oriental Ceramic Art*, p. 491.

47

PLATE XXX

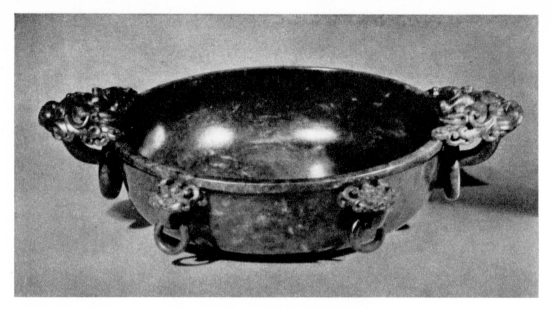

A JADE BOWL (*P'AN*)

With six lion heads supporting loose rings.

COLOUR : Dark Green.　　　Ch'ien Lung Period, A.D. 1736-1795.　　　W. 49.8 c.m.

(Formerly in the Collection of Lord Napier of Magdala.)

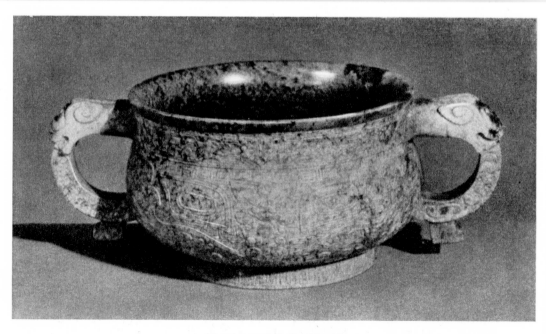

A JADE INCENSE BURNER

COLOUR : Grey.　　　Early Ming Period, *circa* A.D. 1400.　　　H. 8.2 c.m.　W. 21.5 c.m.

(In the Eumorfopoulos Collection, British Museum.)

PLATE XXXI

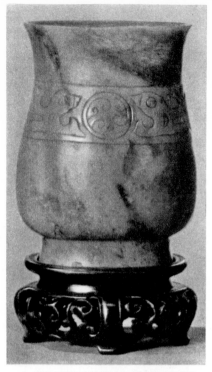

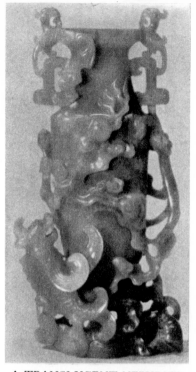

A TRANSLUCENT NEPHRITE
CARVING OF A *CHAN*
With a band of archaic Symbolical
decoration.
COLOUR : Mottled Grey Brown, light and
dark shadings. H. 9.5 c.m. W. 6.6 c.m.
Sung Dynasty, A.D. 960-1279.
(*Formerly in the Melvin Gutman Collection,
U.S.A.*)

A TRANSLUCENT NEPHRITE
CARVING IN THE FORM OF
A VASE
Lavishly decorated with mythological
representations ; including the flying
dragon, *Fêng Huang*, Shell and Bats.
COLOUR : Grey Green, splashed spinach
Green. H. 18.9 c.m. W. 9 c.m.
Early Ch'ien Lung Period, A.D. 1736-
1795.
(*Formerly in the Collection of W. G.
Wrigley, Esq.*)

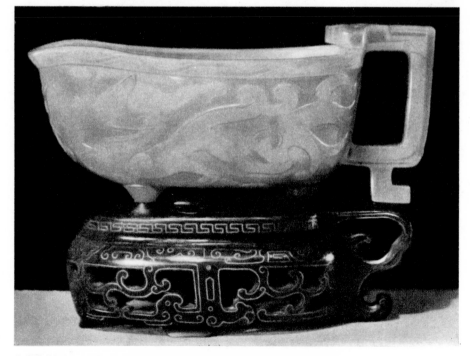

A TRANSLUCENT NEPHRITE CARVING IN THE FORM OF THE BRONZE *I*
A precious vessel for ancestral sacrificial use.
Decorated with Dragon representation and bearing inscribed mark.
COLOUR : Grey Green with underlying bluish sheen. H. 4 c.m. W. 11.2 c.m.
Yung-Chêng Period A.D. 1723-1735.
(*Formerly in the Collection of W. G. Wrigley, Esq.*)

the T'ang Dynasty and during the Ming and Ch'ing Dynasties the Jade *Tou* was used to hold the vegetable offerings placed on the altars in private houses.

THE *CHÜEH* AND *TSAN*.

In the list of the sacrificial bronze vessels enumerated in the first chapter of the *T'ao Shuo* we find reference to the *Chüeh* as being used to warm wine used for libation, and it is probable that from this source its present name of libation cup is derived. It would appear to be a similar vessel to that referred to in the *Ku yü t'ou* as the Jade cup *Tsan*. The bronze *Chüeh*, belonging to the Chinese Government,[1] suggests its prototype. I have been unable so far to find an example of this vessel in jade, which may be classified as belonging to the Chou Dynasty, but I have seen several of the bronze types in jade which date from the Han Dynasty. In the *Li Ki* reference is made to the *Tsan* with a large handle of jade ; this vessel was used to ladle the ritual wine. The *T'ao Shuo* records that a row of six *Chüeh* filled with wine formed part of the ritual vessels used for the ceremonial worship of the Emperor at the *T'ai Miao*.[2] The *Li Ki* states that the *Pi-Chüeh* (a wooden vessel banded or adorned with jade) was used as a wine cup during the *Tsin* ritual by the Feudal Princes.

THE *KIO* AND *SAN*.

These vessels[3] are similar in form to the *Chüeh*. They are referred to in the *Ku yü t'ou p'u* and may be described as :

(1) a kind of cup of boat shape with three incurving feet ; without handles.

(2) a similar cup of round shape with projections on top.

Jade cups of this form are recorded as having been in use during the Chou Dynasty, but I have not met with any example in a European collection, although specimens made during the Ming and Ch'ing Dynasties, for use in the " *Sacrifices to the Ancestors* " held in private houses, are represented in several Jade Collections.

[1] *Chinese Exhibition Catalogue*, No. 42.
[2] Compare the Artificer's Manual, *K'ao Kung Chi* by Liu Hin : a technical writing compiled during the Chou Dynasty, and added as an appendix to the *San Li*.
[3] Two examples of these vessels in Bronze are illustrated in *A History of Chinese Art* : G. S. de Morant, p. 63.

CHAPTER VIII

JADE CARVINGS OF THE MING DYNASTY
A.D. 1368-1644.

THE different types of carving practised during the Ming period may be classified thus :—

Early Ming.—Bold, usually firm in line and archaic in character. Solidity combined with a grotesque refinement seem to dominate the products of this time.

Mid-Ming.—Though still rugged in form, a definite external influence is manifest. Though shapes and forms similar in design to the bronzes and ceramics of earlier periods are found, the craftsmen have used more decorative types of nephrite. From now onwards the influences arising from contact with Europe are clearly perceived in the jade carvers' work.

Late Ming.—The progress which was characteristic of the middle part of this period has diminished, but the refining influence of continuous contact with the outside world remains.

During the Ming period, which lasted nearly three hundred years, many changes in design and character became manifest in the art of the carver. It is during this period that nephrites and jadeites of a fine colour began to appear in large carvings, usually of a bold and grotesque type. Large-scale incense-burners in jade were by now in constant use in the temples (see PLATE XXXVII) ; altar sets of characteristic Ming design formed an essential part of the temple regalia, carvings in the form of mythological monsters appeared in increasing numbers, and the birds and animals, regarded by the Chinese as sacred, were now sculptured in the mystic stone. Tear bottles (*Yao p'ing*)[1] in jade occupied the attention of the carver, for it was the fashion for Mandarins and high dignitaries of state to secret them in the folds of their robes (see PLATE CXXVII).

During this period early Chinese bronze forms were reproduced in jade (see PLATE XXXVI) and care must be exercised in distinguishing between the pieces carved during this period and those of later origin. Gradually, towards the end of this epoch, the carver became still more strongly influenced by contact with the outside world, for the advent of the Ch'ing Dynasty was close at hand.

In the Ming and pre-Ming periods, the method of mining jade was decidedly crude.[2] Large fires were built into the natural cavities of the rock and allowed to burn from sunrise to sunset ; they were then extinguished, the extreme cold of the night causing contractions and thereby fractures to occur. It can readily be understood that this method of splitting the rock often had a most detrimental effect on the appearance of the material, but we know how well this was overcome

[1] Compare Bushell, *Oriental Ceramic Art*, p. 503 ; *Chinese Snuff Bottles*, by M. B. Huish ; No. 37 of the *Opuscula of Ye Sette of Odd Volumes*, 1895.
[2] Bushell, *Chinese Art*, Vol. I, p. 129, and Bauer, *Precious Stones*, pp. 457-470.

by the skill and ability of the craftsmen, as shown in the many superb carvings that have come down to us.

It is worthy of note that the finest specimens of colourful jade carvings of the early periods were not carved from the mined rock, but from the boulders gathered from river beds, exceptional specimens of which are known to-day as *water jade*, many having been found in the Uru Valley. The Kaskem Valley was another source from which the Chinese obtained native mined jade prior to being driven therefrom by invasion.

When, after a long and tortuous journey, the rough rock had been brought to the carver, the task of transforming it into a work of art began. It has been suggested that long periods of time were taken in executing single carvings ; be that as it may, it can easily be imagined that the task was no light one, considering the primitive types of tool used by the craftsmen.

In Canton the processes are classified thus :—1. *Ta Kung* : cutting raw material. 2. *Ta-Yen* : drilling holes. 3. *Shang-Hua* : carving figures. 4. *Ta-mo* : polishing the finished product. (Cf. PLATE II.)

EARLY MING.

CIRCA A.D. 1368-1465.

The craftsman during this period produced works of a hybrid type, inherited from a school influenced by a foreign people ; for had not his forefathers been subjected to Mongolian invasion, and is it not on record that the Khans were well supplied with utilitarian carvings in jade, such as bowls and plates for their food, and vessels or cups for their wines which had been already decanted into jade cisterns.[1] Dr. Laufer illustrates a jade cup[2] which is typical of the early Ming carvers' work, being structurally of the type made under the Yüan Dynasty, but decorated with the mythological Hydra, a product of the Han period.[3] A curious rugged structure, decorated with mythological symbols drawn from types created by previous generations, persists unfailingly throughout the first years of the Ming period. Also some of the material employed by the craftsmen of this time was not imposing, being of a grey shade combined with various other colours, such as brown, mottled yellow, black and an indifferent green. Carvings with high undercut relief decoration appear to have been more beautifully produced during this period. (See PLATE XXXIII.)

The size of the carvings was on a larger scale than the pieces produced during the Han, Sung and T'ang Dynasties, a characteristic also noticeable in the Ceramics, Bronzes and Copper vessels of this time.[4] It is on record that a bell weighing about 52,000 kilograms was cast in the Han-tsing works at Peking at this time.[5] The craftsmen of this

[1] *Jades*, by Dame Una Pope-Hennessy in *Chinese Art*, edited by Leigh Ashton, p. 99.
[2] *Jade*, Plate XLV.
[3] Bretschneider, *Botanicon Sinicum*, Part I, p. 200 ; Laufer, *Jade*, p. 168.
[4] Silcock, *Introduction to Chinese Art*, p. 231.
[5] De Morant, *A History of Chinese Art*, p. 221.

PLATE XXXII

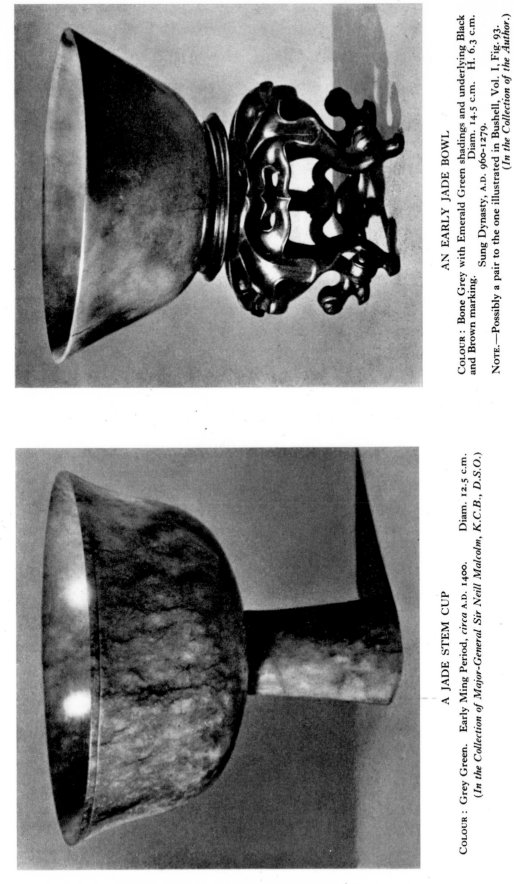

AN EARLY JADE BOWL

COLOUR: Bone Grey with Emerald Green shadings and underlying Black and Brown marking. Diam. 14.5 c.m. H. 6.3 c.m. Sung Dynasty, A.D. 960–1279.

NOTE.—Possibly a pair to the one illustrated in Bushell, Vol. I, Fig. 93. (In the Collection of the Author.)

A JADE STEM CUP

COLOUR: Grey Green. Early Ming Period, circa A.D. 1400. Diam. 12.5 c.m. (In the Collection of Major-General Sir Neill Malcolm, K.C.B., D.S.O.)

PLATE XXXIII

A NEPHRITE LIBATION CUP

A monster head decorating the handle ; the body adorned with representations of grain pattern and archaic Dragon and Phœnix.

COLOUR : Brown and Grey Green weathered Jade.
Mid Ming Period, *circa* A.D. 1500.　　H. 11 c.m.　　W. 15 c.m.
(*In the Collection of Dr. J. W. Fisher.*)

A JADE WINE VESSEL

Body intricately adorned with a pair of Hydra upholding the *Shou* symbol (Longevity) ; the spout is in the form of a Phœnix holding a loose ring ; the handle of dragon design and also supporting a loose ring.

COLOUR : Grey Black and Brown with splashes of Green.
Early Ming Period, *circa* A.D. 1400.　　H. 12.0 c.m.　　W. 16 c.m.
(*In the Collection of H. P. Clausen Esq., U.S.A.*)

NOTE.—The two rings were probably attached to a supporting chain when the vessel was suspended for heating its contents.

PLATE XXXIV

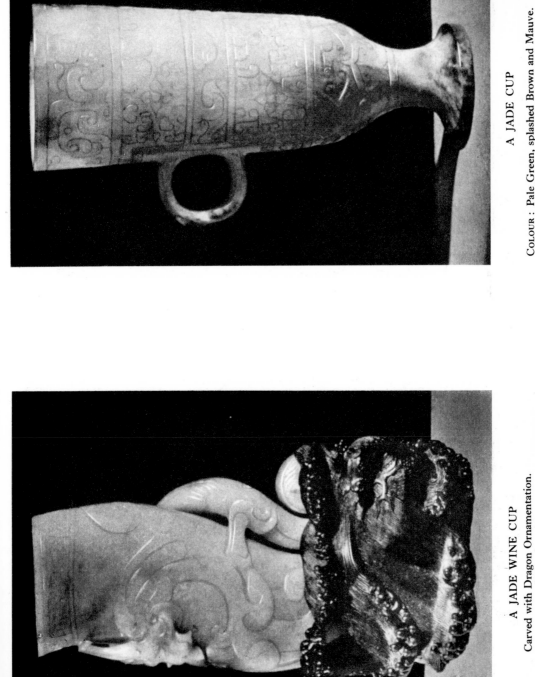

A JADE CUP

COLOUR : Pale Green, splashed Brown and Mauve. H. 12.4 c.m.
Sung Dynasty, A.D. 960-1279.
(*The Property of the Chinese Government.*)

A JADE WINE CUP

Carved with Dragon Ornamentation. H. 18 c.m.
COLOUR : Grey Green, splashed brown.
Ming Dynasty, A.D. 1368-1644.
(*The Property of the Chinese Government.*)

PLATE XXXV

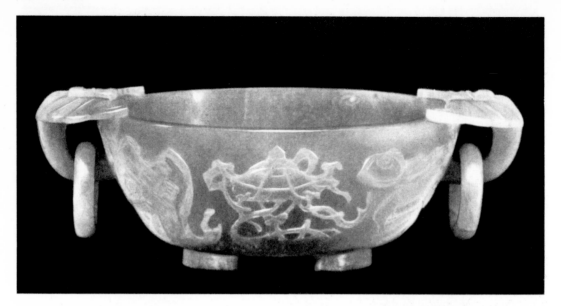

A JADE BOWL CARVED WITH THE EIGHT BUDDHIST EMBLEMS

Two loose rings supported by bats with outspread wings form well-positioned handles.

Colour : Mutton fat. Ch'ien Lung Period, A.D. 1736-1795. H. 6.5 c.m. W. 20.5 c.m.

(In the Collection of the Author.)

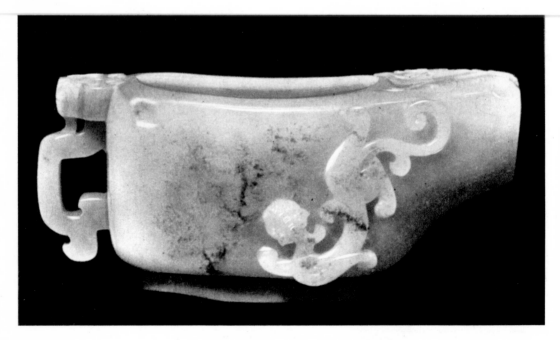

A TRANSLUCENT JADE WINE VESSEL

The handle formed of an archaic stylised dragon ; two newt-like dragons adorn the otherwise plain body.

Colour : White, splashed Russet. Late Ming Dynasty, *circa* A.D. 1600. H. 7 c.m. L. 16.7 c.m.

(In the Collection of the Author.)

PLATE XXXVI

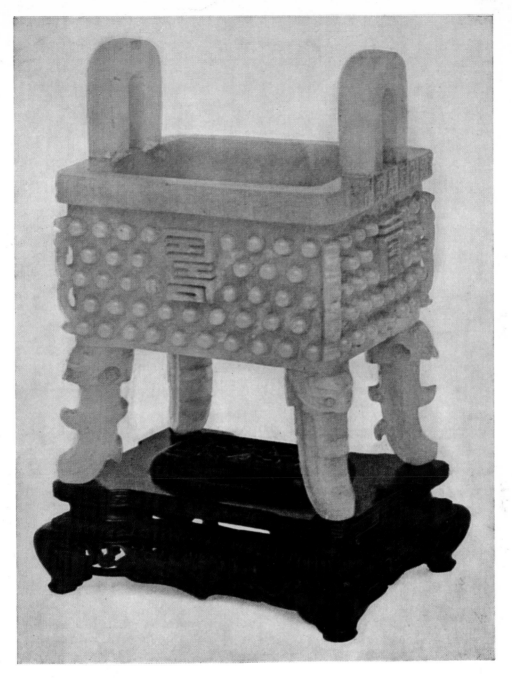

A RECTANGULAR *TING* (CAULDRON)

Decorated with " Grain Design " and " *Shou* " mark. Inscribed round lip with *Fu* (Happiness),
Kuei (Nobility or Honour), *Chang* (Longevity emblems), *Shou* (Longevity), *Wan* (Ten Thousand,
or many Thousand), and other indecipherable characters.

COLOUR : Translucent Grey Green. H. 19.2 c.m. W. 13.5 × 11.4 c.m.

Early Ming Dynasty, *circa* A.D. 1400.

(In the Collection of J. H. Smyth-Pigott, Esq.)

PLATE XXXVII

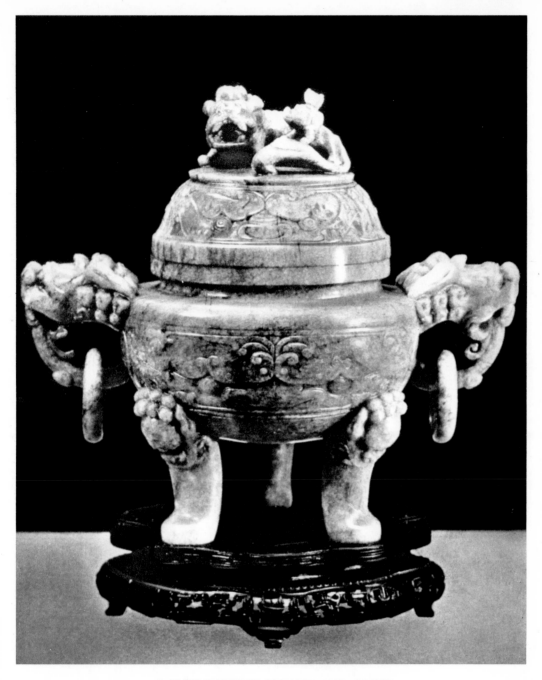

A JADE INCENSE BURNER AND COVER

Boldly carved with archaic representations of symbolic spiritual phenomena ; two large monster heads support bold loose ring handles. The cover is surmounted with a lion and young. The whole is supported on three curved feet emanating from *T'ao t'ieh* masks.

COLOUR : Opaque mottled Grey. Mid Ming Period, *circa* A.D. 1500. H. 28 c.m. W. 30.4 c.m.
(*In the Collection of the Author.*)

PLATE XXXVIII

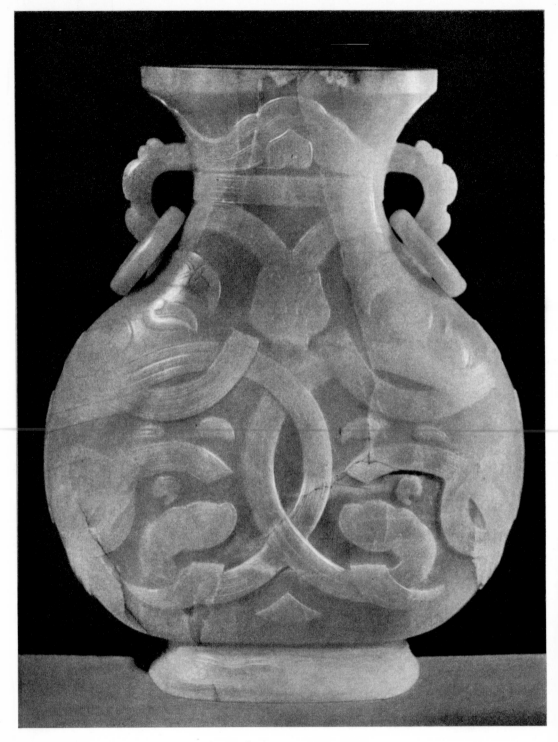

A TRANSLUCENT JADE VASE

Decorated with entwined archaic hydra and T'ao-T'ieh masks, two loose rings are supported at the neck by archaic dragon heads.

COLOUR: Pale Grey Green. Mid Ming Period, *circa* A.D. 1500. H. 34.6 c.m. W. 26.5 c.m.
(Formerly in the Alexander Collection.)

PLATE XXXIX

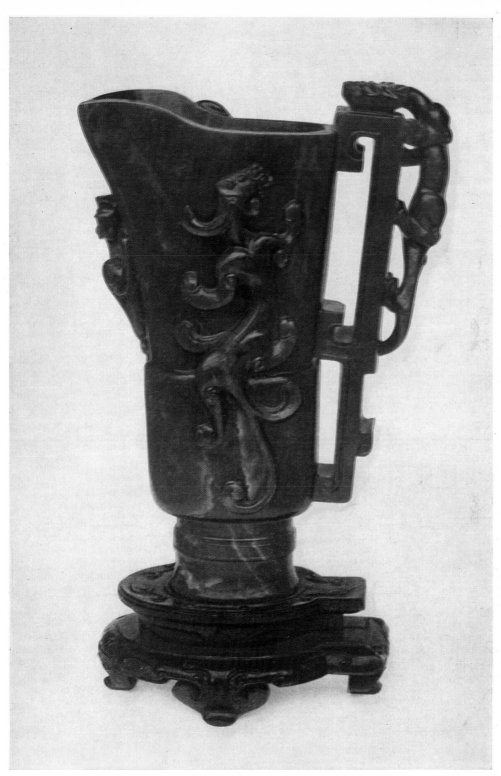

A JADE LIBATION CUP
Carved in bold relief with Newt-like Dragon decoration.
Colour : Spinach-Green. Late Ming Period, *circa* A.D. 1600. H. 17 c.m. W. 12.5 c.m.
(In the Collection of Frank H. Fulford, Esq.)

period, however, cannot be credited with having first introduced the massive type of jade creation, for it is stated in the *Chinese Recorder*,[1] by Bretschneider, that a jade wine jar was " so big that it could hold thirty piculs of wine "—the description being that of one of the large jars made for the Mongol Emperors.[2] Recent research suggests that these jars were in use as early as the late Han Dynasty.[3]

Perhaps the most notable sources from which the Chinese obtained their jade at this time were the primary deposits in the Belurtág in the upper reaches of the Tisnab river, about eighty miles from Yarkand,[4] a type of jade which has an entirely different appearance from that used during the earlier dynasties.[5] Certain of the carvings of this period, particularly those executed in jade brought from Yarkand, were definitely reproductions of earlier forms and styles. It would appear, too, that during the Early Ming period, the jade seeker resorted rather to collecting the crudely mined rock, which has been subjected to heat, than to selecting the jade from the river boulders, which, though weathered on the external crust, possessed internally fine natural colour-grainings ; the choice of mined rock being induced most probably by the carver's desire to produce larger objects than those of his predecessors. Also, the carving is of a cruder and less artistic type, easily discernible to the expert, or even the novice, when compared with the truly archaic jades. Further, there is a noticeable decline in the burial carvings, while reproduction of the earlier ritual vessels is exceedingly rare, a fact which is confirmed by the following quotation from Mr. A. L. Hetherington :[6] " Hung Wu, the illustrious founder of the dynasty, started a fashion of economy which seems to have affected grave ceremonial and equipment ; wooden vessels, rather than pottery utensils, were used and the whole ritual appears to have been on a much more simple plan."

MID-MING PERIOD.

CIRCA A.D. 1465-1521.

Here let us imagine a graph, that we may visualise the rise of Chinese ceramic art from the Sung Period[7] to its later perfection and subsequent decline. History, which records the rise and fall of monarchies through internal and external upheavals, gives us a wavy line with peaks of tranquility and valleys of civil war ; similarly, peaks occur in our comparative imaginary graph, from which an interesting deduction may now be made. As Ceramics arrive at a peak of charm,

[1] Vol. VI, 1875, p. 319.
[2] Laufer, p. 318. See also *Burlington Magazine*, No. 394, Vol. LXVIII, pp. 49-50.
[3] Yule's *Cathay and the Way Thither*, Vol. I, p. 130.
[4] *Writings of Hsi Yü Wên Chien Lu*, 1777.
[5] The material found in this region being of a mottled grey-green or burnt brown colour and lacking in the positive and distinctive green or brown of the previous minings.
[6] *Early Ceramic Wares of China*, p. 27.
[7] Prior to this time the art of the bronze worker, in my opinion, seems to be the obvious inspiration of the jade carver, for in form and general decoration, a strong resemblance is noticeable, though the jade creation conveys a distinct lack of finish and detail when compared with its bronze counterpart.

so within a century, or even within a shorter period of time, a peak of similar importance is found in the jade carvers' art. It is significant, too, that the reigns of Hsüan Tê (1426-1435) and Ch'êng Hua (1465-1487) are considered the classic periods for Ceramics in the Ming era, while it was at the commencement of the 16th century (Mid-Ming) that the most outstanding specimens of jade carving were created. Unfortunately the troublous times which followed brought this period of artistic maturity to an untimely end, and the number of exceptional carvings actually executed were few. Care, therefore, must be exercised when ascribing specimens to this epoch.

The jade carver, during this time, would seem to have been largely occupied with the reproduction of ceramic and bronze forms, but in the decoration of the articles which he produced were embodied his personal characterisation of the symbols used by his ancestors (see PLATES XXXVII and XXXVIII). At the same time he introduced into his art, and made famous, the Ming Dragon, though even this symbol was inspired by his predecessors of the Han period.[1] It was, indeed, during this part of the Ming period that the finest works originated. Intricately adorned carvings of an elaborate type of relief reached a height of perfection not previously seen in this art—the finish and polish leaving little to be desired. "Dark green,"[2] *Ji Yü*, and mottled grey-green, as opposed to pale green and rust brown jade, was chosen for the larger carvings, which are of fine nephrite and jadeite. The influence of contact with the outside world had by now deeply penetrated the art, due probably to the past and ever-present connection of the Chinese with Persia through trade, and further induced by the then recent visits of papal envoys from Italy. It is noticeable, too, that the carver from that time took increasing advantage of the natural colour of his material in order to accentuate the intricacy and beauty of his creations. This suggests an inherent mineralogical knowledge of the stone and may account for the great care exercised by the craftsman in the choice of his material.

LATE MING.

CIRCA A.D. 1522-1620.

During the Late Ming period the art of carving in jade may be said to have reached, first, the zenith of its perfection, and then to have begun to show signs of decay from the effects of a progressive civilisation. The last of the Ming Emperors, unstable and degenerate, allowed the empire to become an easy prey to ambitious, yet decadent, external forces. The approach of a new era was at hand. The crumbling of the mighty Ming Dynasty heralded the advent of a new epoch—that of the Ch'ing Dynasty.

The effect of the change upon the jade craftsmen became manifest in their works, which had lost the intricacy of decoration characteristic

[1] Laufer, *Jade*, pp. 236 and 237.
[2] Obtained from Barkul and Manas in Singaria and in the vicinity of Lake Baikal.

of their predecessors, while retaining some of its refinement—notably the use of the finer varieties of nephrite and jadeite. Excellent examples of the art of this era are illustrated in PLATES XXXIX and XL. Other similar specimens are portrayed by Dr. Laufer in his book[1].

The carver in jade gradually reverted to the style employed at the beginning of the Ming Dynasty. He produced copies of earlier forms, but in a purer type of stone. When he attempted originality or invention the result was no more than a conventional form, characteristic of his era, and lightly embossed with a decoration, either floral or of mythical monsters. It is to this part of the Ming Dynasty that belong many of the grotesque animal carvings, libation cups, incense burners, and mythological symbolic statuettes. These, in contrast to the copies already referred to, are made of a less refined type of nephrite, generally grey in colour, but occasionally blackish, deep green, or mottled with brown. (See PLATE XLI.)

Important translucent carvings were also produced at this time, but only in the few remaining Monastic workshops. Few examples are to be found in European hands, since the Chinese, apparently, guarded them jealously from defilement by the foreigner.

We are gradually passing from the age of archaic Chinese art into that of an interesting, and perhaps more pleasing, type of art from the decorative point of view—a type in which the technique was unrivalled although sometimes the taste was questionable. Notwithstanding this gradual evolution, none of the ancient carver's subtlety of execution was lost. It would, in fact, appear as we progress through the K'ang Hsi period to the great Ch'ien Lung period, that a new standard of perfection in the art of jade carving is being reached, for surely there is little in glyptic art that can approach the achievements of the craftsmen of those sixty years of the reign of that great benefactor to mankind, the Emperor Ch'ien Lung. For those interested in the more decorative type of art, the carvings of the Ming, K'ang Hsi, Ch'ien Lung and Chia Ch'ing periods must take supreme pride of place.

[1] Laufer, *Jade*, p. 320. Plate XLVI and Plate XLVII.

PLATE XL

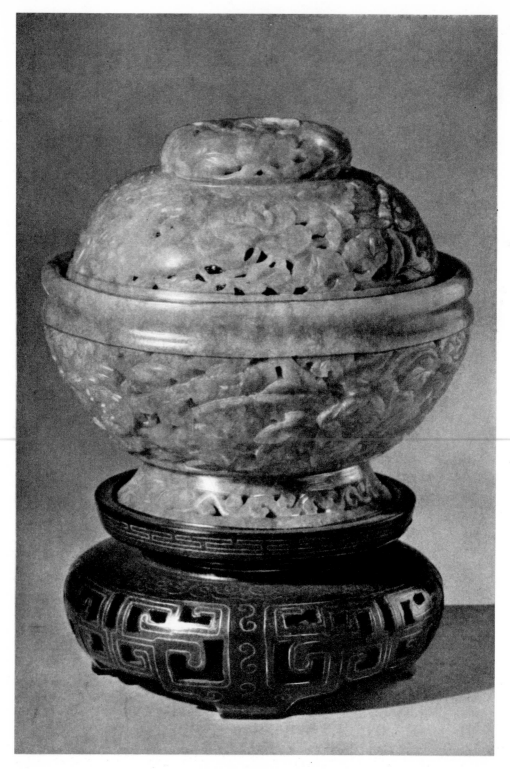

BOWL AND COVER IN NEPHRITE

An excellent example of the pierced floral decoration, embodying the Phœnix and flowering
trees of the " Sterculia " type.

COLOUR : Mottled Grey.
H. 9.5 c.m. Diam. 10.5 c.m.

Late Ming Dynasty, *circa* A.D. 1600.

(Formerly in the Collection of Commander R. E. Gore, R.N.)

PLATE XLI

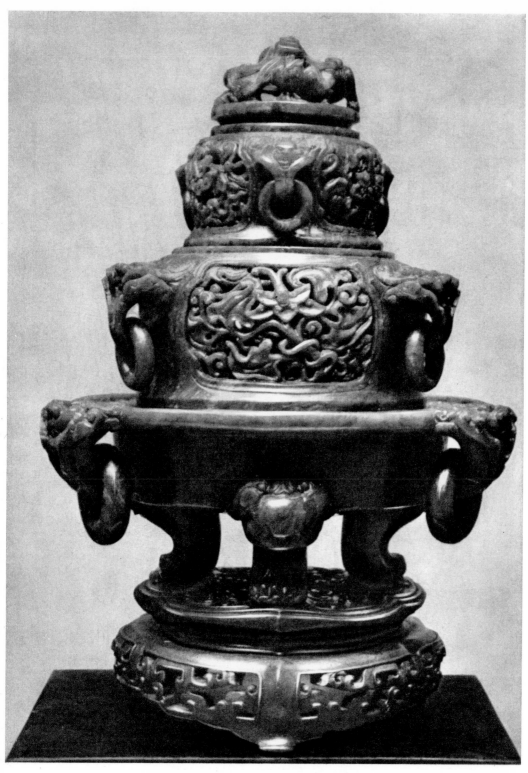

A JADE INCENSE BURNER AND COVER
Built up in four sections.
COLOUR : Light Spinach-Green. Early Ch'ing Dynasty, *circa* A.D. 1650. H. 24.7 c.m.
(In the John Yates Collection, Manchester Art Gallery.)

CHAPTER IX.

JADE CARVINGS OF THE CH'ING DYNASTY
A.D. 1644-1911.

K'ANG HSI PERIOD. A.D. 1644-1722.

THE transition period in Chinese Art was now at hand. In China as in Europe strong, energetic Emperors supplanted the weak and degenerate rulers of past centuries.

The reign of the Emperor K'ang Hsi lasted about sixty years and, as was the case in earlier times, the craft of the jade carver borrowed its inspiration from the creations of the ceramic artist. It is not surprising therefore that this important reign, which was destined to see the beginning of perhaps the greatest of all periods of Chinese Art, and, incidentally, to give birth to a peculiarly distinctive type of carving in jade, should have actually produced but few examples of this art. Many indeed of the works accredited to this period belong in reality to that of Yung Chêng.

The carvers of the early K'ang Hsi period produced work in fine nephrite and jadeite, similar in form and technique to that of the late Ming period, but more beautifully carved and decorated in high relief. The pierced type of work was also revived and numerous specimens of this style were adorned with distinctive floral creations. An excellent example is shown in PLATE XLII ; and another example of this type of carving is illustrated in Gorer and Blacker's book,[1] which is also typical of the jade work of this period. Several exceptional white jadeite carvings, treated in similar style, were also produced ; rarely, however, was a carving made in fine emerald or apple green jade—a vogue which had not yet proved attractive to the carver.

YUNG CHÊNG PERIOD.

A.D. 1723-1735.

During the twelve years of the reign of the Emperor Yung Chêng the jade carver was one of the principal art producers of China. His carvings, of which perhaps the most outstanding were in the form of statuettes, were both graceful and delicate.

Several 18th century Chinese writers record that this reign was marked by its tranquillity which had a remarkable influence on the Arts. A recent writer on Chinese art, Soulié de Morant,[2] sums up this effect as follows :—" The taste of this time for grace and delicacy led it away from plastic works of importance, for strength and great bodily size always go together in our mind. Thus, too, did stone seem too coarse, and finer materials were chosen, so that those works of art which were truly attuned to the prevailing feeling were mainly statuettes in jade, jasper, alabaster, or simply in dried clay painted with brilliant colours."

[1] Vol. II, Plate 236.
[2] *A History of Chinese Art*, p. 249.

The jade carvers of this period effected, in many instances, the completion of subjects started during the previous reign, they also were responsible for the introduction of purely decorative objects in jade, carved in the vividly coloured nephrites and jadeites. This innovation and break with tradition may have been influenced by their contact with Europe, although the carvings themselves show no signs of this influence ; being purely Chinese in character and design.

An important observation made during this period by a Chinese writer[1] is that seldom did the carver copy the archaic jades, possibly because his time was fully occupied in producing statuettes, vases and decorative ornaments for use in the homes of his wealthy patrons.

The main difference in style perceptible in the carvings of this and the preceding period may be summarised as follows :

K'ang Hsi :—Robust in structure : mainly floral in design : ornamentation obtained by bold relief and pierced carving ; the forms chosen obviously being inspired by the works of the Ming Dynasty.

Yung Chêng :—Delicate in structure, devoid of bold outlines, decorative in character and given added brilliance by reason of the material chosen. The decoration, which was introduced sparingly, was executed in low relief or engraved, and was of a symbolical rather than a floral type. The forms chosen were obviously inspired by the ceramics of the K'ang Hsi period.

Mention should be made of the few ritual vessels carved at this time, these were executed in the finest white nephrite and sparsely decorated, contrasting vividly with the carvings of similar character made during the previous and ensuing periods.

CH'IEN LUNG PERIOD.

A.D. 1736-1795.

We now enter an era of jade craftsmanship as distinct and exceptional as any that have preceded it. On account of its flamboyant character and close resemblance in style to European sculpture of the same period, the student familiar with the early ceramics and " Burial Jades "[2] will find it difficult to consider calmly the jade carvings of this epoch, so strongly do they contrast with those which have gone before.

It can be disputed, however, that during this period the art of the jade carver attained its zenith of decorative perfection. It is, indeed, comparable with the achievements of the ceramic artists during the K'ang Hsi period.

During the Ch'ien Lung period many fine copies, reproducing early bronze forms, were made in the palace workshops, the most outstanding

[1] *A treatise on Jade working*, by Liu Tê Huang, written *circa* A.D. 1730.

[2] By which is meant the art of carving in jade up to the beginning of the Ming Dynasty.

PLATE XLII

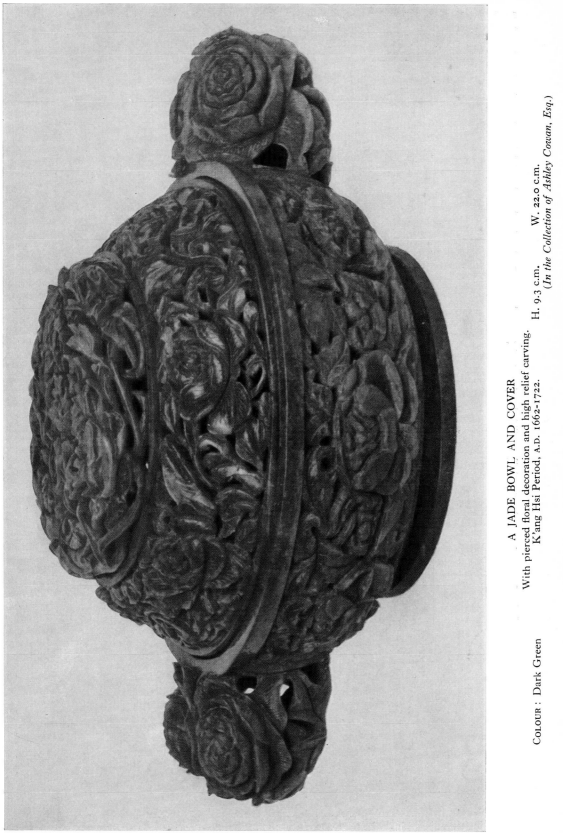

A JADE BOWL AND COVER

With pierced floral decoration and high relief carving.
K'ang Hsi Period, A.D. 1662–1722.

H. 9.3 c.m. W. 22.0 c.m.

(*In the Collection of Ashley Cowan, Esq.*)

COLOUR : Dark Green

PLATE XLIII

A TRANSLUCENT JADE INCENSE BURNER
Decorated in low relief with stylized Dragon forms; two similar designs form well positioned and pleasing handles. The cover is surmounted by a pierced carving in the form of the lotus.

COLOUR: Seaweed Green. Imperial Ch'ien Lung, *circa* A.D. 1770. H. 16 c.m. W. 19.3 c.m.

(In the Collection of Her Majesty Queen Mary, and included by Her Majesty's gracious permission.)

of these sometimes bearing the imperial seal mark[1]—a hall-mark of perfection.

The quality of the nephrite and jadeite used by the carver was the finest ; no fever of haste held the craftsman in its grip, and the minutest detail was not forgotten ; the finished carving had of necessity to be the finest that human skill could produce—commerce had not yet infected this branch of art with its destructive stimulant. An outstanding example of the work of this period is the fine translucent seaweed green Jade Incense Burner in the Collection of Her Majesty Queen Mary, illustrated in PLATE XLIII.

The Emperor, Ch'ien Lung, was a poet, and through the medium of inscriptions on jade carvings many of his compositions have been preserved for posterity. A vase and cover which is in the Collection of His Majesty the King (PLATE XCVIII) has engraved upon it a poem composed by a scholar for the Emperor.

Jade, the sacred stone of the earlier Chinese, became, during this period, not only a medium for mythological representation, but the one through which the most highly skilled craftsmen of a great nation found outlet for their inspirations.

Following this impressive reign, history continued its steady cycle of repetition until, by the end of the Tao-Kuang period, the Art of Jade had commenced its downward trend.

This was most noticeable in the carvings made between the last years of the Tao-Kuang period up to the present day,[2] when the alterations in technique and finish move rapidly with the mechanical age which has given them birth, causing an unreal and non-Chinese character to replace gradually, but perceptibly, the inherent subtle artistry of the formerly secluded craftsman. In fact, the mechanical age rapidly caused the Chinese nation to become commercial, and the jade worker inevitably became involved in industry, as opposed to art. Will this great heritage from remote antiquity survive its present decadence in a machine-fettered world and, returning to its previous principles, regain the celestial ?

[1] An impression of the Imperial Seal is shown in Appendix VIII, page 176.
[2] Compare Grandidier, *La Ceramique Chinoise*, p. 224.

CHAPTER X.

STYLE IN JADE CARVING.

IT perhaps may be thought helpful to endeavour to summarise some of the characteristics of style to be observed in the working of jade throughout the great historic periods of Chinese Art. The subject of course is a very wide one, and it is inadvisable to rely too closely on broad generalisations, which is all that can be attempted in the brief space at our disposal. The classification and dating of jade carvings share something of the difficulty and uncertainty that is associated with other branches of Chinese Art, and indeed this is inevitable when we consider the enormous span of time involved, the vast geographical area covered, and the variety and complexity of the art itself.

As in the case of bronzes, it is remarkable that the earliest specimens which have come down to us, possibly even from the Shang-Yin Dynasty, 1766-1122 B.C., are the products of a practised and sophisticated art. The jade carver of those far-off times possessed marked ability in the working of his material, and if the products of his craftsmanship are archaic and primitive, it would be quite erroneous to regard them as in any way barbaric.

THE CHOU DYNASTY.

As the result of examining many specimens of early carved jade of undoubted authenticity, I have come to the conclusion that in some cases apparent defects or imperfections were deliberately executed : to take two examples, the intentionally imperfect drilling of the holes in the *T'sung* (see PLATES VII, VIII, and IX), and the defacement of Ritual Emblems—the carver having purposely abstained from technical perfection in order to emphasise his desire to produce worthy tokens for use in the worship of the supernatural. Some carvings undoubtedly executed during this period exhibit the height of sculptural skill ; in comparison with them the highly conventionalised human figures appear to us bizarre, but parallel instances occur in the glyptic art of the palæolithic period, with its peculiar and caricature-like renderings of the human form. Speaking generally, the jades of the Chou Dynasty comprise forms of an utilitarian type used in the early ritual sacrifices, and also embody in their design archaic spiritual and mythological formulæ. Even at this early period many objects were executed in jade on account of the special esteem in which this material was held by the Chinese.[1]

For many ages, peculiar animation and life-prolonging power was attributed to jade and gold. The *Yi-King* says " The empyrean region is jade and gold." *T'ien wei yuh, wei kin.* (天 爲 玉 爲 金)

It is probable that eventually research will establish that most of the early carvings of the ritual type in nephrite and chloromelanite are assignable to this dynasty ; and the forms of implement, knife

[1] De Groot, *The Religious System of China*, Vol. I, p. 271, Vol. IV, p. 330.

and weapon which, like the intricately decorated ritual bronze vessels, persisted into later periods, must have originated in a pre-Chou era.

THE HAN DYNASTY.

During this era the style of the Chou Dynasty as it gradually evolved showed a more definite resemblance to external forms; and to the earlier shapes is added a less abstract and conventional type of design, possibly influenced by the arts and crafts of the Occident, derived from the contact of China with such countries as Persia, India, and Egypt. The style of the carving of this dynasty may thus be described as composite. The jade worker, possibly more subtly than obviously, is embodying motives derived from external sources, though still retaining much primitive Chinese mythological symbolism. The previous styles are thus modified by the first distinct indication of imported stylistic influence.

THE PERIOD OF THE THREE KINGDOMS.

During this era, from A.D. 220 to 589, no definite style can be reckoned as characteristic. The time was marked by violent political upheavals, which have caused the destruction of the majority of the contemporary works of art, and few jade carvings remain. At the commencement of this time the influence of Buddhism is not apparent, but in the rare carvings which have survived destruction, there is a definite Buddhist influence, parallel with that which is found in the contemporary sculpture. The carver did not appear to aim at an exact representation of life, but to achieve forms which express a contemplative and super-mundane tranquillity, and his statues show great refinement, though with a possible lack of robust vigour. As might be expected, there is a marked absence of purely abstract carvings, and any articles of ritual which were executed during this period have vanished with most of the other works of art.

THE T'ANG DYNASTY.

In this era the jade carver was once again enabled to carry on the evolution of his craft, following on the excellent example set by the artists of the Sui Dynasty, whose style was probably influenced by contact with Buddhist Monks who had either come from or made journeys to India and Turkestan. Carvings of this dynasty achieve a definite individual style characterised by sweeping forms and vigorous symmetrical designs. Like the contemporary ceramics they are simple in form, but possess an undoubted strength. They are thus differentiated from the ornamentation of earlier works, though they retain much of the remarkable quality displayed by the earlier craftsman—the power to express the motion of life.

THE SUNG DYNASTY.

During the Sung Dynasty there was a considerable development of trade relations between China and Persia, India, Eastern Turkestan,

PLATE XLIV

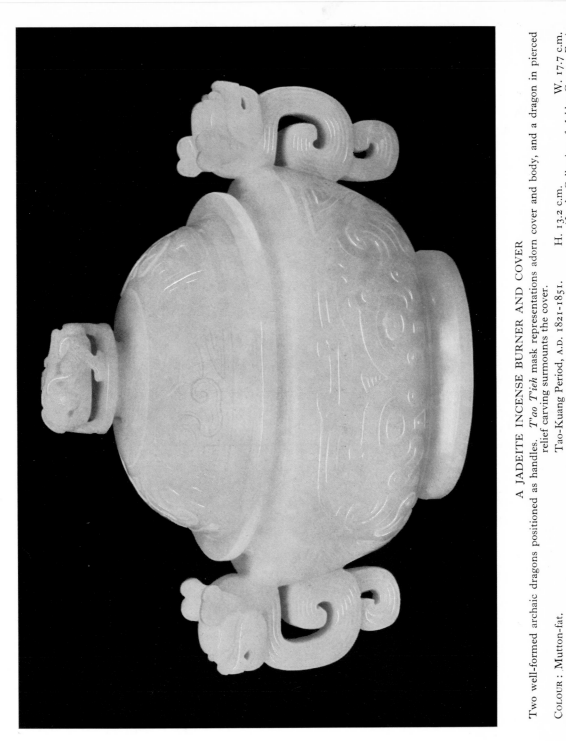

A JADEITE INCENSE BURNER AND COVER

Two well-formed archaic dragons positioned as handles. *T'ao T'ieh* mask representations adorn cover and body, and a dragon in pierced relief carving surmounts the cover.

Tao-Kuang Period, A.D. 1821-1851.

COLOUR : Mutton-fat.

H. 13.2 c.m. W. 17.7 c.m.

(In the Collection of Ashley Cowan, Esq.)

Korea and Japan, and the contemporary jade carvings are perceptibly influenced by the art of these countries. At this period for the first time the jade worker commenced imitative works, reproducing many earlier jade forms of archaic type. These pieces closely resemble some of the productions of the Chou and Han Dynasties, though naturally there are distinctive differences. The Sung Dynasty also marks the definite disappearance of the spiritual and symbolic significance in jade carving, which had been declining since the close of the Han Dynasty. Nevertheless, the ingrained reverence of the Chinese for this mineral remained, but the craftsman turned his attention far more fully to decorative representations of various motives, a tendency which probably arose during the middle of the period, but was cut short by the conquest of China by Mongolian usurpers at its close.

THE MING DYNASTY.

This period is characterised generally by strong graceful forms and broad simple ornamentation, being obviously inspired by the contemporary productions of the ceramic art. This is accompanied by a resurgence of the native tradition and the emergence of a more definite and less composite type of work. At the close of the Ming period there supervened a period of decadence.

THE CH'ING DYNASTY.

With the advent of the Manchu rulers, the jade worker was again much influenced by contemporary ceramic styles. It is inevitable that the majority of specimens of jade met with in public and private collections, and which is possible of acquisition by collectors, dates from this epoch, especially from the Ch'ien-Lung period, 1736-1795. Carvings at this time were produced in large quantities for the palaces of the Emperor, and the technique of the craftsmen reached a very high level, as shown in the undercutting and carving of many outstanding pieces. It, however, must be admitted that, as in the case of other objects of this period, the skill has often resulted in ostentation or vulgarity, but on the other hand it is regrettable, as is the tendency in some quarters, to proceed to a sweeping condemnation of most of the art of what is a very remarkable period. There is no doubt that many fine pieces of good proportions and excellent design were produced at this time. The range of form and the variety of ornamentation, too, are remarkable, and it is possible to avoid and ignore that which is bizarre or grotesque in the period.

The 19th century witnessed a steady decline in the art of jade, brought about by the commercialisation of a mechanical age.

61

CHAPTER XI.

THE *JU-I* OR SCEPTRE.

THE *Ju-i* or sceptre[1] with its " fungus-shaped " head and curved stem, has given rise to much speculation by students of archæology in their attempt to trace its origin (see PLATES XLVI and XLVII). One authority[2] says " the head is obviously related to the ' connected cloud pattern ' and may have been suggested by it " ; and again, that the *Ling chih* fungus " is perhaps the source of its conception."[3] Dr. Bushell appears to be in agreement with this latter derivation and he further tells us that " . . . in the Palace of the Emperor a *Ju-i* is placed in every reception room upon a table before the throne, it is usually made of carved wood or red lacquer, with three plaques of jade inserted and often inlaid with jewels. The *Ju-i* also figures among imperial presents to high dignitaries as a mark of special distinction."[4] An exceptionally beautiful example of the three-plaque type of *Ju-i*, mounted in gilded bronze, is in the Collection of His Majesty The King and is portrayed in PLATE XLV. F. N. Nance[5] tells us that the Emperors in uneasy times required everyone about the Court to carry a *Ju-i*, for, when holding one of these sceptres, the hands were not free for the use of a dagger.

Dr. Laufer is of the opinion that the " cloud band " decoration of a jade girdle ring referred to in the *Ku Yü tu p'u*[6] is similar to the head of the *Ju-i*.

Professor Giles[7] tells us that in his opinion the origin of the *Ju-i* cannot be safely considered to be derived from " a religious source." He further says[8] " We find in history such passages as ' The Emperor pointed at him with his *Ju-i*,' " etc.[9]

What Professor Giles considered to be the earliest allusion in Chinese literature to the *Ju-i* occurs in *T'u shu tsi ch'êng*[10] where we read " during the Wu Dynasty, when digging the ground, there was found a bronze casket in which was a *Ju-i* of white Jade."

Eitel tells us that *Ju-i* literally means " as you wish "[11] and in reality is one of the Saptaratna, or Seven Precious Things (*Ts'in-pao*), a fabulous pearl. In China, it is the symbol of Buddhism, and gods bear it in their hands. It is however found also in the hands of Taoist deities, and seems to have been borrowed from Buddhism.

[1] These sceptres were used by one seeking an audience with the Emperors, especially when seeking a favour.

[2] Honey, *Chinese Porcelain.*

[3] Compare Pétillon, *Allusions Litteraires*, p. 241, note.

[4] Bushell, *Chinese Art*, Vol. I, p. 140, also compare G. Devéria, *Un Mariage Imperial Chinois*, p. 90.

[5] *Chinese Symbolism*, China Journal, Jan. 1934.

[6] Chapter 55, Fig. 110.

[7] l.c., p. 321.

[8] *Adversaria Sinica*, No. 9, p. 321 ; compare Tung t'ien ts'ing lu.

[9] Compare *Chao Si-ku's Writings of the 13th century.*

[10] Section 32, Chap. 237.

[11] *Sanscrit-Chinese Dictionary*, p. 122.

Eitel's summary refers to the *Ju-i* in its developed form, as a symbol of power, seemingly first used in this manner during the Han Dynasty and from then onwards the subject of carvings in rock-crystal, amber,[1] gold, silver, rhinoceros horn, bone, bamboo, and iron,[2] but to-day few indeed of these materials are used.

Dr. Laufer[3] tells us that in his opinion the *Ju-i* " may have grown out of one of the early jade emblems of the Chou period." In my opinion there seems sufficient evidence to assume that the *Ju-i* actually was one of the earliest composite ritualistic jade symbols of the Chinese, embodying the essence of their spiritual beliefs—of the semblance of the Dragon, the intelligence of the stars, the structure of the Diviner's wand—and evolved for the use of the Emperor during the sacred rituals dedicated to the God of Agriculture.

Dame Una Pope-Hennessy[4] formulates an ingenious theory based on the researches of Dr. Gieseler, that the form of this intriguing symbol was derived from the sweep of the constellation of the Dragon, a drawing in support of which she illustrates, here reproduced as FIG. 39.

FIG. 39

This suggestion offers some support to the theory that the form of the *Ju-i* was derived from the rod *shi* (筮) used by the State Diviners. It will be recalled that the Chinese word *shi*[5] (筮) is a combination of two characters : *chuch* (竹) (the bamboo) and *wu* (巫) (a diviner or medium) and that the Diviners were considered of great importance in all affairs connected with the State. The chief Diviners, five in number, were :[6]—

" The Grand Diviner." *T'ai-puh* (太　卜)

" Master of Divination." *Puh-shi* (卜　師)

" Keeper of Tortoises." *Kwei-peu* (龜　人)

" Preparer of the Fuel." *Hwa-shi* (華　氏)

" Observers or Interpreters of the Prognostics." *Chen-jen* (占　人)

[1] In Giles' *Biographical Dictionary*, p. 613, we read that Sun Kuan (A.D. 181-252) whilst he was Prince of Wu, owned a *Ju-i* made entirely of amber.
[2] See writings by Chao Si-ku.
[3] Laufer, *Jade*, p. 339.
[4] *Early Chinese Jade*, p. 78.
[5] Williams' *Chinese Dictionary*.
[6] Wylie, *Notes on Chinese Literature*, p. 4.

PLATE XLV

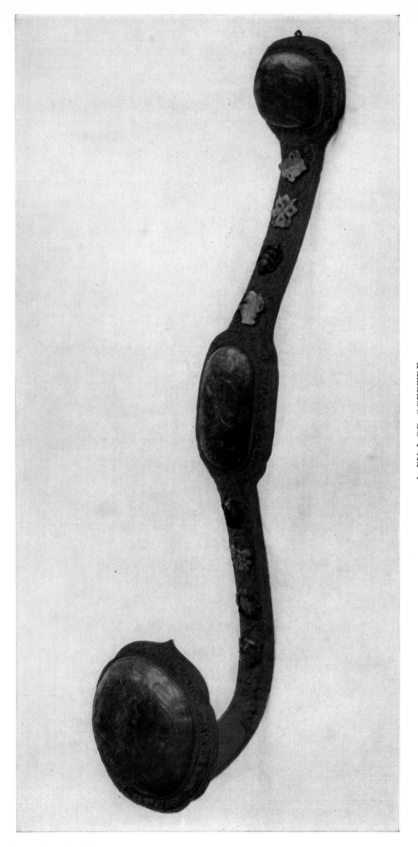

A *JU-I* OR SCEPTRE

Comprising three carved plaques set in a gilt bronze mount. The headpiece decorated with Peach Tree and Fruit and Bat; the centre piece decorated with Finger Citron, Bats and Foliage; the end plaque bearing an engraved representation of the Prunus, Peach and Bat. The stem of the sceptre inlaid with the *Pa Chi-Hsiang*, or Eight Happy Omens, carved in Lapis-lazuli, Coral, Crystal and Jade.

Ch'ien Lung Period, A.D. 1736–1795. L. 53 c.m.

COLOUR: Translucent Emerald Green.

(In the Collection of His Majesty The King, and included by His Majesty's gracious permission.)

PLATE XLVI

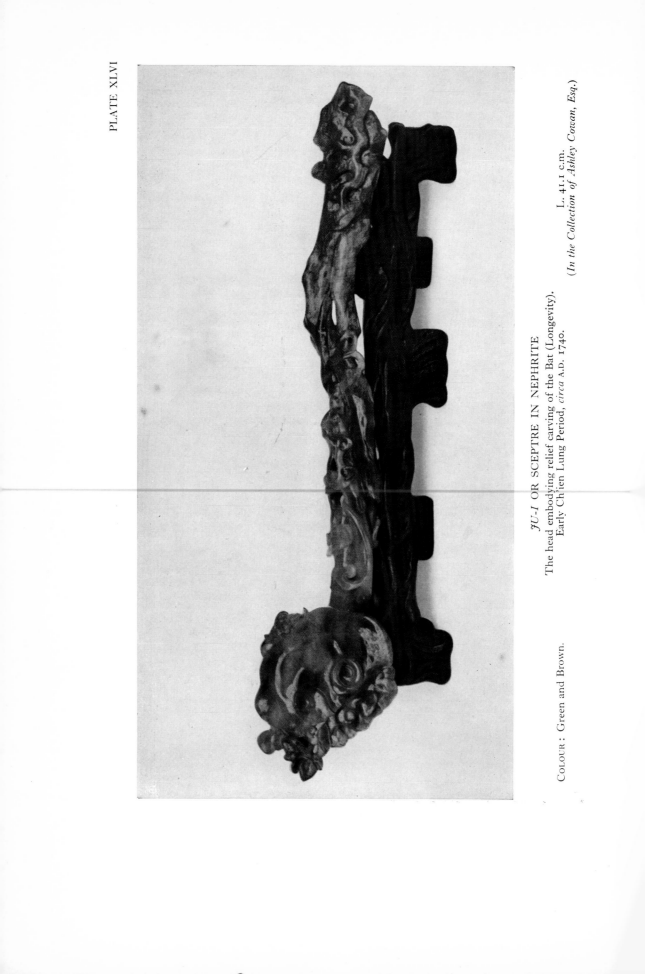

JU-I OR SCEPTRE IN NEPHRITE

The head embodying relief carving of the Bat (Longevity).
Early Ch'ien Lung Period, *circa* A.D. 1740.

L. 41.1 c.m.
(*In the Collection of Ashley Cozean, Esq.*)

COLOUR: Green and Brown.

The *Li-Ki*[1] in referring to these Diviners says they did not presume to use their own private judgment in the service of the Supreme Ruler, but invariably made use of the Divining Rods *Shi* (筮) and tortoise *Kuei* (龜). It is known that these Diviners were also star gazers, for the Yi-King[2] tells us " they penetrated the secrets of Heaven and Earth." From these generalisations it would appear not improbable that the rod of these diviners took the formation of the outline suggested by the stars, and inspired the shape of the *Ju-i*. The bone (antler) wand preserved in the British Museum, suggests a possible connection with the Diviner's Rod (PLATE XLVIII). Its dragon shape obviously relating to the early ritual of weather forecasting.

For the reader interested in the further study of this intriguing symbol, reference to the following writings will be found helpful :—

Anderson, *Catalogue of Japanese and Chinese Paintings*, p. 32.
Ball, *Decorative Motives of Oriental Art*, p. 28.
Bushell, *The Bishop Collection of Jades*, Vol. I, p. 49, and Vol. II, p. 147.
Bushell, *Chinese Art*, Vol. I, p. 148.
Devéria, *Un Mariage Imperial Chinois*, Paris, 1887, p. 90.
Edkins, *East of Asia Magazine*, Vol. III, 1904, p. 238.
Eitel, *Handbook of Chinese Buddhism*, p. 130.
Giles, *Biographical Dictionary*, p. 613.
Giles, *Introduction to the History of Chinese Pictorial Art*, p. 159.
Laufer, *Jade*, pp. 187, 335-339.
Pope-Hennessy, *Early Chinese Jade*, p. 77.
Williams, *Outlines of Chinese Symbolism*, p. 236.
Pétillon, *Allusions littéraires*, p. 240.

[1] Book XXIX, para. 52, *pia-ki*, and Book IV, para. 4, Part 1, No. 11.

Kiai-shi t'ien-ti-chi-shen-ming (皆 事 天 地 之 神 明)

Wu-fei puh-shi-chi-yung (無 非 卜 筮 之 用)

Puh-kan i-k'i sze-sieh-shi shang-ti. (不 敢 以 其 私 褻 帝 上 事)

[2] *Legge's Translation*, p. 360.

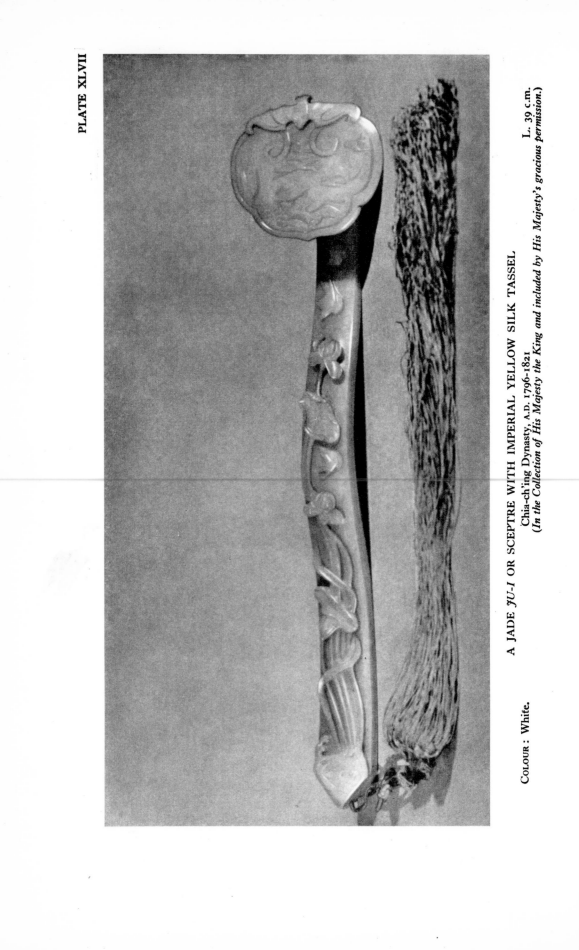

PLATE XLVII

A JADE *JU-I* OR SCEPTRE WITH IMPERIAL YELLOW SILK TASSEL

Chia-ch'ing Dynasty, A.D. 1796-1821

(In the Collection of His Majesty the King and included by His Majesty's gracious permission.)

COLOUR: White.

L. 39 c.m.

PLATE XLVIII

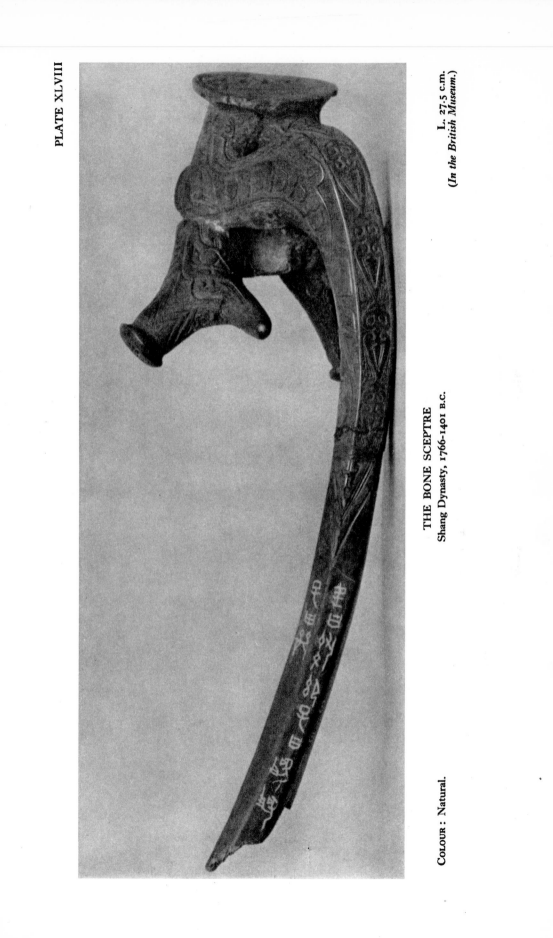

THE BONE SCEPTRE
Shang Dynasty, 1766-1401 B.C.

COLOUR: Natural.

L. 27.5 c.m.
(*In the British Museum.*)

CHAPTER XII.

ANIMAL CARVINGS IN JADE.

THE DRAGON.

PROBABLY the first mention of this monster in Chinese mythology was made during the reign of Fuhsi (2852-2737 B.C.).[1] Later we find the legend that at the birth of Confucius (551 B.C.), " two dragons came and kept watch . . . while a spring of clear water bubbled up from the ground."[2]

Dragon worship in China probably is connected with the snake worship of Northern India, for we find that in Chinese translations of Buddhist writings the Indian term *naga* (snake) is frequently rendered *lung* (dragon). In the West, the dragon was a power for evil ; in the East, a symbol of beneficence.

It is the opinion of some Chinese scholars of the present day that these mythological beliefs were the inventions of the early rulers of China, who sought to instil fear into a naturally superstititous people, and thereby increase the nation's reverence for its rulers.[3]

We gather from Chinese mythology that the dragon may be recognized by any or all of the following characteristics : a head similar to that of a camel ; ears like those of a cow ; one or two horns, similar to those of the deer ; eyes similar to the rabbit (or demon) ; a neck elongated like that of a snake ; a frog's belly ; a tiger's paws, with the claws of a hawk ; the entire body covered with the scales of a carp.

The variations of type are, however, numerous : De Groot[4] mentions a hornless dragon (*Pi hsieh*) carved on the tombstones of Imperial Princes and high officials during the Ming period, whereas the classic book *Hills and Rivers*[5] written in the 12th century B.C. refers to Winged Dragons (*Yi Lung*).

In Chinese legend, as in that of other races, the dragon is accredited with the power of transformation, especially into the form of a fish, usually a carp,[6] and is, moreover, believed to be able to disappear at pleasure.[7]

The dragon-motive, in the form of *Kuei*, constantly appears on Shang-Yin bronzes.

One of the earliest recorded dragon carvings in jade appears in the form of a girdle ornament, and is mentioned in the *Fang-shih mo p'u*[8] and therein attributed to be the work of the Chou period. The *Ku yü t'u p'u* portrays a similar carving—a Cloud Dragon—also assigned to the Chou period. Another specimen is referred to by Laufer : this is a

[1] Chavannes, *Memoires historiques de Se Ma-ts'ien, Annales des Troissonnerains*, p. 6.
[2] Legge, *Biography of Confucius*, p. 59.
[3] Doré, *Chinese Superstitions*, Vol. V, p. 680.
[4] *The Religious System of China*, Vol. III, p. 1142.
[5] Wylie, *Notes on Chinese Literature*, p. 43.
[6] Mayers, *Chinese Readers Manual*, p. 142.
[7] See the carp, Williams, *Dictionary of the Chinese Language*.
[8] *Fang-shih mo p'u*, Chap. 2, p. 3.

jade carving in the shape of a dragon, for use on the altar.[1] The first carvings of this type which, until recently, were considered to be of the Han period, are now considered to be of earlier date. Dame Una Pope-Hennessy (in a recent article on jade[2]) says, " The less early jades, those now classed as of the period of ' The Warring States ' (481-205 B.C.) are ornamented with elegant stylized dragons. . . ." Our scheme forbids a detailed and intricate account of those recent researches which are gradually establishing the important place in Chinese Art held by the Dragon, but it is, nevertheless, necessary to augment slightly the foregoing generalisation. The carved Antler in the British Museum (see PLATE XLVIII) would appear to be one of the earliest forms of the Horned Dragon's neck and head. The dragon decoration is seen there in the shape of a representation in bone of the Dragon of the Shang-Yin Dynasty. The jade counterpart of this carving would seem to have been executed after the Ch'in revolution, and some

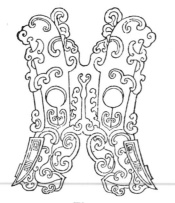

Fig. 40

authorities still accept the theory that the appearance of definite animal forms in jade commenced about the time of the " Spring and Autumn Annals."[3]

We will now consider interesting references in Chinese writings to dragon carvings and attempt to establish some sequence of type and development.

FIG. 40 (from the *Ku yü t'u p'u*) described therein as a *Kiao-ch'ih* (a young dragon whose horns have not grown) is probably an imperial charm. Of duplicate form and symbolical type, it may best be described as " A dragon charm, symbolic of the

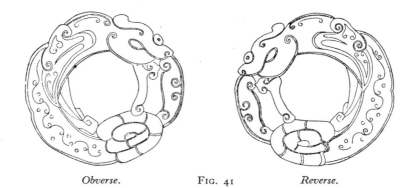

Obverse. FIG. 41 *Reverse.*

emperor," in the same manner as the " twin *Fêng huang* charm " is symbolical of the empress. The date of this carving would not appear to be earlier than the " Spring and Autumn Annals " (722-481 B.C.).[4]

[1] Laufer, *Jade*, p. 186.
[2] *Chinese Art*, edited by Leigh Ashton.
[3] Article on *Jades*, by W. A. Thorpe, *Burlington Magazine*, Vol. LV, Number CCCXX, p. 245.
[4] Compare *Chinese Art Exhibition Catalogue*, 1935-36, No. 359.

FIG. 41 (from the *Ku yü t'u k'ao*) described therein as a carving in white jade covered with a yellow sheen and bearing russet colour spots. This carving being of *pi* shape and dragon motive, suggests at once the " *Lung* symbol " which was used in an early ritual to *Shên-nung*,[1] described as " a jade for prayer used to end a drought ; it has the form of a dragon, and is made to possess the voice of the dragon."[2] An interesting comparison can now be made with PLATE L, which is definitely sonorous and upholds in character and design the description of the *Lung* symbol given in the *Shuo Wên*. It seems safe therefore to assume that the specimen drawn by Wu Ta Ch'êng is of the period of " The Spring and Autumn Annals " (722-481 B.C.).

FIG. 42 (from the *Ku yü t'u p'u*) and described therein as " a *P'an k'ui* (a winding young dragon without horns),[3] carved from a piece of white jade possessing red natural stripings, of which the carver has taken advantage." This specimen appears to belong to the first transition stage, depicting the dragon evolved from the Shang Yin tiger type,[4] and perhaps also inspired from the sonorous bronze instrument which

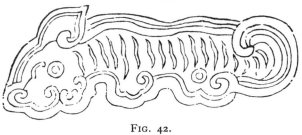

FIG. 42.

dates obviously from that period (see FIG. 43). It is probable that this type of carving belongs to the Chou dynasty.

FIG. 43 (from the *Po ku t'u* edition of A.D. 1603) described therein as a bronze sonorous instrument, but apparently misdated. This example belongs obviously to the Shang Yin dynasty and derives its form from the mythical unicorn, an elephant type of beast.[5]

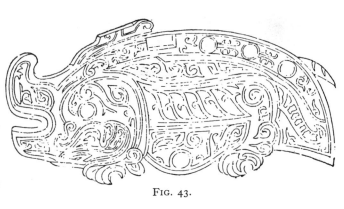

FIG. 43.

[1] Legge, *She King*, Vol. II, p. 378.
[2] Refer to *Shuo Wên Dictionary*, under " *Lung*," also *Giles' Dictionary*, No. 7491.
[3] Giles, No. 2346.
[4] Compare *Chinese Exhibition Catalogue*, Nos. 302 and Plate LXXVIII.
[5] Compare *Chinese Art Exhibition Catalogue*, No. 165.

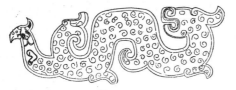

Obverse.

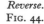

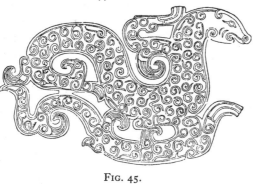

Reverse.

FIG. 44.

FIG. 44 (from the *Ku yü t'u k'ao*) and described by Wu Ta Ch'êng as "carved from white jade bearing russet spots." Here we notice a significant combination, for both the dragon and *Fêng huang* are represented. It would appear to be a ritual-pendant, rather than a charm, and may possibly have played some part in the marriage service. This type of carving probably belongs to the Period of the Warring States[1] (481-221 B.C.).

FIG. 45.

FIG. 45 (from the *Ku yü t'u k'ao*) and described therein by Wu Ta Ch'êng as carved from green jade spattered with russet spots. Upon inspection, this carving is seen to posses a flamboyant character foreign to the Chinese carver prior to the Han Dynasty. It is possibly an expression of external influence, maybe of the cult and teachings of snake worship from India.

During the period of unrest and chaos that persisted from the Han to the T'ang periods the dragon motive apparently disappeared, as far as the carver in jade was concerned; at least there do not seem to be any large specimens recorded in any European collection known to me. It is possible, of course, that if carvings of this monster were produced during this period the examples were destroyed in the upheavals of the time. It is, however, interesting to note that some authorities attribute to the South Native dynasties several of the dragon-headed buckles still extant.

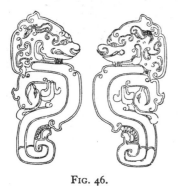

FIG. 46.

FIG. 46 (from the *Ku yü t'u k'ao*) and described therein by Wu Ta Ch'êng as of white jade covered with a yellow sheen. This carving definitely possesses the strength and character of the T'ang period, and is undoubtedly a work of that time inspired possibly by the dragon-headed buckles which preceded it.

Another important dragon carving in jade, recorded as of undoubted authenticity, is one in the form of a wine vessel, which one of the Kings of Khotan (1023-1031)

Compare *Chinese Art Exhibition Catalogue*, No. 356, and *Chinesische Kunst*, Nos. 211 and 212.

PLATE XLIX

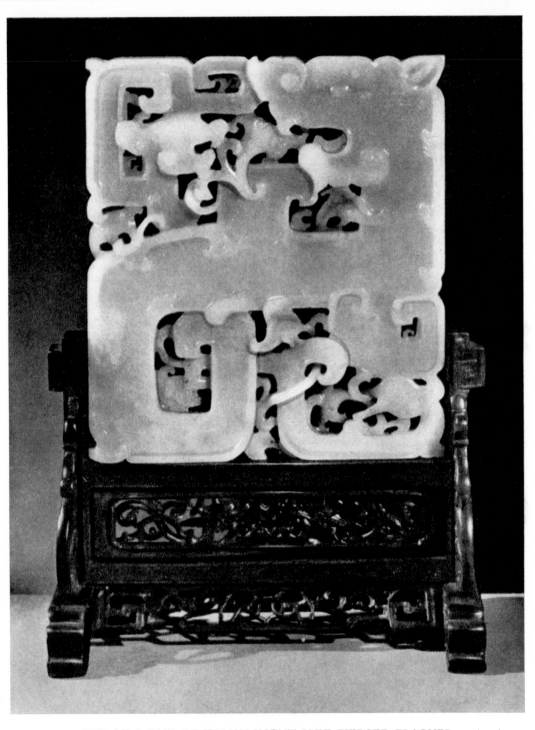

ONE OF A PAIR OF TRANSLUCENT JADE PIERCED PLAQUES
In archaic Dragon form.
COLOUR : White. Ch'ien Lung Period, A.D. 1736-1795. H. 17.3 c.m. W. 15.2 c.m.
(*In the Collection of His Majesty The King, and included by His Majesty's gracious permission.*)

PLATE L

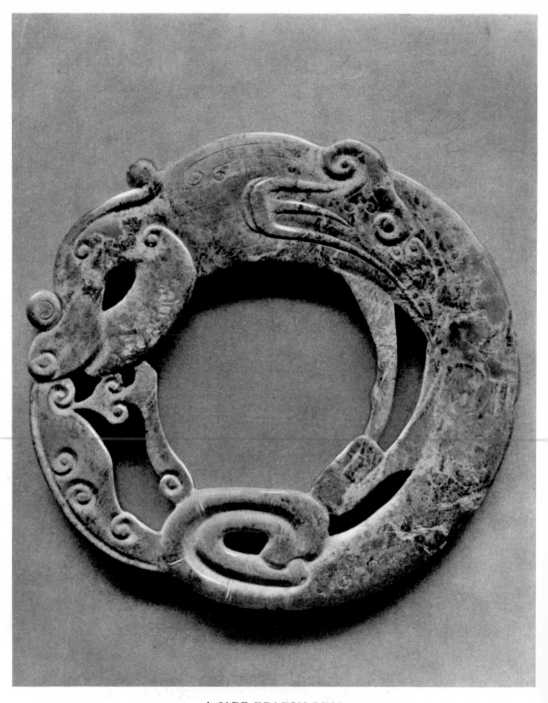

A JADE DRAGON RING

COLOUR ; Mottled Grey, Green and White. Chou Dynasty, 1122-249 B.C. Diam. 16.5 c.m.

(In the Eumorfopoulos Collection, Victoria and Albert Museum.)

PLATE LI

A JADE DRAGON PLAQUE

COLOUR : Green. Left : L. 5.3 c.m. W. 3.3 c.m. ; Right : L. 5.4 c.m. W. 3.5 c.m.
Period of the Spring and Autumn Annals, 722-481 B.C.
(In the Collection of H.R.H. the Crown Prince of Sweden, and included by the permission of
His Royal Highness.)

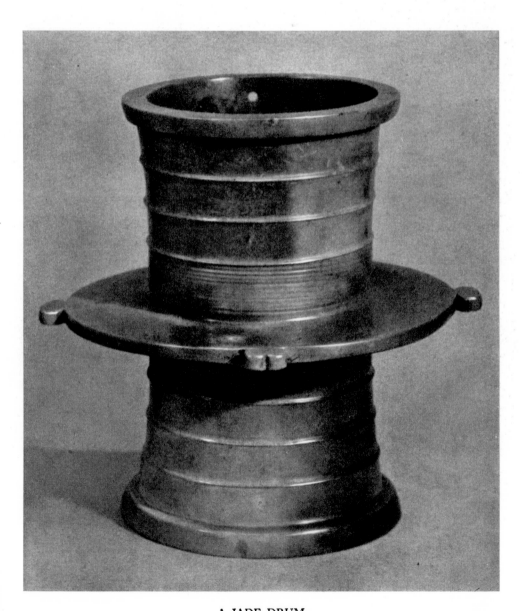

A JADE DRUM

COLOUR : Green. Han Dynasty, 206 B.C.-A.D. 220. H. 11.3 c.m.
(In the Eumorfopoulos Collection, British Museum.)

PLATE LII

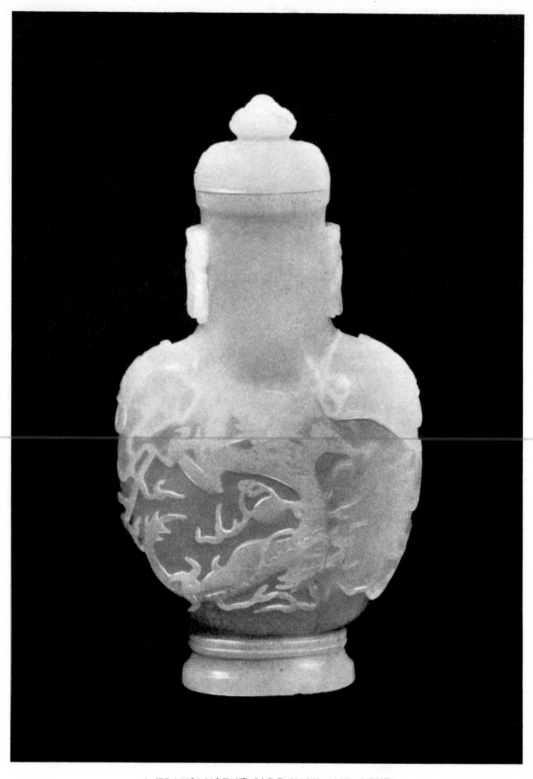

A TRANSLUCENT JADE VASE AND COVER

Decorated in bold relief with Dragon.

COLOUR : White. · Ch'ien Lung Period, A.D. 1736-1795. H. 23 c.m.

(In the Collection of Mrs. Emma Joseph.)

PLATE LIII

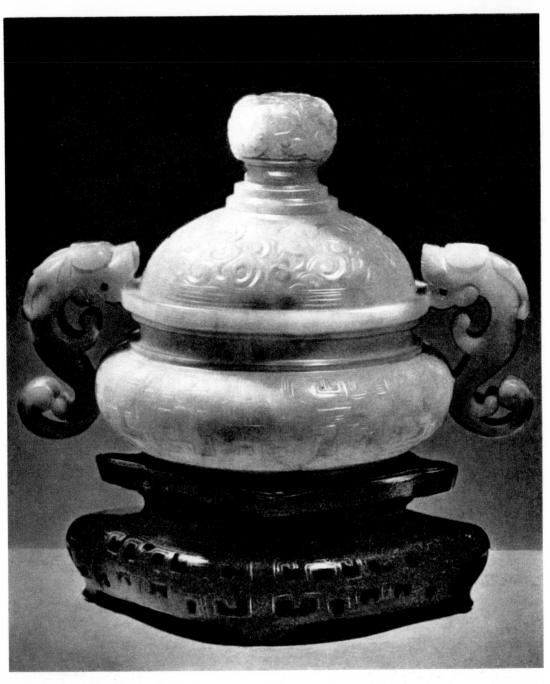

A JADE INCENSE BURNER AND COVER

Decorated with archaic representation of dragons and cloud : two flourishing dragons form the handles.
The cover is decorated in pierced cloud design, the knob being formed of a dragon and cloud.

COLOUR : Pale Green, splashed Reddish Brown Nephrite.　　　　　H. 13.5 c.m.　W. 19 c.m.

K'ang-Hsi Period, A.D. 1662-1722.

(Formerly in the Collection of Sir Alfred Jodrell, Bt.)

PLATE LIV

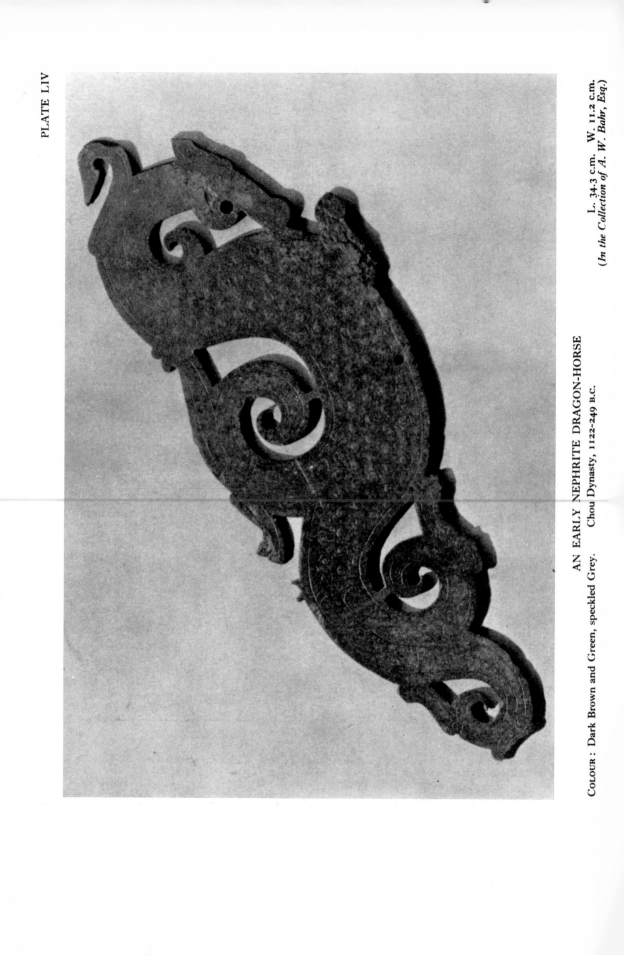

AN EARLY NEPHRITE DRAGON-HORSE

L. 34.3 c.m. W. 11.2 c.m.
(In the Collection of A. W. Bahr, Esq.)

COLOUR: Dark Brown and Green, speckled Grey. Chou Dynasty, 1122-249 B.C.

PLATE LV

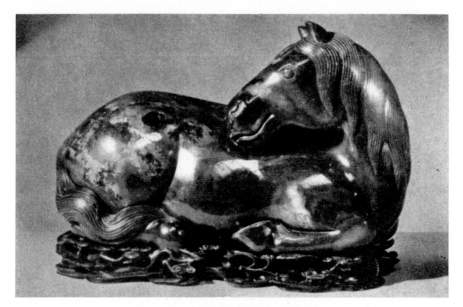

A JADE RECUMBENT HORSE

COLOUR : Black, splashed Green and Grey White.　　H. 16.2 c.m.　L. 25.5 c.m.
A.D. 9th century.

(*In the Collection of Oscar Raphael, Esq.*)

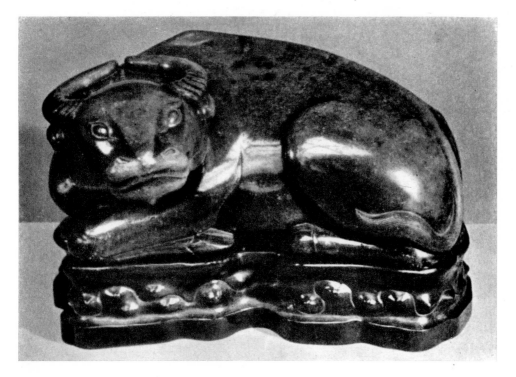

A JADE BUFFALO OR OX

Brought to Peking by the Emperor Yung-lo in A.D. 1422.
COLOUR : Green.　　Han Dynasty, 206 B.C.-A.D. 220.　　H. 15 c.m.　W. 40 c.m.

(*In the Collection of Oscar Raphael, Esq.*)

PLATE LVI

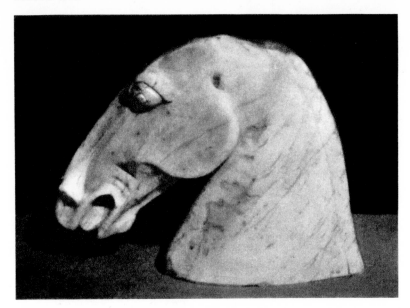

A JADE HORSE'S HEAD

COLOUR : Grey, splashed Green. H. 10.3 c.m.

A.D. 3rd or 4th century.

(*In the Collection of Oscar Raphael, Esq.*)

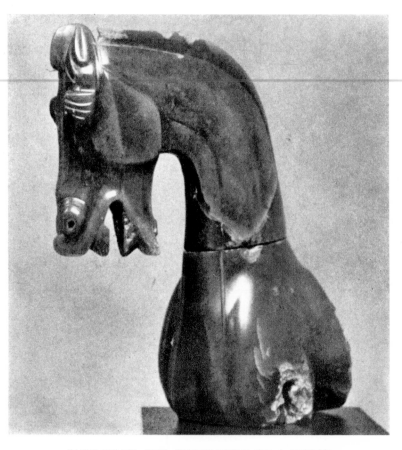

JADE HEAD AND SHOULDERS OF A HORSE

COLOUR : Green. Han Dynasty, 206 B.C.-A.D. 220. H. 18.9 c.m.

(*In the Eumorfopoulos Collection, Victoria and Albert Museum*).

bestowed as a gift during the time of the Sung Dynasty.[1] An excellent plate of this form of carving which appears in Gorer and Blacker,[2] shows it to be of the same type of design as those in the Imperial Catalogue of the Po Ku.

It may be instructive, in passing, to refer to the ceramic art of the Sung and Yuan periods for, as previously stated, we must bear in mind the fact that the jade worker of those periods appears to have derived much of his inspiration from this source. Important specimens of the ceramics of these periods, in the possession of Sir Percival David, Bt., are illustrated in colour in Mr. R. L. Hobson's beautiful catalogue of this famous collection. Three examples bearing Dragon decoration are as follows:

(1) " A Basin of Lung-Chuan Celadon, described by the authors as of the Sung or Yuan Dynasty, on the inside of the bottom of which is a three-clawed dragon surrounded by six cloud scrolls. . . ."[3]

(2) " Flask of Lung-Chuan Celadon, attributed to the Yuan or early Ming period . . . on each side of which is a quatrefoil panel with raised border enclosing a three-clawed dragon and clouds in low relief. . . . Greyish porcelain with jade green celadon glaze irregularly crackled."[4]

(3) " Hsuan Te Bowl, assigned to the Hsuan Te period (A.D. 1426-1435). Above, the rings on which are two red five-clawed dragons among blue clouds ; and below, a band of crested waves in blue."[5]

According to the T'ao shuo[6] the jade cups used by the Emperors in the solemn sacrificial ritual paid to their ancestors, were, in his opinion, copies of the porcelain cups made in the Sung Dynasty, and were copied at later periods.

It will now be of interest to note how the jade carver has utilised the dragon motive in his executed works from Early Ming to the present day. Laufer illustrates in Plate XLV in his book an excellent example of the dragon employed as an adornment at the commencement of this period. It is of newt-like form,[7] slightly advanced in technique to that of the carvers of the Han and Sung period, but—when compared with the productions of the potters of the Sung Dynasty—nothing more than an imperfect copy.

Passing through this period, and reaching the beginning of the 16th century, we find that a more imposing form of dragon design has come into being. Instead of the three-clawed newt form, we find an Imperial five-clawed type, a fearsome creation. This type, however, did not persist ; for at the close of the dynasty many carvers reverted to the earlier symbolical type of monster. Upon the advent of the Ch'ing Dynasty the conventionalised dragon was again foremost in the minds of the craftsmen, as can be seen in PLATES LII and LIII.

[1] Bretschneider, *Notices of Mediæval Geography*, Chapter 90, p. 5.
[2] *Gorer and Blacker*, Vol. II, p. 231.
[3] Hobson, *Pottery and Porcelain in the David Collection*, p. 54, Plate LIII.
[4] Ibid. P. 58, Plate LVII.
[5] Ibid. P. 138, Plate CXXXVII.
[6] Bushell, *Description of Chinese Pottery*, p. 96.
[7] Compare Bushell, *Oriental Ceramic Art*, p. 144. "A Lizard Dragon in Moss Green Jade."

The reader wishing to study further this interesting subject may find the following quotations and references of value :—

(1) " The Dragon, in shape, is probably derived from the crocodile, which hides itself in the winter, and appears again in the spring."[1]

(2) " The Dragon is the emblem of Spring and the East. In ancient descriptions of the heavens, the Eastern quadrant is called the ' Azure Dragon ' *Ts'ing-lung*."[2]

(3) " The Dragon is a deity, symbolic of fertile rain, rain-sending clouds, thunder and lightning. As a water-god, he soars in the clouds, and pours out his blessings on the parched earth."[3]

(4) " The five-clawed dragon is appropriated solely to pictures, embroideries or figures, used by the Imperial Court. A dress with a five-clawed dragon worked on it can be used only by one of Royal blood."[4]

(5) " In Southern China, especially in Canton, typhoons are believed to be caused by the passage of a ' bob-tail dragon,' and it is sometimes averred that this animal is actually seen on such occasions passing through the air."[5]

(6) " The religious mind of China has never made a scientific distinction between snake and dragon."[6]

(7) " One early Chinese observing a cloud, thought that it looked like an alligator."[7]

(8) " Birds in connection with dragons symbolize clouds, as we see from the Han bas-reliefs on stone."[8]

(9) G. Elliot Smith : *The Evolution of the Dragon*,

(10) Visser : *The Dragon in China and Japan*.

(11) Eitel, *Dragon Worship*, Vol. III, No. 3, p. 35.

THE HORSE.

The horse,[9] one of the signs of the Zodiac, is also one of the twelve cyclic animals of the diviner, and an important Taoistic emblem associated with ancient Chinese Mythology.

The first mention of the horse in Chinese mythology is that of the Dragon Horse (*Lung Ma*) which appeared to the Emperor Hwang-ti (2697-2597 B.C.), it being recorded that, in conjunction with the tortoise, this monster appeared from out of the waters of the Yellow River (*Ts'ai*), bearing on its back a scroll inscribed with the Eight Diagrams (*Pa-kua*). This legendary monster, best described as a Dragon Horse, is a member of the crocodile family, and has been the cause of several wrong interpretations of later legends in which similar monsters

[1] *Encyclopædia Sinica*, p. 147.
[2] De Groot, *The Religious System of China*, Vol. I, p. 317.
[3] *Ibid*, Vol. III, p. 1194, and *Encyclopaedia Sinica*, p. 147.
[4] Dennys, *The Folk-lore of China*, p. 107.
[5] *Ibid*, p. 109.　　　　　　　　　[6] *Ibid*, p. 107.
[7] Yetts, *Chinese Symbolism*, p. 22.
[8] Laufer, *Chinese Grave-Sculptures of the Han period*, p. 29.
[9] Section 24 of the *Pen Ts'ao*. The Chinese Materia Medica, published A.D. 1596.

appear ; the horse[1] being erroneously represented in place of the dragon horse. (See PLATE LIV).

Probably the first historical record of the horse in China is contained in the classic writing which narrates the life of the Emperor Mu Wang (1001-946 B.C.). In this work, reference is made to the Emperor's visit to the Paradise of Taoism in the K'un Lun Mountains, the gardens of Hsi Wang Mu, and also relates how Tsao Fu, the Emperor's charioteer, drove his chariot—drawn by eight famous horses—" wherever wheel ruts ran and the hoofs of horses had trodden." Carvers in jade, sculptors and painters, have immortalised these stories throughout the ages. One of the most notable of the early painters of horses and oxen was Shih Tao Yen, who lived in the Ch'in Dynasty (221-206 B.C.), and it is interesting to note that immolation of human beings, and especially horses, which was first deplored by Confucius, was during the reign of Hsi Hwang-ti (246-209 B.C.), definitely trending towards abolition, and was finally prohibited during the reign of Ming Hwang (A.D. 713-756).[2] From this time wooden horses were used instead of the live beast in sacrifices to the spirits (*manes*) of the departed.[3]

Perhaps the first representations in jade of the horse were in the form of amulets, an interesting reference to these being made by Pope-Hennessy.[4] Dr. Laufer, in his book on jade,[5] illustrates, in a drawing, a damaged jade carving of a horse mentioned in the *Ku yü t'u*, the colour of which is described as " like rouge with spots shining like peach blossoms, mixed with light green." It is further recorded that this specimen was repaired by one Liu Kia at a later date, with the aid of drawings of similar objects made in remote ages. It has been suggested by some writers that the earlier drawings used were the work of Shih Tao Yen, but this supposition appears to lack documentary confirmation.

At this point it will be instructive to consider the Chinese artist's treatment of horses. An important representation of these animals comes at once to mind—a stone stele, made for T'ai Tsung, founder of the T'ang Dynasty, who intended it to perpetuate the memory of the six Mongolian chargers ridden by him prior to his ascendance to the throne (618-626).[6] The great importance of this monument has been recognised, not only as a masterpiece of stone sculpture, but also as a valuable document of the type of horse used at this period. Each of the horses is fully described, its colour and name being given, and also the battle in which each was ridden. Even the details of their wounds are recorded. We read that one named " Autumn Dew," of the colour of the red wild goose, was ridden in the year 621 by the Crown Prince, when he conquered in battle the defenders of Tung Tu, the eastern capital of Honan. It is interesting to observe further that the

[1] For a description of the Horse see *Ma Ching* (horse classic), published circa A.D. 1620 and *The Chinese Repository*, Vol. VII, December 1838, article 1, pp. 396-397.
[2] Compare Edmunds *Chinese and Japanese Art*, p. 393.
[3] Compare Doré, Vol. V, p. 482, Note 3 " Chi-Ma."
[4] *Jade*, p. 109. [5] p. 246.
[6] Bushell, *Chinese Art*, Vol. I, p. 33, Plate 18.

type of horse portrayed at this period is practically identical with the thick set Mongolian type used in China to-day. The bridle and saddling also appear the same. The horse was a favourite subject with the jade carver during the T'ang and Sung Dynasties (see PLATE LVII).

A black jade horse, one of the finest in the possession of any European, is in Mr. Oscar Raphael's collection. It is probably of the Sung period and is said to have been taken to Peking by Yung Lo in 1420, where it was perhaps used in the ritual devoted to the annual worship of spirits of the departed (*Kiah-ma*) see PLATE LV.

During the Ming period several fine white Jade statuettes and carvings of the Horses of Mu Wang, also group carvings of horses with riders were carved in jade, of which perhaps some of the most impressive are the statuettes of the God of War (*Kuan-ti*). (See PLATE CXLII, which portrays a soapstone carving of this type.)

Contrary to what might be expected, the horse was no longer in favour with the carver by the beginning of the Ch'ing Dynasty, and it is not until the Ch'ien Lung period that a renewed epoch of horse representation begins. These carvings, however, lack the movement of the earlier pieces.

The Sea Horse, which appears in a decoration known as *Hai ma p'u t'ao*—" Sea Horse and Grapes "—does not seem to have been used by the jade carver of early periods, although introduced into China following the visits of the Emperor Wu Ti's envoys to Central Asia in the 2nd century B.C. An example of this Græco-Bactrian type of decoration may be seen on a Bronze Mirror of the Han Dynasty, in the Victoria and Albert Museum.

THE OX (*NIU*).

The Spring-Ox (*Ch'un-niu*), according to the Record of Rites, was in early times sacrificed at the commencement of spring, in a ritual consecrated to the god of Agriculture.[1] A monument in bronze was erected during the reign of K'ang hsi[2] and, on account of the vicinity in which it was placed (at the outlet of the Hung-tseh lake), it would appear that at this time the Ox was still considered to be a river god.[3] We are told that in the Chou period there was a group of state officials, " whose duty was to breed special coloured strains of oxen for sacrificial purposes," and that one of these animals was offered in sacrifice to the Mountain and River Gods.[4]

From the earliest times the Ox has been a sign of the Zodiac. The reference by Chavannes,[5] to a white horse[6] being thrown by the

[1] The ceremony of beating the Ox on the first day of Spring (3rd or 4th February) to hasten the departure of the cold weather, referred to in Frazer's *Golden Bough*, 2nd edition, Vol. II, p. 277, etc., dates back to at least as early as the Tsin dynasty and is probably a modification of the sacrifice referred to in the Book of Rites.

[2] A.D. 1662-1723.

[3] Doré, *Chinese Superstitions*, Vol. V, p. 663.

[4] Pope-Hennessy, *Early Chinese Jade*, p. 106.

[5] *Se-ma Ts'ien*, Vol. III, p. 533.

[6] Laufer, describing this ritual, refers on p. 156, *Jade*, to " A white horse with a Jade ring " being thrown into the River as a sacrifice to the River God. Pope-Hennessy in *Early Chinese Jades*, p. 33, refers to " a white stallion and a jade *Pi* " being thrown into the river when recording the same episode.

Emperor into the Yellow River in the year 109 B.C., in an effort to appease the River God, applies more probably to the ox for, undoubtedly the ox was at this time considered the guardian of the River, and obviously a fitting subject for sacrifice, whereas the horse was comparatively a newcomer, and was, incidentally, first produced in jade only at this period. I suggest, therefore, that we may safely assert that in such an important ritual, it was unlikely that the horse should have supplanted the ox ; though possibly the early recorders of this legend may refer to the Dragon Horse which, according to mythology, appeared to Fu shi, having risen out of the Yellow River, bearing the plan from which this mythical emperor evolved the diagrams ; but this theory is less acceptable than that of the ox.

An excellent example of the Dragon Horse of the Chou Dynasty, from the Bahr Collection, is shown in PLATE LIV.

Several fine jade representations of the Ox head, of the Chou period, are illustrated[1] in *Archaic Chinese Jades in the Bahr Collection*, by Laufer, who believes their inspiration to be derived from the decorations of the sacrosanct bronze vessels. (See PLATE LXXVIII.)

These ox-head ornaments, designed alike for the living and the dead, were followed, during the Han and succeeding dynasties, by both small and large carved images of the same animal.

In the Raphael Collection there is a massive image of this animal, which is accredited to the Han period, and is the fourth largest jade carving in Europe. Until 1900 it was in a corridor in the Palace of Peking.[2] (See PLATE LV.)

As previously mentioned, the carvers of the T'ang Dynasty excelled in their portrayal of living movement. The carving of a reclining buffalo or ox (PLATE XXVI) in the Collection of Mr. A. W. Bahr, vividly displays this animation. Comparison of this carving with the reclining ox (PLATE LV) effectively portrays the development, between the Han and the T'ang periods, of this particular style of carving.

During the Ming Dynasty, the style of portraying the ox was still individual. Many large carvings depicting it, ridden by a boy, or forming part of a group, are undoubtedly not earlier than the Ch'ing dynasty, and are probably the work of Ch'ien Lung craftsmen. Several jade statuettes of the Ox, which are ascribed to even later periods than this, being carved in a nephrite which was not found during this epoch, must be misdated, having obviously come from the Ming Dynasty.

A diligent study of the different varieties of jade used during the various periods will be found of great assistance to collectors in correctly determining the dates of their possessions. Special varieties peculiar to certain districts are known to have been in use at certain periods, while in some districts the mines became extinct, so that no further supply of identically the same stone was thereafter procurable.

[1] Plate XXI.
[2] Pope-Hennessy, *Jade*, p. 107.

The tiger, esteemed by the Chinese as the greatest of four-footed beasts and lord of all wild animals, is said by them to live to the age of a thousand years.

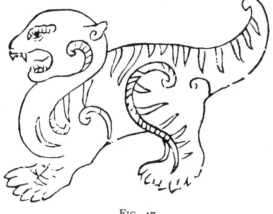

FIG. 47
A JADE CARVING OF A TIGER
From the *Ku yü t'u p'u*

The use of the tiger as a subject for portrayal by the jade carver extends as far back as the Shang Yin Dynasty. An excellent example of the craft of this period is seen in PLATE LXXVIII, which represents the tiger in a grey green jade. According to De Groot[1] its introduction was due to " the murderous character of that most ferocious of Asiatic brutes." Dame Una Pope-Hennessy says, " It is almost possible to say on looking at this early and amazing design (see FIG. 47) that it determined the whole course of Chinese Art."

In the *Chou Li*, the commentator Chêng, when explaining the functions of the Master of Religious Ceremonies, informs us that, " With the white tablet of jade in the shape of a tiger (*hu*), he renders homage to the region of the West,"[2] also, that the Tiger jade was buried with the corpse facing west. L. de Saussure[3] suggests that the tiger was the symbol of Orion and, finally, it is one of the signs of the zodiac.

The first carvings in jade to represent the tiger would appear to be

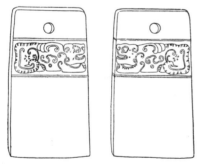

FIG. 48

the tablets used in the Worship of the West,[4] which may possibly have taken a similar form to the specimen shown in PLATE LXIX, and later have been used in the decoration of ritual tablets similar to that shown in FIG. 48, illustrated by Wu Ta Ch'êng and described as of white jade. It is further suggested that the *T'ao t'ieh* mask on the earliest bronzes may represent the tiger.[5]

During the Sung and Ming periods

[1] De Groot, *The Religious System of China*, Vol. VI, p. 955.
[2] Compare Biot, Vol. I, pp. 434-435.
[3] T'oung Pao, 1909, p. 264.
[4] Compare *China Review*, Vol. XXV, p. 179, and Doré, *Chinese Superstitions*, Vol. III, p. 307, Note 3.
[5] Pope-Hennessy, *Jade*, p. 49.

tiger statuettes were made in fine white jade and worn on the body to prevent illness and keep away demons ; also nephrite carvings of H'suen-t'an p'u-san (the Taoist God of Wealth), Chang Tao-ling and Kiang Tze-Ya, riding on tigers, were produced ; and by the commencement of the Ch'ing Dynasty, group carvings embodying this animal were being made.

THE *CH'I-LIN*.

The *Ch'i-lin*, a monster comprising the male (*ch'i*) and the female (*lin*), employed as an emblem to signify perfect good and happy married bliss, is said to have attained the age of ten thousand years. It is described as the noblest form of animal creation,[1] and is said to have trod so lightly as to leave no footprints, and so carefully as to crush no living thing. The *Ch'i-lin* must not be confused with the Buddhist lion or Dog of *Fo*, for it is really quite distinct and unrelated, and belongs to the Unicorn type. The *Ch'i-lin*, like other Chinese subjects for carving descended from remote antiquity, and like the Dragon and the *Fêng Huang*, is mentioned in the early writings as having first appeared during the reign of Huang-ti (2697-2597 B.C.). It is also referred to in the *Life of Confucius*. R. L. Hobson described it[2] as follows : " In form he is composite, with the body of a deer, slender legs and divided hoofs, the head of a dragon, a curled and bushy tail and flame-like attributes on his shoulders." De Groot informs us that a *Ch'i-lin* was " discovered in the alley leading to Hung-wu's tomb at Nanking ; and like the unicorn had a scaled dorsal back and a pair of straight horns bent backwards."[3]

The earliest recorded carving of the *Ch'i-lin* (*P'i-sieh*)[4] dates from the Shang-Yin Dynasty (1766-1122 B.C.), and was found, according to the *Ku yü t'u p'u*, in the grave of T'ai-k'ang (2188-2160 B.C.). For excellence, as an individual archaic jade carving of large size, this example gives precedence to the *Ch'i-lin* over the Dragon (see FIG. 49).

Laufer records, as being in his collection, a "rare and exceptional" specimen, weighing 4¼ pounds, which he attributes to the Han period. Another example of the *Ch'i-lin*, attributed to the T'ang period, is preserved in the Museum of East Asiatic Art, Cologne.[5] The specimens referred to are depicted with one

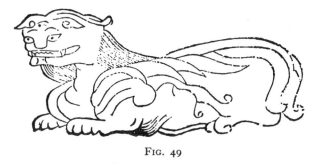

FIG. 49

1 Bushell, *Oriental Ceramic Art*, p. 594.
2 *The Wares of the Ming Dynasty*, pp. 131 and 132.
3 The Pah Ya says : " It has the body of a horse, a tail like an ox, and one horn." Compare De Groot, *Religious System of China*, Vol. II, p.822.
4 De Groot, *Religious System of China*, Vol. III, pp. 1143 *et seq.* and Laufer, *Jade*, pp. 263 and 331.
5 Illustrated in Pope-Hennessy, *Archaic Jades*, Plate LI, Fig. 1.

horn, and it is significant that the few archaic carvings of this beast which now remain, are portrayed in similar style. There are, however, specimens of the potter's and metal-worker's arts, which portray the Unicorn or *Ch'i-lin* with two horns.

T'ang carvings in jade of the *Ch'i-lin* are very rare, and the motive does not appear to have been used by the carvers of this epoch as a form of decoration. It again appears, however, during the late 16th century, when small white nephrite carvings began to be made, possibly to serve as emblems of good wishes ; but examples of these are also extremely rare.

During the early part of the Ch'ing Dynasty the *Ch'i-lin* became more popular for jade carving and we find representations of it in many of the cruder types of nephrite, usually copied from earlier models, but of a more formal shape and roughly finished.

During the Ch'ien Lung period the jade artist excelled in his characterisation of the *Ch'i-lin*, an excellent example being illustrated by Gorer & Blacker,[1] who draw our attention to the fact that the design used by the carver has been copied from the Imperial catalogue of the *Po ku*. It has the form of an ancient bronze, and was obviously made for use in the Chinese sacrificial rites ; perhaps as a wine vessel.

It is worthy of note that by the beginning of the 19th century the jade carver had again almost abandoned this mythical form, and few outstanding examples have been made in recent times.

THE LION (*SHI TZE*) OR DOG OF *FO*.

The Lion was first introduced into China from India, following the introduction of Buddhism, and has no connection whatever with the *Ch'i-lin*, sea-horse, sea-monster (*hai shou*) or dragon (*Lung*). It is not represented in jade carvings earlier than the Han Dynasty.

The Lion was held to be the defender of the Law and the Guardian of Sacred buildings.[2] Most Buddhist temples in China have two lions, carved in stone, set as guards at the entrance. These guardian images are referred to by Dennys[3] as " . . . mere charms."

According to the Buddhist tradition, the Buddha was born ten times as a lion, six as an elephant, once as a hare, but never as a woman, an insect or a preta.

The conventionalised form, which resembles the familiar Pekinese, is known as the Lion dog (*shih tzu kou*), and it is this beast, represented playing with a brocaded ball—the symbol or jewel of the law—that is usually the Temple Guardian. Another type is the winged, or flying lion (*fei-shih*), and, lastly, the archaic representation (*ts'ang*) which means venerable, or hoary.

The Winged Lion, of which twelve magnificent examples in stone

[1] *Chinese Porcelain and Hard Stones*, Vol. II, Plate 231.
[2] " The Lion symbolises boldness, bravery and a fresh, eager and advancing spirit." Edkins, *Chinese Buddhism*, p. 385.
[3] *Folklore of China*, p. 48.

PLATE LVII

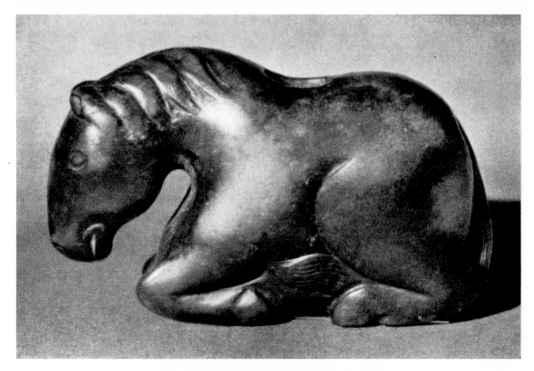

AN EARLY JADE RECUMBENT HORSE

COLOUR : Brown, splashed Orange and Green.　Sung Dynasty, A.D. 960-1279.　　L. 7.2 c.m.
(In the Collection of Major-General Sir Neill Malcolm, K.C.B., D.S.O.)

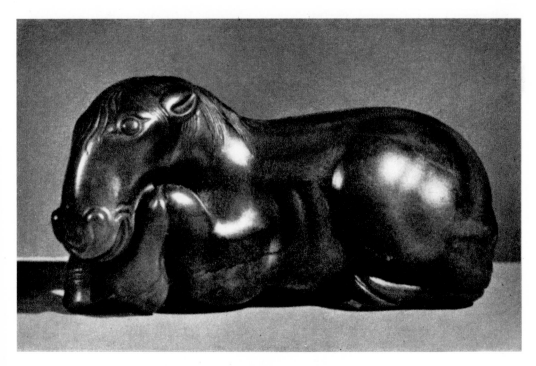

AN EARLY JADE RECUMBENT HORSE

COLOUR : Brown and Green.　　T'ang Dynasty, A.D. 618-906.　　H. 2.5 c.m.　W. 5.6 c.m.
(In the Collection of F. Schiller, Esq.)

PLATE LVIII

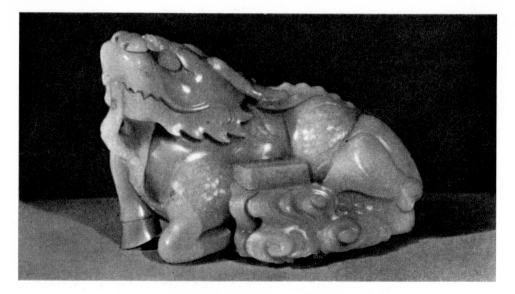

A JADE DRAGON-HEADED HORSE (*LUNG-MA*)

Represented with the Book of Knowledge.

COLOUR : Pale Grey Green. Early K'ang-Hsi Period, A.D. 1662-1722. L. 18.6 c.m.
(In the Collection of Oscar Raphael, Esq.)

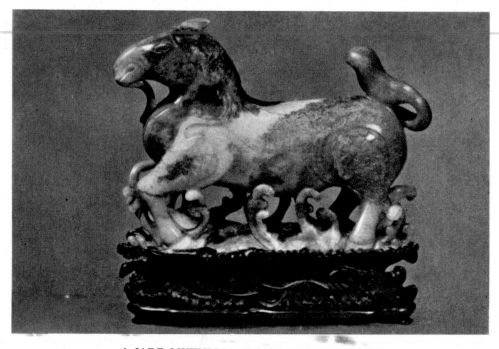

A JADE MYTHICAL HORSE OF THE WAVES

COLOUR : Grey Green, splashed light and dark Brown. H. 14.6 c.m. L. 20 c.m.
Mid Ming Period, *circa* A.D. 1500.
(In the Collection of Major-General Sir Neill Malcolm, K.C.B., D.S.O.)

PLATE LIX

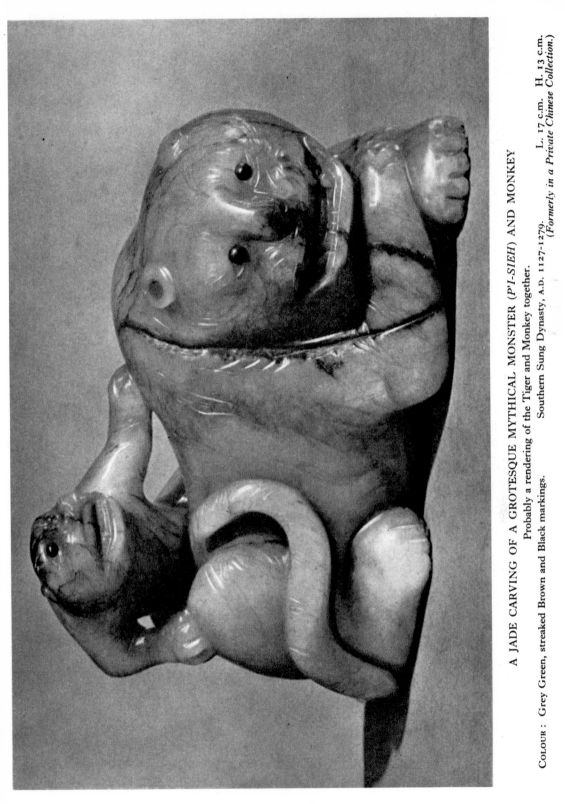

A JADE CARVING OF A GROTESQUE MYTHICAL MONSTER (*PI-SIEH*) AND MONKEY

Probably a rendering of the Tiger and Monkey together.

COLOUR: Grey Green, streaked Brown and Black markings. Southern Sung Dynasty, A.D. 1127-1279. L. 17 c.m. H. 13 c.m.

(Formerly in a Private Chinese Collection.)

PLATE LX

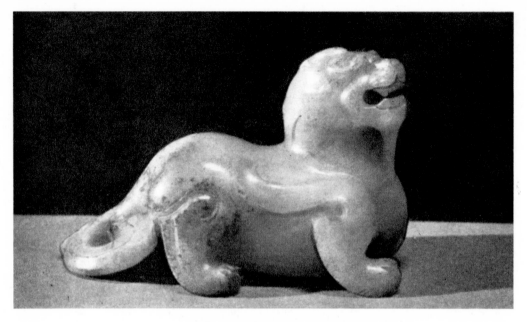

A WINGED CHIMAERA IN NEPHRITE

COLOUR : Pale Green and Iron Brown speckled. H. 5.8 c.m. L. 9.0 c.m.
Liang Dynasty, A.D. 502-556.
(In the Collection of A. W. Bahr, Esq.)

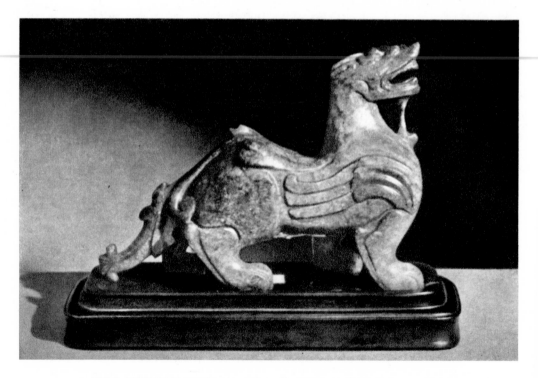

A JADE REPRESENTATION OF A *PI HSIEH* (FABULOUS ANIMAL)

Possibly a rendering in archaic form of the flying lion (*Fei-shih*). The Imperial seal mark of the
Emperor Ch'ien-Lung is cut on the chest.

COLOUR : Green, speckled Brown and Orange. H. 9.6 c.m. L. 13 c.m.
T'ang Dynasty, A.D. 618-907.
(The property of the Chinese Government.)

PLATE LXI

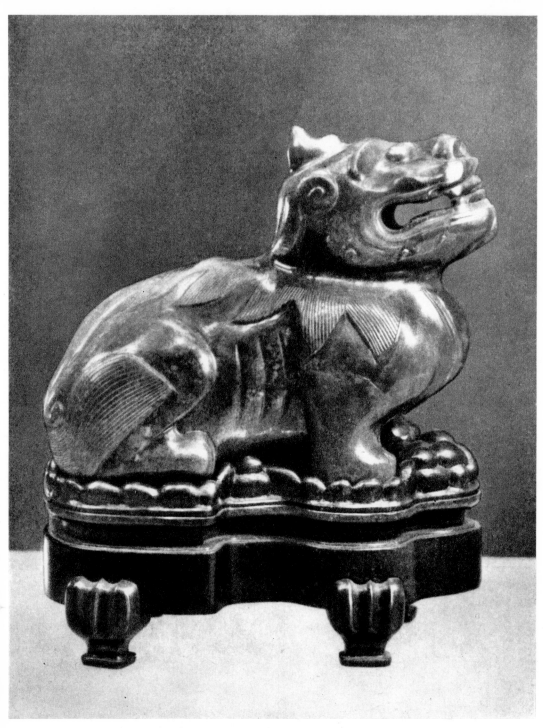

ONE OF A PAIR OF JADE DOGS OF *FO*

COLOUR : Dark Green. Late Ming Period, *circa* 1600.A.D. H. 13 c.m. L. 16.5 c.m.
(In the Author's Collection.)

PLATE LXII

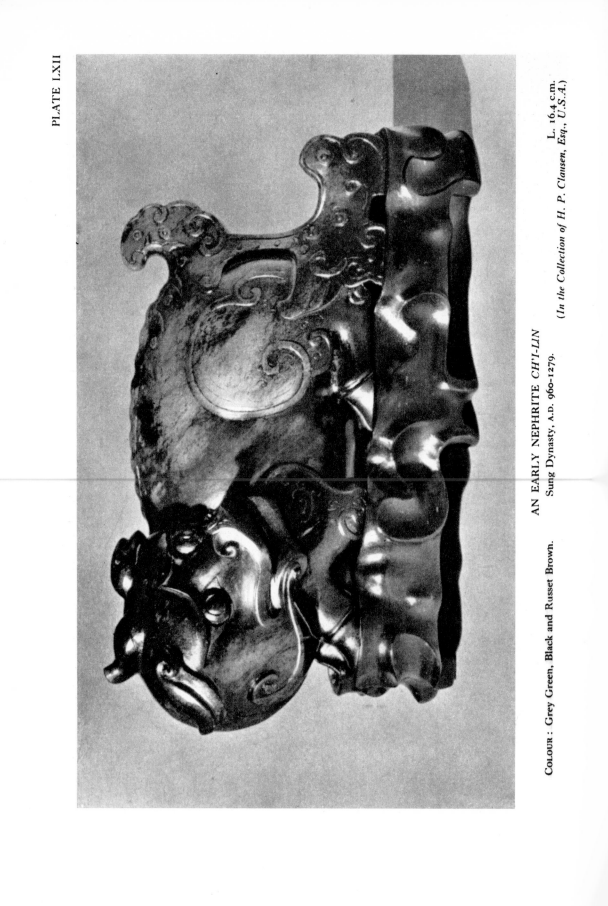

AN EARLY NEPHRITE *CH'I-LIN* L. 16.4 c.m.
Sung Dynasty, A.D. 960–1279.

(*In the Collection of H. P. Clausen, Esq., U.S.A.*)

COLOUR: Grey Green, Black and Russet Brown.

PLATE LXIII

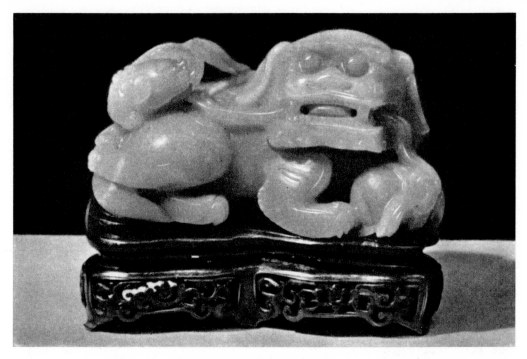

A JADE DOG OF *FO* WITH BROCADED BALL AND YOUNG

COLOUR : Mutton fat. K'ang-Hsi Period, A.D. 1662-1722. H. 9.5 c.m. L. 16 c.m.
(Formerly in the Collection of W. G. Wrigley. Esq.)

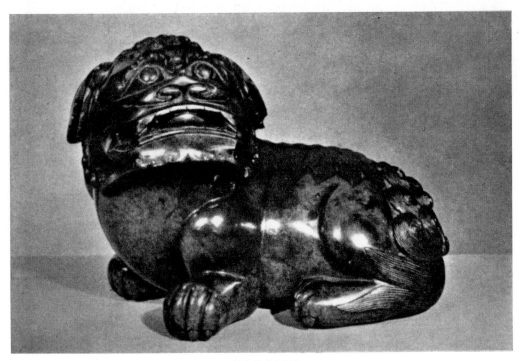

JADE LION

COLOUR : Sage Green. Ch'ien Lung Period, A.D. 1736-1795. H. 15.3 c.m. L. 19.8 c.m.
(In the Collection of R. C. Bruce, Esq.)

PLATE LXIV

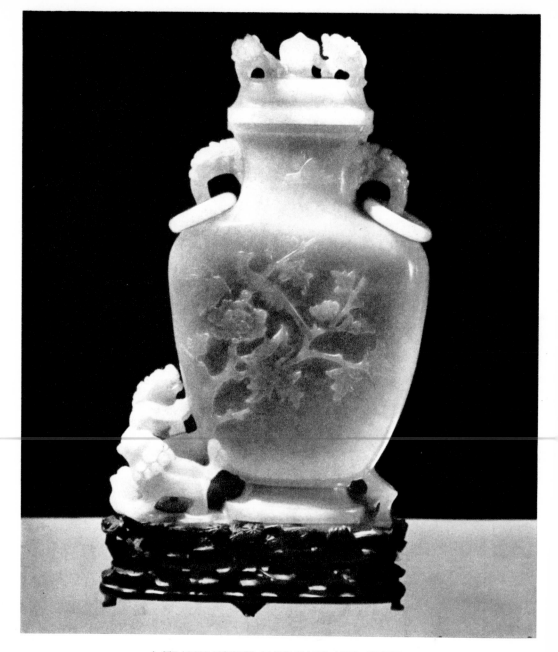

A TRANSLUCENT JADE VASE AND COVER
Depicting the lion portrayed in bold relief carving.
COLOUR : White. Ch'ien Lung Period, A.D. 1736-1795. H. 24.4 c.m. W. 14 c.m.
(Formerly in the Collection of Commander R. E. Gore, R.N.)

guard the Liang tombs, dates from the 6th century A.D. From these examples the jade carvings of similar type probably owe their conception. (See Plate lx.)

The Lion in the form of the *ts'ang*, or Chimera, is sometimes confused with the *Ch'i-lin* as they apparently owe their conception to the Unicorn. An excellent jade example of the Chimera is shown in Plate lx. Another example, illustrated by Laufer,[1] may be considered one of the finest examples of unconscious transition in Chinese art. The author describes it as " an independent work of plastic art . . . the head and long beard not unlike a dragon head. . . ." He is, further, of the opinion that this monster is to be associated with the *P'i-hsieh*, which, in its turn, had taken its conception from the Unicorn (*Ch'i-lin*) of the earliest Chinese mythology. According to Williams' *Dictionary of the Chinese Language* :—

" *Chi*. . .the male of the Chinese unicorn.

" *Lin*. .(from deer and ignis fatuus, because it appears flittingly) the female of the unicorn, which is represented with a scaly body."

Here, maybe, is the explanation of a very common error : that of confounding the Buddhist Lion with the *Ch'i-lin*. During the Han Dynasty the carver had two similar subjects for portrayal—the Unicorn of his forefathers, and the Lion of Buddha, recently brought to his country from India. Here, then, is but a recurrence of the phenomenon of the portrayal of Kuan Yin ; further confusion being caused to the uninitiated by the representation of the Lion in pairs.

Jade carvings of the *P'i-hsieh*, recorded in the *Ku yu t'u*, became increasingly less common during the Han and Six Dynasties until, by the T'ang period, the Buddhist Lion had become the predominating type for representation. During the Ming period, the carver gives his attention to the Lion Dog (*shih tzu kou*), which is a developed conception of the Lion (*shi tze*), and the craftsmen of the Ch'ing Dynasty, especially those of the Ch'ien Lung period, produced copies of the Chimera and of a flamboyant type of Lion.

An excellent example of the Lion as the mount of the Gods, is preserved in the *Sicawei* Museum of Antiques, where the Goddess Kuan-Yin is represented sitting sideways on the lion, with left leg pendent. The head of the animal is turned upwards towards the Goddess. The whole work strongly suggesting Indian influence.

THE DEER OR STAG.

The Deer or Stag (*Luh*), though not holding a place of honour in the Zodiacal circle, is nevertheless prominent in the thoughts of the Chinese. Its name, a popular symbol meaning " Longevity " and " Income," was probably suggested by the great length of life that tradition has ascribed to this animal. The Stag is considered to live a thousand years ; at that age its coat becomes grey ; after a further five hundred years, snow white ; and with an additional five hundred years its horns

[1] *Jade*, Plate XLIII.

79

turn back, denoting that it has attained immortality.[1] We find
mention of the stag legends in writings prior to the 4th century. Ko
Hung records that " The pure white stag, having reached immortality,
had the power of self-transformation." Another tradition is recorded
by Miss Ball : " In the time of the Emperor Huang Ti (2697 B.C.) a
thousand Barbarians rode on stags when visiting the Emperor to pay
their yearly tribute."[2]

The jade carver has represented the Deer and Stag since the Chou
Dynasty, examples of which are shown in PLATES LXIX and LXXV.
An exceptional specimen of the Ming Dynasty is illustrated in PLATE
LXVIII.

THE ELEPHANT.

The Elephant[3] and Lion have from time immemorial been asso-
ciated in the Arts, possibly on account of the natural enmity which has
always existed between them. In the Sung-shu we are told that
general Tsung Chüeh, when attacking barbarians who were using
elephants for transport, in the country of Ling Yi, ordered his army to
cover their horses in lion skins ; this strategical manœuvre proved
successful, and avoided bloodshed, for as soon as the elephants per-
ceived the counterfeit lions, they turned and fled, throwing the hostile
army into disorder, and making it an easy prey for Tsung Chüeh's men.[4]

It would seem that the elephant was known both to prehistoric
China and India, for we find it used as a motive in the archaic Bronze
works of both nations.[5] FIG. 50 (reproduced from the *K'ao ku t'u*,

FIG. 50

ch. 8, p. 2) and described therein as a " tiger Jade " *hu*, is believed by
Laufer to represent an animal of the tapir family ; there is no doubt
that he is correct in this assumption, as the carving certainly possesses
strong tapiroid characteristics, but the proboscis-like trunk is also
similar to that of the elephant, and it may be reasonable to assume that
it is in reality a Chou jade representation of the elephant, conven-

[1] De Groot : *The Religious System of China*, Vol. IV, p. 198.
[2] Compare Ball, *Decorative Motives of Oriental Art*, p. 112.
[3] " The Elephant indicates a weighty dignity, care, caution and gentleness." Edkins : *Chinese
Buddhism*, p. 385. Waddell : *The Buddhism of Tibet*, p. 358. Hackmann : *Buddhism as a Religion*
p. 211.
[4] Compare Ball *Decorative Motives of Oriental Art*, p. 82.
[5] *Chinese Exhibition Catalogue*, London, No. 165.

tionalised by an attempt to embody the mythological form of the unicorn. The bronze sonorous instrument shown in FIG. 43, p. 69, is quite possibly its counterpart. An exceptional specimen of Jade in the form of an elephant head reputed to be of the Shang-Yin Dynasty is illustrated in PLATE LXXI.

During the Han Dynasty, judging from extant bronzes,[1] an advanced type of elephant imagery was in being. There are very few jade carvings of this huge quadruped which date earlier than this period,[2] in fact, it is not until the Ming Dynasty that we find large representations of it in this stone. Mr. Oscar Raphael has in his Collection a good specimen of this period : it is carved in a green and brown nephrite ; its size being 19 c.m. high by 43 c.m. long. (See PLATE LXX).

During the Ch'ing Dynasty the elephant became a popular subject for portrayal. It is usually represented harnessed with costly trappings, in Indian style, and carries on its back one or other of the following objects : a shrine, an incense burner, the flaming pearl, a flower vase, or a receptacle for holding collections of Buddhist and Taoist emblematic objects. Many excellent carvings of this period are in private collections, and I am privileged to record the presence of an exceptional pair of such carvings in the private Collection of Her Majesty Queen Mary. These specimens are obviously the work of the Imperial workshops of the Ch'ien Lung period.

An excellent example of the craft under Indian influence is also to be found in the *Sicawei* Museum of Antiques where is represented an elephant carrying the Goddess Kuan Yin.

THE BEAR.

In China the Bear is known as *Hsung*. It is found represented on the stone slabs of ancient tombs, where it appears in mythological hunting scenes usually associated with the emperor. Several excellent bear forms are to be found in the glyptic art of the Chou, Han and T'ang Dynasties.[3] Although it is said by some writers that the bear never played an important part in the life and thought of the early Chinese, this statement is not supported by evidence. Indeed, among the existing legends there are several about the bear.

It is recorded, for instance, that one of the early Chou Emperors dreamed that a bear entered his room through the window and seating himself on a chair by his bed, foretold truthfully several important affairs of State. We also know that the bear was well represented in the jade carver's craft during the early Chou Dynasty. An example of this work is in the Collection of M. Calmann of Paris. (See PLATE LXXI).

A girdle ornament in the form of a bear in jade of the Han Dynasty is in the Collection of Mr. Chang Nai-chi.[4] It would seem certain, however,

[1] *Chinese Exhibition Catalogue*, London, No. 555.
[2] In the David Weill Collection is a green Jade Elephant which was exhibited at the Cernuschi Museum in April 1927 and assigned to the Chou Dynasty.
[3] *Decorative Motives of Oriental Art* : Ball, p. 146.
[4] *Chinese Exhibition Catalogue*, London, No. 284.

that the bear-form was not in favour with the jade carvers of later periods, for few carvings of bears from the T'ang, Sung, Ming and early Ch'ing Dynasties are to be found in European collections. Notwithstanding, it is recorded that the bear-dog has been considered a potent charm throughout the ages, and it is believed to keep away thieves.[1] It is possible that future archæological research may bring to light further representations of this animal in jade. In the meantime Collectors who possess such specimens have every reason to be proud of what are undoubtedly rare examples.

THE GOAT AND THE RAM.

The Ram, one of the Zodiacal animals, is symbolical of the anchorite. It occurs in jade statuette characterisations since the Han Dynasty. Several fine carvings of this type, usually of bold and pleasing design, have come through to us from the Sung period onwards. During the Ming and Ch'ing Dynasties it was one of the subjects much favoured by the carver, who depicted it either separately or in group formation.

The Goat, one of the five sacrificial animals,[2] is mentioned in several mythological stories, notably those connected with Su Wu, Ko Yu and Hwang Ch'i-p'ing. The latter personage is reputed to have lived in the 4th century A.D., and in landscape carvings in jade he is often depicted in the gardens of Hsi Wang Mu, where he is seen transforming herds of goats into stone.[3] In pre-Ming carvings it is not uncommon to find the Goat and Ram depicted in an involved type of representation, suggesting an attempt on the part of the carver to portray the sacred wild sheep,[4] which has a deer-like body[5] and a Ram-like head with long spiral horns. An excellent carving in White Jade of the Celestial Goats is illustrated in PLATE LXXII. A figure of the Ram, of the Ming Dynasty, in White Jade, with black markings, is shown in PLATE LXXIII.

THE BADGER.

The Badger[6] is another animal considered by the Chinese to possess the mystic power of transformation. Its place in Chinese mythology seems difficult to locate, but it would appear that the reference by de Groot[7] to the Cat-demon is in fact an allusion to the badger. The

[1] Doré, *Chinese Superstitions*, Vol. V, p. 709.
[2] Which are the Ox, Goat, Pig, Dog and Fowls.
[3] Compare Edmunds, *Chinese and Japanese Art*, p. 132.
[4] *Li Ki*, Book XX, Tsi-fah (Law of Sacrifice), para. 3, where mention is made that in the Chou Dynasty : " A sheep or pig were sacrificed to the sun at the altar called the ' Royal Palace,' and in the pit called the ' Light of the Night,' they were sacrificed to the Moon." *Mai shao-lao, wang-kung tsi jeh yeh ; yeh-ming tsi yueh yeh.*
埋　少　牢,　王　宮　祭　日　也；夜　明　祭　月　也.
[5] Compare Williams, *Outlines of Chinese Symbolism*, p. 352.
[6] *Li* or *Yeh Mao* " wild cat." *Mao*, or in poetry *Nu Mu*, " Hand Maiden " or *Mao-tze*. See Williams, *Dictionary of the Chinese Language*.
[7] *Religious System of China*, Vol. V, p. 610 (Cat-spectre in the service of sorcerers).

PLATE LXV

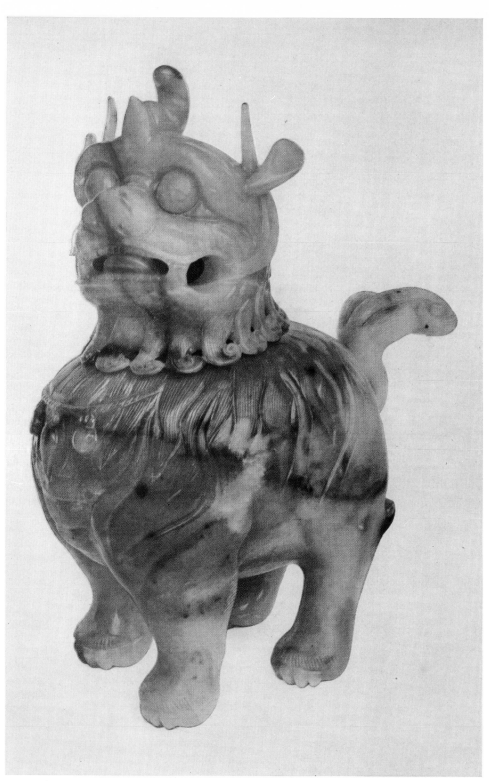

A TRANSLUCENT JADE INCENSE BURNER IN THE FORM OF A DOG OF *FO*
COLOUR : Apple and Emerald Green, splashed Orange and Brown. H. 24.4 c.m. W. 20.8 c.m.
Ch'ien Lung Period, A.D. 1736-1795
(*In the Collection of Sir Bernard Eckstein, Bart.*)

PLATE LXVI

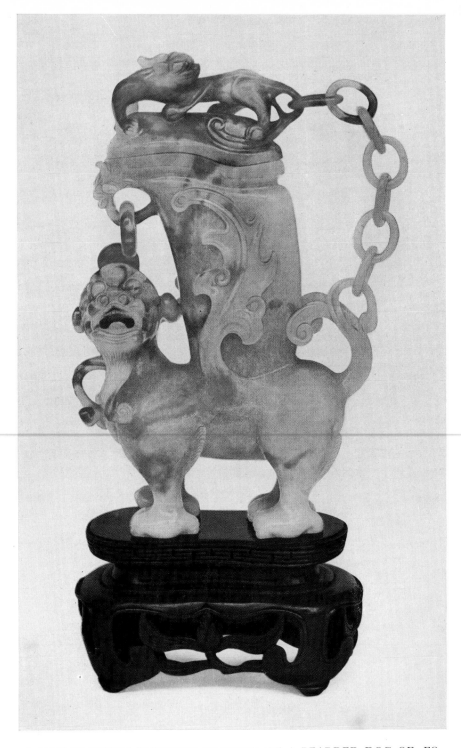

A TRANSLUCENT NEPHRITE CARVING OF A BEARDED DOG OF *FO*
Supporting vase and cover joined by an endless chain, the whole being carved from
one piece of stone.

COLOURS : Translucent Apple and Emerald Green with Yellow markings.
Imperial Ch'ien Lung, *circa* A.D. 1760. H. 15.6 c.m.
(*In the Collection of Frank H. Fulford, Esq.*)

PLATE LXVII

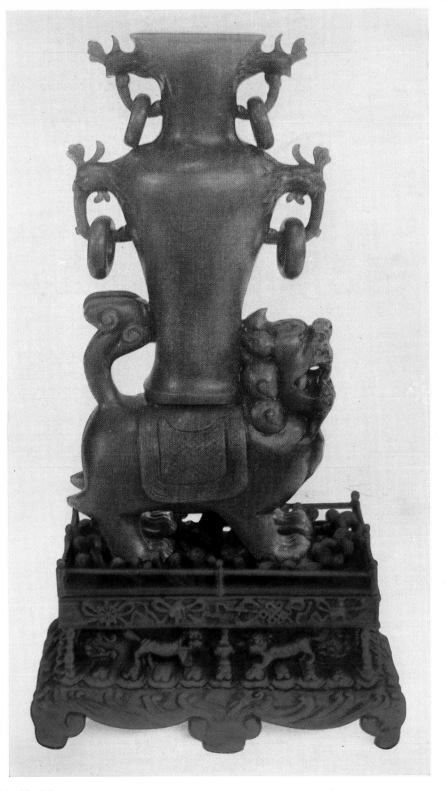

ONE OF A PAIR OF TRANSLUCENT JADE CARVINGS IN THE FORM
OF ALTAR VASES

Representing bearded Dogs of Fo, saddled and supporting a vase, the four loose
handles of which hang from *Fêng Huang* bird heads.

COLOUR : Sea Green. Ch'ien Lung Period, A.D. 1736-1795. H. 30 c.m. W. 15.5 c.m.
(In the Collection of Sir Bernard Eckstein, Bart.)

PLATE LXVIII

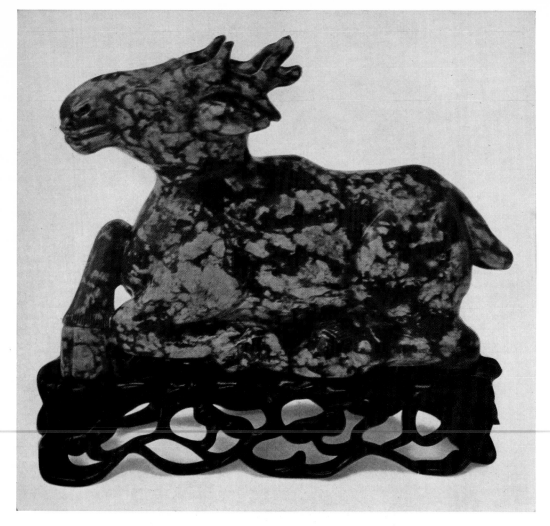

A JADE CARVING IN THE FORM OF A RECLINING STAG

Colour : Black and Green. Mid Ming Period, *circa* A.D. 1500. H. 16.0 c.m. W. 23.5 c.m.
(Formerly in the Collection of Commander R. E. Gore, R.N.)

reference in the *Elucidation of Historic Annals* to a female slave belonging to Prince T'ao evoking " Cat-demons " for nefarious purposes[1] during the reign of Wen Ti (A.D. 509-605) may also be accepted as another reference to the badger.

A bronze mythical quadruped of the period of the Warring States in the Collection of Mr. H. J. Oppenheim appears to possess characteristics of the Badger[2] whilst a Jade carving in the same collection may well be a more developed rendering of the same animal. Another example of the Sung Dynasty is shown in PLATE LXXIII. It seems probable that the absence of the badger in jade representations after the Sung period, may be accounted for by the cat having taken its place, probably on account of the latter animal's great importance in the silk-worm industry of those times.

THE RAT.

" The Rat is known to the Chinese as *shii*. The ancient Chinese saw in this generally despised creature such extraordinary qualities that they gave to it the first place in their Zodiac, where it represents the beginning of things or the first cause. The intelligence it manifests in locating, acquiring and hoarding booty, caused it to be selected as the symbol of industry and prosperity, for which reason one particular specie known as the *Chin Ch'u*, ' cash rat,' is never molested by the Chinese, but is allowed to remain in their houses."[3] (See PLATE LXXIV).

THE DOG (*KOU-TZU*).

The Dog is one of the twelve animals of the Zodiac, its position, according to the diviners, being in opposition to the Cock. In jade, the portrayal of the dog seems to have commenced during the Han Dynasty, about the same time as that of the horse. Baron Cuvier says of the dog " it is the completest and most useful conquest ever made by man since prehistoric times." The Dog in Chinese Art first appears as the impetuous hound of the chase, becoming next the ferocious dog of war, and lastly the fearless guardian of the Palace and the Temple. A. L. Hetherington,[4] referring to the Han hunting dog, divides it into two species, the fleet greyhound used for hunting the deer and the stockier-built mastiff, and further refers to a powerfully built animal, with well developed teeth, which carries its tail curled on its back, similar to the Chow of to-day.[5] Dr. Laufer,[6] discussing the introduction of the mastiff into China, suggests that it was brought to that country by the ancient Turks, and points out its marked similarity to the Pekinese, which he considers was introduced during the T'ang

[1] Compare de Groot, Vol. V, p. 612.
[2] *Chinese Exhibition Catalogue*, London, No. 136. Compare Plate 974, *Animated Nature* Vol. I, p. 217.
[3] K. M. Ball, *Decorative Motives of Oriental Art*, p. 164.
[4] The *Early Ceramic Wares of China* : A. L. Hetherington, p. 38.
[5] *Dogs of China and Japan in Nature and Art* : V. W. F. Collier, Chapter IV.
[6] *Op. cit.*, p. 264.

Dynasty. From ancient times the flesh of the dog has been considered a delicacy in China, worthy even of the Emperor. Thus we read in the *Li Ki* " In the first month of Autumn the Son of Heaven is clothed in white, he eats Hemp-seeds and dog's flesh."[1]

During the T'ang Dynasty the jade carver produced several excellent images of the dog,[2] which are of hound type, but lacking in the quality of motion. With the advent of the Sung Dynasty a type was developed seemingly influenced by the Lion of Buddhism (see PLATE LXXIV), and under the Ming Dynasty the dog type of carving has given place altogether to the Buddhist lion.[3] The dog form again appears during the Ch'ing Dynasty but is now definitely of the Pekinese type.

THE BOAR.

In China, the pig, being so extensively associated with food, made no appeal to the æsthetically inclined, and is therefore only found in the arts as the attribute of some deity. In the Yüan Hsien T'sa (an ancient book) it is related that " Prince Shên, being exceptionally fond of pork and wishing it to be clean and pure, kept his pigs on a velvet carpet, gave them the same food he provided for his servants, and had the beasts bathed twice a day."

Representations of the boar and pig as one of the signs of the Zodiac, date back in China to a remote past.[4]

It is frequently depicted in early jades. The bodies of the dead were supposed to be supplied with jade pigs under the arm-pits (see PLATE XXI). Another interesting specimen is shown in a drawing in the *Ku yü t'u p'u* of a jade implement to loosen knots.[5]

The Boar is also one of the twelve cyclic animals used for divining purposes and is considered by the fortune teller to be mutually opposed to the Monkey. In the *Historical Annals* (*Shoo King*)[6] we read that Hwanwang (719-696 B.C.) ordered every family to rear two sow-pigs and five hens,[7] and also that Chao-kien-tze delighted to eat pork procured for him by Tze-lu[8] after his expulsion from the Feudal States of Ch'en and Ts'ai.

During the Sung Dynasty a number of small white jadeite Charms in the form of the pig were made, but during the Ming Dynasty this novelty seems to have been discontinued. During the Ch'ing Dynasty, however, several excellent carvings of the pig or boar appeared in various coloured nephrites and jadeites.

[1] *Li Ki* or *Record of Rites*, Book IV. Yueh-Ling (The proceedings of government in the different months). Legge's translation, Vol. I, p. 284.
[2] *Chinesische Kunst*, 1929, No. 231.
[3] Compare Legge, *Li Ki*, Book XLIV, p. 443, Note
[4] K. M. Ball, *Decorative Motives of Oriental Art*, p. 125; Laufer, *Jade*, pp. 203 and 164; Legge, Vol. I, p. 77.
[5] *Ku yü t'u p'u*, Chap. 56.
[6] Compare *Refutation of False Doctrine*, Father Hwang, Vol. II, p. 65.
[7] Vol. I, p. 131, note 3 ; Vol. IV, p. 329, note 3.
[8] Giles, *Chinese Biographical Dictionary*, p. 208, also compare *Confucian Analects*, Lun-yü Book X, Chap. 8.

We find the Cat[1] in the earliest records of Chinese mythology. The Book of Rites tells us that *Li Shou*[2] was worshipped by the pre-historic farmers of China. The Emperor, Hsi Hwang-ti, when offering sacrifices to the *Pa Shen*,[3] included the cat under the *Yin* or female principle.[4]

The cat, like several other animals, is in Chinese mythology considered to possess the power of transformation. It usually takes a human form.[5] The following legend demonstrates this belief. The first wife of the Emperor T'ai Tsung (A.D. 763-780) met her death at the hands of a lady named Wu, who became later the Empress Wu, second wife of the Emperor T'ai Tsung. Whilst on her death bed the dying Empress, confronted by Wu, vowed revenge on her murderess. " I will," said she, " return in the form of a cat, and turning you into a rat, you shall die at my will." This so frightened Wu, that she ordered that all cats in the vicinity of the palace should be killed, and, further, that from that time forward no cat was to be allowed within the palace or in its precincts.[6] The Chinese regarded an image of a cat as possessed of spiritual power akin to that of the Unicorn.[7] This myth gained in importance when the cat became the recognised guardian of Silkworms (*Ts'an-mao*).[8] The first appearance of the cat in Chinese Art, would seem to be in the paintings of the T'ang Dynasty which were inspired in the following manner :

Whilst the Emperor Ming Huang was walking in the gardens of his palace a cat jumped from some peony-bushes and, pursuing a butterfly, crossed his path. This so impressed the Emperor that he set himself the task of recording the incident in poetry. It is believed that this poem was later the inspiration of the painters.[9]

The first jade carvings of cats appear during the Ming Dynasty, in the form of small charm-carvings of white and multi-coloured jadeite. During the Ch'ing Dynasty many excellently carved cat-symbols were produced. PLATE LXXVI shows a cat chasing a butterfly, and is a masterly production, revealing the carver's clever usage of the natural colour characteristics of the stone, an outstanding feature of the jade artists' skill under the Ch'ing Dynasty.

THE FOX.

In China the Fox has, of all animals, the worst reputation.[10] This is, perhaps, on account of its mischievous character and inherent

[1] *Mao* or in poetry *Nu Mu* " Hand Maiden."
[2] A cat divinity.
[3] " Eight Spirits."
[4] *Chinese and Japanese Art* : W. H. Edmunds, p. 302.
[5] De Groot, *The Religious System of China*, Vol. V, p. 612.
[6] Compare Ball : *Decorative Motives of Oriental Art*, p. 152.
[7] Doré, *Chinese Superstitions*, Vol. V, p. 676.
[8] *Ibid*, Vol. V, p. 710.
[9] Ball, *Decorative Motives of Oriental Art*, p. 154.
[10] De Groot, *The Religious System of China*, Vol. V, p. 596.

cunning.[1] It is accredited with a power of transformation similar to the dragon, its favourite and most baneful metamorphose being to take the form of a young and beautiful girl[2] in which shape it is believed that it lures its victim to destruction.[3] The fox is believed to be ridden by ghosts, and to become, when it has attained the age of a thousand years, the Celestial Fox that serves in the Halls of the Sun and Moon.[4] De Groot[5] tells us that Fox mythology and legends usually represent the animal as a malicious being, holding rank with the tiger, wolf and other evil demon representations. In fact it is in this manner that the Chinese refer to the fox both in thought and tradition. There are numerous tales in Chinese folk lore, in all of which the fox is referred to as a Fox demon, and reverenced solely by a sense of fear. The heavenly patroness of this Fox demon is T'aibshan niang-niang, the T'ai shan goddess, who dwells on the summit of one of the sacred mountains.[6]

The worship of the fox is said to date back to 3200 B.C. Shan-kai Ching records that during the reign of Wên (12th century B.C.) a Celestial Fox appeared before the emperor, bearing in its mouth a book of knowledge. In recording this same story, Keio Pu, a writer of the Ch'ing Dynasty, says, " The Celestial fox came from Ching Chiu— ' Green Mountains '—her nine tails are the symbol of her wonderful power. She came when the Chou empire was prosperous, bringing as a greeting, a book which she carried in her mouth. But after the overthrow of the Chou Dynasty and the corruption of the empire, she degenerated into a witch and brought no end of trouble for the people."

If we accept this record, it helps us to understand why there do not appear to be any representations of the fox among early works in jade.

During the T'ang Dynasty we find several carvings of the fox in black and white nephrite, and in the Ming period the animal assumes a decorative motive form. The craftsmen of the Ch'ing Dynasty depict the fox both in landscape carvings and composite types, such as " the fox and grapes," etc.

THE HARE.

Records of the Han Dynasty assert that the hare not only derives its origin from the vital essence of the moon,[7] being ever subject to its influence,[8] but also inhabits the moon. Subsequent to this, the Taoists claimed that a white hare is the servitor of Ch'ang-o—the queen of our luminary—and her genii, for whom it compounds the elixir of life.

The white hare, which has had to live a thousand years to acquire its unsullied coat, has, from ancient times, been held divine. Its appearance, therefore, has always been regarded as an auspicious omen,

[1] So also in mediæval European literature : *Le Roman du Renart* ; *Le Renart le contrefait*, etc. (French); also German, Flemish, and Latin. So also Æsop, La Fontaine.
[2] Dennys, *The Folk Lore of China*, p. 94.
[3] *Ibid*, p. 96.
[4] Compare Bushell, *Oriental Ceramic Art*, p. 595.
[5] De Groot, *The Religious System of China*, Vol. IV, p. 195.
[6] Doré, *Chinese Superstitions*, Vol. V, p. 701.
[7] Compare Mayers, *Chinese Readers Manual*, Pt. 1, p. 724.
[8] Compare Chang Hua in the *Po Wu Chih*.

PLATE LXIX

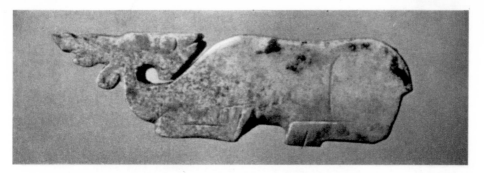

AN EARLY JADE CROUCHING STAG

COLOUR : Grey White, splashed Blue Green. H. 8 c.m.
Period of the Warring States, 481-221 B.C.
(In the Collection of M. Calmann, Paris.)

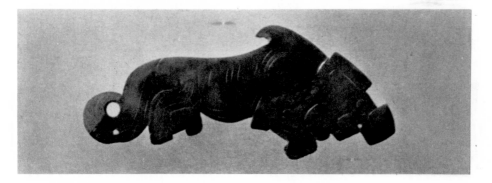

AN EARLY JADE CARVING OF TIGER FORM

This form may possibly be an early representation of the Unicorn (*Ch'i-lin*).
COLOUR : Dull Grey Green. Chou Dynasty, 722-481 B.C. L. 13.9 c.m.
(In the Collection of Mrs. Christian R. Holmes, New York.)

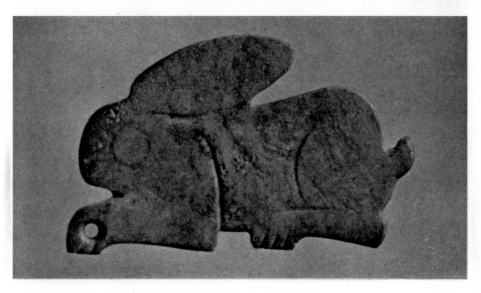

AN EARLY JADE HARE

COLOUR : Brown Green, speckled White. H. 3.1 c.m. L. 5.8 c.m.
Period of the Warring States, 481-221 B.C.
(In the Collection of Oscar Raphael, Esq.)

PLATE LXX

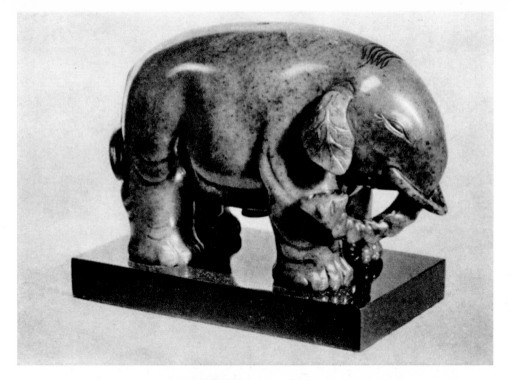

A JADE ELEPHANT

COLOUR : Grey, speckled Black and Green. H. 14.5 c.m. L. 22 c.m.
Ch'ien Lung Period, A.D. 1736-1795.
(In the Collection of Oscar Raphael, Esq.)

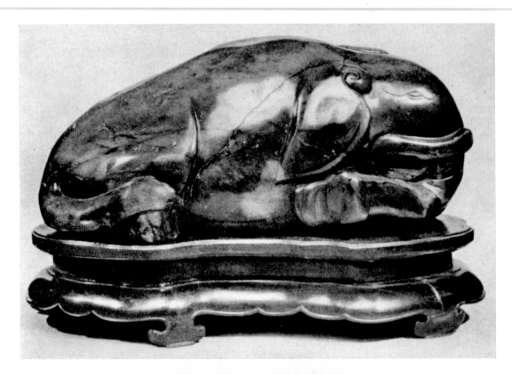

A RECUMBENT JADE ELEPHANT

COLOUR : Green and Brown. Early Ming Period, circa A.D. 1450. H. 19 c.m. L. 43 c.m.
(In the Collection of Oscar Raphael, Esq.)

PLATE LXXI

AN EARLY JADE ELEPHANT HEAD FINIAL

COLOUR : Green. Shang-Yin Dynasty, 1766-1122 B.C. L. 4.5 c.m.
(In the Collection of Chang Nai-Chi, Esq , Shanghai.)

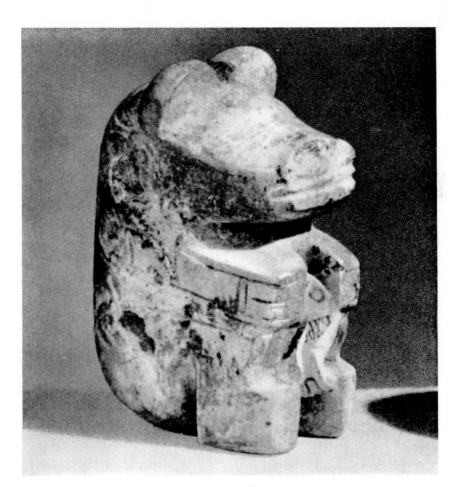

A SITTING JADE BEAR

COLOUR : Grey Green. Early Chou Dynasty, 1122-722 B.C. H. 4.5 c.m.
(In the Collection of M. Calmann, Paris.)

PLATE LXXII

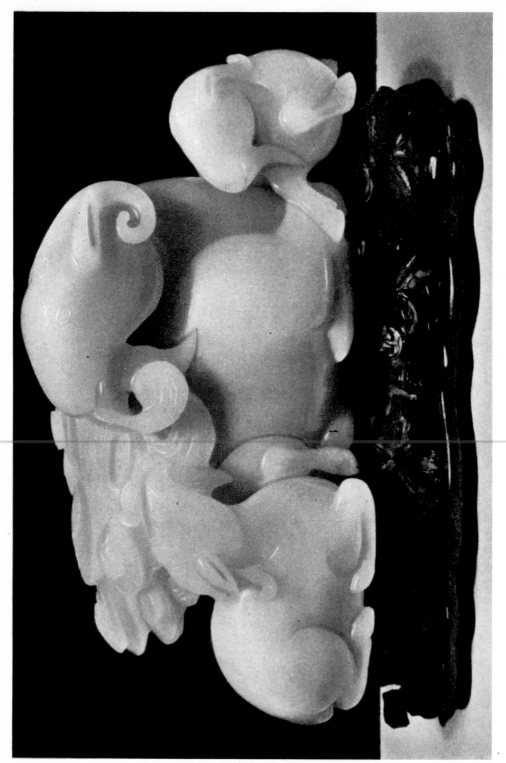

A JADE CARVING OF RAMS

Depicting the *Yin* and *Yang* Symbol in scroll cloud formation.

Colour: Translucent White splashed Brown and Orange markings. Ch'ien Lung Period A.D. 1736-1795

H. 9.8 cm. W. 22.6 cm.

PLATE LXXIII

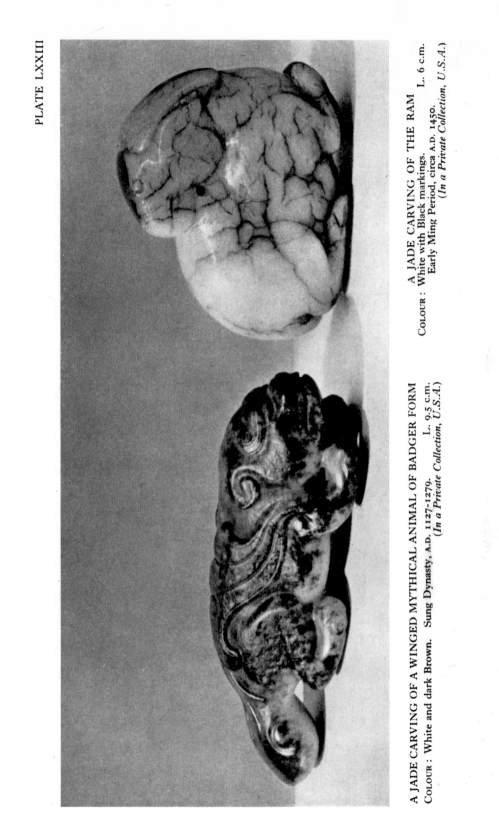

A JADE CARVING OF A WINGED MYTHICAL ANIMAL OF BADGER FORM L. 9.5 c.m.
COLOUR : White and dark Brown. Sung Dynasty, A.D. 1127-1279.
(*In a Private Collection, U.S.A.*)

A JADE CARVING OF THE RAM L. 6 c.m.
COLOUR : White with Black markings.
Early Ming Period, circa A.D. 1450.
(*In a Private Collection, U.S.A.*)

PLATE LXXIV

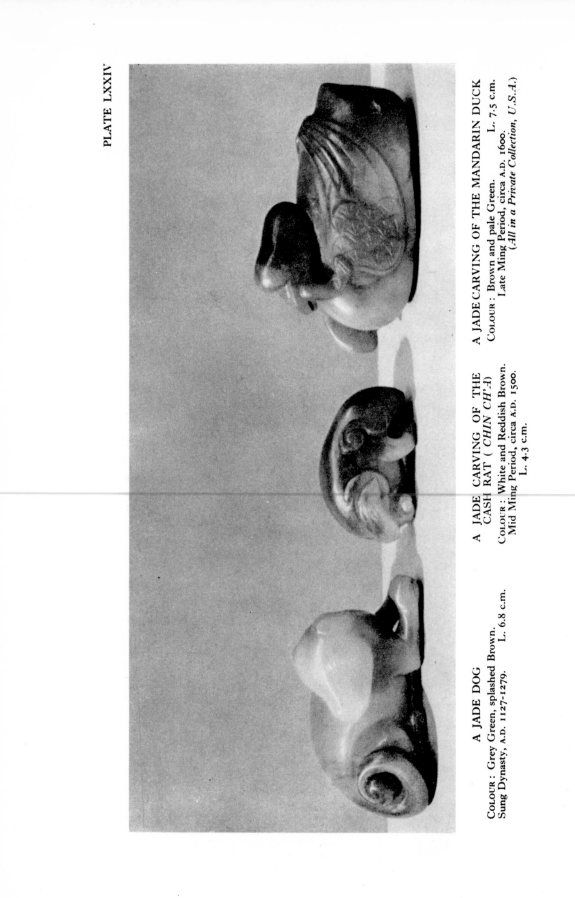

A JADE DOG

COLOUR: Grey Green, splashed Brown. L. 6.8 c.m.
Sung Dynasty, A.D. 1127-1279.

A JADE CARVING OF THE
CASH RAT (CHIN CH'A)

COLOUR: White and Reddish Brown.
Mid Ming Period, circa A.D. 1500.
L. 4.3 c.m.

A JADE CARVING OF THE MANDARIN DUCK

COLOUR: Brown and pale Green. L. 7.5 c.m.
Late Ming Period, circa A.D. 1600.
(All in a Private Collection, U.S.A.)

PLATE LXXV

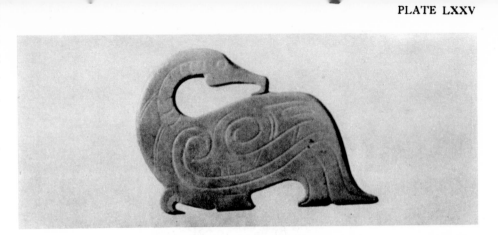

A JADE CORMORANT

COLOUR: Grey. Period of the Spring and Autumn Annals, 722-481 B.C. H. 4.4 c.m.
W. 6.5 c.m.
(*In the Eumorfopoulos Collection, British Museum.*)

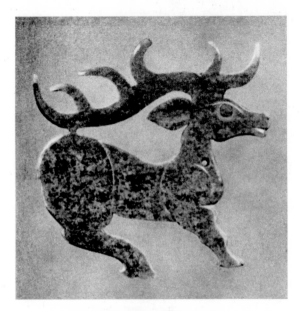

A JADE STAG

COLOUR: Dull Green. H. 5.6 c.m. W. 5.8 c.m.
Period of the Warring States, 481-221 B.C.
(*In the Collection of H. J. Oppenheim, Esq.*)

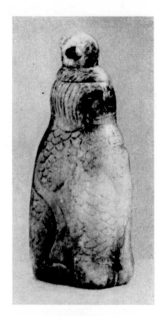

**A JADE
DOUBLE-TAILED CAT**

COLOUR: Russet Brown with
Grey and Black shadings.
Han Dynasty, 206 B.C.-
220 A.D. H. 6.7 c.m.
(*In the Collection of W. G.
Wrigley, Esq.*)

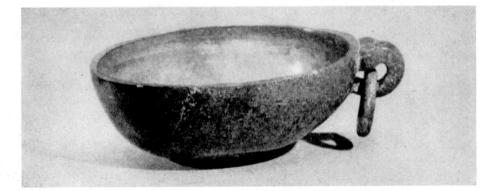

A JADE CUP

COLOUR: Dull Grey Green. Early Ming, *circa* A.D. 1400. H. 3 c.m. W. 9.4 c.m.
(*In the Eumorfopoulos Collection, British Museum.*)

PLATE LXXVI

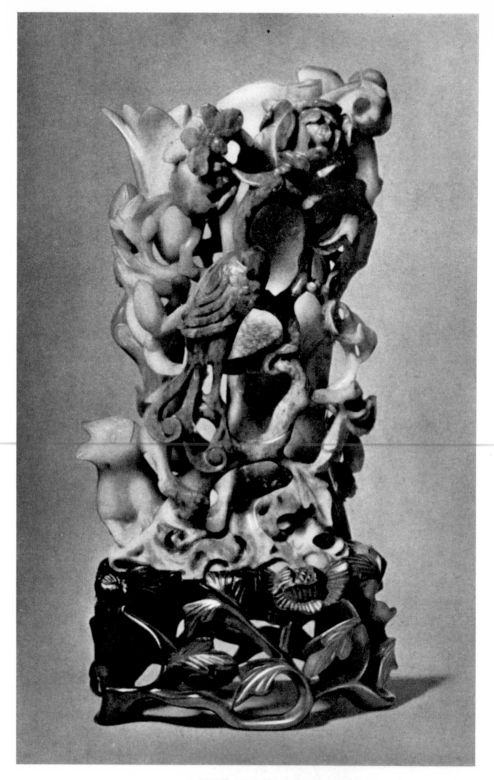

A JADE SPILL VASE
Carved in bold relief with cat and Fêng Huang.
COLOUR: Green and White. Chia-ch'ing Period, A.D. 1796-1821. H. 18.5 c.m.
(Formerly in the Collection of Commander R. E. Gore, R.N.)

portending the reign of a beneficent and just ruler. This idea had its inception in the tradition that in the golden age of the Chou Dynasty white hares gambolled in the streets of the Capital city.[1]

The hare is also one of the animals sacrificed in the temple of the Imperial Ancestors. When so used it is known by the name *ming shih*, " bright eyes," because it is said that the hare's eyes, unlike those of any other animal, grow larger and brighter with age. The eyes of the hare were regarded by the Chinese as significant of the Beginning of events and periods, and particularly of pubescence.

Not all the divine hares are white, for the ancient writings describe a red hare which, in company with the phœnix and the unicorn, appears as a harbinger of peace and prosperity, and also a black hare of great beauty.

Referring to the latter, Chang Ssu Wei writes : " The black hare is more uncommon than the white hare. It comes from the North Pole, bringing greetings from the moon goddess and is auspicious of a successful reign. Now may the magic medicine be pounded with jade pestle and the divine nectar be prepared in a crystal cup."

The Jade carver has represented the Hare in his works from the earliest times. An outstanding example of the period of the Warring States (481-221 B.C.) shown in PLATE LXIX is in the Collection of Mr. Oscar Raphael.

THE SQUIRREL.

Known to the Chinese as *sung shu*, " pine rat," the Squirrel is usually represented in conjunction with the vine, a subject which we find first in a painting by Ming Yüan Chuang, an artist of the Sung Dynasty. The Chinese say that as the vine is able to creep everywhere and cover everything in its course, so the squirrel, in its perpetual scampering about, can with equal facility cover every available surface within the range of its activities.[2]

THE MONKEY.

The Monkey appears in the art and folklore of most of those oriental countries which are a native home of the Simian species. Its name in Chinese is *heu*, which is said to have been devised from the sound of its chattering.

Concerning the many varieties of the monkey tribe there are numerous traditions, all of which invest the creature with superhuman and magical powers. It is credited with great longevity and the power of transformation ;[3] and, in accordance with the human custom in the Orient, at stated periods it acquires the dignity of a new name. For example : in the Pao Pu Tzu it is related that when the *hou* is eight hundred years old, it becomes an *yüan* ; then, after five hundred years more, it is known as a *chū'eh ch'üeh* and, after an additional one thousand

[1] K. M. Ball, *Decorative Motives of Oriental Art*, p. 159.
[2] K. M. Bull, *Decorative Motives*, p. 164.
[3] Doré, *Chinese Superstitions*, Vol. V, p. 701.

PLATE LXXVII

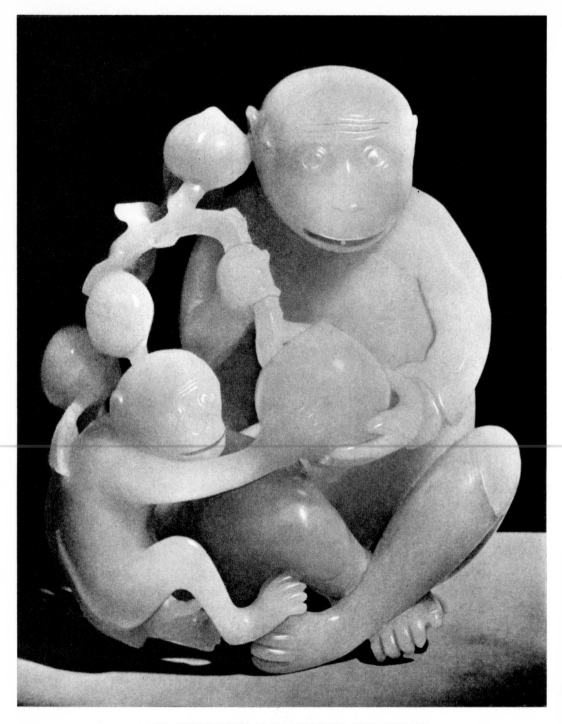

A TRANSLUCENT JADE MONKEY AND YOUNG
Holding symbolical Peach Branch.

COLOUR : White.　　　　Early K'ang Hsi Period, circa A.D. 1675.　　　　H. 24 c.m.
(In the Collection of Mrs. Emma Joseph.)

PLATE LXXVIII

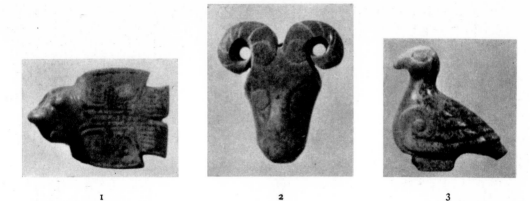

1 2 3

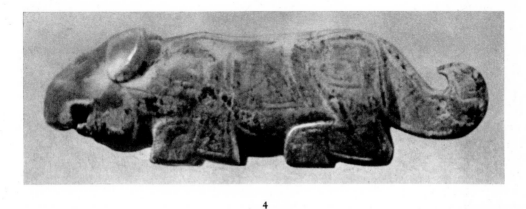

4

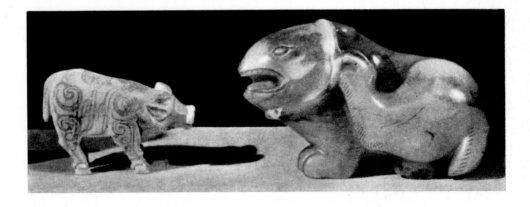

5 6

1. A JADE PIGEON PENDANT. COLOUR: Green. Early Chou Dynasty, 1122-722
 B.C. L. 3.8 c.m. (*In the Collection of Chang Nai-Chi, Esq., Shanghai.*)
2. A JADE RAM'S HEAD. COLOUR: Buff with Red pigment. Period of the Spring
 and Autumn Annals, 722-481 B.C.
 (*In the Collection of H.R.H. The Crown Prince of Sweden.*)
3. A JADE PIGEON PENDANT. COLOUR: Grey Green. Early Chou Dynasty, 1122-
 722 B.C. H. 3.2 c.m. L. 3.6 c.m. (*In the Collection of Chang Nai-Chi, Esq., Shanghai.*)
4. A JADE TIGER. COLOUR: Grey Green. Shang Yin Dynasty, 1766-1122 B.C.
 L. 6 c.m. (*In the Collection of Chang Nai-Chi, Esq., Shanghai.*)
5. A JADE BUFFALO. Stylised surface decoration. COLOUR: Buff. Early Chou
 Dynasty, 1122-722 B.C. L. 4.5 c.m. (*In the Collection of H. J. Oppenheim, Esq.*)
6. A JADE BEAR. Carved in the round. COLOUR: Greenish White. Han Dynasty,
 206 B.C.-A.D. 25. H. 4.7 c.m. (*In the Collection of H. J. Oppenheim, Esq.*)

years as a *ch'an ch'u*, under which name it may continue its life another three thousand years, when it assumes the form of an old man.

The worship of the monkey has prevailed in China since the T'ang Dynasty,[1] when it was deified in return for services which a particular ape—Sun Wu K'ung—rendered to the Buddhist priest, Yüan Chuang, during his quest in India for the *Sacred Scriptures*. The Emperor conferred upon this animal the title of " The Great Sage Equal to Heaven." His birthday, which occurs on the twenty-third day of the month of the second Chinese calendar, is celebrated by all classes of society, not only in temples erected to his worship, but also at shrines placed in walls of buildings at the corners of streets and other places.

The earliest monkey forms in jade appear to date from the Sung Dynasty, when they were usually associated with the pig, probably on account of the mutual occult opposition supposed to exist between these two animals ; the horse and monkey, on the contrary, being associated.[2] There would appear to be confirmation of this during the Ming Dynasty, from which period dates a carving of a monkey riding a horse, inscribed as from the time when the " monkey was domiciled in the Royal stables, for the purpose of keeping the horses in good temper." There are, however, few jade carvings of the monkey that date earlier than the Ming period ; and it would seem that it was not until the later years of this dynasty that vase forms, supported by the three Mystic apes, made their appearance inspired by the glyptic art of India and Japan. An excellent example of the Monkey, carved during the K'ang Hsi period, is in the Collection of Mrs. Emma Joseph and is illustrated in PLATE LXXVII.

The Monkey is found represented during the late Sung Dynasty on two Temple Vessels (*tsung yi*), one bearing the image of the tiger, the other of the monkey. These vessels form part of *the Twelve Ancient Ornaments* which derived their symbolical ornamentation from that of ancient ritual bronzes.[3]

THE BAT (*PIEN-FUH-TZE*).

Among the numerous motives occurring in Chinest Art perhaps none is more in evidence than the Bat. This is due to its special significance as an important factor in the expression of congratulations and in accompanying good wishes for happiness and longevity. Its selection in this connection was not determined by the natural characteristics of the little marauder, but like all Taoist emblems, which express an abstract idea in concrete form, it was derived from a homophane. Hence notwithstanding that the Chinese character for " bat " and " happiness " are quite different, they are both pronounced *fu*, for which reason the bat, quite consistently, became the symbol of happiness; and since longevity is regarded by the Chinese as an essential of happiness, the bat, which, moreover, is believed to live to a great age, was endowed with this additional symbolic significance.

[1] *Pointers and Clues to Chinese and Japanese Art*, W. H. Edmunds, p. 498.
[2] Doré, *Chinese Superstitions*, Vol. IV, p. 326 ; compare W. H. Edmunds, *Duodenary Cycle*.
[3] See p. 116.

Often the bat is used in combination with other symbols of longevity, (see PLATE LXXIX), such as : the *Shou*, signifying " old age " or the " years of a long and prosperous life " ; the *t'ao*, also called *pao-t'ao*, " fabulous peach," which is said to bestow upon those who eat it three thousand additional years of existence ; the *wan szu*, the *swastika*, a symbol significant of " the heart of Buddha," or of his great and abiding love : worshipped by the Lotus School, but used as a longevity symbol by the Taoists long before the introduction of Buddhism into China.

The bat is also associated with the cloud motive, a combination signifying " May your longevity and happiness be as great as heaven is high." The decorative end papers of this book are actually enlarged photographs taken from a specimen of jade illustrated in PLATE CXXX, which admirably depicts the uses by the Jade carver of this combination. Another, and one of the most popular applications of the bat motive occurs in the design known as the *Wu-fu*, " Five Bats," emblematic of the five blessings : virtue, riches, offspring, long life and a peaceful death.[1] The bat[2] is also called the fairy rat (*Sien-chu*), the flying mouse (*Fei-shu*), the Heavenly rat (*t'ien shu*) and the night swallow (*Yeh yen*).[3] The bat motive is rarely found in jade carvings prior to the T'ang Dynasty,[4] but it frequently occurs in examples of the art of later periods, often in conjunction with the pine trees and stag, and in cloud formations.

THE BUTTERFLY.

The Butterfly (*hu tieh*) would seem to be of Teutonic origin, being introduced into the Arts of the Chinese during the Han Dynasty. Mythology records it to have been a symbol inspired by Chang Chow[5] and later connects it with Kiu-Ko the Taoist sage.

Ancient Chinese writings refer to the butterfly as representing an ancestor, suggesting that it embodied the spirit of the departed person. This idea was most likely inspired by the metamorphosis of the butterfly from the caterpillar, and may account for its being first represented in jade as a burial carving. Dr. Laufer[6] refers to a carving of this type being excavated from the grave mound of the Emperor Ts'in Shih. It would appear therefore that the butterfly, like the earlier creature representations, gradually evolved from a burial type into a charm and thence into a symbol.

[1] Miss Katherine M. Ball's *Decorative Motives of Oriental Art*, published by Dodd Mead & Co., N.Y., and John Lane, London, 1927, p. 257, from which comprehensive and valuable book a number of interesting details relating to the folklore connected with certain of the animals referred to in this chapter have been extracted. Miss Ball's work is one that deserves a place in the library of every student of Oriental Art.

[2] See the Pên Ts'ao or Chinese Herbal for description of Bat.

[3] Williams, *Dictionary of the Chinese Language*, " Pien-puh-tze."

[4] Laufer, *Archaic Jades in the Bahr Collection*, Plate XXXIV, No. 2, where he portrays an implement of dark brown glossy stone with Bat Motive, which he considers to be of the Han Dynasty. Another specimen accredited to the Han Dynasty is in the Collection of Mrs. C. Holmes and was exhibited in the Chinese Exhibition 1929, Berlin. See specimen, No. 214.

[5] Edmunds, *Chinese and Japanese Art*, pp. 119 and 103 (Chang Kiu-Ko), Williams, *Chinese Symbolism*, p. 50, Gulland, *Chinese Porcelain*, Vol. I, p. 99, and Ball, *Decorative Motives of Oriental Art*, pp. 260-264.

[6] Laufer, *Jade*, p. 310.

PLATE LXXIX

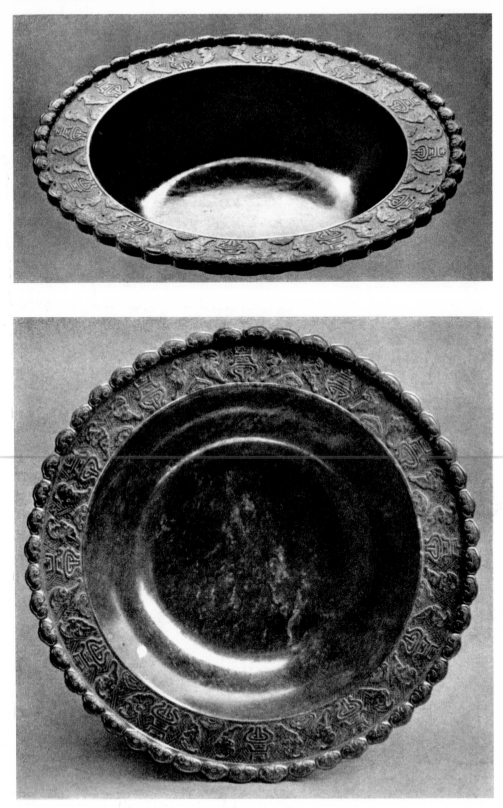

JADE BOWL

The border carved with bats and longevity signs, edged with *Ju-i* heads.

COLOUR : Deep Moss Green. Diam. 40.6 c.m. Depth 10.2 c.m.

Ch'ien Lung Period, A.D. 1736-1795.

(*The Property of an American Collector.*)

PLATE LXXX

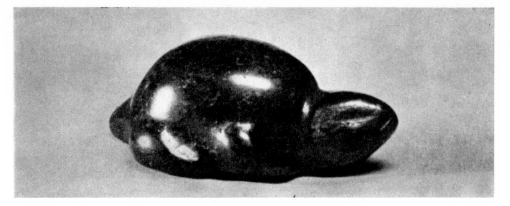

A JADE TORTOISE

COLOUR : Black, slightly speckled bright Green. L. 9 c.m. H. 3.4 c.m.

T'ang Dynasty, A.D. 618-906.

(In the Collection of A. W. Bahr, Esq.)

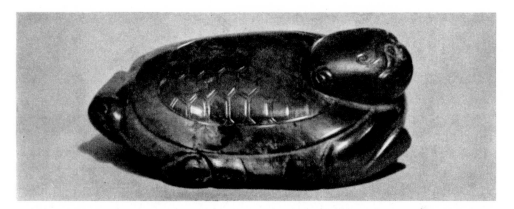

A "WEATHERED" JADE (HAN JADE) TORTOISE OR TURTLE

COLOUR : Green, Brown and Black. Ming Dynasty, A.D. 1368-1644. L. 12 c.m. H. 3.7 c.m.

(In the Collection of the Hon. H. Asquith.)

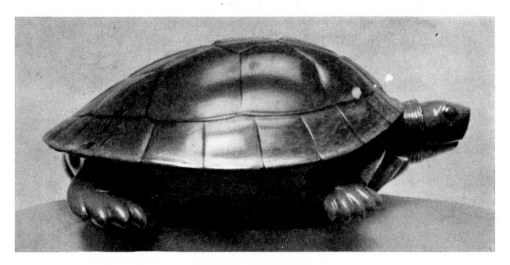

A JADE TORTOISE

One of the five largest specimens of carved Jade in European possession.

COLOUR : Pale Grey Green. Ming Dynasty, A.D. 1368-1644. L. 52 c.m. H. 22.5 c.m.

(British Museum.)

The representation of it in pairs is symbolical of conjugal felicity ; in which sense it is introduced by the carver as a mode of decoration primarily on vessels for use during the marriage ritual.

PLATE LXXXII represents an exceptionally fine specimen of this type in the form of an incense burner, which I am privileged to portray by the permission of H.R.H. The Duke of Kent.

THE TORTOISE (KUEI).

The Tortoise, Dragon, Phœnix and Ch'i-lin are regarded by the Chinese as the Four Supernatural Creatures. The tortoise, shen kuei (" Divine tortoise ") was supposed to have made its first appearance in the waters of the Yellow River during the reign of Huang-ti, 2693 B.C. Reference to this is made by Legge :[1] " Yueh-shang sent to the Emperor Yao (2357-2255 B.C.) the carapace of a large tortoise, upon whose back appeared ancient characters."

Couvreur,[2] Legge,[3] De Groot[4] and Mayers[5] also mention the tortoise and its appearance in early Chinese folklore stories. Finally, it became the River God of the Chinese,[6] and it may well be that the jade tortoise in the British Museum (considered to be one of the five largest pieces of jade sculptural work in European hands) is, in fact, a representation of this river Deity.[7] (See PLATE LXXX.)

In my search through numerous records of existing Jade Collections, both European and Chinese, I have been unable to find any authentic large scale representation of the tortoise earlier than the Han period, and Mr. A. W. Bahr's small nephrite tortoise of the period of the " Spring and Autumn Annals " (see PLATE XX) is practically unique as an early representation of this reptile. It would appear, therefore, that although definitely associated with early Chinese mythology, the tortoise was not regarded as a deity[8] until the time of the Han Dynasty. Dr. Laufer[9] referring to the use of black tortoise-shell, says, " The Emperor, Kao-tsu (A.D. 618-627), of the T'ang Dynasty, was the first to institute regulations for the girdles, and he bestowed girdles of black tortoise-shell on civil officials." During this period many types of girdle ornament, in which the tortoise-shell motive figured, were carved in jade, but, as previously stated, I have not met with any example earlier than the Han Dynasty showing a tortoise in the round.

A jade carving of a tortoise-shell of the Han Dynasty is in Mr. Oscar Raphael's Collection, and an example in the form of a tortoise, in honey colour and brown jade, of the Sung Dynasty, is included in Mr. H. J. Oppenheimer's Collection.

[1] Annals of the Bamboo Books, p. 117, also The Elucidation of Historic Annals.
[2] Chinese Text, Vol. I, p. 393.
[3] Record of Rites, Book IV, Pt. I, No. 11 (Legge's translation, Vol. I, p. 298).
[4] The Religious System of China, Vol. I, p. 53 ; Vol. III, p. 1147.
[5] Chinese Readers Manual, p. 94.
[6] Giles, Chinese Biographical Dictionary, p. 439.
[7] This specimen in the British Museum was discovered at the bottom of a tank in India. It is therefore possible it may not be of Chinese origin, although this would appear extremely improbable.
[8] The Tortoise is symbolical also of " Lewdness, Profligacy and Lax Morals." See Doré, Chinese Superstitions, Vol. V, p. 662, and Vol. VI, p. 183. Note 2.
[9] Jade, p. 286.

De Groot[1] tells us that the custom of erecting tortoise-shaped pedestals[2] began in the time of the Sui Dynasty (A.D. 590-620)—" . . . a tablet then raised for a high officer must stand on the back of a large stone tortoise." Notwithstanding this, jade representations of the tortoise from the Sui and even from the Ming period are extremely rare. The tortoise appeared in jade carvings of the Ch'ing Dynasty and several excellent examples, carved in various types of nephrite, were executed during the Ch'ien Lung and Tao Kuang periods.

THE SERPENT OR SNAKE (*SHA*).

The five poisonous creatures of China are the viper, centipede, scorpion, toad and spider. Together, they are considered to possess the power to counteract all pernicious influences. Doolittle tells us[3] that in South China images of these five animals are made, and worshipped, in the belief that these charms will protect from all pernicious influences.

According to the Oriental Zodiac the serpent is entirely distinct from the dragon, though it is believed that, like the dragon, the snake has the power of metamorphosis, and thereby produces droughts and floods.

To quote Fu Huan of the Chin Dynasty : " The potency of the divine serpent is beyond comprehension, it can fly in the sky without wings, it can swim in the sea without fins, it can walk in the sky without wings, it can walk on the earth without feet, it dwells in the air in happiness and self-sufficiency. In due time it evolves a flaming pearl whereupon it becomes transformed into a dragon."

The snake figures quite extensively as a symbolic ornament for the debased *Maha-Tantra* system of Tibetan Buddhism,[4] but it is rarely found in this form in China.

We are further informed that the religious mind of China has never made a scientific distinction between the snake and dragon.[5]

In South China, especially in Canton, sacred serpents reside in many temples. When sacrifices are offered, the serpent crawls out of its hole, drinks the wine and devours the eggs placed on the altar, without being deterred by the sight of the persons standing by. After finishing its meal the creature silently glides away.[6]

From numerous mythological references to the serpent it would seem certain that this creature has been revered by the Chinese from the commencement, almost, of their empire.

We find the serpent used as a mode of decoration both in the bronzes[7] and jade carvings of the Chou Dynasty. Dr. Laufer illustrates a

[1] *Religious System of China*, Vol. III, p. 1140.
[2] See specimen depicting this type in the Collection of Mr. F. Schiller, *Chinesische Kunst*, 1929, No. 368.
[3] *Social Life of China*, Vol. II, p. 316.
[4] Ball, *Decorative Motives of Oriental Art*, p. 178.
[5] Dennys, *The Folk Lore of China*, p. 107.
[6] *Ibid*, p. 105.
[7] *Chinese Exhibition Catalogue*, London, No. 105.

PLATE LXXXI

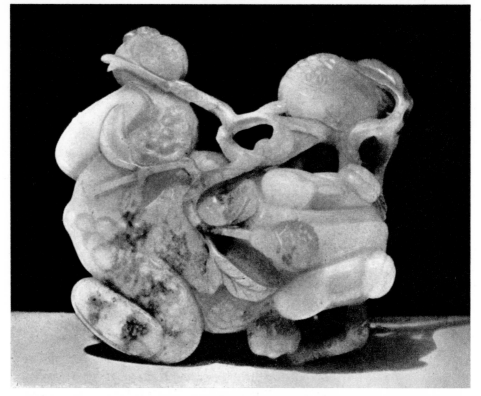

TOP SIDE

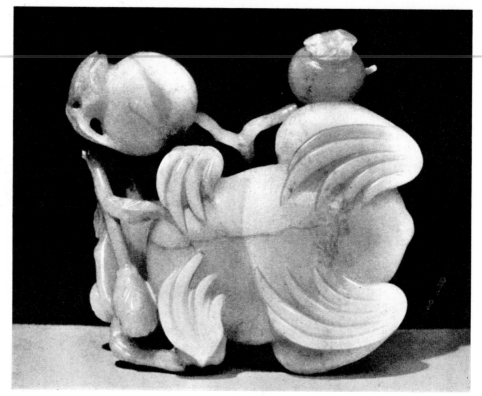

UNDERSIDE

A JADE TOAD

COLOUR : White with underlying Grey Green tone, splashed Russet Brown markings.
Mid-Ming Period, circa A.D. 1500.　　　　　　　　　L. 11.3 c.m.　W. 11.6 c.m.
(Formerly in a Private Chinese Collection.)

PLATE LXXXII

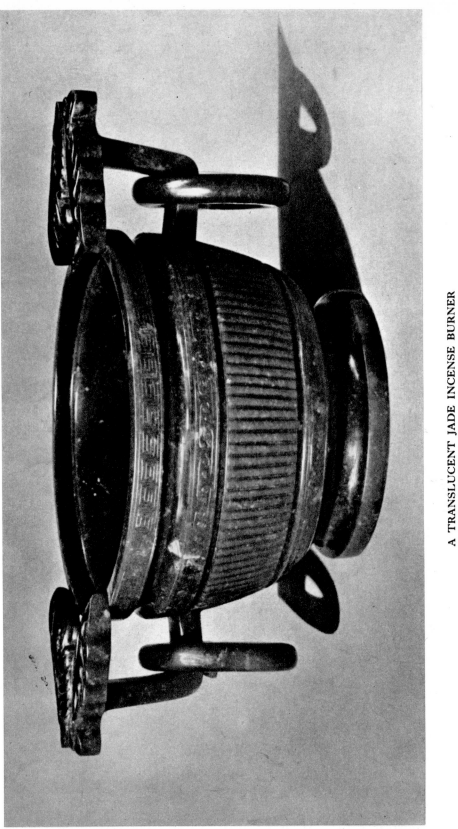

A TRANSLUCENT JADE INCENSE BURNER

Two loose ring handles supported by butterfly carvings, the body of the bowl decorated with key fret, cloud and ribbed design.

Early Ch'ing Dynasty, *circa* A.D. 1650.　　H. 8.6 c.m.　W. 18.9 c.m.　Dia. 11.2 c.m.

(In the Collection of H.R.H. the Duke of Kent, and included by His Royal Highness' permission.)

COLOUR: Mottled Sage Green.

specimen[1] which he considers to be of the Han Dynasty, and it would seem that these types were charms, made to safeguard their owners against the bite of the reptile itself (see PLATE IX). After the Sung Dynasty individual carvings of the snake in jade do not appear to have been numerous. In an extensive search in jade collections known to me for representations made during the Ming and early Ch'ing Dynasties, I have not met with a single example. During the Ch'ien Lung and later periods the snake was again a popular subject with the jade carver. But even of these there are few to be found in private collections.

THE TOAD AND FROG.

There is a reptile in Chinese mythology called *Ha ma* which appears in the bronzes of the Chou Dynasty[2] and in the bas-reliefs of Shrines of the Han Dynasty. The jade carvers of the Chou Dynasty also represent a similar reptile in their works, and judging from the grain-like pattern covering the forms, they would seem to have been attempting to portray the Toad. The earliest references to the Toad in Chinese literature connect it with the Moon, and suggests an association with the curious markings visible on the Moon's face which, without undue imagination, may be considered to bear some resemblance to this creature's general form. It will be recalled that the Toad in mythology is associated with the Moon. Miss Ball recounts[3] the legend of the transformation of Ch'ang-o into a three-legged toad (*chou chu*) as punishment for her wrongful appropriation of the " dew of immortality" given to her husband, Hou I, by Hsi Wang Mu, as a reward for skilful archery. *The Shoo King* or *Historical Classic*[4] illustrates a set of symbols (*The Twelve Chang*) one of which portrays the Moon (*Yueh*) as a disc supported on clouds, bearing upon its surface the figures of a hare, a three-legged toad and a cassia tree.

Dr. Bushell[5] tells us that the toad was the legendary messenger of Liu Han (a minister of State in the 10th century A.D.). Williams records that the reptile served as the steed of Chang Kuo-Lao[6] (one of the Eight Immortals).

Doolittle[7] says that the toad was included in a powerful Charm believed by the Chinese to protect its owner from all pernicious influences.

After carefully reviewing the records of various reptiles in early Chinese scripts, I have been impressed by the absence of any reference to the frog in European writings while this reptile is not even referred to as connected with Chinese folklore before the Han Dynasty. It is therefore significant that the jade carvers from the earliest time up to that period created images of a reptile called, by the Chinese, *Ha ma*,

1 *Archaic Jades in the Bahr Collection*, Plate VII, No. 1, p. 20.
2 Laufer, *Jade*, p. 128 and Plate XVI.
3 *Decorative Motives of Oriental Art*, p. 179.
4 Translated by Legge, V, iii. *The Shoo King*, p. 80.
5 *Oriental Ceramic Art*, p. 583.
6 *Outlines of Chinese Symbolism and Art Motives*, p. 399.
7 *Social Life of the Chinese*, Vol. II, p. 316.

the form of which suggests a toad. Edmunds,[1] refers to the *Frog* as an emblem used during the T'ang Dynasty, but I am of the opinion that it is not until the Sung Dynasty that any definite representation of the frog in jade makes an appearance. During the Ming Dynasty it is found along with the toad in landscape relief-carvings, and it also appears associated with various deities in other carvings.

PLATE LXXXI shows a toad, portrayed in an imposing life-like manner, obviously inspired by the living reptile.[2] The carver has also embodied the symbolical *Ling Chih* (" *Branch of the Soul* "), which is represented growing out of the reptile's mouth. This figure has clearly no relation to the archaic *Ha ma* or to the mythological three-legged toad, *Chou Chu*. This life-like portrayal of animals in jade began as far back as the Han Dynasty, reaching perfection during the Sung Dynasty, and declining by the close of the Yuan Dynasty. With the Ming Dynasty this form of representation reappears, reaching perfection by the middle of the period and disappearing at its close. During the Ch'ing Dynasty several artists attempted to revive the old tradition, but the result is merely a lifeless form, devoid of movement.

[1] *Chinese and Japanese Art*, p. 133.
[2] Another Jade carving representing the Toad of the Ming Period is in the Collection of H. Hardt, Esq., Berlin. See *Chinesische Kunst*, No. 785.

BIRDS, FISH AND INSECTS IN JADE.

BIRD forms occur in Chinese Art as far back as the Shang Yin Dynasty, but their first appearance in jade was not until the Chou period. We know that symbols of felicity were extensively used in ancient China. Thus " dragons produced rain and fertility ; stags bestowed old age ; ducks and the phœnix prompted conjugal fidelity and love ; cranes lengthened life and gave happiness ; tortoises endowed man with longevity, and bats furthered his felicity. Unicorns heralded the advent of wise and excellent rulers ; coins and pears produced wealth and pecuniary profit ; rice, peas, and wheat secured numerous off-spring."[1]

If we bear in mind that religion in China is not an effort to apprehend the Infinite, and thereby to love and enjoy it, but is rather a belief that " The Isles of the Genii or Western Paradise " exist principally for man's sake, and that man having made his Gods, the Gods must therefore be subservient to all his needs and purposes, we shall find the numerous forms and devices used in ancient China more intelligible.

The art of the jade artist under the Chou Dynasty is generally impersonal, ritualistic and sacrosanct, bearing little or no trace of realism ; it can, however, be divided into two classes—the one following the conventional patterns of the bronze-founders, and the other freely and independently producing naturalistic types of animals, birds, fishes and insects.[3]

FÊNG-HUANG

(MISCALLED THE CHINESE PHŒNIX)

The *Fêng-Huang*, a divine bird, the product of the Sun, the great *Yang* principle, is an omen of prosperity and harmony. The terms *Fêng* (male) and *Huang* (female) combined together explain the derivation of its name.[2]

According to the oldest known Chinese writings[4] the first mention of this bird occurs in the reign of Huang-ti (2697-2597 B.C.). It is described by Williams, Mayers[5] and Giles,[6] as a fabulous bird of good omen, resembling the Argus pheasant, embellished and exaggerated— a bird somewhat similar to the Indian peacock. Doré in his references to it[7] says : " Among the three hundred and sixty kinds of the feathery tribe, the *Fêng-Huang* is the King of all. It has a hen's head, the eye

[1] De Groot, *Symbols of Felicity*, Vol. VI, p. 1032.

[2] Compare Laufer, *Archaic Jades in the Bahr Collection*, p. 11.

[3] For further references to the *Fêng-Huang*, see *Shoo King* (Legge, *Chinese Classics*, p. 494), Book II, Ode VIII, Vols. VII and IX). Also compare the *Simorg*, the Phœnix of Islamic Legend. See particularly the celebrated Persian poem, the " Mantic-Uttair " (" The Parliament of Birds ") by Farid-Uddin Attar (1119-1229) ; published by Garcin de Tassy, 1857.

[4] Legge, *Annals of the Bamboo Books*, Chapter IV, p. 104 ; and *Confucian Analects*, Lun-yu, Book IX, para. 8.

[5] Mayers, *Chinese Readers Manual*, pp. 27 and 41.

[6] Giles, *Adversaria Sinica*, No. I, p. 9.

[7] Doré, *Researches into Chinese Superstitions*, Vol. V, p. 670.

of a man, the neck of a serpent, a locust's viscera, a swallow's brow."
Its tail, similar to that of a fish, is composed of twelve or thirteen feathers.

FIG. 51 illustrates a charm in the form of the *Fêng-Huang* (from the *Ku yü t'u p'u*) which is undoubtedly of the Han Dynasty.

FIG. 52 shows a *Fêng-Huang* charm or girdle ornament (from the *Ku yü t'u p'u*) probably not earlier than the T'ang Dynasty. It is possibly an Imperial Charm of the Empress, corresponding to the Dragon Charm of the Emperor.

The use of the *Fêng-Huang* motive in jade dates back to the Shang Yin period and examples occur on the girdle ornaments of the Chou and Han Dynasties.

FIG. 51

Just as the Dragon became associated with the Emperor, so the *Fêng-Huang* (phœnix) became associated with the Empress. The device figures in ear-rings, head-dresses and brocades of the Empress and Princesses of the Royal blood.

On account of its mythological importance it is not surprising to find that the jade worker often employed both the male and the female forms, and this was especially so during the Han and T'ang periods.

In the early Ming period the carver, influenced probably by the ceramic artist, again began to produce more life-like effects; although

FIG. 52

the work is still somewhat grotesque in character. An improvement both in the style of portrayal and in the technique of execution becomes apparent at the commencement of the 16th century, followed by a return to primitive characterisation at the close of the Ming Dynasty.

At the commencement of the Ch'ing Dynasty, the carver introduced once again into his work a subtle life-like character, and by the latter part of the K'ang Hsi period the *Fêng-Huang* device is well represented in many pieces—usually among clouds, or alighting on trees of the " sterculia " type.

In the Ch'ien Lung period the carver utilised to the full the mythological importance of this bird, portraying it in a group type of carving, with Kuan Yin and other immortals.

In the Tao Kuang period, and in the present century, the jade carver has abandoned the exclusive, characteristic style of his ancestors, and it was during these times that most of the pairs of *Fêng-Huang* statuettes, met with to-day, were produced.

There are still in existence examples from all periods which show characteristics in technique corresponding to the dates of their production.

PLATE LXXXIII

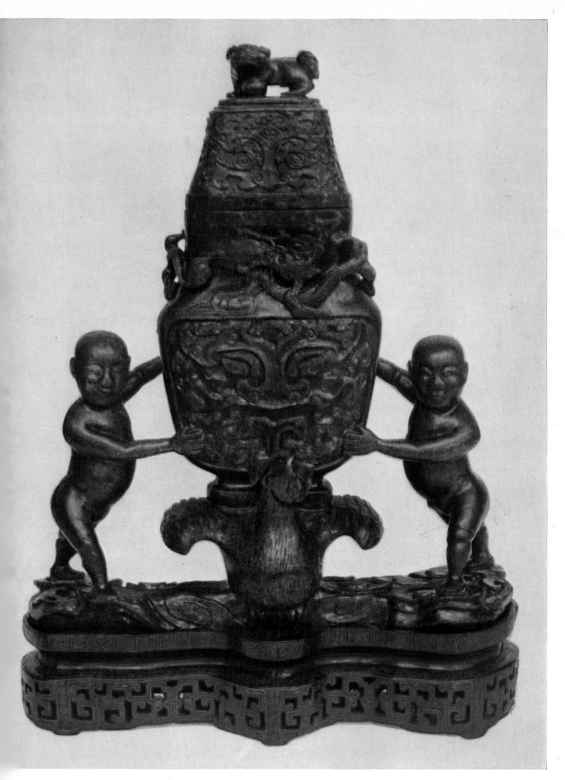

MASSIVE JADE CARVING OF A VASE SUPPORTED BY TWO BOYS AND A *FENG HUANG*.
.OUR : Dark Green. Ch'ien Lung Period, A.D. 1736-1795. H. 42.5 c.m. W. 35 c.m.
(In the Collection of Sir Bernard Eckstein, Bart.)

PLATE LXXXIV

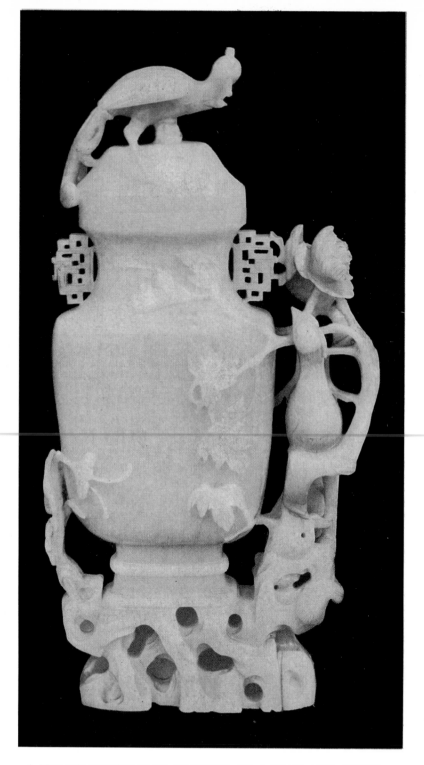

A TRANSLUCENT JADE CARVING OF A VASE AND COVER
Displaying Phœnix and flowering Prunus.
COLOUR: White. H. 32.7 c.m. W. 16 c.m.
Early Ch'ien Lung Period, *circa* A.D. 1740.
(Formerly in the Collection of Commander R. E. Gore, R.N.)

PLATE LXXXV

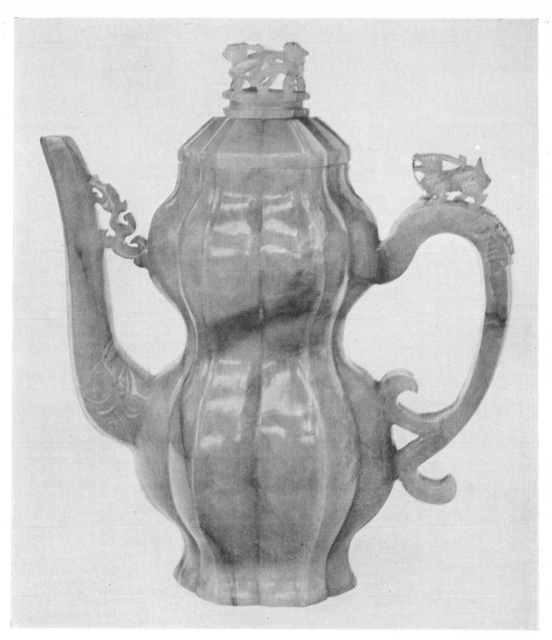

A GOURD-SHAPED WINE VESSEL IN TRANSLUCENT NEPHRITE

COLOUR : Grey Green, splashed Brown. Early Ming Dynasty, *circa* A.D. 1460. H. 21.8 c.m. W. 19 c.m.
(In the Collection of Frank H. Fulford, Esq.)

PLATE LXXXVI

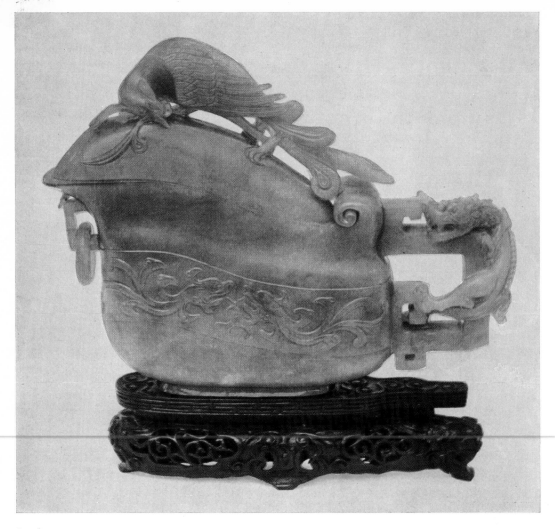

A TRANSLUCENT NEPHRITE LIBATION CUP AND COVER

Carved with Phœnix on cover and Dragon encircling handle. The body is carved with archaic representations of mythological monsters.

Colour : Emerald Green. Ch'ien Lung Period, A.D. 1736-1795. H. 13.8 c.m. W. 17.4 c.m.
(Formerly in the Collection of Sir Alfred Jodrell, Bt.)

An excellent reproduction of a carving of the 19th century, embodying the *Fêng-Huang*, is to be found in Gorer and Blacker's *Chinese Porcelain and Hardstones*.[1]

THE DOVE OR PIGEON.

The Dove or Pigeon has, from time immemorial, figured not only as a model of connubial affection but as a symbol of peace. In China it is known as *Kiu*, in mythology it would appear to be personified by the *Ts'ing Nia*, the azure-winged deity, reputed to be the messenger of *Hsi Wang Mu* (The Royal Mother of the West). W. H. Edmunds[2] records the legend that two of these birds perched upon the shoulders of the Emperor Wu Ti (140-86 B.C.) upon the occasion of the visit of *Hsi Wang Mu* to the Emperor during the Han Dynasty.

Miss Ball[3] tells us that during this dynasty the dove became a symbol of longevity, possibly on account of its exceptional digestion, and that its image (in the form of a jade handled staff, see PLATE XXI) was bestowed as a gift on any person attaining the age of eighty years, " to imply a wish that further years might be blessed with like power and consequent good health." Wu Ta Ch'êng[4] in his book illustrates two figures of " doves " (*chiu*), FIGS. 53 and 54, which are obviously staff handles, and which Wu Ta Ch'êng considers to be of the Han Dynasty.[5] He unfortunately omits to describe the colour of these pieces, but their size is recorded as being approximately 5 c.m. and 8 c.m. respectively. Another interesting specimen of this type of carving, in the possession of Mrs. C. Holmes, is recorded in the German Chinese Exhibition Catalogue.[6]

FIG. 53. FIG. 54.

Dr. Bushell[7] tells us that " Dove Chariot Vases " (*chiu ch'ê tsun*) made their first appearance in bronze during the Han Dynasty for use on the altar during the ceremonial of the ancestral ritual.[8] Thus from the early Chou pendants of pigeon-form, fashioned alike in jade and bronze, was gradually evolved a miniature dove-form of great beauty.

[1] Plate 241.
[2] *Chinese and Japanese Art*, p. 175.
[3] *Decorative Motives of Oriental Art*, p. 254.
[4] *Ku yü t'u k'ao*.
[5] Compare Pope-Hennessy, *Jade*, p. 114.
[6] *Ausstellung Chinesischer Kunst*, 1929, No. 230.
[7] *Chinese Art*, Vol. I, p. 83.
[8] Compare Pope-Hennessy, *Jade*, p. 113.

PLATE LXXXVII

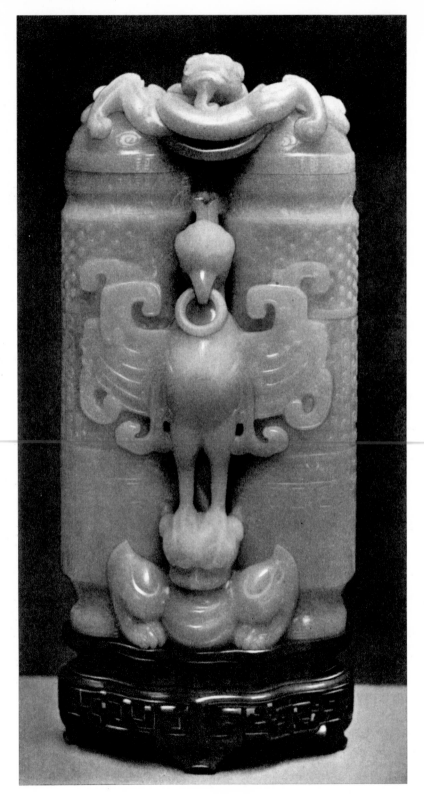

**A TRANSLUCENT JADEITE HONORIFIC VASE OF TWIN
CYLINDER FORM**

Decorated with Dragon, Phœnix, and Mythical monster.
Colour : White. H. 24.5 c.m. W. 13 c.m.
Ch'ien Lung Period, A.D. 1736-1795.
(*In the Salting Collection, Victoria and Albert Museum.*)

PLATE LXXXVIII

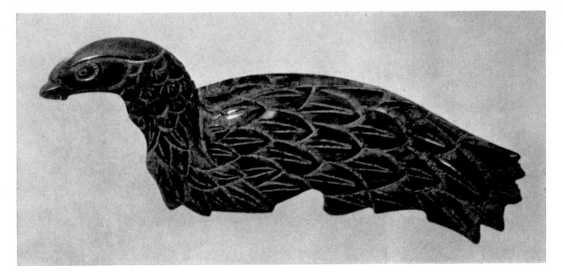

A JADE PHŒNIX
With pronounced red pigment.

COLOUR : Dark Brown. T'ang Dynasty, A.D. 618-906. L. 10 c.m.
(*In the Eumorfopoulos Collection, British Museum.*)

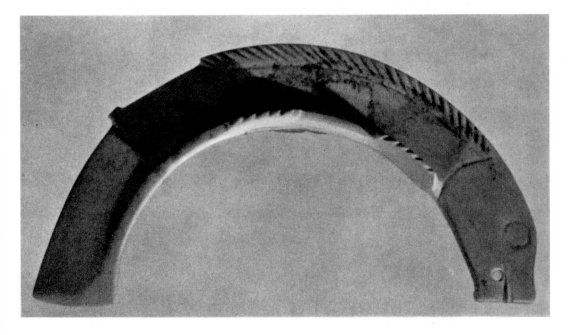

A JADE CARVING IN THE FORM OF A FISH-PENDANT

COLOUR : Grey Green. Period of the Spring and Autumn Annals, 722-481 B.C. H. 8.3 c.m.
(*In the Collection of H.R.H. The Crown Prince of Sweden, and included
by His Royal Highness' permission.*)

The naturalistic form persisted and gradually became characteristic of the Han, T'ang, and Sung Dynasties. See PLATE LXXVIII, where two interesting specimens 1 and 3 in the Collection of Mr. Chang Nai-Chi are portrayed, these show the development of form in carving from the Chou period to the Han period in a most convincing manner.

An important collection of birds carved in jade is in the possession of Mr. A. W. Bahr, by whom I have been privileged to examine and compare the various types and designs.

By the time of the Ming Dynasty a different style of portraying birds came into being : this type, which has a mythological character, persists to the present day. During the Ch'ien Lung period many copies of the earlier designs were made, but in no instance has the carver employed the same type of nephrite and jadeite which was used in the earlier works, though it must be admitted that in some cases detection is difficult prior to chemical analysis.

THE CROW AND HERON.

One of the most notable examples of the persistence, through the centuries of the ancient Chinese principle, the *Yang* and *Yin*, is the symbolic union of the crow and the white heron. These two birds, on account of their extreme dissimilarity in appearance and characteristics, lend themselves admirably, not only as emblems of this ever dominating principle of opposites (such as day and night, light and dark, good and evil) but as artistic units of contrast for decorative compositions.[1]

The Crow, being connected with the sun,[2] according to the astrology of the Chinese definitely represents the Yang principle, which is that of *light* or of *good*. *Yü Hwa* (the three legged crow) according to the Chinese myth is a resident of the Sun. Huai Nan-tzu, in the 2nd century B.C., tells us that the crow has three legs because the number three is the emblem of the *Yang*, and that the crow resides in the sun because that orb is the supreme essence of the *Yang* principle.[3]

The Crow is represented in the *Twelve Chang* or " Ornaments," with which the Sacrificial Robes were embroidered (see FIG. 63, p. 117). These ornaments are referred to in the earliest of Chinese Classics,[4] where we read that the Emperor Shun desired " to see these emblematic figures of the Ancients."[5]

In the official *History of the Wei Dynasty* (3rd century B.C.) we read : " More than thirty times, tributes, consisting of three legged crows, were brought from the neighbouring countries."

I have not been able to find any representation of the Crow in jade, which could be dated earlier than the Han Dynasty, though it is possible that figures in jade of this bird may have been made

[1] Compare Ball, *Decorative Motives of Oriental Art*, p. 241.
[2] Edmunds, *Chinese and Japanese Art*, p. 317.
[3] Compare Bushell, *Oriental Ceramic Art*, p. 109.
[4] *The Chinese Classics*, translated by Dr. Legge, V, iii ; *The Shoo King*, p. 80.
[5] See page 116 of this book, and *Wen-hsien t'ung-kao*, by Tuan-Lin.

PLATE LXXXIX

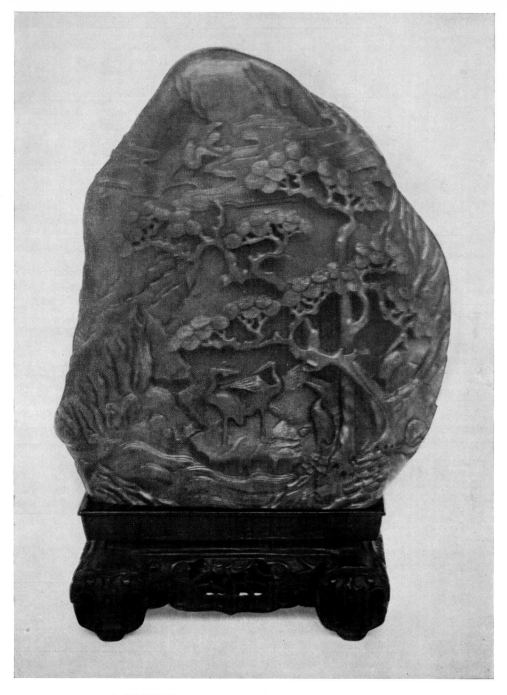

A NATURAL BOULDER CARVING IN NEPHRITE

Depicting *P'eng Lai Shan*, one of the three Fortunate Islands of the genii, also portraying
Sü She in boat crossing the sea to visit the Rock of Jade which fountains the wine
of Immortality.

COLOUR : Sage Green. Ch'ien Lung Period, A.D. 1736-1795. H. 24.6 c.m. W. 20.6 c.m.
(*Formerly in the Collection of Commander R. E. Gore, R.N.*)

under the Chou Dynasty. During the T'ang and Sung Dynasties, the crow was used as a motive of decoration, and from that period to the present day has continued as a subject for the jade carver.

THE FALCON AND EAGLE.

The ancient records of China relating to periods as early as 2,000 B.C., contain accounts of falconry (*fang yin*) ; in fact the female species of the hawk family was used by the Chinese as one of their chief agents for obtaining food up to the time of the introduction of the gun. The name of the falcon in Chinese (*Ying*) is derived from a homophone of the word which signifies " heroic."

Falconry was long a favourite recreation of the ruling monarchs of China ; Marco Polo records that Kublai Khan used falcon, eagle and kite when he set out, with no less than seventy thousand men, on his hunting expeditions.

During the Han Dynasty it is most noticeable that the painters gave as much prominence to the falcon as they did to the horse.[1] An excellent example of painting of the Sung Dynasty, executed by the Emperor Hui Tsung, is the famous " White Falcon " now preserved in the British Museum.

It was under the Sung Dynasty that the jade carver utilized the falcon as a subject for his art. These pieces are usually of miniature size and are exquisitely rendered. Outstanding specimens in white or green nephrite are now very rare.

During the Ming and Ch'ing Dynasties we find that an entirely new bird-subject was introduced. This was the Eagle, which appears in group carvings, often associated with the fox, or with a female form, from the belief that the bird is a demon expeller. The female figure which represents a fox transformed is referred to elsewhere in this book. This is but one instance of the gradual change in the basic characteristics of the jade carver's craft which appears to have set in after the Yüan Dynasty.

THE DUCK.

In China the Duck (*yüan yang*) symbolizes connubial affection, mutual consideration, and fidelity. This significance would seem to have been bestowed upon the duck by the Buddhists,[2] by whom it was given the name of Mandarin Duck. As a protection against drowning the Chinese wear an amulet formed in the shape of a duck. This symbol, which is known as the " Sacred Duck," would seem to have been suggested by the following ancient legend : A Mandarin's daughter walking by the Yangtse-Kiang River inadvertently slipped into the water. She sank rapidly and, to the horror of her companions, seemed certain of losing her life. Mysteriously and silently a duck appeared on the surface of the disturbed waters and, diving beneath the sinking body, supported it and guided it to the bank. This wonderful power

[1] Ball, *Decorative Motives of Oriental Art*, p. 213.
[2] Compare Ball, *Decorative Motives of Oriental Art*, p. 233.

PLATE XC

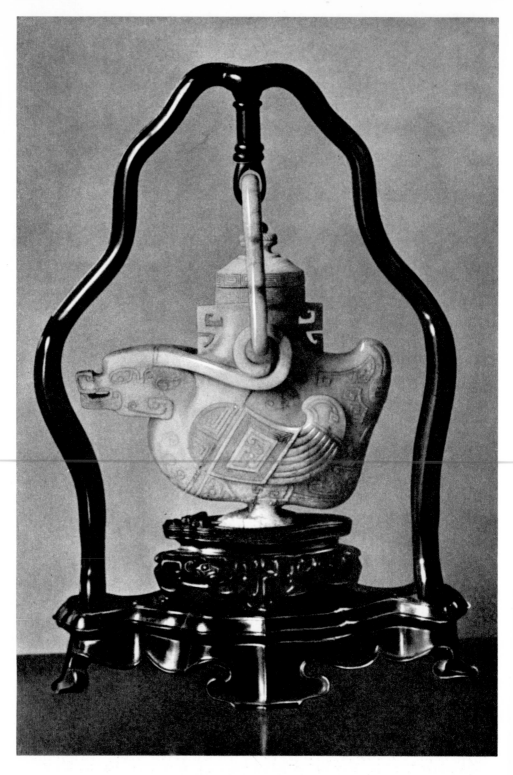

A JADE DUCK INCENSE BURNER

COLOUR : Bone Grey with dark Brown markings.

H. 20 c.m.

Early Ming Period, circa A.D. 1450.

(*In the Collection of Madame Vittoria Modiano, Italy.*)

PLATE XCI

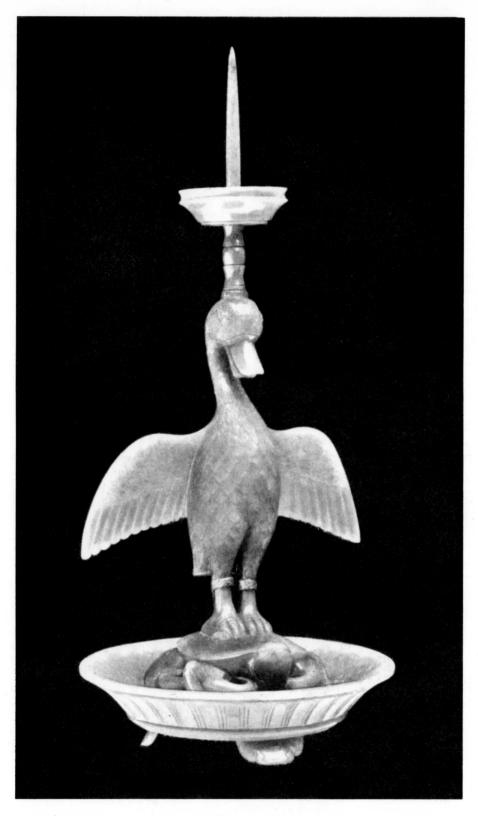

ONE OF A PAIR OF PRICKET CANDLESTICKS IN TRANSLUCENT
NEPHRITE

COLOUR : Grey-Green. Early Ch'ien Lung Period, *circa* A.D. 1750.
Overall height 26.8 c.m. Height to the head of the bird 17.2 c.m.
Diam. of Bowl 12.2 c.m.
(*In the Lady Lever Art Gallery Collection*)

of preservation from the demon of the river, displayed by the duck, gave it, among the fishermen and watermen of China, the reputation of being a great talisman of safety. In mythology we find Prince T'sin, the son of Ling Wang of the Chou Dynasty (571-544 B.C.) associated with the duck.[1]

Dr. Laufer refers to jade specimens of the Mandarin Duck in his collection, but does not ascribe to them any definite date.[2] PLATE LXXIV portrays a carving of this form of the late Ming period. Carvings in jade for girdle ornaments, in the form of a pair of ducks with interlinked necks, adorned with sprigs of Lotus, are explained by the rebus of the word " *hien,*" which means both " Lotus " and " Partnership." Carvings of this type are not of earlier date than the Ming Dynasty, and in the majority of cases date from the latter part of the Ch'ien Lung period up to the present day. During the Chou Dynasty it would seem that the duck was represented in a conventionalized form.[3] An excellent example of this type is shown in PLATE LXXV. The duck as a shape of a statuette does not appear in jade until the Han Dynasty. Examples of these early statuettes are extremely rare. In the form of buckles the duck appeared in the T'ang and Sung periods. During the Ming Dynasty the jade carver used the duck in his craft to form into vessels of various kinds. An important carving of this type, from the Collection of Madame Vittoria Modiano, is shown in PLATE XC.

THE COCK.

The Cock is one of the Solar birds. It is the emblem of the Sun and of the South, because every morning it loudly announces the arrival of the Day God. As a deity its residence is in the Sun.[4] *The Classic of Hills and Rivers* tells us that the " Mountain Cock " is found in the Siao-hwa Hills.[5] From prehistoric times the Chinese have attached great significance to the cock, for we find it included in the duodenary cycle. The astrologers consider it to be in opposition to the dog. It is one of the potent symbols of the *Yang* principle.[6]

The homophone of *Chi*, derived from that word's double meaning " cock " and " fortunate," has made of the cock a charm for " luck." Mythology connects this bird with the following deities : Liu Ngan ; Chao-chin Tao-shih ; Hiang Tsi and Chuh Chih Ung.[7] The Cock does not appear to have been used as a subject by the jade carver until after the Han Dynasty, notwithstanding that specimens occur in the other Arts of China prior to this time.[8]

[1] Edmunds, *Chinese and Japanese Art*, p. 202.
[2] Laufer, *Jade*, p. 243.
[3] Laufer, *Archaic Jades in the Bahr Collection.*
[4] De Groot, *The Religious System of China*, Vol. I, p. 200.
[5] Compare Doré, *Chinese Superstitions*, Vol. V, p. 707.
[6] Compare Ball, *Decorative Motives of Oriental Art*, p. 225.
[7] For the stories connected with these deities see Edmunds, *Chinese and Japanese Art*, pp. 150, 316, 125, 116.
[8] *Chinese Exhibition Catalogue*, London, 1935-36, Nos. 276 and 444, where we find a bird resembling the cock carved in stone, of the Chou Dynasty, and a similar bird in bronze, of the period of the Six Dynasties.

During the Early Ming Dynasty jade carvers used the cock-motive in a decorative form, and from Late Ming onwards it was employed as a subject for group carvings associated with the deities of whom it was the emblem. An example of this type is shown in PLATE CXLVII.

THE CARP (*LI-YU*) AND OTHER FISH.

The Carp is the fabled King of Fish and is held to be able to turn into a dragon at pleasure.[1] Chinese tradition concerning the carp relates that it was a native of Huang Ho, the Yellow River, and each year in the third month, in order to reach the head waters of the stream to spawn, it had to leap the *Wu-Mên* cataract[2] and swim the rapids of *Lung Mên*, an achievement which was so greatly admired by the Chinese that they chose this fish as a symbol of vigour, endurance, perseverance and power ; and for centuries have held it up as an example for emulation for their youths.[3] " They taught their boys that the carp which succeeded in leaping the waterfall and making the ascent of the river became a dragon, and strongly impressed upon them the idea that as this fish overcomes all the obstacles of the river, so they must surmount all the difficulties and trials of life if they would become the human dragon."[4] Compare fable in the *Records of Western Travels*[5] which says, " The father of T'ang-seng was resuscitated by Tung-Wang, whom he had previously set free as a Carp in the Yellow River."

The fish motive is symbolically employed as the emblem of wealth or abundance on account of the similarity in pronunciation between the Chinese words *yu* (fish) and *yu* (superfluity)

Owing to its reproductive powers the fish was regarded as a symbol of regeneration. A brace of fish among the presents to a bride elect was deemed a happy augury and emblematic of the joys of union.

A fish is one of the charms included among the auspicious signs in the footprints of Buddha. *Mu yu*[6] " wooden fish "—silent, yet wakeful and watchful[7]—occupy a prominent place in Buddhist temples and sacred carp are found in most Buddhist monasteries.[8]

Jade fish are found in tombs from the earliest times. One of the earliest representations of a fish in jade is in the form of a *huang*, and is described in the *Ku yü t'u p'u* as of white jade, with a " Yellow Mist," and, according to the commentator it is undoubtedly of the Chou Dynasty. An excellent example in the Collection of H.R.H. The Crown Prince of Sweden, is illustrated in PLATE LXXXVIII. It would appear that the *huang* in this form, placed at the feet of the corpse upon

[1] Compare Mayers, *Chinese Reader's Manual*, p. 142, and *Chinese Superstitions*, Vol. V, p. 677, Note 1.
[2] Compare Doré, *Chinese Superstitions*, Vol. V, p. 694.
[3] A recondite allusion (" *Li-yu t'aio-lung-men* "), " *Leaping the Dragon's Gate* "—" *Rapid promotion in getting degrees.*"
[4] K. M. Ball, *Decorative Motives of Oriental Art*, p. 189.
[5] Wylie, *Notes on Chinese Literature*, p. 202 ; Giles, *Chinese Biographical Dictionary*, p. 313.
[6] Compare Doré, *Chinese Superstitions*, Vol. V, p. 554.
[7] Compare Paul Carus, " The fish as a mystic Symbol in China and Japan," " Open Court," July, 1911, and Doré, *Chinese Superstitions*, Vol. V, p. 554.
[8] *Der Ursprung des christlichen Fischsymbols*, p. 24.

PLATE XCII

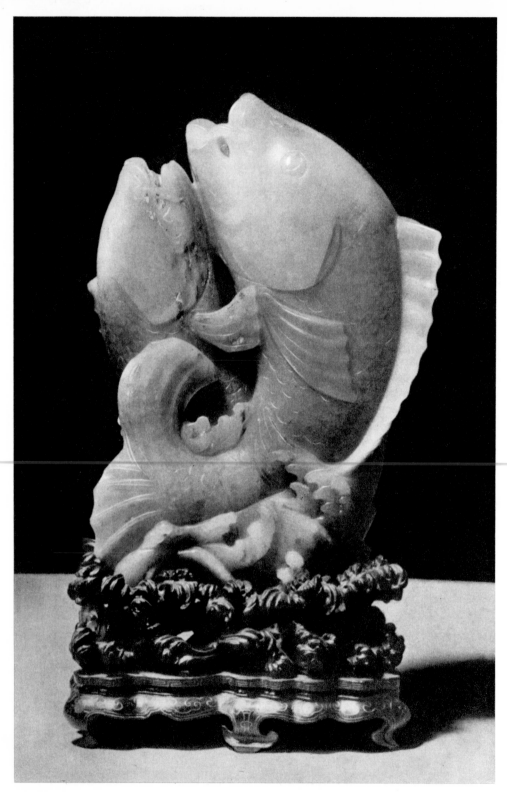

THE TWIN FISH IN NEPHRITE
With weathered markings.
COLOUR: White. Ch'ien Lung Period, A.D. 1736-1795. H. 17.1 c.m. W. 11.5 c.m.
(Formerly in the Charles Jewel Collection.)

PLATE XCIII

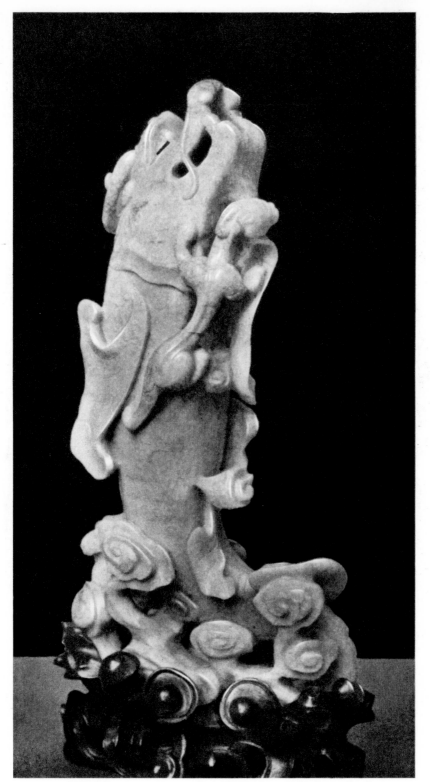

A JADE DRAGON-HEADED FISH
With small archaic newt-like form of Dragon carved in bold relief.
COLOUR : Pale Grey. Ch'ien Lung Period, A.D. 1736-1795. H. 20.9 c.m.
(In the John Yates Collection, Manchester Art Gallery.)

burial, suggested abundance and prosperity in the next world.[1] The pair of fish (*Yu*) are represented in the Eight Buddhist Emblems (*pa Chi hsiang*), and were considered to be one of the " Signs of the sole of Buddha's foot."

The twin fish portrayed in the Buddhist emblems is often found on Han bronzes, and represents happy wedded bliss. In jade carvings they were first portrayed on girdle ornaments during the Chou period.[2] Several such ornaments are mentioned in the *Ku yü t'u p'u*.

FIG. 55

FIG. 56

FIG. 55 depicts a pair of fish in green Jade forming a *Küeh* (from the *Ku yü t'u p'u*) dated therein as A.D. 3rd or 4th century, but probably of the Western Han Dynasty, 206 B.C.-A.D. 25.

FIG. 56 illustrates a pair of fish (from the *Ku yü t'u p'u*) dated therein (A.D. 535-554) but more likely of the Han Dynasty. This example represents probably the *p'ei yü yü*, an investiture symbol worn by the heir-apparent, first introduced during the Ch'in Dynasty (221-206 B.C.).[3]

The fish, during the T'ang Dynasty, became a symbol of power, for we read[4] that in A.D. 618 the Emperor Kao-tsu abolished a badge in the form of a plant and substituted a silver fish (*yin yu fu*). This talisman, in its turn, was abolished by the Empress Wu, who established insignia in the form of a tortoise (*kuei*). The Emperor Chung-tsung, however, restored the fish symbol, which remained in vogue until A.D. 1055 ; by this time the fish badge, or medal, in recognition of dutiful service, had been instituted.[5]

The *History of the Kin Dynasty*[6] records that fish carved in Jade (*P'ei Yü Yü*) were worn by Princes, and a twin fish pendant by the heir-apparent. Chavannes[7] mentions fish purses (*yu tai*) as being bestowed as gifts on Turkish princes.

According to Si king tsa ki (quoted in *P'ei wen yun fu*) we learn that " . . . In the Han Palace, Kun ming ch'ih, a piece of jade was carved into the form of a fish. Whenever there was a thunderstorm accompanied by rain, the fish roared incessantly, moving the while its dorsal fin and tail. At the time of Han they offered sacrifices to this fish with their prayers for rain, which were always fulfilled."

By the end of the Ming period the religious significance of the fish seems to have been forgotten, and under the Ch'ing Dynasty we find the jade carver using the fish as a mere mode of decoration. These

[1] Compare Laufer, p. 172.
[2] There is a pair of fishes in jade (late Chou) in Mr. A. Shoenlight's collection at the Hague.
[3] *History of the Kin Dynasty*.
[4] Laufer, *Jade*, p. 219.
[5] Chavannes, *T'oung Pao*, 1904, pp. 30-38.
[6] Compare Laufer, *Jade*, p. 220.
[7] Chavannes, *l.c.*, pp. 30-32.

fish-images may represent any one of the four following forms : the carp (*li*), the perch (*kuei*), the mackerel (*ch'ing*), or the Japanese *mi koi*, a type of carp (*p'o*). PLATES XCII, XCIII and XCIV portray specimens of these forms, made for the adornment of the Literati's Study, emblematicly exalting achievement of the highest merit.

THE CICADA.

The Cicada (*semi*), is the most conspicuous of a group of insects known as " Instrumentalists " or " Insect Musicians,"[1] by reason of the sounds they produce through the oscillation of certain of their members or the friction of others. In the case of the cicada the sound is caused by vibrating the membrane of a drum-like organ under the abdomen.[2]

" While there are a few varieties of this species which may be termed songsters, they are, nevertheless, very noisy, and their crying, which occurs at the time of high summer,[3] accentuates the suffering imposed by the temperature, a fact voiced in many poems, of which the following is an example :

> The chirrup of the *Semi* aggravates the heat until I wish to cut down the pine tree on which it sings."[4]

I have been unable to trace any direct mention of this insect in the early records of Chinese ritual, and although it is found as part of the decoration on some bronzes of the Shang-Yin Dynasty, it is doubtful if at that time it bore any spiritual significance.

The significance of the cicada as a symbol of life may possibly be traced to Divination ; for, according to the *Yang-chu*, " The Early Diviner received his messages from the Gods by means of Oracles, Dreams, Signs, Omens and Portents conveyed through the medium of the starry heavens, the earth, the air and water, animal, birds, and even insects." This kind of fortune-telling, coeval with the very birth of the Chinese nation,[5] was dealt with in a learned writing by Sun-Kw'ang, a public officer of the State of Chao in the 3rd century B.C. It would seem probable that the cicada, an insect possessing the exceptional gift of making itself heard in a mysterious manner, appealed to the fortune-teller as an admirable means to his end ; for here was a living oracle to substantiate his power of deduction and forecast of the person's future he was supposed to foretell. The cicada of Taoism may be described as the symbol of the *hsien* (soul) disengaging itself from the body at death,[6] the voice of the departed being conveyed to the living through the medium of the insect. Knowing the Chinese to be an extremely superstitious race, it may well be that from this cause the cicada became

[1] Including, in addition to the cicadas, the crickets, locusts, grasshoppers and beetles.
[2] Williams, *The Middle Kingdom*, Vol. I, p. 273.
[3] *Hsia siao ch'ing* and *Li Ki*.
[4] K.M. Ball, *Decorative Motives in Oriental Art*, p. 268, and also compare the *Po Ku T'u* and Williams, *Outlines of Chinese Symbolism* p. 70.
[5] The practice of Divination from remote antiquity : " I will not say 5200 years B.C." (Legge's " Classic of changes," *Sacred Books of the East*, Vol. XVI, Oxford 1882, p. 40.) See also *Li Ki*, Book X, para. 2, No. 17, and Book IV, para. 4, Part I, No. 2, and Book XVIII, para. 1, Part I, No. 12.
[6] Rev. *Arch.*, 1919, XI.

PLATE XCIV

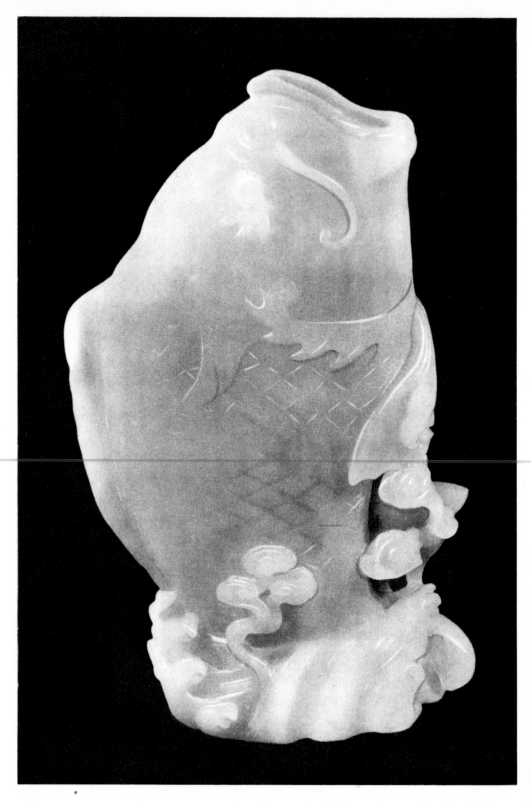

A LEAPING CARP IN TRANSLUCENT JADE

COLOUR : White. Ch'ien Lung Period, A.D. 1736-1795. H. 19.6 c.m.

(*In the Collection of Sir John Buchanan-Jardine, Bt.*)

PLATE XCV

A. B. C.

THREE JADE CARVINGS OF THE *CICADA*

A.—Colour : Translucent White Jadeite. H. 3.8 c.m. W. 1.6 c.m.
Sung Dynasty, A.D. 960-1279.
B.—Colour : White, splashed Brown Nephrite. H. 5 c.m. W. 2.4 c.m.
Sung Dynasty, A.D. 960-1279.
C.—Colour : Translucent Green Nephrite H. 5.5 c.m. W. 2.8 c.m.
Chou Dynasty, 1122-249 B.C.

(In the Collection of A. W. Bahr, Esq.)

D. E. F.

D.—A JADE OX HEAD.
 Colour : Grey, speckled light Green. Chou Dynasty, 1122-249 B.C. H. 4 c.m. W. 3.2 c.m.
E.—A JADE REPRESENTATION OF THE SILK WORM.
 Colour : Light Grey, weathered. Chou Dynasty, 1122-249 B.C. H. 4 c.m. W. 2.1 c.m.
F.—THE TWIN FISH IN TRANSLUCENT NEPHRITE.
 Colour : Mottled pale Green. Chou Dynasty, 1122-249 B.C. H. 4.1 c.m. W. 3.3 c.m.

(In the Collection of A. W. Bahr, Esq.)

associated with life. Its use in the Burial Ritual may possibly be explained by the following quotation from *Lun-Hêng* by Forke.[1] " Prior to its casting off the exuviæ, a cicada is a chrysalis. When it casts off the former it emerges from the pupa state, and is transformed into a cicada. The vital spirit of a dead man leaving the body may be compared to the cicada emerging from the chrysalis."

The fact that carved representations of cicadas and dragons appear on the Bone Antler or Sceptre (reputed to be of the Shang Dynasty) now preserved in the British Museum, suggests that this wand may have been a part of the equipment of the diviner of that period.

The jade images of birds, fish and insects used in the Taoist rites of burial are possibly relics of a period earlier than the Han Dynasty, and in those specimens whose material corresponds with that used by the early Chou Craftsmen, there is good reason to assign them to this earlier period,[2] See PLATE xcv which illustrates an example of the Chou Dynasty from the Collection of Mr. A. W. Bahr. A specimen of the Spring and Autumn Annals in white and green jade (2.6 c.m.) is in the Collection of Mr. and Mrs. E. Sonnenschein, Glencoe, Ill.[3]

THE MANTIS.

The Mantis (whose usual victim was the Cicada) is another predacious insect, which is quite an important figure in the oriental decorative arts, several representations of it being found in carvings out of jade and other valuable stones. It is also known as the " praying mantis " (*t'ang-lang*),[4] so-called from its habit, when still, of extending its forelegs above its head, as if in prayer.

" The mantis is a large insect, sometimes attaining the size of three inches. Its colour is a beautiful green, which the female ever retains. In China it is known both as the *t'ien ma*, " heavenly horse," and the *sha ch'ung*, " insect killer," and was esteemed a courageous warrior on account of its bravery and tactics, qualities which are described in a number of legends,[5] one of which relates that Duke Chuang of Ts'ai of the T'ang Dynasty, while on the way to a hunt, noticed a mantis with uplifted arms trying to stop his chariot. " Ah ! What is this ? " he enquired, to which an attendant replied, " A mantis, an insect which knows how to advance, but not to retreat. Without even measuring its strength, it ever offers resistance." The Duke then said, " Truly, if it were a man it would be a champion here of the Empire." It is this legend[6] which, although of Taoist origin, was appropriated by the Buddhists for their proverb : ' Even the sharp mandibles of the fighting mantis are set at naught by the wheel of fate.' "[7]

There are recorded in the *Ku yü t'u p'u* (chaps. 57 and 58) several Jade buckles, one of which appears to represent " The praying-mantis

[1] Forke, *Lun-Hêng*, Part 1, p. 200.
[2] Compare Pope-Hennessy, *Jade*, p. 125.
[3] *Chinese Exhibition Catalogue* (London), No. 337.
[4] Giles, t'ang (No. 10774) may be character (No 10762).
[5] Giles, *Chuan Tzu, Mystic, Moralist, and Social Reformer*, p. 258, London (1889).
[6] Related by Han Ying in the *Han shih wei chuan*.
[7] K. M. Ball, *Decorative Motives of Oriental Art*, p. 267.

(*mantia religios*) catching the cicada." The mantis here forms the head of the buckle.

The representation in jade of the mantis does not appear to date earlier than from the Han Dynasty, at which period it took a symbolic form, possibly inspired by the *t'en-lu* which Giles explains as a fabulous creature like a deer with one horn.

Jade carvings representing either the Mantis, the Grasshopper or Dragon-Fly do not appear but rarely before the Sung Dynasty. During the Ming Dynasty these insects were much used as a form of decoration, inspired perhaps by the works of the painters of the T'ang and Sung periods. During the Ch'ing Dynasty, however, they were used mostly as decorative symbols.

CHAPTER XIV

DESIGNS EMBODYING SYMBOLICAL EMBLEMS AND CHARACTERS.

JADE carvings throughout the ages have embodied in their decoration various distinct designs derived, directly or indirectly, from ancient ritualistic beliefs or superstitions. These may be divided into five separate classes as follows :—

1. Symbols of ancient Chinese Lore embodying the *Pa kua* and *Yin* and *Yang* : the *Pa Yin* : the *Shih-êrh Chang*, etc.:
2. Buddhist Symbols embodying the *Pa Chi-hsiang* and the *Ch'i Pao*.
3. Taoist Symbols embodying the *Pa An Hsien*.
4. The Hundred Antiques *Po Ku* : embodying the *Ch'in*, *Ch'i*, *Shu*, *Hua* and the *Pa Pao*.
5. Devices portrayed to give a rebus meaning.

SYMBOLS OF ANCIENT CHINESE LORE.

THE *PA KUA* OR EIGHT TRIGRAMS, AND THE *YIN* AND *YANG*.

The *Pa Kua* is probably the earliest of the Chinese motives of decoration, and its origin, as a spiritual emblem, the most ancient. It may, indeed, originate from the reign of Fu Hsi (2953 B.C.). According to the Chinese belief the eight figures forming this emblem, together with the sixty-four combinations to which they are extended, were the basis of an ancient system of philosophy and divination ; of which no manuscript records have been preserved beyond the traditional names of its schools.

An explanation of the diagrams and their philosophical significance is given in the *Yi King*, or Book of Changes,[1] from which the following particulars are extracted :—

(1) Heaven : depicting the male conception

(2) Cloud ; atmospheric phenomena

(3) Light, fire, heat :

(4) Thunder :

(5) Wind :

(6) Water :

(7) Mountains :

(8) Earth, or the female principle :

[1] Mayers, *Chinese Readers Manual*, pp. 333, 353-356 ; Legge's Yi King, *Sacred Books of the East*, Vol. XVI, 1882 ; and Legge, *The Great Plan*, p. 321.

107

The diagrams are fully described in the writings of Dr. Laufer, Dr. Bushell, Dame Una Pope-Hennessy and Henry Doré, where detailed arguments are given assigning their origin to remote antiquity.[1]

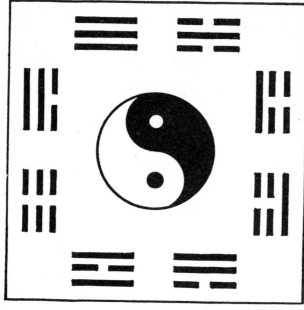

FIG. 57.

FIG. 57 represents these symbols in pictorial form, copied from a Jade Ritual carving of the Han Dynasty. In the centre is the *Yin* and *Yang* ; depicting day and night, light and dark, female and male, in fact, " a symbol of dualism, which embodies the ultimate principle or creative monad." Bordering this symbol is portrayed the divided lines of the *Pa kua* in its broken formula symbolising a similar characterisation of nature and its mysticisms.

The *Pa Kua* was probably first used by the jade carver on a rectangular type of vase, inspired by the *Ts'ung*. The motive is found on many pieces up to the Han period, from which time onwards the jade craftsman evolved a somewhat different treatment of the motive, which took the form of a deep-cut relief decoration, obviously inspired by the earlier symbols.

Certain archæologists appear to be agreed that the *Pa Kua* was derived from the *Yin* and *Yang* symbols,[2] depicting respectively the female and male creations. These symbols, first represented as distinct designs, gradually became inseparable, finally becoming combined in a decorative manner with the Eight Trigrams. The jade craftsman has, from the Chou period up to the present day, made full use of these symbols, which are often shown subtly interwoven in his productions.

THE KEY-FRET AND MEANDER PATTERN.

(*FANG SHENG.*)

This pattern, according to Grube,[3] is a geometrical figure formed by two overlapping squares portrayed in a "flourishing condition " and, like the " Cloud and Thunder pattern " (*Lei Wen*) dates back to remote antiquity. The *Lei Wen* is probably, as suggested by Dr. Yetts,[4]

[1] Laufer, pp. 137-143; Pope-Hennessy, *Early Chinese Jades*, pp. 36-42 ; De Groot, *Religious System of China*, Vol. III, p. 959 ; and Bushell, *Oriental Ceramic Art*, p. 108.
[2] Couling, *Encyclopædia : Yin* and *Yang.*
[3] *Zur Pekinger Volkskunde*, p. 147.
[4] Yetts, *Symbolism in Chinese Art*, p. 3.

derived from the symbol and characters meaning Cloud and Thunder, used by the early Chinese in their ritual devoted to the worship of rain.[1] The Meander pattern was used by the jade carvers of the Han and Wei periods, and is found on bronzes of the Shang Yin and Chou Dynasties.[2] Confirmation of its use by the earliest Chinese artists is given in the famous classic *Po ku t'u l'u.*

During the Han period this motive of decoration reached a high standard of perfection, but during the Ming period its execution was indifferent. With the advent of the Ch'ing Dynasty, however, it was again employed in a manner worthy of its symbolical importance. The key-fret design of the early Ch'ing Dynasty is excellently portrayed on the Jade Incense Burner in the Collection of H.R.H. The Duke of Kent, illustrated in PLATE LXXXII. In the Ch'ien Lung period many otherwise excellent carvings in jade would appear unfinished had not the craftsman introduced this intricate decoration to perfect his masterpiece.

The earlier jades were severely plain, whereas those of the Chou and Han periods were lavishly decorated with symbolic phenomena evolved during the Shang period as seen in the Bronzes of that era. Some of the jades of the early Ming period are roughly adorned in grotesque style, but under the Ch'ing Dynasty the carvers excelled in their ability to embody numerous decorative symbols in a delightfully subtle yet unpretentious manner.

Another type of early symbolic decoration usually associated with the Meander pattern is that of a scroll formation of the conventional " cloud pattern," sometimes rendered in shield form—when it is known as the " stiff leaf " type. PLATE CXVI illustrates a jade vase in the Collection of H.R.H. the Duke of Kent, which admirably portrays the use made of the combination of these symbols as a mode of decoration during the Ch'ing Dynasty. The *Po ku t'u*[3] contains four engravings of bronze resonant instruments, one of which, in the form of an aquatic monster, has its body covered with cloud spirals and thunder pattern. It is probable that these bronze instruments were used in the rain ritual of the prehistoric Chinese which may explain the significance of the symbolic emblems portrayed thereon.

It is uncertain at what period the bronze ritual " thunder drum,"[4] was first executed in jade, but it was possibly during the Chou Dynasty, continuing in Han times and from thence onwards through the Sung and later periods.[5]

RECUMBENT SILKWORM PATTERN.

The Recumbent Silkworm pattern, or Silkworm-cocoon pattern is a favourite scroll decoration for jade. It was used on carvings attributed

[1] The old hieroglyphic for thunder was a spiral, but this gradually became square in form when used for decoration.

[2] When it was formed by separate pairs of spiral figures.

[3] Chap. 26.

[4] " The Stone Drums of the Chou Dynasty," by S. W. Bushell in *Transactions of the North China Branch of the Royal Asiatic Society*, Vol. VIII, 1873.

[5] Bushell, *Chinese Art*, Vol. I, p. 148.

to the Han period, for in the *Ku yü t'u p'u* we find reference to a lower central-piece of a girdle-pendant lavishly decorated with this design.

There is much divergence of opinion as to the origin of the motive, but it seems reasonable to assume that it was derived from the silk industry[1] which existed in China from a very early date. Whatever its source, it is a fact that the pattern was used in the decoration of jade articles from early times. During the latter part of the Ming Dynasty it occurs as a decorative motive in the form of S shaped scroll-work on the borders of bowls and plates. An excellent jade representation of the silkworm, which is in the Bahr Collection, is shown in PLATE CXV.

THE GRAIN MOTIVE AND SIMILAR PATTERNS.

This group of patterns is found in Chinese art from remote antiquity.[2] Sacrificial bronzes made during the Chou period bear this type of decoration; the Grain (*Ku*) being represented in a geometric pattern formed of several rows of raised dots (see PLATE XXXVI). It is also found in the earliest jade carvings, and it is on record that carvings engraved with this design were given by the Emperor to his betrothed.[3] Wu Ta Ch'êng illustrates a *Ku pi*, FIG. 58, described by him as a " disc with Grain design " of green Jade with carnelian markings. This carving is a ritual disc and would appear from its design to be not earlier than the period of the Warring States, 481-221 B.C. A similar carving of the same period, 21.7 cm. in width, is in the William Rockhill Nelson Gallery of Art, Kansas City,[4] and an earlier example of the Chou Dynasty is in the Collection of Mr. Oscar Raphael, London.[5]

FIG. 58.

The grain form of jade decoration persisted through the later periods, and in that of the Han, T'ang and Ch'ing Dynasties especially, the carvers engraved it on various forms identical to those of the earlier types, but executed in different kinds of Nephrite, one variety used in more recent times known as *Fei ts'ui* being easily distinguishable to the discerning collector.

The Millet is a type of diapered lozenge pattern (see PLATE LXXX, fig. 2) frequently engraved on the oblong rectangular slabs of jade used for ceremonial purposes in ancient times. Taoistic deities during the

[1] W. B. Honey, *Chinese Porcelain*, p. 99.
[2] An instructive survey of the various diaper Patterns embodied in the decoration of Chinese Art is included in Williams : *Outlines of Chinese Symbolism and Art Motives*, pp. 116-123, together with three full-page plates embodying most of the designs.
[3] Biot, Vol. II, p. 525.
[4] *Chinese Art Exhibition Catalogue*, No. 341.
[5] *Chinese Art Exhibition Catalogue*, No. 338.

Han, Sung, T'ang and Ming Dynasties were portrayed with these slabs held traditionally in the right hand—these emblems finally developed into spear form.

BAMBOO PATTERN.

The Bamboo has been described as a symbol of the aspiration of the soul which bends before the storms of life but does not break.[1] Its green foliage is probably the reason for its being regarded as an emblem of longevity :

The Bamboo is frequently used in proverbs, as :—

" A single bamboo does not form a row " (i.e. mutual help is useful).

" Young bamboos are easily bent " (i.e. educate when young).

" Good bamboos spring up outside the fence " (i.e. good daughters marry and leave home).

According to De Groot[2] " Bamboo roots are the terror of robbers and thieves, ghosts also fear them and decoctions of them are used in a medicinal manner."

There are said to be no less than 200 different varieties of the Bamboo, of which 160 are natives of Asia.[3] The *Chu p'a* (treatise on the Bamboo), published in the 3rd or 4th century of the Christian era, gives an account of the different species and the uses to which they were put.[4] References to the Bamboo occur frequently in the *She-King*, Book of Poetry.

The bamboo, prunus and pine are symbols known jointly as the " Three Friends," and represent Buddha, Confucius, and Lao Tzu. The bamboo twig (*Chuh*)—sometimes accompanied by other symbols— was used as a rebus by jade carvers.

A Han tablet decorated with bamboo leaves is reproduced in the *Kiu Shih So*.[5] They are also found upon rare jades of the Sung Dynasty, and in the *Ku yü t'u p'u* reference is made to carved hair ornaments of the T'ang period in the form of bamboo stems.

In the Sung catalogue of Jades,[6] mention is made of a jade back-scratcher in the form of a bamboo, which is considered to be of the Sui or T'ang Dynasty. According to the records of Liang chou[7] a further example, in the form of a flute in white jade, was found in the Tomb of Chang Kium, in the year A.D. 276.· The bamboo in the form of a diaper or brocaded pattern occurs in the decoration of jade bowls, plates and other flat carvings of the Early Ming and later periods.[8]

1 Compare the Fable of " The Oak and the Reed "—Æsop : Lafontaine.
2 *Religious Systems of China*, Vol. VI, p. 1075.
3 Porterfield, *China Journal*, Vol. III, 1925.
4 *Chinese Materia Medica*, trans. Stuart, p. 62.
5 Vol. VI, p. 52.
6 Chap. 76, p. 7.
7 Laufer, *Jade*, p. 333.
8 Laufer, *Jade*, p. 320.

It is also on record that bamboo tablets were used before the invention of paper.[1]

THE *T'AO T'IEH*.

A grotesque mask called by Sung critics the *t'ao t'ieh*, or glutton, on the assumption that it was a symbol of greed and lust, was used as a warning against those vices. Dr. Yetts hazards the guess that the ogre-face was really a symbol for the Spirit of the Storm and hence for fertility.[2] Dr. Bushell[3] supports this assumption, but Hirth[4] advances the theory that it derived its origin from the ferocious Mastiff of Tibet by reason of that animal's local connection with certain barbarian tribes credited with unpleasant qualities.

Dame Una Pope-Hennessy[5] favours the opinion that it is derived from the Tiger, rather than from the Dragon, and refers to its appearance, in conjunction with the Dragon, on several jade carvings. Dr. Laufer[6] supports the theory suggested by Prof. Hirth. On the other hand, Hamilton Bell[7] is of the opinion that it was inspired by the Gorgon's head of Greek Art.

Whatever may be the explanation of the mysterious introduction into Chinese art of this grotesque conception it is certain that the device was used by Chinese artists from Shang Yin or even earlier times. It would seem to have had a special attraction for the jade craftsman, who introduced it into his work during the Chou Dynasty and, in many varying forms[8] during later periods : indeed the *t'ao t'ieh* is perhaps the most frequently recurring of the many symbols used in the art of the jade carvers throughout the ages (see PLATES CIV, CV, etc.)

FIG. 59.

A white jade carving in the form of a *t'ao t'ieh* mask, possibly utilizing the tiger formula, is illustrated in Wu's book (FIG. 59).

From the appearance and style of this example it would seem to be of the late Chou period. The origin of the Tiger head or mask as a charm would seem to belong to remote antiquity[9] and it is possible that they were later supplanted by the *t'ao t'ieh*.

[1] Williams, *Outlines of Chinese Symbolism*, p. 45.
[2] Dr. W. P. Yetts, *Burlington Magazine Monograph on Chinese Art*, 1925, p. 43.
[3] Bushell, *Catalogue of the Bishop Collection*, Vol. II, p. 106.
[4] Hirth, *Ancient History of China*, p. 86.
[5] *Early Chinese Jades*, p. 49.
[6] *Jade*, p. 185.
[7] *Burlington Magazine*, Vol. XXVIII, p. 231 (1926).
[8] Some examples bear a strong resemblance to one or other of the " four wondrous creatures " (the Dragon, *Ch'i-lin*, *Fêng Huang* and Tortoise.) (*Chinese Porcelain*, W. B. Honey, p. 85.)
[9] De Groot, Vol. VI, p. 962. Compare *Chinese Art Exhibition Catalogue*, London : Specimen, No. 261.

PLATE XCVI

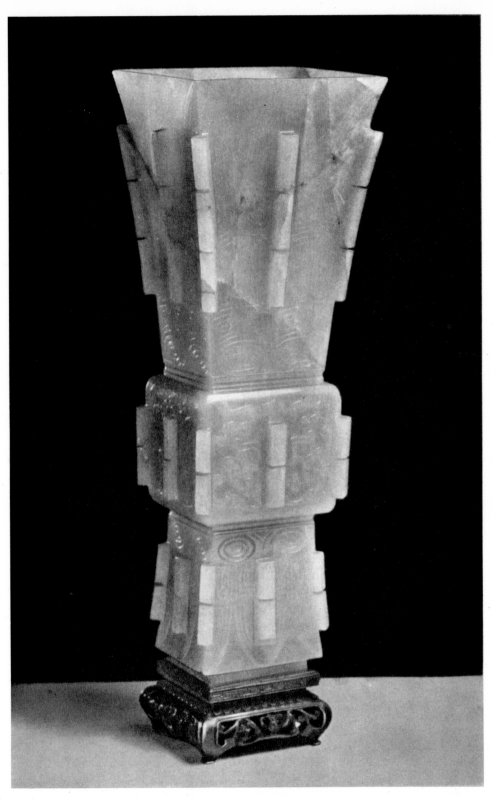

A NEPHRITE SPILL VASE (*KU*)
Of conventional bronze form, decorated with the *pa-kua* or eight Trigrams, closed spirals and
the *T'ao-t'ieh* mask.
COLOUR : Pale Green and White. Early Ch'ing Dynasty, *circa* A.D. 1650. H. 20 c.m.
(*In a Private Collection.*)

PLATE XCVII

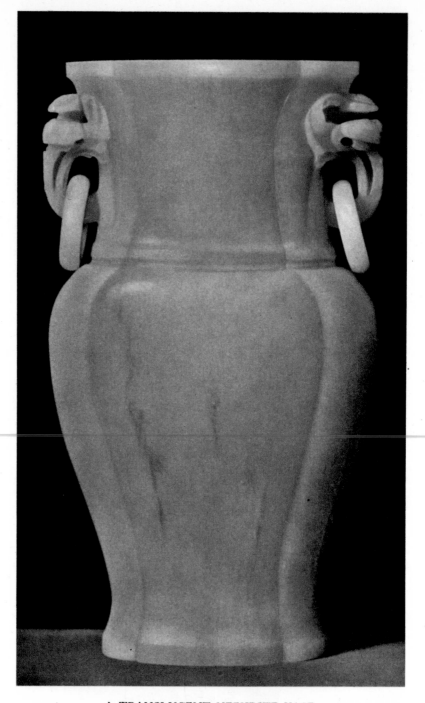

A TRANSLUCENT NEPHRITE VASE

With two loose ring handles supported by *Ju-i* carvings.

COLOUR : White, splashed Brown markings. H. 27.5 c.m. W. 16 c.m.
Early Ch'ing Dynasty, *circa* A.D. 1650.
(*Formerly in the Summer Palace Collection, Peking.*)

PLATE XCVIII

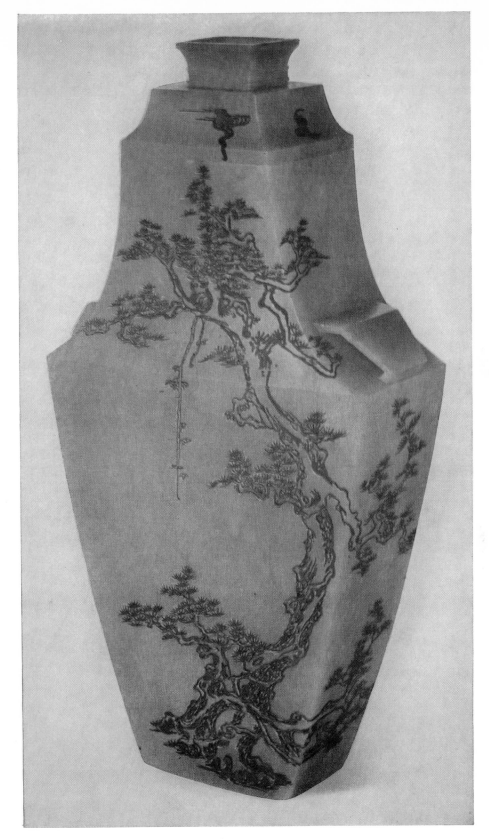

A TRANSLUCENT JADE VASE AND COVER
Lightly engraved with Bats, Cloud and Prunus decoration inlaid with gold. On the reverse
inscribed with a poem.
COLOUR : Pale Celadon. Ch'ien Lung Period, A.D. 1736-1795. H. 33.8 c.m. W. 17.5 c.m.
(*In the Collection of His Majesty The King, and included by His Majesty's gracious permission.*)

PLATE XCIX

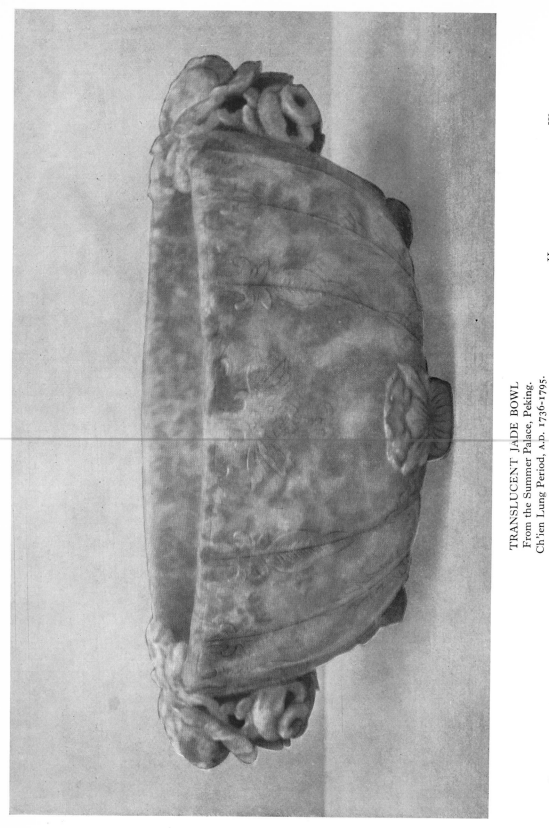

TRANSLUCENT JADE BOWL
From the Summer Palace, Peking.
Ch'ien Lung Period, A.D. 1736-1795.

H. 13·3 c.m. W. 19 c.m.
(The property of Miss Elizabeth T. Brown.)

COLOUR : Emerald Green.

PLATE C

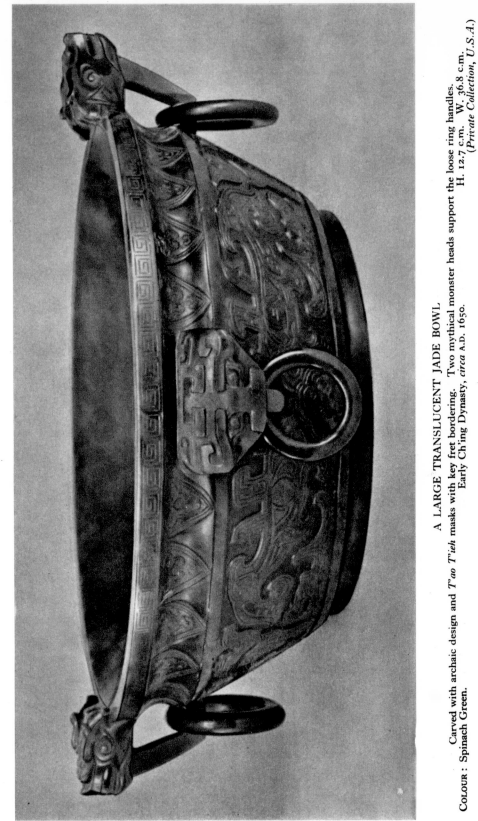

A LARGE TRANSLUCENT JADE BOWL

Carved with archaic design and *T'ao T'ieh* masks with key fret bordering. Two mythical monster heads support the loose ring handles.

COLOUR : Spinach Green.

H. 12.7 c.m. W. 36.8 c.m.

Early Ch'ing Dynasty, *circa* A.D. 1650.

(Private Collection, U.S.A.)

PLATE CI

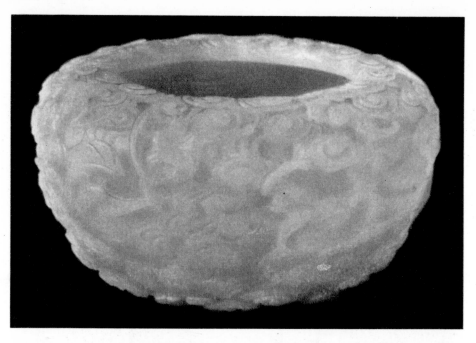

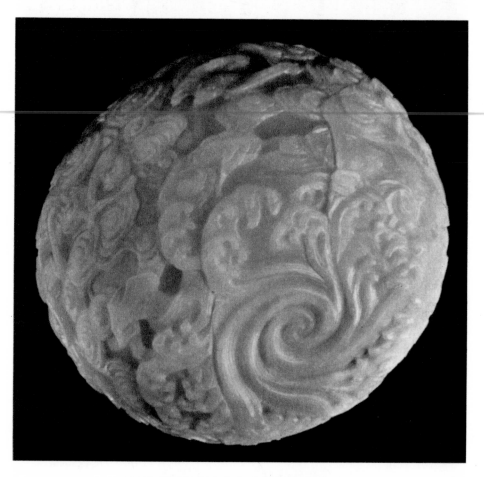

AN INTRICATELY CARVED JADE BOWL
Showing high relief carving of Bats in Clouds above a pattern of crested waves.
COLOUR : Mutton fat. K'ang-Hsi Period, A.D. 1662-1722, Diam. 16.7 c.m.
(In the Lady Lever Art Gallery Collection.)

PLATE CII

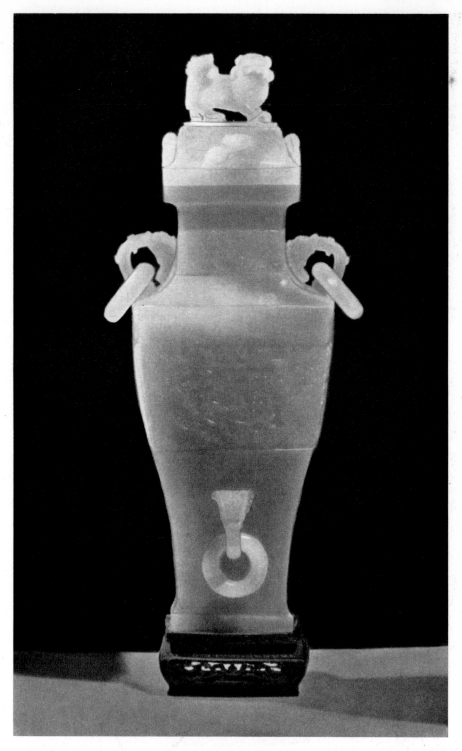

A TRANSLUCENT JADEITE VASE AND COVER

Decorated with *T'ao T'ieh* and grain pattern ; three loose rings are supported by well-formed monster heads. The cover is surmounted by a Dog of *Fo*, and kneeling rams encircle the lower edge.

COLOUR : White. H. 29 c.m. W. 11.5 c.m.

Ch'ien Lung Period, A.D. 1736-1795.

(*Formerly in the Collection of Capt. Vernon Wentworth.*)

PLATE CIII

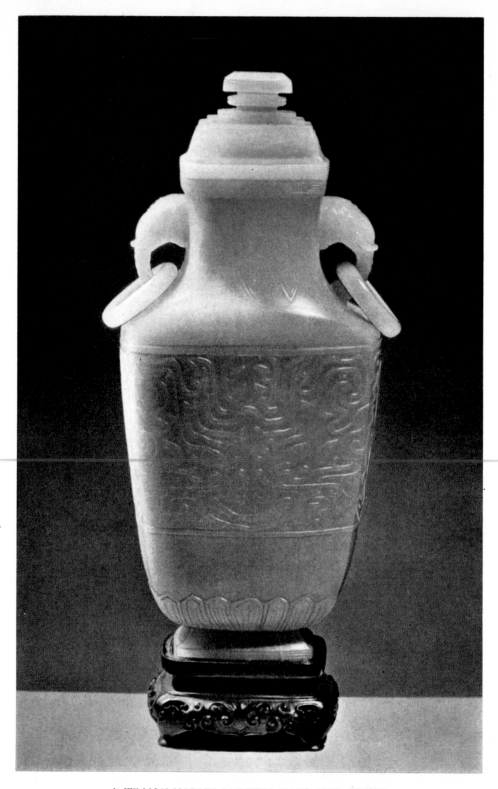

A TRANSLUCENT JADEITE VASE AND COVER
With two loose rings supported by elephant heads at neck.
COLOUR : White. K'ang Hsi Period, A.D. 1662-1722. H. 22.4 c.m. W. 9.5 c.m.
(*In the Collection of the Author.*)

The Eight Musical Instruments (*Pa Yin*)[1] are divided into the following 8 classes, corresponding to the material used for their manufacture.

1.	Stone.	4.	Bamboo.	7.	Gourd.
2.	Metal.	5.	Wood.	8.	Earth.
3.	Silk.	6.	Skin.		

(1) *Ch'ing.* " Sounding Stone," suspended from a frame and struck with a wooden mallet. When made of jade is usually in the shape of a mason's square, with a hole pierced near the angle for suspension : it is a homonym of *Ch'ing* " Good fortune."

(2) *Chung.* " Bell," made of metal and used in similar manner to the *Ch'ing*.

(3) *Ch'in.* " Lute," with strings of silk.

(4) *Ti.* " Flute," often found made in jade imitating the bamboo of which it was formerly made.

(5) *Chu.* " Box," usually made of wood with a hammer inside. During the Ch'ien Lung period several *Chu* were made in jade and contained a metal instrument as a hammer.

(6) *Ku.* " Drum," covered with skin.

(7) *Shêng.* " Reed Organ," a mouth instrument dating from very early times, the body is made of gourd, containing reed pipes of varying lengths inserted in the top.

(8) *Hsüan.* " Icarina," a vessel in the shape of a cone, pierced with six holes.

Of the eight types of instruments named above those made of Jade are as follows[2] :—

FIG. 60. The *Tê'-ch'ing*, or " single sonorous stone," is a stone cut in the shape of a carpenter's square, and supposed to render the sound of the triple octave below *huang-chung*. The side which is to be struck by the performer's hammer measures 2.25 feet ; the other side is only 1.8 feet in length. It is suspended in a frame by means of a string passing through a hole bored at the apex. It is also known under the name of *li-ch'ing*, perhaps on account of its sound being so deep. Its place at the Confucian ceremonies is outside the temple, on the left side of the " Moon Terrace." Its use is to give one single note at the end of each *verse*, in order to " receive the sound." Formerly the stone was cut in a fantastical form, representing some monstrous animal, fish, dragon, or the like. According to the *Illustrated Description of the Instruments of the present Dynasty* there are 12 *t'ê-ch'ing*, one corresponding to each of the *lüs* ; and they are employed only at the religious and court ceremonies.

[1] Bushell, *Oriental Ceramic Art.*
[2] See *China, Imperial Maritime Customs. Chinese Music.* By J. A. Van Aalst. Published by order of the Inspector General of Customs, Shanghai, 1884, from which source the present descriptive matter and illustrations are reproduced.

113

FIG. 61. The *Pien-ch'ing*, or "stone-chime," is an instrument composed of 16 stones suspended on a frame. The stones, which measure 1.8 feet one way and 1.35 feet the other, are all of equal length and breadth, and differ only in thickness ; the thicker the stone the deeper the sound.

FIG. 60

Formerly the size of the stones was in a gradually diminishing progression, following the degrees of the scale of the *lüs*. The number of stones has also not always been the same. The ancient Chinese used 16 stones ; the Hans 19 ; the Liang, 21 ; the Wei, 24 ; the Northern Chou, 14 ; the Ming, 24 ; K'ang Hsi reverted to the old custom, which, besides, had been the one prevalent during the Chin, Sung, Ch'i, and Sui Dynasties.

FIG. 62. The *Ko-ch'ing*, or "singers' stone-chime," which has now totally disappeared, was an instrument the same in principle as the *pien-ch'ing*, with these exceptions : it was composed of either 12 or 24 stones, which were cut in fantastical forms ; the pitch was an octave

114

FIG. 61

higher, and the notes, instead of following each other in two series of *yin* and *yang* sounds, were placed in a chromatic succession.

FIG. 62

115

(THE *SHIH-ÊRH CHANG*)[1]

The *She King* or Historical Classic compiled during the Sung Dynasty refers to a series of designs, illustrated in FIG. 63. These represent the ideas of that period of the forms of the twelve ancient ornaments. These early symbols are mentioned in other ancient Chinese writings but are rarely illustrated. It would seem that their conception was inspired by the earliest Chinese religious ideas, for undoubtedly they embody the fundamental principles of the ancient Chinese Solar and Agricultural superstitions as recorded in Chinese mythology. It seems probable, therefore, although no ancient script substantiates the supposition, that these emblems were first portrayed entirely in hieroglyphic form compiled by the ancients as a record of their religious principles. Legge[2], quoting from the *She King*, refers to these records being mentioned by the Emperor Shun, 2255-2205 B.C. and further suggests that this Emperor instituted the arrangement of them into ornaments for use on the Imperial Sacrificial Robes. In attempting to understand the involved meaning of these emblems it will be seen that they are of four distinct classes :—

(1). Those representing early Chinese cosmogony.
(2). Those emblematic of the Emperor and Empress.
(3). Those symbolically representing early ritual.
(4). Those purely hieroglyphic in form and representation.

Taken collectively they suggest the following interpretation :—

The Emperor and Empress attend the solemn ritual sacrifices, held on the sacred mountains, to offer to the gods the sacred female plants of Hemp. In reply to this supplication the visible signs of lightning and the voice of thunder herald the pleasure of the Gods in granting the imperial prayers for rain.

(A) represents the *Jih* or Sun drawn as a disc supported by clouds, embodying the outlines of the crow. It would appear to convey an attempt to portray the *Yang* principle in pictorial form.

(B) represents the *Yueh* or Moon drawn also as a disc supported by clouds but embodying the outlines of the Hare and Cassia Tree, suggesting a pictorial representation of the *Yin* principle.

(C) represents the *Hsing Chên* or three Stars joined together by lines : pictorially conveying the *Yin* and *Yang* principles in harmonious union.[3]

[1] The illustrations of the "Twelve Ancient Ornaments" (Fig. 63, p. 117), as also those depicting the "Eight Happy Omens" (Fig. 64, p. 119), the "Seven Gems" (Fig. 65, p. 121), the "Eight Precious Things" (Fig. 68, p. 126), and Miscellaneous Symbols (Fig. 69, p. 128) are copied from those appearing in the magnificent Catalogue of the *Walters' Collection of Oriental Ceramic Art*, edited by Dr. Bushell, New York, 1897. The late W. T. Walters was one of the earliest and most assiduous collectors of Oriental ceramics, and his splendid collection covered every branch and type of Chinese porcelain, pottery and stoneware. The Catalogue, which is of an extraordinarily complete and authoritative character, is illustrated by a superb series of plates in colour and monochrome.
[2] *The She King*, "Chinese Classics," Vol. III, part 1, p. 80.
[3] Early Chinese Astrology embodied the belief that the stars in unison, appearing in the darkness of night, demonstrated symbolically the inseparable *Yin* and *Yang* principle of creation.

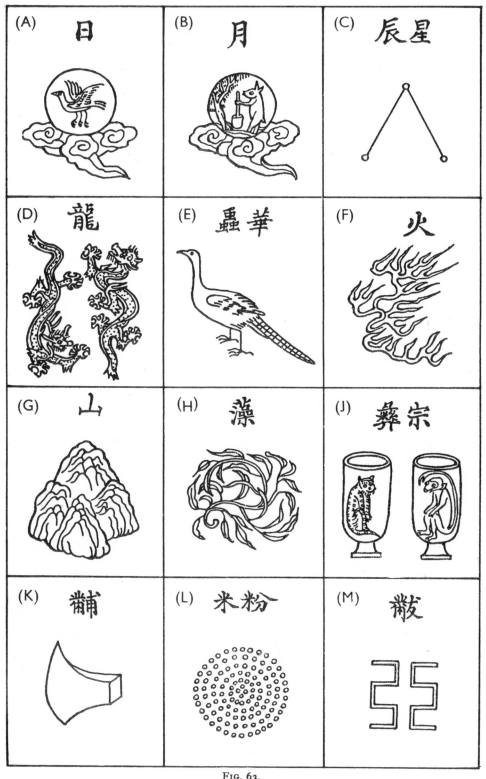

FIG. 63.
THE *SHIH-ERH CHANG*. OR TWELVE ANCIENT ORNAMENTS

117

(D) represents the *Lung* or Dragon and in its dual form is symbolical of the Emperor.

(E) represents the *Hua Chung* portrayed as a pheasant or phœnix, symbolical of the Empress.[1]

(F) represents the *Huo* or pictorial rendering of lightning.

(G) represents the *Shan* or Sacred Mountains embodying the five sacred peaks.

(H) represents the *Ts'ao* or Aquatic Grass derived from the earlier female plants of Hemp, the sacred vegetable offering made to the God of Agriculture.

(J) represents the *Tsung Yi* or Temple Vessels.[2]

(K) represents the *Fu* or Axe, the emblem of Imperial Sovereignty.

(L) represents the familiar grain Pattern (*Fên Mi*).

(M) suggests an involved representation of the ancient rendering of the Cloud and Thunder symbol altered to embody as well the " embroidered " symbol, inspired in all probability by the fact that during the Sung Dynasty these emblems had primarily become adornments embroidered on the Imperial Sacrificial Robes.

BUDDHIST SYMBOLS

THE *PA CHI-HSIANG.* " OR EIGHT HAPPY OMENS."

The *Pa Chi-Hsiang* or " Eight Happy Omens " (FIG. 64) were first represented in the Arts of China following the introduction of Buddhism. It is the opinion of some authorities that the Chinese actually adapted these symbols from Lamaism. This, however, does not appear well founded, for this Tibetan form of Buddhism was unknown to the Chinese before the Mongol Dynasty, whereas the *Pa Chi-Hsiang* are to be found represented in the sculptural decorations of temples erected during the Chin period, and also on Buddhist Altar Shrines of even earlier dates. It would appear safe therefore to assume that the introduction of the *Pa Chi-Hsiang* was effected by the Buddhist Monks upon the occasions of their visits to China during the 1st century A.D.

The Jade carvers have used the *Pa Chi-Hsiang* for decorating their works since the Early Ming Period. Certain of these emblems supposed to have been imprinted upon the sole of the foot of Buddha[3] were used during the T'ang and Sung Dynasties. The Emblems usually considered to comprise the *Pa Chi-Hsiang*, taken from a white jade bowl, PLATE XXXV, are as follows :—

FIG. A. The *Lun* or " Wheel " to-day considered symbolical of the law and the universal monarch, is usually portrayed as a whirling sphere surrounded by flames similar to a meteor which probably inspired its conception. Metempsychosis was an early Buddhist

[1] The artists of the Sung Dynasty often portrayed the mythological *Fêng Huang* in this manner, influenced probably by Buddhism.

[2] It will be noticed that these drawings show the Monkey and Tiger portrayed on the vessels, which is the characteristic Sung method of depicting Imperial Ritualistic sacrificial vessels.

[3] A stone bearing inscribed outlines of the emblems of Buddha's foot is preserved in the T'ien-t'ai Monastery on the Western Hills near Peking.

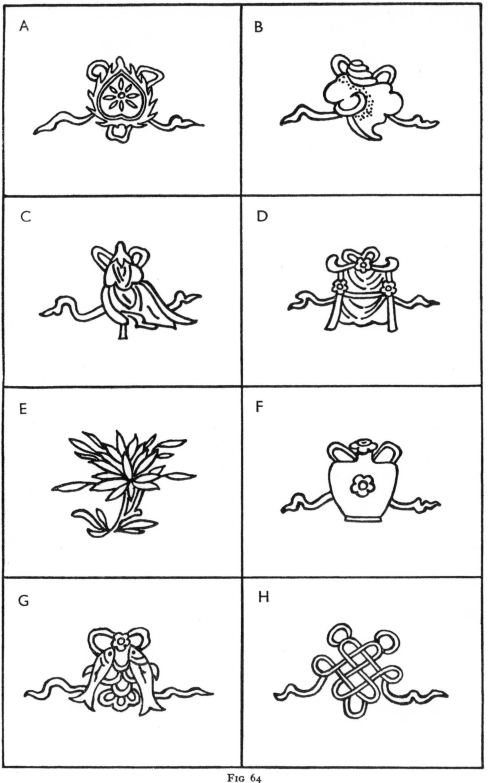

FIG 64
THE *PA CHI-HSIANG* OR "EIGHT HAPPY OMENS"

119

doctrine and it was believed that *Chwen-lun Wang*, " The King of the revolving Wheel," decided in what form the parting spirit of the deceased should be reincarnated ; hence the *Lun* in its earliest form symbolised the doctrine of transmigration. The " Wheel " is sometimes replaced by a large " Hanging Bell,"[1] also inspired by the doctrine of metempsychosis, it being believed that the departed spirits revived upon hearing the tolling of the Bell[2] ; further, the vibrations set up by its ringing were believed to deaden the torments which the soul would otherwise suffer pending its time of transmigration.

FIG. B. The *Lo* or " Shell," symbolical of victory, supposedly connected with the couch-shell trumpet, which is blown in an effort to draw the attention of the spirits of the Ancestors, during certain religious services.

FIG. C. The *San* or " Umbrella," deemed to be endowed with the power of raising storms of thunder and rain, and in other cases symbolical of the God of Night, possessing the power to cover the earth with universal darkness,[3] thereby becoming the symbol of sovereignty.[4]

FIG. D. The *Kai* or " Canopy," believed by some authorities to be a flag. The actual significance of this emblem has not been positively allocated ; its streamers and jewelled tassels suggest the Shrine sometimes carried by the Elephant, and it is thought that it may possibly represent the throne of Buddha.

FIG. E. The *Hua* or " Lotus Bloom," symbolical of the evolution of Buddhist worlds from eternal cosmic matter.[5]

FIG. F. The *P'ing* or " Vase," a symbol usually associated with Padmapani, Amitabha and Maitreya,[6] derived from the Kalasa, a vessel peculiar to Brahma.

FIG. G. The *Yü* or " Fish " symbolical of abundance, rank or power and connubial felicity. This emblem is often represented in Buddhist Temples in the shape of drums and gongs.

FIG. H. The *Chang* or " Entrails " emblematic of longevity. This symbol owes its origin to the ancient custom of cutting open the abdomen of the sacrificial animals thereby to divine from the length and position of its entrails the span of years of prosperity to come, and the opportunities of the Gods satisfactorily answering the supplication to be put in the ensuing ritual.[7]

THE *CH'I PAO* OR SEVEN GEMS.

The *Ch'i Pao* are the attributes of the universal monarch derived from Buddhism, and usually appear upon the base of the throne in

[1] Compare *Hwo-wu-yin.*
[2] Compare *Liang-pan ts'iu-yü-hoh* and *Shi wen lei ts*1.
[3] Compare Edkins, *Chinese Buddhism*, p. 240 and Hackmann, *Buddhism as a Religion*, p. 215.
[4] Compare Bushell, *Oriental Ceramic Art*, p. 112.
[5] Beal, *A Catena of Buddhist Scriptures from the Chinese*, p. 1.
[6] Compare Getty, *The Gods of Northern Buddhism*, p. 59, and Johnston, *Buddhist China*, p. 285, note 2.
[7] Compare Bushell, *Oriental Ceramic Art*, p. 112.

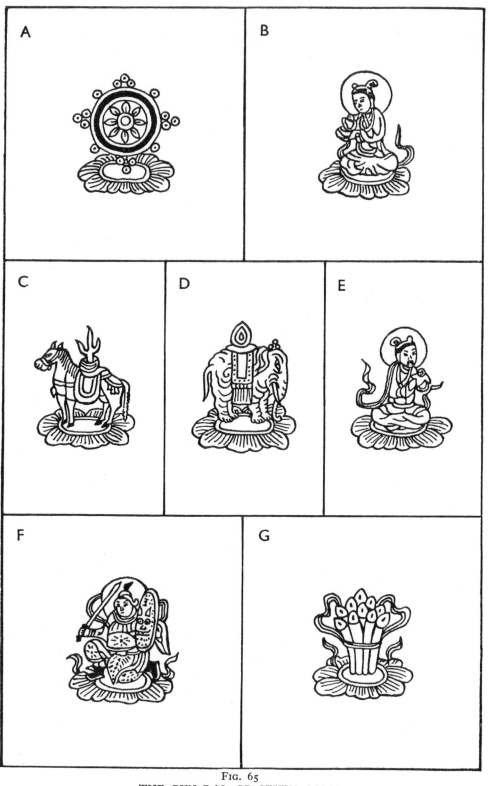

FIG. 65
THE *CH'I PAO*, OR SEVEN GEMS

121

Buddhist temples. They have been utilised by the Jade carvers as subjects for both statuette carvings and motives of decoration and appear in their works from the Sung Dynasty onwards. They are as follows :—

FIG. A. The *Chin Lun* or " Golden Wheel " symbolical of Victory and believed to herald the advent of a *Chakravartî Râja*. In all probability derived from the ancient Aryan sun emblem, used during the Vedic sun-worshipping ceremonies.[1]

FIG. B. The *Yü Nü* or " Jadelike Girl " reputed to have been the beautiful consort of all just Rulers, is in all probability of purely Chinese conception, evolved from the mythical Princess Miao-Shen.

FIG. C. The *Ma* or Horse symbolising the horse-chariot of the Sun and evolved from the form of the celestial steed.[2]

FIG. D. The *Hsiang* or Elephant evolved from Indra's elephant *Airâvata*, the reputed courier of the sacred Jewel of the Law.

FIG. E. *Chu Ts'ang Shên,* " The Divine Guardian of the Treasury," reputed to be the Minister who regulates the affairs of the Empire, derived from the Brahmanic deity Kuvera and one of the Catur Maharaja or Four Heavenly Kings.

FIG. F. *Chu Ping Ch'ên,* " The General who Commands the Army," divinely invested with the power to overthrow all enemies.

FIG. G. The *Ju I Chu,* " The wonder-working Jewels," capable of fulfilling every wish.

TAOIST SYMBOLS.

The *Pa An Hsien* or eight emblems of the Taoist Immortals are perhaps the chief symbols under this heading. The Jade carvers of the Ming and Ch'ing Dynasties have portrayed them in varying forms as motives of decoration. FIG. 66 represents the eight as carved on a pair of translucent Jade bowls and covers of the Ch'ien Lung period. They are as follows :—

(A) The Fan (*Shan*) considered to be possessed of the power to revive the souls of the dead, emblematic of Chung-li Ch'üan, sometimes replaced by the flywhisk (*ying shua*). The origin of these emblems are obscure, the fan seemingly being of earlier introduction than the fly-whisk, which latter is a Buddhist emblem derived from India,[3] significant of the first commandment, and represented in Taoist writings as an implement of magic. Possibly akin to that ascribed to the fan.

(B) The Sword (*Chien*) used by Lü Tung-pin. Emblematic of victory and Celestial serenity.

[1] Williams, *Outlines of Chinese Symbolism and Art Motives*, p. 421.
[2] *The Chinese Repository*, Vol. VII, December 1838, Art. 1, p. 396.
[3] Compare Couling, *Encyclopædia Sinica* : Fly-whisk.

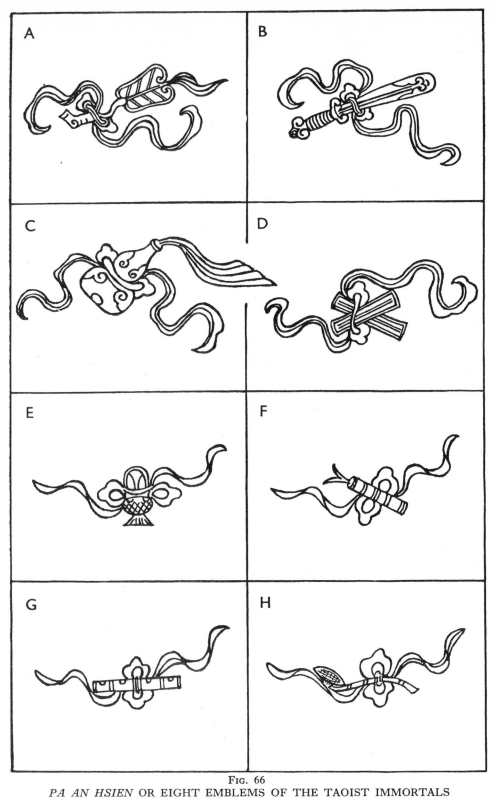

PA AN HSIEN OR EIGHT EMBLEMS OF THE TAOIST IMMORTALS

(c) The Pilgrim's Gourd (*Hu-lu*). Emblematic of Li T'ieh-kuai and symbolising necromancy. This emblem is sometimes portrayed with the crooked iron staff (*kun*) of the lame beggar, which joint representation means Celestial interpreter.

(D) The Castanets (*Pan*) attributed to Ts'ao Kuo-ch'iu. Emblematic of revival in a similar manner to the Buddhist Bell.

(E) The Basket of Flowers (*Hua Lan*) carried by Lan Ts'ai-ho, sometimes combined with the spade (*chan*). Emblematic of Pietistic superlativeness.

(F) The Bamboo Tube and Rods (*Yu ku*), the symbol of Chang kuo. Emblematic of longevity and pious affection.

(G) The Flute (*Ti*) played by Han Hsiang Tzu. Emblematic of the seat of life and intellect.

(H) The Lotus Flower (*Lien Hua*) possessed by the Virgin damsel Ho Hsien Ku. Emblematic of fertility

THE HUNDRED ANTIQUES (*PO KU*).

Many vase and involved utensil forms are used in the decoration or the Ch'ing jades, most of which belong under the heading *Po Ku*, of "Hundred Antiques." The four most frequently met with are the *Ch'in, Ch'i, Shu, Hua*. These four symbols are emblems of the Chinese scholar depicting the " Four Accomplishments "—music, games, calligraphy and painting. Fig. 67 depicts drawings copied from a representation of them on a White Jade bowl belonging to a Chinese literary scholar.

FIG. A depicts the set of books tied together by ribbon. Emblematic of calligraphy.

FIG. B depicts the two scroll paintings tied together by ribbon. Emblematic of painting.

FIG. C depicts the lyre encased in a cloth wrapper. Emblematic of music.

FIG. D depicts the Gô-board (*Wei-Ch'i*) with two round receptacles for the black and white " checkers." Emblematic of games.

THE EIGHT PRECIOUS THINGS (*PA PAO*)

(A) The Jewel or Pearl (*chu*). The dragon is generally depicted pursuing this jewel. It may be considered to represent the Buddhist jewel of the law and the symbol of a universal monarch.

(B) The " Cash " (*ch'ien*) derived from the round copper coin pierced with a square hole in the centre for convenience of stringing.

(c) An open lozenge (*fang-shêng*) with ribbons entwined round it. A symbol of victory or success.

(D) A pair of books (*shu*) strung together by a ribbon. This is one of the four symbols of the Chinese scholar, representing elegant accomplishment, referred to above.

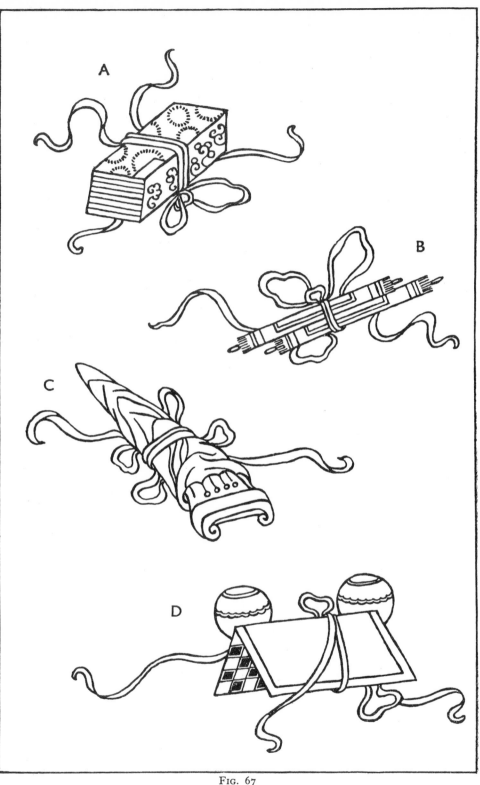

Fig. 67
THE *CH'IN, CH'I, SHU, HUA*, OR FOUR ACCOMPLISHMENTS

FIG. 68
THE EIGHT PRECIOUS THINGS (*PA PAO*).

126

PLATE CIV

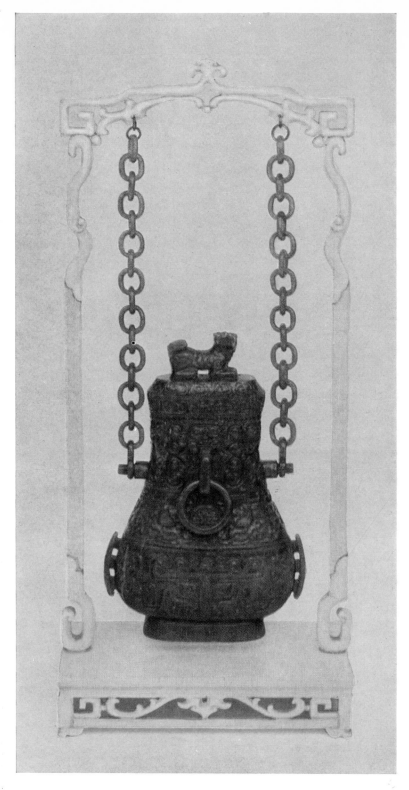

A JADE *HU* (WINE VESSEL)

Suspended by two jade chains from ivory stand. The body of the vase supports two loose rings, and is decorated with the *T'ao-Ti'eh*, archaic dragons, and *Shou* signs.

COLOUR : Translucent Sage Green. H. 14.9 c.m. W. 9.7 c.m.

Ch'ien Lung Period, A.D. 1736-1795.

(*In the Collection of Sir Bernard Eckstein, Bart.*)

PLATE CV

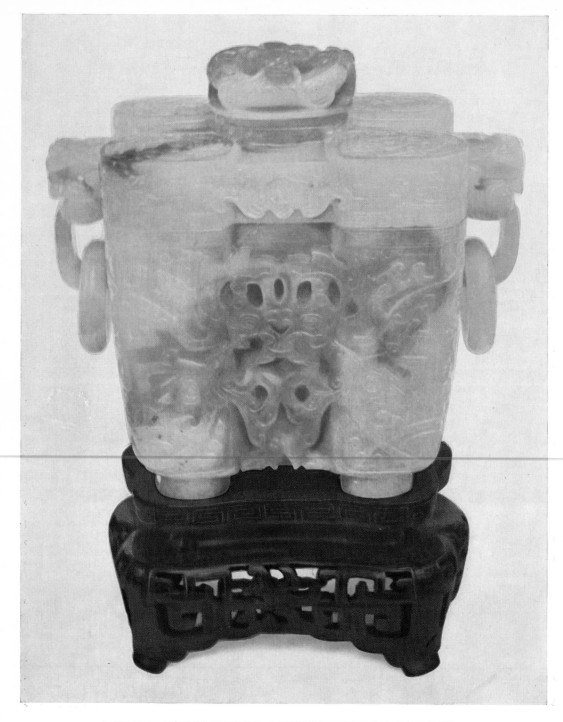

A TRANSLUCENT JADEITE INCENSE BURNER AND COVER

Carved with archaic *T'ao T'ieh*, Dragon and Phœnix. Two monster heads support well-positioned loose-ring handles. The cover is adorned with five dragon representations in medallion form and two bats.

Colour : Pale Translucent Green, splashed Emerald. H. 15 c.m. W. 16 c.m.

Ch'ien Lung Period, A.D. 1736-1795. Imperial Ch'ien Lung seal-mark.

(Formerly in the Collection of Commander R. E. Gore, R.N.)

PLATE CVI

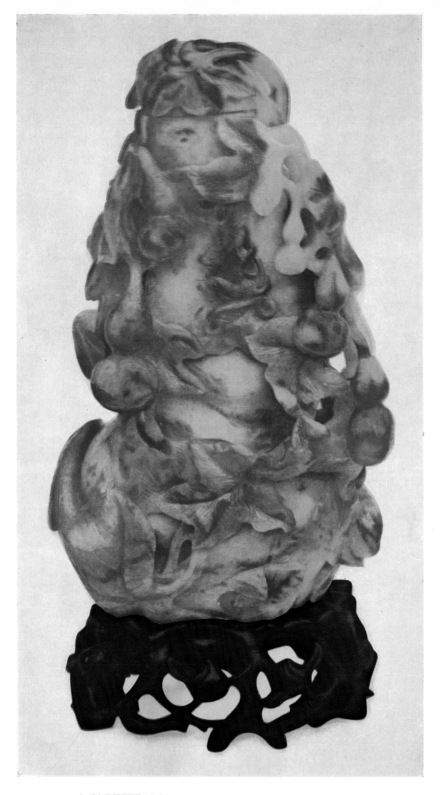

A JADEITE GOURD-SHAPED VASE AND COVER
Carved in bold relief with fruit and foliage.
Early Ch'ien Lung Period, *circa* A.D. 1745.
COLOUR : Apple and Emerald Green. H. 20.1 c.m.
(In the Collection of Frank H. Fulford, Esq.)

(E) A solid lozenge (*fang-sheng*) derived from the open lozenge. Usually the form taken by one of the musical Jade stones.

(F) A *ch'ing* or musical stone of jade, struck with a hammer. Both a Taoist and Buddhist musical instrument. The *ch'ing* is a very ancient instrument and great pains are taken in ancient Chinese writings to explain and detail its mode of form and construction. A set of sixteen stones of different sizes and thickness, form the *pien ch'ing* or " Stone chime."

(G) A pair of horns (*Chüeh*) emblematic of plenty, similar to the cornucopia.

(H) An artemisia leaf (*ai yeh*). A fragrant plant of good omen used from ancient times for the " moxa."

MISCELLANEOUS SYMBOLS.

Various well known devices were and still are embodied in the decoration of many types of jade carvings and they invariably possess a symbolic meaning. They are not introduced for the purpose of indicating the work of any particular carver or School of Craftsmen. The practice adopted by the potter of marking his wares with his name or the place of manufacture was not followed by the jade craftsmen, but during the Ch'ien Lung period choice pieces of jade wrought in the Imperial workshops usually bore the Imperial Seal Mark in addition to the decorative symbols introduced by the craftsman. Among the symbols most frequently met with in jade carvings are the following :—

(A) The *Swastika* : a mystic emblem of great antiquity, mentioned in the Râmâyana and found engraved on certain of the rock temples of India. Emblematically used by Teutonic nations to symbolise Thor. In China the *Swastika* symbolises esoteric doctrines of Buddha. It is one of the 108 figures reputed to be imprinted on the sole of Buddha's foot. It appears as the emblem of all deities worshipped by the Lotus School, who believed it to symbolise the Heart of Buddha. The first drawing in FIG. 69 depicts the *Swastika* combined with the Lozenge and in this form it is often found embodied in the decoration of ritual vessels in Jade of the Ch'ing Dynasty.

(B) The *pao ting* or precious censer : a crudely designed representation of an antique bronze vessel possessing three or four legs. This emblem appears from very early times as a form of decorative embellishment for Jade vessels of various types, and it seems likely that it actually represents one of the earliest measures of capacity of the Chinese nation.

(C) The *Lien Hua* or Lotus flower, sometimes portrayed amidst waving reeds, symbolising Buddhistic enlightenment. When the Lotus is used by the Jade carver as a subject of decoration it is sometimes encased in fillets entwined with ribbons. This sacred symbol

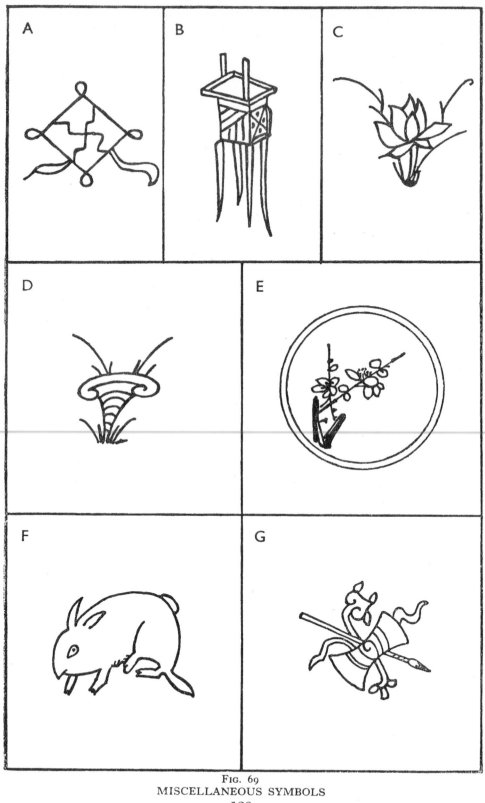

FIG. 69
MISCELLANEOUS SYMBOLS
128

representation with its attendant adornments represents " The halo emanating from the mystic flower."[1]

(D) The *Ling-chih* or " Sacred fungus " is emblematic of longevity and is derived from the ancient custom of placing dried cuttings of this plant upon the altar of Taoist Temples. It is portrayed in various ways by the Jade carvers of different periods ; when represented placed in the centre of three or five blades of grass it is a symbol of the greatest ritualistic importance.

(E) The *Mei Hua* or " Sprig of Prunus." Emblematic of longevity in a similar manner to the Pine (*Sung*) and Bamboo (*Chu*). The *Mei Hua* derives its significance from the fact that it flowers before any leaves appear, and lives to a great age ; the ancient Chinese perceived therefore in this plant an excellent subject for emblematic use. The Pine and Bamboo owe their place in the plant emblems of China because they are evergreen and flourish during the winter after the passing of other shrubs and trees.

(F) The *T'u* or Hare is perhaps one of the most popular of the animal emblems of the Chinese, and is found in company with the Deer and Tortoise.

(G) The *Pi ting ju-i* " May (things) be arranged as you wish."

BUDDHA'S FOOT-PRINTS.

The symbols supposedly imprinted on the sole of Buddha's foot (*Scripâda*) are 108 in number corresponding to the 108 names of the Brahmanic deity *Vishnu*. In the *Vinâyasutra* it is suggested that these symbols were evolved from the forms evoked by tears shed at the feet of Buddha by sinful women.

Mr. Williams tells us[2] that the imprint of these characters was recorded on a stone at Kusinara in the year 477 B.C. when Buddha stood facing the South at this place. FIG. 70 (reproduced from Williams' excellent book, *Outlines of Chinese Symbolism and Art Motives*, by kind permission of the

FIG. 70

[1] Williams, *Outlines of Chinese Symbolism*, p. 256.
[2] Williams, *Outlines of Chinese Symbolism*, p. 192.

Author and of Kelly & Walsh Ltd., its publishers) shows a tracing from one of the " Buddha Foot Stones." It will be noticed that many of the outlines are quite familiar, being used as emblems in other groups of Chinese characters. Dr. Bushell tells us that of the large number of symbols imprinted on the Foot of Buddha only 65 are easily distinguishable.[1] The Jade carvers of the Ming and Ch'ing Dynasties have portrayed involved representations of these symbols in the decoration of their works. The designs most often met with are :—

The *Swastika*, symbolical of Buddha's Heart.

The Wheel, symbolical of dominion and " Universal Kings."

The Lotus, symbolical of self creation.

The Triple Lotus (*Tri-râtna* or " Three Treasures ") symbolical of the three Triads of the Tantra School of Buddhism, founded by Asangha, a Buddhist monk of Gandhara, comprising *Nirvana Buddha, Lochana Buddha* and a *Manuchi* or human Buddha.[2]

The five sacred peaks shown on the heel.

The *Jü-i*, representing one of the Saptaratna or " Seven Gems."

The Twin fish (*Ts'ih-pao*), the shell, the jagged thunderbolt usually held in the hands of Jen-teng, mistaken by early Chinese painters for a pagoda,[3] and even to-day regarded by some as a representation of the Flaming Pearl ; and other well known representations which have obviously been adapted from Brahmanism.[4]

[1] Bushell, *Oriental Ceramic Art*, (Walters' Collection), p. 114.
[2] *Chinese Superstitions*, Vol. VI, p. 122.
[3] Compare Mayers, *Chinese Readers Manual*, p. 161, and Giles, *Chinese Biographical Dictionary*. p. 600.
[4] Monier-Williams, *Buddhism*, p. 221.

CHAPTER XV

PLANT AND FLOWER FORMS IN JADE CARVINGS.

THE Peach (*T'ao-shu*), the Pomegranate (*Shih-liu*) and Buddha's Hand Citron, are known as the Three Abundances, symbolical of longevity, fertility and happiness.

THE PEACH.

The Peach, according to *Chinese Superstitions*[1] and to De Groot,[2] is a symbol of the vernal sun, by whose influence it bursts into blossom before any green or leaf appear ; it is deemed, therefore, to possess more vitality than any other tree and on this account it became one of the symbols of longevity and immortality.

According to early Taoist mythology, the peach was a sort of talisman in the quest of everlasting life.[3]　It is recorded that the founder of the Ts'in Dynasty (246-209 B.C.) ate the peach in an attempt to attain immortality.

It may be that the carvers of the Ming Dynasty were inspired to place peaches in the hands of their statues of the gods by memories of the ritual worship of the Sun in bygone centuries, when, according to De Groot and Biot,[4] the Emperor having a *Ta kuei* in his girdle and *Chen Kuei* in his hands offered, during the Spring, the Sacrifice to the Sun in the morning.[5]　The *Chen Kuei* here referred to being replaced by the peach.

There is no doubt that this fruit, traced to remote antiquity in the mythological annals, was used by the jade carvers, as early as the Sung Dynasty, though only in exceptionally few instances.　By the latter part of the Ming Dynasty the peach form was being used for Wine Ewers.[6]　Also very fine carvings of Shou Lao, the God of Longevity, with the peach, were made during the Mid Ming period (see PLATE CXXXVIII).　As a general rule, however, the majority of statuettes comprising the peach owe their origin to the Ch'ien Lung period.　A mottled white jade carving of the peach in the form of a box, used during the Wedding Ritual, is shown in PLATE CVII.　With the peach we find the Deer, Tortoise and Stork—each an emblem of longevity.

THE POMEGRANATE.

The Pomegranate (*Shih-liu*) is the emblem of fertility, and in particular of the birth of numerous sons, first, on account of its natural ability to cast its many seeds, and secondly, and perhaps still more, from the pun on the word *T'zu*—which means offspring or progeny, as well as seed, grain or stone.　The pomegranate (*Punica granatum*) was not

[1] Vol. V, pp. 504-505.
[2] *The Religious System of China*, Vol. VI, p. 957.
[3] Mayers, *Chinese Readers Manual*, " *T'ao* " (the peach), p. 213.
[4] Vol. I, p. 484.
[5] Laufer, *Jade*, p. 82.
[6] Plate CXLIX, Fig. 2.　*The Art of the Chinese Potter*, Hobson and Hetherington.

PLATE CVII

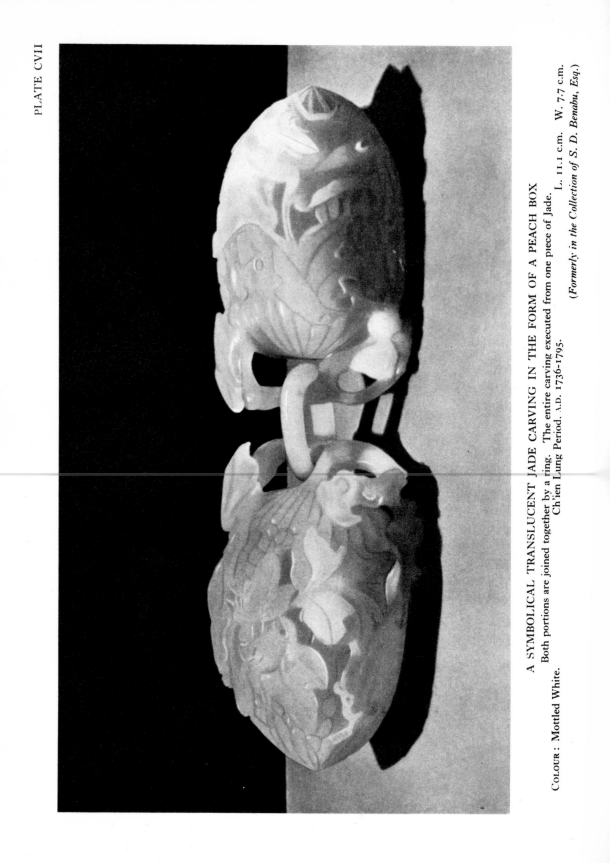

A SYMBOLICAL TRANSLUCENT JADE CARVING IN THE FORM OF A PEACH BOX

Both portions are joined together by a ring. The entire carving executed from one piece of Jade. L. 11.1 c.m. W. 7.7 c.m.
Ch'ien Lung Period. A.D. 1736-1795.

COLOUR: Mottled White.

(Formerly in the Collection of S. D. Benabu, Esq.)

PLATE CVIII

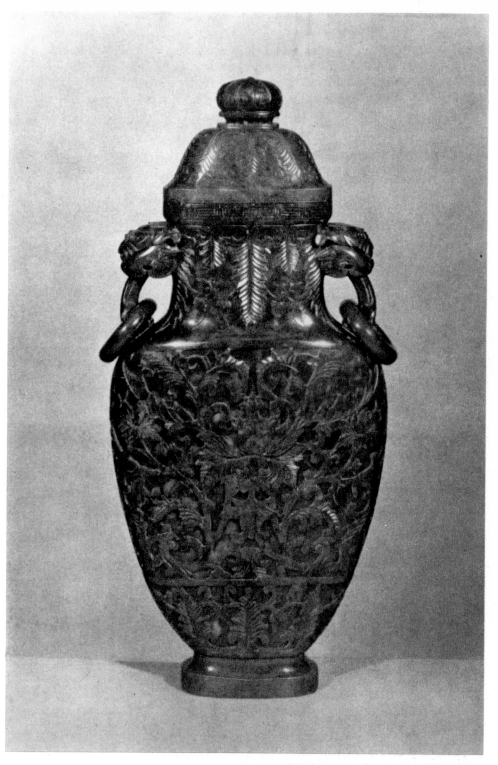

A NEPHRITE VASE AND COVER

The body and cover decorated in floral representation ; masks support two loose rings at neck.
COLOUR : Dark Green. Ch'ien Lung Period, A.D. 1736-1795. H. 28.5 c.m.
(In the Collection of Sir John Buchanan-Jardine, Bt.)

introduced into China until the beginning of the Christian era—when it was brought from Central Asia. It is not surprising, therefore, to find that its first appearance in jade was during the Ming Dynasty, when small pomegranates were made for betrothal gifts—sometimes in the form of vases in the shape of the fruit—at other times, merely as symbolical representations of the fruit fully ripe.

THE BUDDHA'S HAND CITRON.[1]

The Buddha's Hand Citron, or finger-citron (*Citrus decunana*) the symbol of happiness, appears to have been used first by the jade carvers during the Ming Dynasty, during which period it was also introduced to form emblematic decoration.

In an extensive search of records of known jade carvings, I have been unable to trace any representation of this fruit and tree by any jade carver which reasonably could be ascribed to an earlier date. It is significant that Dr. Laufer does not mention it anywhere in his book on Jade, nor that any other writer has given more than a few words to it. The Chinese frequently utilised it, together with the pomegranate and sacred peach, as part of the altar decoration of Buddhist shrines. PLATE CXI, from the Collection of Mrs. Butter, portrays an excellent carving of a Buddha's Hand Citron in the form of an altar vase, carved during the Ch'ien Lung period and bearing the imperial Ch'ien Lung seal mark.

THE LOTUS.

The Lotus (*Nelumbium speciosum*), the Chinese emblem for purity and numerous progeny,[2] has been immortalised by Buddhism, flower, fruit and petals being all symbolic. The Lotus represents the evolution of the Buddhistic worlds from the eternal cosmic matter.[3] In short, it is the emblem of purity, and typical of Buddhist India[4]; being derived from the Indian water-bean. Its roots are of jade-like whiteness, and glistening drops of water resting on its spread leaves, are symbols of Buddhist enlightenment.

The appearance of the Lotus in jade carvings probably followed the official introduction of the Buddhist faith into China, A.D. 67. There is recorded in the *Ku yü t'u p'u*, a jade headpiece of a girdle pendant in the shape of an inverted lotus leaf—this, according to the manuscript, is of the Han period, but Dr. Laufer discredits this attribution, and suggests that is is more likely to have been made in the T'ang period. It is certainly an innovation from any previous design or motive. This plant appears in jade decoration during the Sung Dynasty, and by the commencement of the Ming Dynasty the design, like the Prunus, was

[1] A peculiar kind of inedible citron (*citrus medica*) running almost entirely to rind and terminating in long fingers. It has a very powerful and fragrant odour. It is nailed on altars at Chinese New Year and other festivals. Its juices were used to wash linen and scent the hands.
[2] Doré, *Chinese Superstitions*, Vol. V, p. 723.
[3] Beal, *A Catena of Buddhistic Scriptures from the Chinese*, p. 11.
[4] Compare Getty, *The Gods of Northern Buddhism*, p. 172.

PLATE CIX

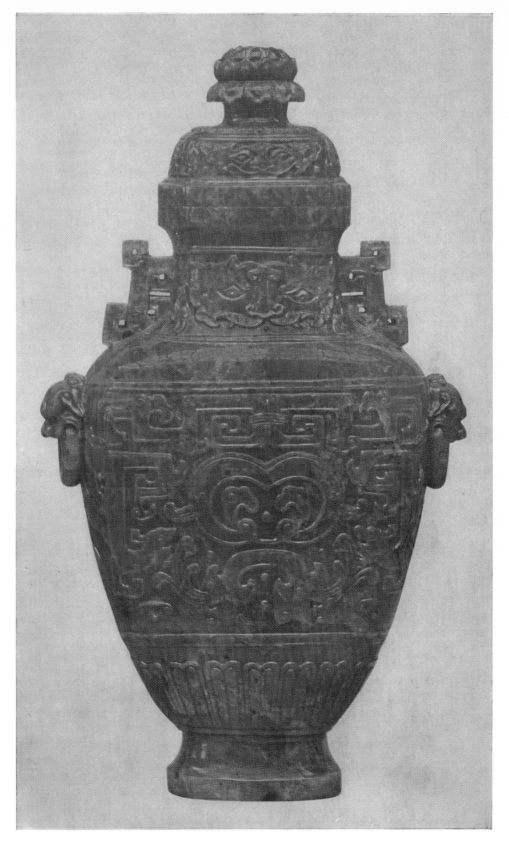

A JADE VASE AND COVER

Carved in relief with mask handles and fret shoulder adornments, ornamented with conventional
archaic dragons and tiger masks.

COLOUR: Spinach Green, bearing light and dark shadings with underlying bluish sheen.
K'ang Hsi Period, A.D. 1662-1723. H. 28.5 c.m. W. 17.5 c.m.

*(In the Collection of H.R.H. The Duke of Kent, and included
by His Royal Highness' Permission.)*

already established as a favourite with the craftsman of the Ch'ing Dynasty. By the 16th century we perceive a different manner of rendering this design, suggesting Persian influence, and it seems probable that the carvers copied the lotus scroll design (*Hui Hui Wên*) of the contemporary ceramic artists. By that time, several carvers were using the stalk, flower and leaf of the lotus in their carvings, and Laufer's *Jade*[1] shows a pleasing example of this era in the form of a bowl. Another example is shown in PLATE CXII, where the Lotus bud has been artistically introduced into the design of a wine vessel. Under the Ching Dynasty we find the lotus portrayed with an intricate skill and symbolic grandeur that would appear impossible for human hand to realise.

THE FLOWERS OF THE FOUR SEASONS. (*SSU CHI HUA*)

Spring	..	The Peony	Paeonia Mutan (*Neu-tan-hwa*).
Summer	..	The Lotus	Nelumbium speciosum (*Lieun hua*).
Autumn	..	The Chrysanthemum	C. indicum (*Chu hua*).
Winter	..	The Plum	Prunus Mumei (*Mei*).

THE FLOWERS OF THE TWELVE MONTHS.

January	..	Prunus	Prunus Mumei (*Mei hua*).
February	..	Peach	Amygdalus Persia (*T'ao hua*).
March	..	Peony	Paeonia Mutans (*Mu tan*).
April	..	Cherry	Prunus pseudocerasus (*Ying t'ao*).
May	..	Magnolia	Magnolia Yulan (*Yu lan*).
June	..	Pomegranate	Punica granatum (*Shih liu*).
July	..	Lotus	Nelumbium speciosum (*Lien hua*).
August	..	Pear	Pyrus spectabilis (*Hai t'ang*).
September	..	Mallow	Malva verticillata (*Ch'iu k'uei*).
October	..	Chrysanthemum	C. indicum (*Chu hua*).
November	..	Gardenia	Gardenia florida (*Chih hua*).
December	..	Poppy	Papaver somniferum (*Ying su*).

THE SACRED FUNGUS (*LING-CHIH* OR *FUH-LING*).

The Sacred Fungus according to mythology grew in the lands inhabited by the Immortals. It is a matter of conjecture what type of fungus was first adopted as an emblem by the Chinese. Mythology, however, suggests that the *Fuh-ling* (*Pachyma Cocos* or " *China root* "), the sponge-like growth which forms at the roots of the Pine Tree, was in reality their earliest inspiration.

We know that the early Taoists ate resin, believing that by so doing they would attain immortality. Also it is recorded[2] that Kiu-sheng,

[1] Plate XLV.
[2] De Groot, *The Religious System of China*, Vol. IV, p. 297, and Doré, *Chinese Superstitions* Vol. V, p. 724.

PLATE CX

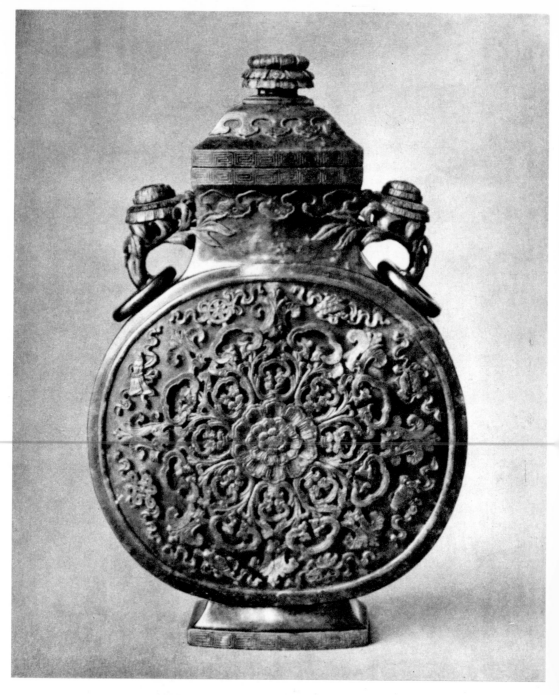

JADE VASE OF PILGRIM BOTTLE FORM

With two handles in the form of flowers and foliage with loose rings attached. Dome-shaped cover with flower knob, and carved designs in relief. On each side is a large medallion with a rosette in the centre from which radiate formal floral arabesques and *Ju-i* heads. Round this design are ranged the eight Buddhist emblems. Borders of key fret and *Ju-i* heads.

COLOUR: Dark mottled Green. Ch'ien Lung Period, A.D. 1736-1795. H. 35.5 c.m.

(In the Lady Lever Art Gallery Collection.)

PLATE CXI

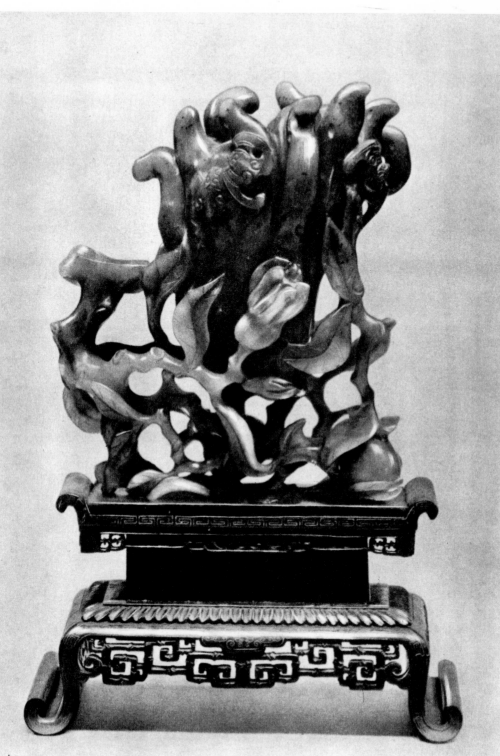

A TRANSLUCENT NEPHRITE CARVING IN THE FORM OF THE FINGER-*CITRON*
Bearing the Imperial Ch'ien Lung Seal Mark.
COLOUR : Dark Green, speckled Black. Ch'ien Lung Period, A.D. 1736-1795. H. 14 c.m.
(*In the Collection of Mrs. Butter.*)

the founder of the Shang Dynasty (1766 B.C.) attributed his long life to the fact that he consumed the gum of the pine.

Ch'u Siao San, a writer of the 1st century B.C., tells us, in the *Historical Records*, that the " hidden soul power is the root of the millenial pine, which when eaten causes one not to die."[1]

De Groot[2] tells us that " . . . The ancient Chinese believed that very old trees housed spirits[3] ; on account of this, tree and plant worship became general. Centennial trees were believed to be able to produce blood should an attempt to fell one be abortive. In the time of Wu-wang (12th century B.C.) the inhabitants of Yung Chow offered sacrifices at the foot of a large tree which housed a *Shen*." Very probably it is this belief in a great tree (and the pine is certainly one) that assists to establish which fungus actually inspired the Sacred Fungus design. It is known that at the foot of the pine tree a growth of the Agaric family, the *Fuh-ling* (*Pachyma cocos*) is often found.

From the jade collector's point of view the decoration of the jade carving *Yü*,[4] which resembles those in the *Ku yü t'u p'u*, is worthy of special notice. Is not this carving one of the earliest renderings in jade of the formula from which the Sacred Fungus was derived ? Or, as is suggested by " Dame Una Pope-Hennessy,[5] might it not have been derived from a gradual transformation of the cloud spiral decoration of the early jade carvers' symbolical representations, the head, as in the Dragon carvings, being represented by symbolical clouds? Later in the Han Dynasty the dragon appears, belching clouds from the mouth and, later still, the clouds envelop the entire head of the monster, which in course of time is transformed, appearing as the sacred fungus."

It is apparent that the origin of the portrayal of the *Ling-Chih* is wrapt effectively in remote antiquity, and must be traced with an open mind. My impression is that the earliest carvers were producing the more material Agaric, the *Fuh-ling*, or growth from the root of the pine tree which is sponge-like and porous, instead of the *Ling-Chih*.

The *Ling-Chih* according to Bretschneider[6] belongs to the Agaric family (*polyporus lucidus*) and was chosen as an emblem of good omen by the Chinese on account of its natural ability to absorb the vapours of the earth. Some authorities are of the opinion that this fungus was introduced to the Chinese as an emblem from India, and support to this theory is forthcoming by the fact that representations of this form of fungus in the works of the Jade carver do not seem to appear before the use by them of the peach and bat, which suggests that it most likely was inspired at the time of the introduction of Buddhism. If this line of thought is pursued it assists us to understand the introduction of the *Ling-Chih* in carvings of the Ming Dynasty, in which it is

[1] De Groot, Vol. IV, p. 299.
[2] *Ibid*, p. 280.
[3] Compare the Greek *Hamadryads* (see W. S. Landor's poem " The Hamadryad ").
[4] Pope-Hennessy, *Jade*, p. 72.
[5] *Jade*, p. 79.
[6] *Botanicon Sinicum*, Parts 2 and 3.

134

found portrayed in conjunction with the peach and bat and, furthermore, as it was primarily significant of water, its connection with the dragon as a rain deity would be in symbolic harmony.

The previous mythological connection of the Sacred Fungus with Longevity is portrayed by its representation in conjunction with the Crane, Stag, and Pine Tree, all of which individually symbolise great age, and it may well be that for this reason it was embodied in the ancient *Ju-i* sceptre.

During the Ming period the *Ling-Chih* is crudely represented as a form of decoration in high and low relief. During the Ch'ing Dynasty many excellent carvings in which it appears were created. PLATE CXIII portrays an exceptionally fine white Jade Bowl, now in the Collection of Dr. J. W. Fisher, and said to have previously been in the Imperial Collection of the Emperor Ch'ien Lung. This specimen is adorned in bold relief with a representation of the Sacred Fungus.

The introduction by the carver of a tuft of grass interwoven in his representation of the Sacred Fungus, was an innovation which seems to have commenced in the carvings of the Ming Dynasty, and is accounted for by the Chinese belief that the Sacred Fungus is more potent, symbolically, after a tuft of grass has grown through its substance. Several authorities have been puzzled by this inclusion which appears to be a representation of some foreign leaf-like plant.[1]

[1] Compare Bushell, *Oriental Ceramic Art*, p. 117.

PLATE CXII

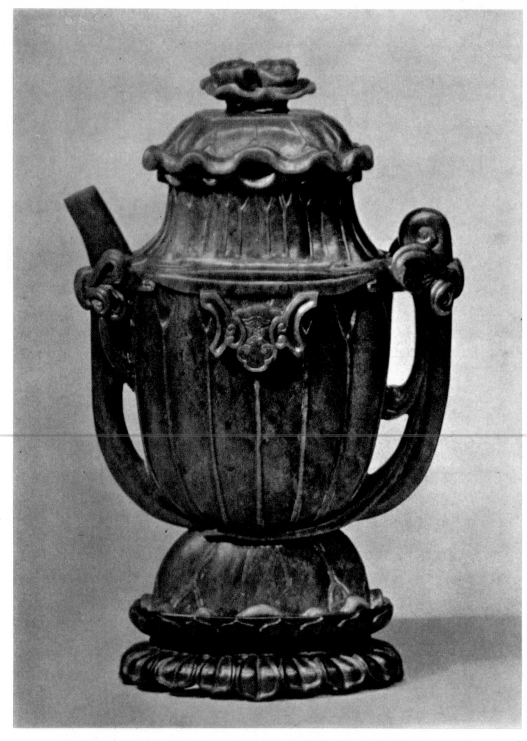

A TRANSLUCENT NEPHRITE WINE VESSEL IN LOTUS BUD FORM

Colour : Sage Green. Early Ch'ing Dynasty, *circa* A.D. 1650. H. 18 c.m. W. 12 c.m..)
(In the Collection of Frank H. Fulford, Esq.)

PLATE CXIII

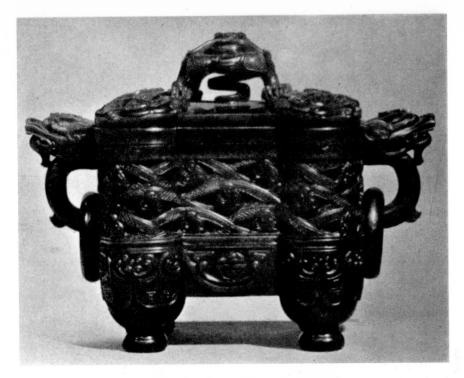

A JADE CASKET AND COVER OF BRONZE FORM

COLOUR : Opaque dark Green. H. 10.6 c.m. W. 14.4 c.m.

Ch'ien Lung Period, A.D. 1736-1795.

(In the Collection of Sir John Buchanan-Jardine, Bt.)

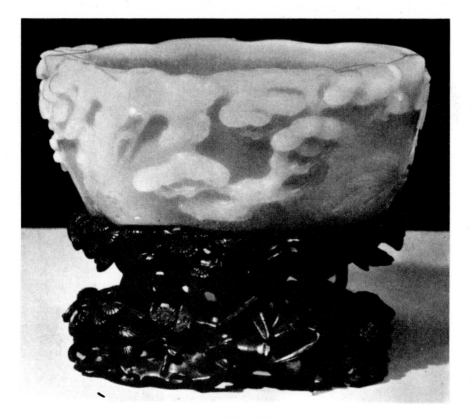

A JADE BOWL

Carved in bold relief with flowering Prunus and Sacred Fungus.

From the Imperial Collection in the Summer Palace, Peking.

COLOUR : Mutton fat. H. 8 c.m. W. 18.9 c.m.

Ch'ien Lung Period, A.D. 1736-1795.

(In the Collection of Dr. J. W. Fisher.)

PLATE CXIV

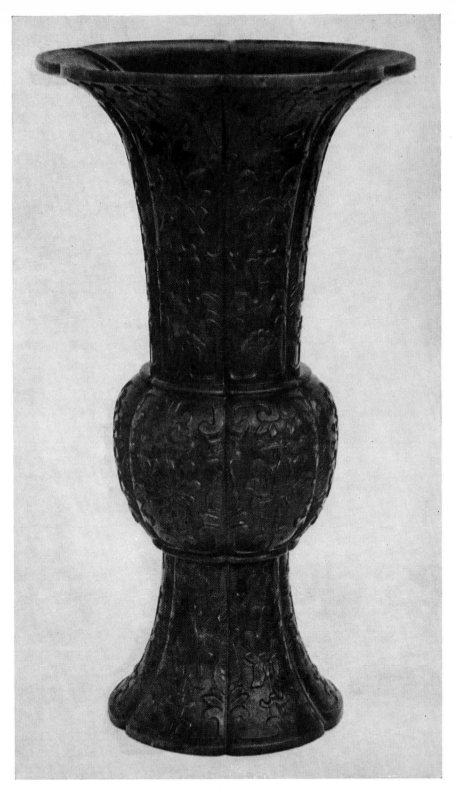

ONE OF A PAIR OF JADE BEAKERS (*KU*) OF BRONZE FORM

Colour : Dark Sage Green.　　Ch'ien Lung Period, A.D. 1736-1795.　　H. 22.7 c.m.
W. 12.7 c.m.　　　　　　　　　　　　　　*(Formerly in the Collection of Dr. R. Hearn.)*

PLATE CXV

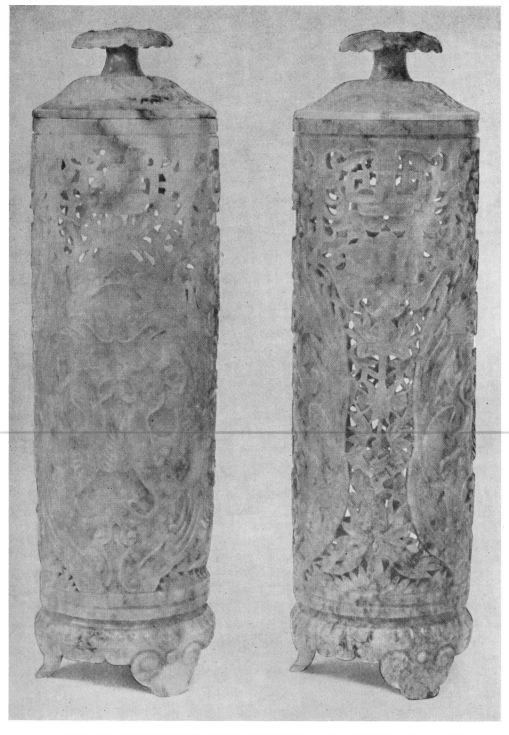

**A PAIR OF CYLINDRICAL *LIEN* (CASKETS) AND COVERS OF EARLY
BRONZE FORM**

Intricately pierced and carved with floral representations of the *T'ao T'ieh* mask and a pair of
Phœnix of archaic design.

COLOUR : Translucent Apple and Emerald Green. H. 26.7 c.m. Diam. 8.5 c.m.

Late 19th century.

(In the Collection of Frank H. Fulford, Esq.)

CHAPTER XVI

VASE FORMS IN JADE.

THE numerous carved jade vases dating from the commencement of the Sung Dynasty to the present time are of four distinct types, namely :

(1) Those which are copies of earlier ritual bronze vessels and were themselves made for a like purpose.

(2) Those objects made solely for use on the family altar and for other Private Ritual Services.

(3) Those vases which were made to serve as objects of use in the reception rooms and libraries of the Imperial household and of other wealthy Chinese families.

(4) Those made for the same patrons, but primarily for decorative purposes.

Under the first heading may be classed the various incense burners, libation cups, and altar vessels. An outstanding example is the emerald green jadeite incense burner from the Imperial Collection of the Summer Palace illustrated in PLATE CXVII. This carving is an excellent example of the fine coloured jade which was held in great esteem during the Ch'ien Lung period ; it is perhaps one of the finest specimens of translucent emerald green jadeite at present in Europe. Another example of this period derived from the same source, and lavishly carved with archaic ornamentation, is shown in PLATE CXVIII. It is of translucent green colour and displays a refined grace of line not always associated with the carvings of this late period.

The Libation cup illustrated in PLATE XXXIII, which is in the Collection of Dr. J. W. Fisher, provides a good comparison between the form and style of the ritual vessels made for private individuals during the Mid-Ming period and the later decorated types. This vessel possesses much strength of design, and retains many of the ancient characteristics of form and decoration. It is also interesting as showing the first signs of that tendency towards flamboyancy which became more marked in later carvings, commencing with the Ch'ing Dynasty, and which finally became distasteful, as is seen in many pieces of modern commercialised jade.

To assist in describing the objects which come under our second heading, namely, those made for religious use in Private Rituals, important information may be obtained from the following Chinese writings :—*Li-Ki* (Chap. V, Tseng tze wen) ; *Yuh-lih ch'ao-chw'an* : " Treatise on the Infernal regions" ; *Peh-hu t'ung* : "Annals of the White Tiger," written by Pan Ku during the Han Dynasty, circa A.D. 85 ; *Yao liu lu shu* ; and *Fung-shen-kia li-tsig-shwoh.*

To reach an understanding of the forms which come under our third heading, abbreviated quotations from two Chinese writers, Yuan Hung-tao[1] and Chang Ch'ien tê[2] will be helpful. Yuan says, " Among

[1] *Ping shih* (" History of Vases ").
[2] *P'ing hua p'u.*

137

vases in private collections, the finest are in the forms of ancient beakers (*ku*) with trumpet-shaped mouths ; next come copies of the forms made in the Imperial potteries of the Sung Dynasty, which are slender and graceful ; Vases for the decoration of the Scholar's study ought not to be large and heavy, and those most attractive, are those shaped like paper beaters; those with goose necks ; those fashioned in the shape of fruit and sacred plants, flower bags or baskets, and flower beakers (*hua tsun*) used to hold the divining rod and those of bulrush-shape. Any of these that are short and small are suitable for engraved decoration."

An exceptionally fine example of this ancient beaker type referred to by Yuan in the foregoing paragraph, is in the Collection of His Royal Highness the Duke of Kent and is illustrated in PLATE CXVI.

Chang when describing the selection of vases for floral decoration says that the " larger vases are placed in the reception hall, the smaller in the library. Rings and pairs are to be avoided, and special attention is to be given to rarity and beauty. The mouth of a vase should be small and the foot thick, so that it may stand firmly and not emit unpleasant vapour."

The fourth classification comprises objects made principally as decorative ornaments. To this division belongs the great majority of the vases and carvings found in Hardstone of the Ming and Ch'ing Dynasties. These, although made primarily for decorative purposes, are in their forms the lineal descendants of the earlier flower vases, wine receptacles, and ritual vessels. Examples in this division include screens for windows and plaques for bed carvings ; representations of mythological stories for the long side-tables placed in the reception hall ; small vases for the toilet table, bowls, teacups, wine cups, dishes and platters for everyday use, also marriage cups, of elaborate design, and pans and jars of manifold forms and capacity.

THE HOUSEHOLD ALTAR.

From remote ages the Chinese have possessed their family Altars[1] which are placed in the principal room of the house, and occupy an honoured position on the *Kung-choh* (Long table). The objects usually found in a miniature shrine are as follows :

A Jade Tablet bearing an inscription, usually concerning the " Gods to whom is offered incense " ; a pair of pricket candlesticks ; and, in the centre, an incense burner. To these may be added a statuette of Kuan-yin, or of other divinities.

OBJECTS USED IN THE RITUAL BEFORE BURIAL.

On a table placed at the head of the coffin before burial, the following objects are laid :[2]—In the centre of the table, a tablet or screen inscribed with the name of the departed spirit ; immediately in front of this screen, a small lamp, of the type shown in FIG. 71 ; on each side of the

[1] *Chou Li*, Chu-shu (" Glossary of the Chou ritual ").
[2] Doolittle, *Social Life of the Chinese*, Vol. I, p. 207.

lamp, a pricket candlestick flanked on the right hand side by a large pure white bowl, which contains usually an uncooked chicken, with the head placed towards the coffin. Between the lamp and the screen is placed an incense burner, and at the rear of the table, on the left of the tablet, the "rice offering" (*T'ao-t'eu-fan*) in another plain white bowl. To these essential objects are sometimes added a wine cup, a jar of wine, a pair of chopsticks, a wash-hand basin, and a pair of shoes, the soles of which have been cut in two.[1] A drawing depicting the general arrangement of these objects is shown in Doré's *Researches into Chinese Superstition*, Vol. I, Fig. 24.

FIG. 71 taken from Wu Ta Ch'êng's book illustrates a typical lamp used in connection with this ritual. He describes it as of a soft cream shade and assigns it to the Han Dynasty, but considering its form and especially the intricate lotus motive design of its base, I am of opinion that it belongs to the Sung Dynasty. The actual lamp shown in this drawing is now in the important collection of Mrs. William H. Moore, New York.

FIG. 71

VESSELS USED IN PRIVATE ANCESTRAL WORSHIP.

The general arrangement of the objects used in the Solemn Ritual Sacrifice of Ancestral Worship, which originated at the very birth of the Chinese nation,[2] comprises six bowls containing wine, meats, fruit and vegetables[3] and, as in other rituals, the screen,[4] incense burner, and pricket candlesticks.

THE WU KUNG.

The *Wu Kung*,[5] or set of five sacrificial utensils, was an essential part of the ritual "regalia" of an Ancestral Temple. The vessels were placed in the foreground on a special table set apart for them. The

[1] Plate XVIII—Laufer: *Archaic Chinese Jades in the Bahr Collection*, portrays the jade coverings sewn on to the bottom of these shoes: these specimens are of the Chou period.
[2] *Tze-chi t'ung-kien kang-muh*: *Chou Li chu-shu*: *Chou Li t'ien kwan shen-fu*, and *T'ung-suh-pien* (Record of Popular Customs).
[3] *Li Ki*, Chap. T'an-Kung, Sect. II, Part II, No. 8.
[4] *Ming-tu-muh t'ing-yü Ki-t'an.*
[5] *Chinese Exhibition Catalogue*, No. 2508.

centre piece consisted of an incense urn (an outstanding example of such a vessel, of the Ch'ien Lung period, is in the Collection of Her Majesty Queen Mary and is illustrated in PLATE XLIII), flanked on either side by two pricket candlesticks (see PLATE XCI) and by two side pieces. These side pieces were changed at each season.[1]

In the Spring are used a pair of rhinoceros vases (*hsi tsun*) ; in the Summer, a pair of elephant vases (*hsiang tsun*) ; in the Autumn, a pair of cup-shaped vessels (*chu tsun*) ; and in the Winter, a pair of plain ovoid vases with spreading lips (*hu tsun*).

The incense urn forming the centre piece remained unchanged. These sets of vessels were used on Taoist and Buddhist altars, and in later times in the larger Chinese houses.

In some cases a single censer is used on the private altar, which may be of various forms, in others, a tazza-shaped cup, " *Ch'ing shiu wan* " (pure white bowl), or a plain pure white bowl, flanked by a pair of Lions (see PLATE LXVII), was used to hold the moulded rods of fragrant sawdust, commonly known as " joss sticks."

THE *SAN SHE* OR " SET OF THREE."

This apparatus placed on a separate table was always before the throne of the Emperor. It comprised an urn (*lu*) for burning incense, a box (*ho*) with cover for the storage of the incense in readiness for use. Two exceptionally fine examples of these boxes, which form part of the Collection of Jades of His Majesty King Edward VIII, are illustrated in PLATE CXXI by the gracious permission of His Majesty.

A vase (*p'ing*), to hold the miniature tongs, poker and shovel used to replenish the burning incense, is illustrated in PLATE CXIII.

WINE VESSELS.

During the marriage ceremony in China it is customary for the bride and bridegroom each to drink in succession three cups of wine.[2] The vessels used during the ceremony are mentioned in the ancient books on ritual ; they comprise a jar (*tsun*) to be filled with wine, and to stand on the east side of the altar ; four single cups (*chüo*) in the shape of the ancient libation cups, to stand on the south side ; and, in the centre, a double cup or box (*ho-ch'êng*) of emblematic peach shape (see PLATE CVII), or decorated with relevant designs, such as two interlacing lozenges, a pair of linked hollow rings (emblematic of union and success), peaches and bats (symbols of longevity and happiness), and (or) bearing the *Shuang hsi* hieroglyphic (signifying " double joy "), all of which are the special attributes of conjugal happiness.

THE *CHIU HU*.

This vessel is similar in form to the European tea-pot. Ancient Chinese writings record[3] that such vessels were made for the early

[1] Bushell, *Oriental Ceramic Art*, p. 491.
[2] Compare Doolittle, *Social Life of the Chinese*, Vol. I, p. 85 and p. 90.
[3] See the *T'ao Shuo*.

PLATE CXVI

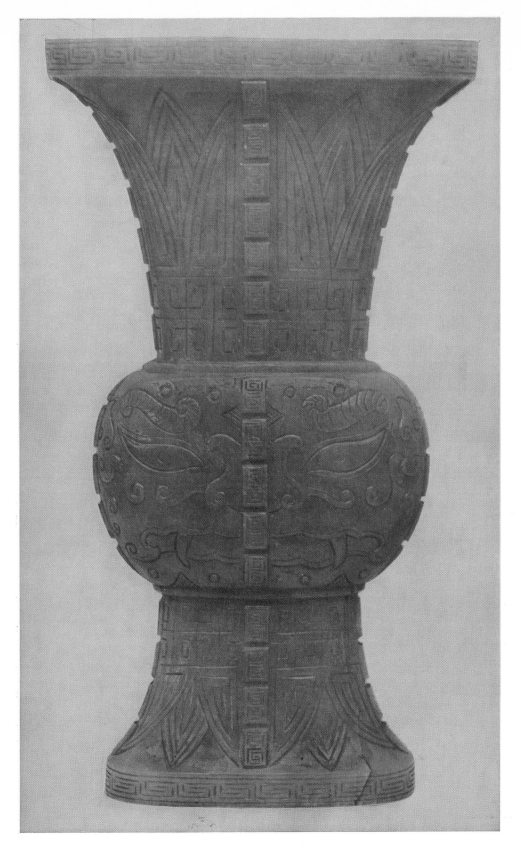

A TRANSLUCENT JADE BEAKER VASE·OF EARLY BRONZE FORM

Carved in bold relief with representation of the *T'ao T'ieh* and conventional leaf and key-fret designs.

COLOUR: Pale celadon Green.　　　　　　　H. 28.7 c.m.　W. 16.4 c.m.

Early Ch'ien Lung Period, *circa* A.D. 1740.

(*In the Collection of H.R.H. The Duke of Kent and included by His Royal Highness' Permission.*)

PLATE CXVII

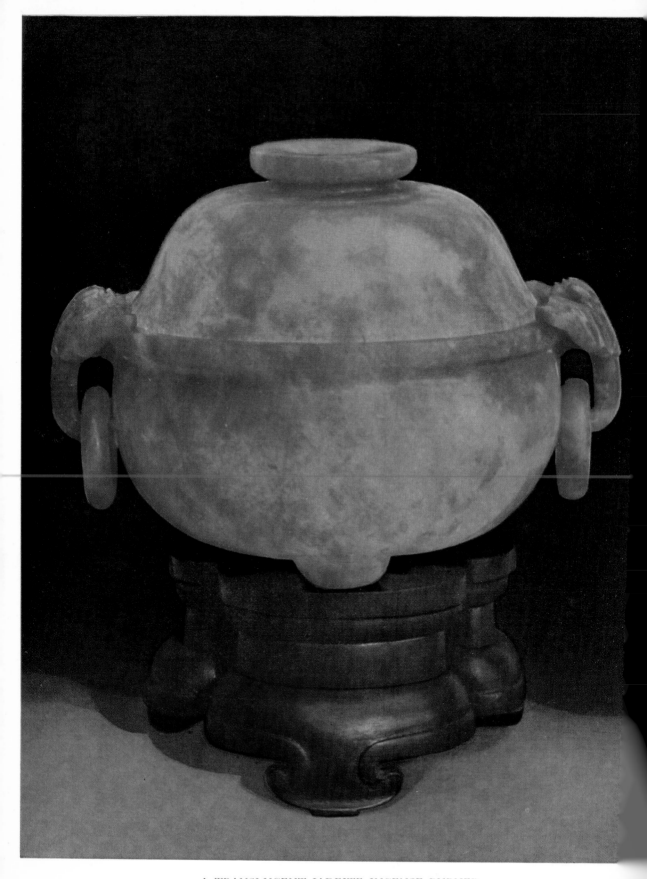

A TRANSLUCENT JADEITE INCENSE BURNER

COLOUR : Emerald Green. Ch'ien Lung Period, A.D. 1736-1795. Diam. 13.5 c.m. W. 17 c.m. H. 12.2 c.m.
Formerly in the Imperial Collection, Summer Palace, Peking. (*In the Collection of the Author.*)

PLATE CXVIII

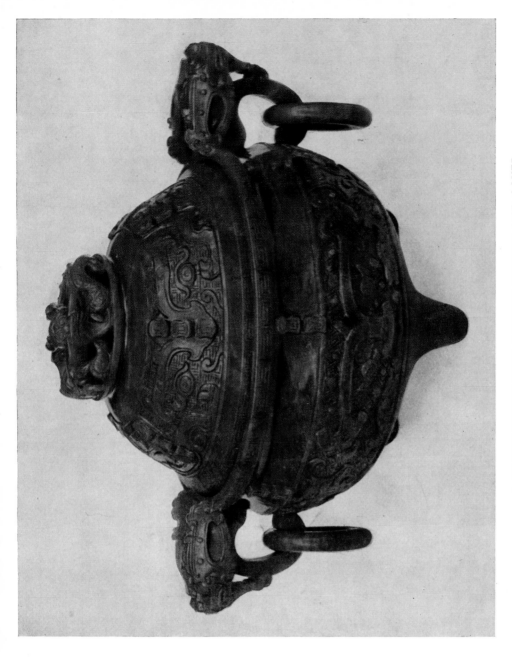

A TRANSLUCENT JADE INCENSE BURNER AND COVER

Intricately carved in relief with archaic representations of Buddhist Emblems, on a ground-work of cloud pattern; two monster heads support loose ring handles; the cover is surmounted by the Imperial Dragon.

COLOUR: Sage Green. Ch'ien Lung Period, A.D. 1736-1795. H. 12.5 c.m. W. 19.2 c.m.

(Formerly in the Summer Palace Collection, Peking.)

PLATE CXIX

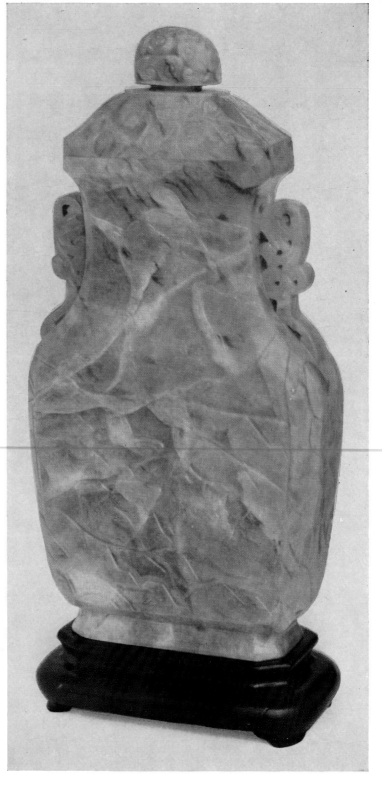

A VASE AND COVER CARVED IN NEPHRITE

Carved in relief with a representation of the Isles of the Blest, stags,
bats, and the *Yin* and *Yang* symbols. The handles on the neck of the
vase are of hydra form.

COLOUR : Apple Green with splashes of Emerald.

K'ang-Hsi, A.D. 1662-1722. H. 22.5 c.m. W. 11.0 c.m.

(*In the Collection of the Author.*)

PLATE CXX

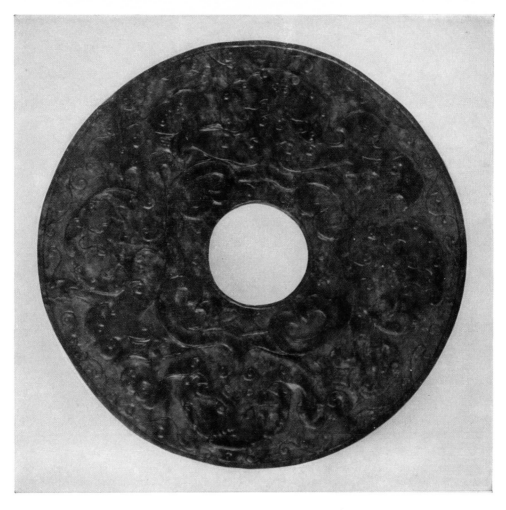

A JADE *PI* (RITUAL DISC)

Carved in relief with *T'ao T'ieh*, Tiger and Ox Masks.

COLOUR : Green, splashed Orange, Brown, Black and speckled Yellow and Red. Diam. 18.5 c.m.
Early Ch'ing Dynasty, *circa* A.D. 1700.

(*In the Collection of His Majesty The King and included by His Majesty's gracious permission.*)

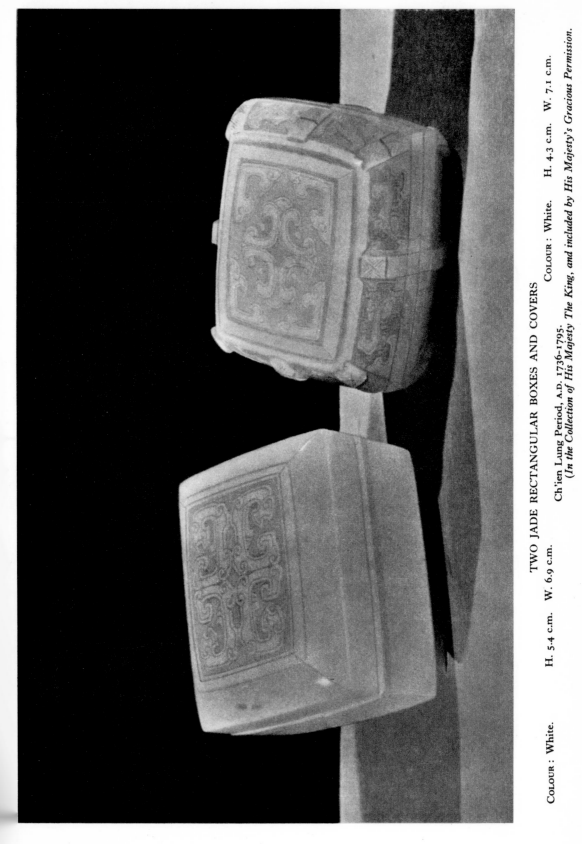

COLOUR : White.　　　H. 5.4 c.m.　　W. 6.9 c.m.

TWO JADE RECTANGULAR BOXES AND COVERS　　　COLOUR : White.　　　H. 4.3 c.m.　　W. 7.1 c.m.

Ch'ien Lung Period, A.D. 1736-1795.

(In the Collection of His Majesty The King, and included by His Majesty's Gracious Permission.)

PLATE CXXII

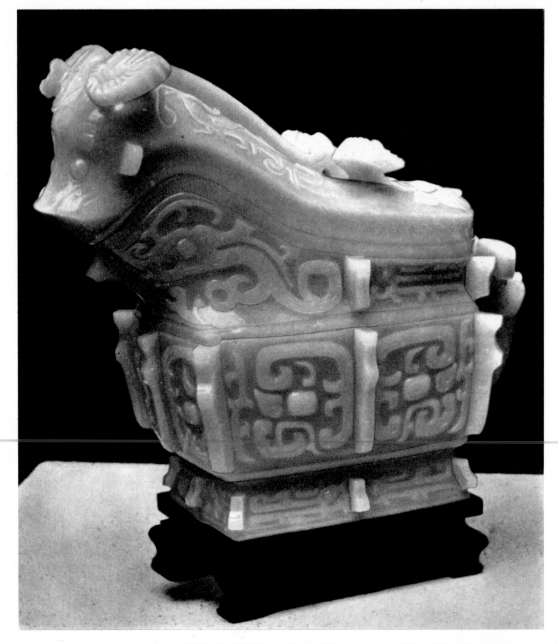

A TRANSLUCENT NEPHRITE EWER AND COVER OF BRONZE *KUANG* FORM

COLOUR : White. Tao-Kuang Period, A.D. 1821-1851. H. 20.3 c.m.

(In the John Yates Collection, Manchester Art Gallery).

PLATE CXXIII

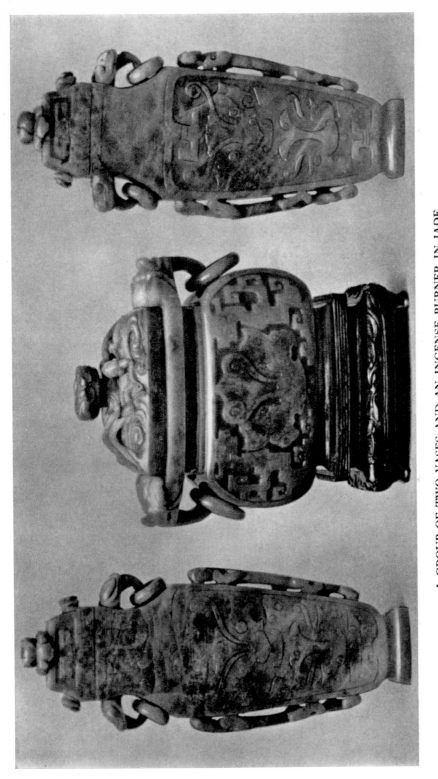

A GROUP OF TWO VASES AND AN INCENSE BURNER IN JADE

Carved in openwork and relief. The body of the Incense Burner is decorated in the centre with an archaic ogre (*t'ao t'ieh*) which is upheld on each side by a conventional dragon (*chih-lung*). Two loose ring handles are supported from lion masks. The cover is ornamented with an interwoven representation of a *Fêng-huang* among clouds, the knob of the lid being similarly designed. All borders are decorated with the key pattern. The pair of vases are similarly adorned on their bodies with pierced relief carving of two hydra (*chih-lung*) and the necks of each vase are engraved with inverted palmettes. Two loose ring handles are supported by double *ling-chih*. The covers are surmounted with Lotus flowers flanked on each side with a bat.

COLOUR : Vases and Incense Burner, Apple Green. Incense Burner, H. 14.6 c.m. W. 13.9 c.m. Vases, H. 20.3 c.m. W. 8.3 c.m.

Ch'ien Lung Period, A.D. 1736-1795.

(*In the Collection of Major R. W. Cooper.*)

PLATE CXXIV

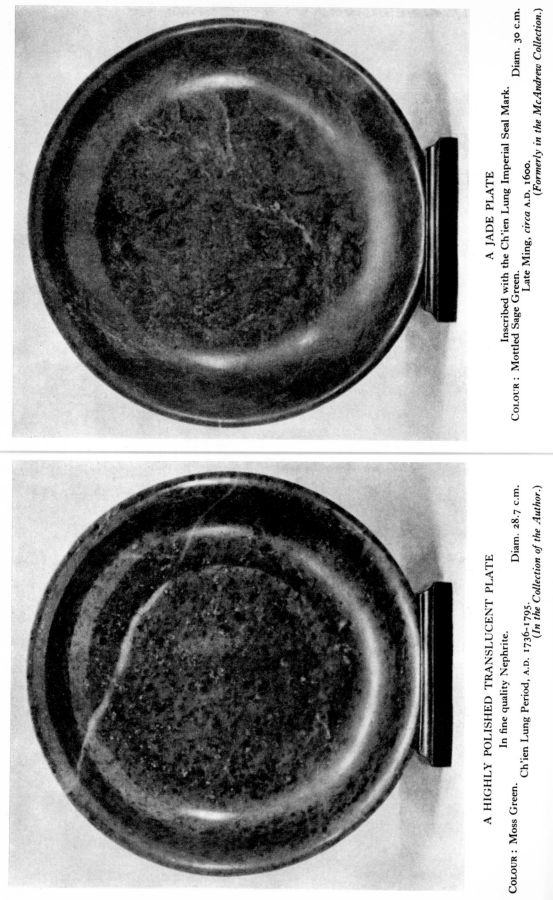

A HIGHLY POLISHED TRANSLUCENT PLATE

COLOUR : Moss Green. In fine quality Nephrite. Diam. 28.7 c.m.

Ch'ien Lung Period, A.D. 1736-1795.

(In the Collection of the Author.)

A JADE PLATE

Inscribed with the Ch'ien Lung Imperial Seal Mark. Diam. 30 c.m.

COLOUR : Mottled Sage Green.

Late Ming, *circa* A.D. 1600.

(Formerly in the McAndrew Collection.)

PLATE CXXV

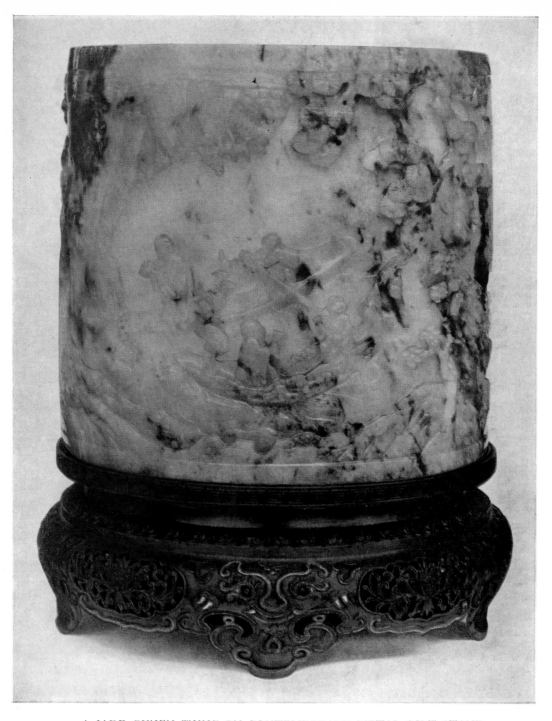

A JADE *CH'IEN T'UNG* ON CONTEMPORARY METAL-GILT STAND

COLOUR : Translucent Apple Green Nephrite, splashed with Rust Brown and Black. H. 18.5 c.m.
Ch'ien Lung Period, A.D. 1736-1795. Diam. 20.2 c.m.

The specimen is carved externally in bold relief with the mythical representation of *Shou Lao* crossing
the waters with another deity on his journey into the " Isles of the Blest " ; on the reverse side is
portrayed an imposing representation of this Land of Paradise with the Stag (emblem of longevity)
roaming therein.

(Formerly in the Collection of Commander R. E. Gore, R.N.)

PLATE CXXVI

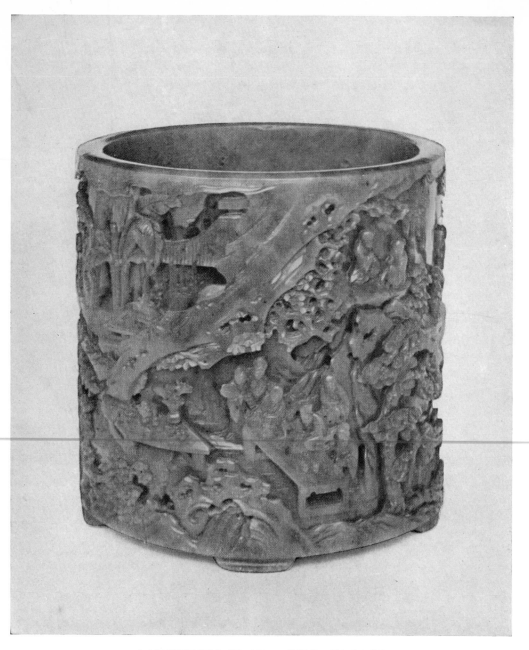

A TRANSLUCENT NEPHRITE BRUSH POT

The bold relief and pierced carving representing several mythological events and portraying well-known figures, of which the following are easily recognisable :

1. " The Club of the Seven Worthies of the Bamboo Grove " (*Chuh Lin Ts'i Hien*) accredited to have been formed *circa* A.D. 275, depicting :
 Shan T'ao, the old man carrying a staff.
 Wang Jung, seated at the rear of the assembly.
 Ki K'ang, also at the table.
 Hiang Siu, holding a Scroll.
 Liu Ling, carrying a book.
 Yüan Tsi and *Yüan Hien*, carrying a fan.
2. " The Six Poets of Noble Birth," portraying the Female Court Figure, Three Nobles, and Two Priests.
3. *Hui Yüan* on Mount Lu, near the Temple Tung Lin, where he is seen interviewing two Literati, Tao Yüan-ming and Liu Sui Ching.
4. The God *Sun Têng* is seen playing on a stringed instrument.

COLOUR : Sage Green. Ch'ien Lung Period. H. 17.6 c.m. Diam. 17.9 c.m.
(In the Collection of E. L. Paget, Esq.)

emperors, and were designed with curved open-work handles in the form of a dragon, their spouts being terminated in the shape of a phœnix head. I have been unable to find any example of this type of vessel in jade which could with certainty be dated earlier than the Sung Dynasty. Two fine examples of the Ming period are included in the collection of Mr. Frank H. Fulford (PLATE CXII), and Mr. H. P. Clausen (PLATE XXXIII).

The later porcelain flower vases (*Yu hu ch'un*) bear a strong resemblance in form to these jade vessels, and it seems obvious that the ceramic artists in this instance were inspired by the jade carvers, rather than the contrary and more usual practice.[1]

Another form of jade carving which appears to have inspired the later Ceramic Art is the quadrangular vase decorated with the *pa kua* symbols. These vases, according to one authority,[2] were designed for the use of the diviner, and were usually placed on Taoist Altars, containing slips of bamboo to be used by the divining officials attending the Emperor.

THE *CHIEN T'UNG* OR THE QUIVER-RECEPTACLE.

This form of vessel carved in jade does not appear to have been made earlier than the K'ang Hsi period. The Manchu Tartars, renowned for their skill in archery, may have used them as prizes, to be bestowed upon military officers who rose in rank according to the ability they displayed in the use of the bow. The *chien t'ung* was either cylindrical or square in form, and lavishly decorated with mythical hunting scenes embodying some subtle reference to skill in archery, or with scenes of military prowess. They were usually supported on strong specially constructed metal stands. An outstanding example of this kind of vessel, of the Ch'ien Lung period, complete with its original stand, and said to be from the Imperial Collection in the Summer palace in Peking, is illustrated in PLATE CXXV.

PI T'UNG OR THE BRUSH CYLINDER.

This vessel is also cylindrical in shape, but is usually not so elongated as the *chien t'ung*. The *pi t'ung* dates at least from the Han Dynasty, reference to it being made in the *Ku yü t'u p'u* in the description relating to jade carvings used by the Literati. The decoration of this vessel contrasts with that of the *chien t'ung* in that it embodies literary symbols rather than representations of a military character. One or other of the *Ch'in, Ch'i, Shu, Hua* (four accomplishments) symbols are usually to be found interwoven in the subjects represented, which are sometimes mythological deities in appropriate settings. An excellent example of this type of vessel, in the collection of Mr. E. L. Paget, is illustrated in PLATE CXXVI.

[1] *Chiang hsi T'ung chih*: Book XCIII, folio 13-16 (vases sent to the emperor in Peking A.D. 1796-1895).
[2] Bushell, *Oriental Ceramic Art*, p. 472.

Other symbols found in the decoration of these vessels are :

(1) The *Wên chan shan tou* (" Scholarship equal to the Hills and the Great Bear ") implying the wish that its owner may not only attain the exalted heights of the *Tai Shan* (the ancestral mountain of China) but also reach that of the *pei tou* (the polar constellation), the celestial abode of the god of Literature.

(2) The *Chuang yuan chi ti* meaning, " may you obtain the degree of chuang-yuan " ! (the highest literary degree obtainable in China).

SNUFF AND MEDICINE BOTTLES.

In concluding this chapter reference must be made to the smallest vase form utilised in the art of jade carving, viz. the snuff-bottles (*yen hu*) and earlier " medicine-bottles " (*yao p'ing*).

The *Yao p'ing* of ancient China were originally intended to hold aromatics or rare drugs, and probably were first used during the Han Dynasty. PLATE LXXV illustrates one of these early " medicine-bottles," of that period, from the important Collection in the possession of Mr. W. G. Wrigley.

Another example, in the same collection, of natural rock form, of the Ming Dynasty, is shown in PLATE CXXVII.

The tobacco plant, indigenous to America, was introduced to the Far East by Portuguese or Spanish seamen at about the same time that it was brought to Europe. It is on record that the Emperor Wan-li (A.D. 1573-1660) unsuccessfully attempted to stamp out the use of tobacco. At the same time the practice of snuff-taking became the fashion of the wealthy classes in China. It is obvious therefore that the snuff-bottle proper cannot be dated prior to the 16th century, while the medicine-bottle is indubitably a product of ancient China.[1]

An extensive traffic in precious aromatics was in early times carried on by Chinese ships off the coasts of Africa and Arabia, and quantities of these small medicine-bottles must have been used to store the precious cargoes. Jade snuff-bottles have for long periods attracted the European Collector, probably on account of their variety and compactness. They are made in practically every kind of stone, but the specimens carved in rare coloured jades are the most treasured of all.[2]

[1] See article by Sir Walter Medhurst and Sir Harry Parkes in the *Transactions of the China Branch of the Royal Asiatic Society*.

Compare *I Monumenti dell' Egitto*, etc., Vol. II, p. 337, Pisa, 1834, in which an obviously false and ridiculous claim is made that a " snuff " bottle of great antiquity had been discovered in an ancient tomb! This may, however, have been one of the Early *Yao p'ing*, though even this seems unlikely.

[2] Marcus B. Huish, *Chinese Snuff Bottles*. No.37. " The Opuscula of the ' Sette of Odd Volumes.' 1895."

CHAPTER XVII

JADE OBJECTS FOR THE WRITING TABLE.

In the *T'ao Shuo* and the *Ku yü t'u p'u* we find accounts of these objects, those represented in jade being described as follows :

On the writing table :

(a) The *yen* or ink pallet, is stated to have been used by the Han and Sung emperors.[1] These pallets consist of oval slabs with a curved depression at one end. It is recorded that in the *Hsuan ho Palace* the emperor used " a *yen* the outline of which is like that of a vase, with loop handles at the sides for passing a string through for hanging the pallet upon the wall."[2] In the fifth book of the *T'ao Shuo* reference is made to an ink pallet of *Ko Yao* belonging to Ku Lin of which the author says " even pallets of the finest stone (jade) must be ranked below this specimen." In the Sung Dynasty (judging from a description of a jade ink pallet belonging to one of the Sung emperors)[3] the form was still oval but decorated with dragons bearing a band of triangular fret round the border.

(b) The *Mo Juan* or ink jar.

(c) The *Shui Chêng* or water pot was during the Han Dynasty a type of tazza-shaped cup similar in design to the bronze cups of oval form with foliated rims. During the T'ang Dynasty the *Shui Chêng* was of globular form with slightly spreading mouth and three small mammillated feet, obviously inspired by its bronze prototype.

During the Sung Dynasty it was of ovoid form with slightly spreading mouth and two small loop handles supporting loose rings. At that time the vessel was embellished with an archaic dragon in bold relief, similar to some of the porcelain vessels of the same period.

During the Ming Dynasty it followed closely the design of the Buddhist *patra* or alms bowl, having ribbed sides and a floriated type of decoration. These bowls contained a small spoon made of coral or other material, a vogue seemingly introduced during the later Sung Dynasty. With the advent of the Ch'ing Dynasty the *Shui Chêng* lost its early distinctive types, and was carved in a variety of forms.

(d) *The T'i-tzu*, or water-dropper, was made in jade in numerous shapes, sometimes taking the form of a tortoise. An excellent example of this form is in the collection of bottles belonging to Mr. W. G. Wrigley, illustrated in PLATE CXXVII. Other favourite designs were : the three-legged toad, a miniature wine ewer, or a lotus pod.

(e) *Chên Chih*, or paper weights. Wên Chên-hêng,[4] when describing objects of the Sung Dynasty, says : " In white jade we have Pencil

[1] The *T'ao Shuo*.
[2] Bushell, *Ceramic Art*, p. 140.
[3] Bushell, *Ceramic Art*, p. 203.
[4] Author of the *Ch'ang wu chih*.

rests (*Pi Ko*) of three hills, of five hills and of children reclining on flowers," and Dr. Bushell tells us the *Chên Chih* are made representing a scantily clad urchin or gaily dressed girl reclining on a leaf.[1] In the *Annals of the Kin Dynasty* (*Kin shih*) we read that mountains carved in jade were given by the Emperor as presents to his great grandson. Dr. Laufer tells us that these carvings are known as "*shou shan*" (longevity mountains).[2] In the *Ku yü t'u p'u* is recorded a jade carving of buckle form, probably of the Han Dynasty, which represents, according to the commentator, the sacred mountains of China. It is probable that the "mountain pencil rests," referred to by Wên Chêng-hêng, were in fact material objects derived from this Han representation as recorded in the *Ku yü t'u p'u*. It may be that from these "mountain pencil rests" the Ming craftsmen evolved the jade mountain representations of which an excellent specimen is to be found in the collection of Mr. H. P. Clausen (PLATE CXXXII). From these objects evolved the paper-weights of the Ming period. Other paper-weights, used by the Literati in ancient times and developed in later periods, were carved in the form of coiled dragons, lions, drums and mythical monsters, examples of which can be traced from the Han Dynasty, through the T'ang, Sung, Ming and Ch'ing periods.

(f) *The pi ko*, or hand rest, used by the scribe to steady his arm, was of oblong form with a convex surface. In the *T'ao Shuo* it is recorded that during the Sung Dynasty[3] "the *pi ko* was made in the form of a boy lying on a flower." During the Ming Dynasty the *pi ko* seems to have been simplified as is shown by an example in the form of a fish in the collection of Mr. H. P. Clausen. This specimen is so clearly an object for practical use that we can understand the popularity of such a simplified type among the scribes of past times.

(g) The *pi*, or brush-like pencil, is sometimes embellished with a jade handle.

(h) The *Pi hsi*, or bath, in which the brush is washed, was also made of jade. The *T'ao Shuo*[4] describes various types of this vessel made during the Sung Dynasty: some are "round and saucer shaped, of the form of an althæa flower with a rim of the foliated outline of a Buddhist stone gong, others are shaped like a lotus leaf with tilted margin; round dishes with a pair of fishes carved in bold relief upon the inter-rim, or take the form of chrysanthemum flowers, Buddhist alms bowls, and plaited and fluted platters." An exceptionally fine example of this kind of vessel is in the Collec-

[1] *Oriental Ceramic Art*, p. 494.
[2] Dr. Laufer's use (*Jade*, p. 331) of the term "*shou shan*" is a little misleading. The type of carving referred to usually portrays a pine clad mountain with pavilion and temples, representing the Taoist paradise. The *shou shan* are the immemorial hills where the immortal hermits wander eternally.
[3] See fifth book of *T'ao shuo*, dealing with objects of the Sung Dynasty, in which the writer tells us that the orthodox form is a "Miniature range of hills."
[4] See Book 5.

PLATE CXXVII

1 2 3

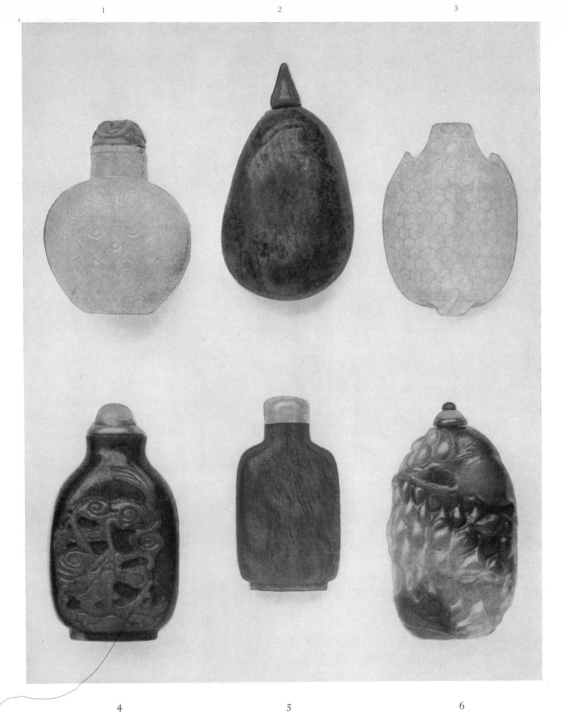

4 5 6

FIVE JADE SNUFF BOTTLES AND ONE TEAR BOTTLE

1. JADEITE SNUFF BOTTLE, carved with the eight *Taoist* Emblems.
 COLOUR : Mauve. 20th century. H. 5.8 c.m.
2. NEPHRITE TEAR BOTTLE.
 COLOUR : Brown and Green with Black and Yellow marking. Late Ming, *circa*
 A.D. 1600. H. 6.8 c.m.
3. JADE BOTTLE in the form of a Tortoise.
 COLOUR : Mutton-fat. Ch'ien Lung Period. A.D. 1736-1795. H. 6.8 c.m.
4. JADE SNUFF BOTTLE carved in relief with Dragon and Clouds.
 COLOUR : Black and Grey. K'ang Hsi Period, A.D. 1662-1722. H. 7.4 c.m.
5. JADE SNUFF BOTTLE.
 COLOUR : Emerald Green. 20th century. H. 5.9 c.m.
6. NEPHRITE SNUFF BOTTLE decorated with plant and leaves.
 COLOUR : Varied. Ch'ien Lung Period, A.D. 1736-1795. H. 7.5 c.m.

(In the Collection of W. G. Wrigley, Esq.)

tion of His Majesty King Edward VIII. It is of the Ch'ien Lung period and is here illustrated in PLATE CXXIX by the gracious permission of His Majesty. Another similar carving in white Jade decorated in bold relief is in the Walters Collection, U.S.A.[1]

(i) *The pi chuang*, " a bed for the *pi* to lie down in,"[2] would seem to have been of oblong form and shallow design.

(j) The *Yin*, or ancient seals of the Han Dynasty, were carved in jade or moulded in copper ; they are of oblong shape surmounted by handles, fashioned in various animal forms. Wu Ta Ch'êng in his book illustrates forty-nine types, mostly of the Mongol period, with their appropriate seals attached and described.[3] One of these of sky blue and white jade is reproduced in FIG. 72. This example would not seem to be earlier than the T'ang Dynasty.

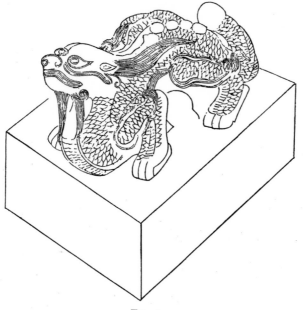

FIG. 72

(k) The screen tablets, used by writers to protect the unrolled work from the splash of the brush, were carved with an almost infinite variety of mythological subjects. These tablets are usually of rectangular shape and serve the double purpose of protecting and steadying the manuscript. Some are mounted in an oblong wooden pillow, which served as a cool rest for the scribe's head during the heat of summer. Others of both circular and oblong shape, usually carved on both sides, are inserted into the woodwork of beds, the round slab being mounted in the centre of the framework at the head of the bed, flanked on either side with oblong carvings.

[1] Compare Bushell, *Oriental Ceramic Art*, p. 124, note.
[2] This is the literal translation of the description of this vessel in the *T'ao Shuo*.
[3] For further information on seals, see P. Hoang, *Mélanges sur l'administration*, pp. 57 et seq., Shanghai, 1902. See also Getty, *Chinese seals found in Ireland*, Dublin, 1850.

PLATE CXXVIII

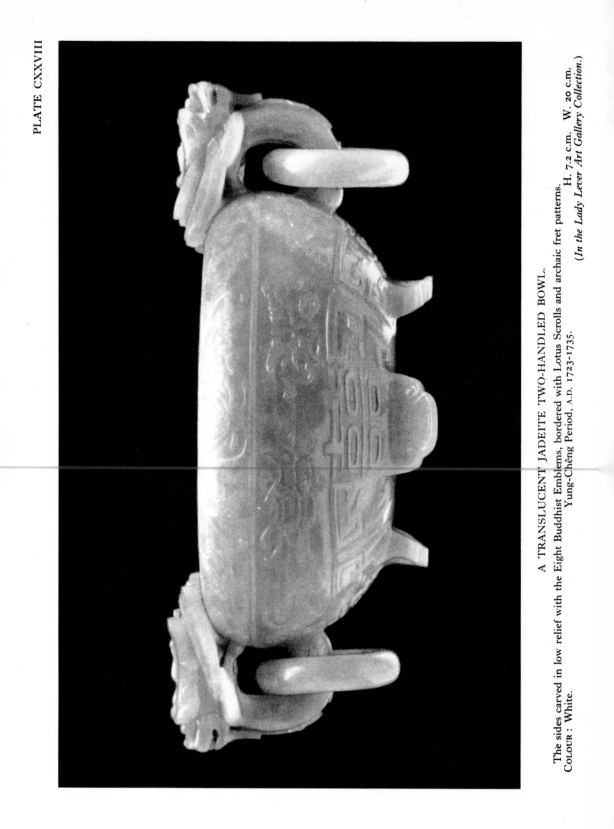

A TRANSLUCENT JADEITE TWO-HANDLED BOWL.

The sides carved in low relief with the Eight Buddhist Emblems, bordered with Lotus Scrolls and archaic fret patterns.
H. 7.2 c.m. W. 20 c.m.
COLOUR: White.
Yung-Chêng Period, A.D. 1723-1735.
(*In the Lady Lever Art Gallery Collection.*)

PLATE CXXIX

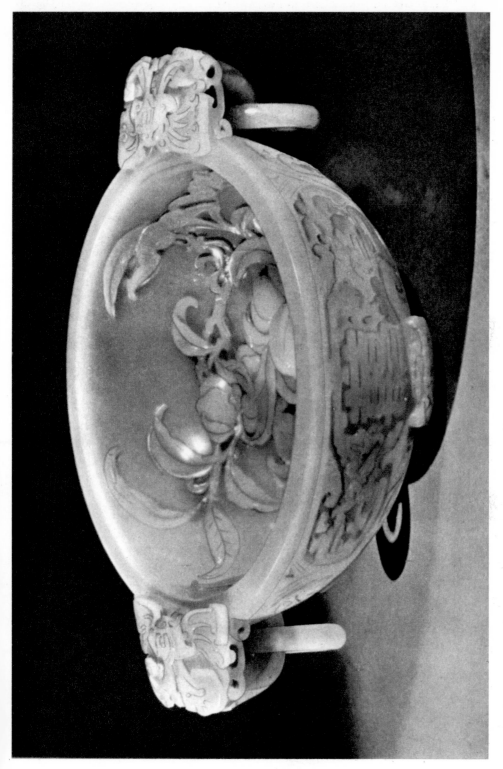

A JADEITE BOWL.

Carved in bold relief with two loose ring handles. On the outside the wedding symbol ; on the inside bats and peaches signifying longevity ; butterfly handles.

COLOUR : White.

Ch'ien Lung Period, A.D. 1736-1795. H. 10.4 c.m. L. 31 c.m.
(*In the Collection of His Majesty the King, and included by His Majesty's Gracious Permission.*)

An admirably carved white jadeite "screen," exemplifying this type of work, is in the collection of Dr. Fisher (illustrated in PLATE CXXXI). The vividly coloured and intricately carved screen tablets in jade would appear to have been introduced at the commencement of the Ch'ing Dynasty. The numerous specimens of this type of screen that I have seen in European Collections certainly do not date earlier. An example of the ornamental screen placed in windows, and in some cases forming the centre-piece for the family altar, is shown in PLATE CXXX. This example has its original metal stand. The bats and clouds carved on the reverse of this example have been reproduced on a larger scale to form the decorative " end papers " to this volume.

PLATE CXXX

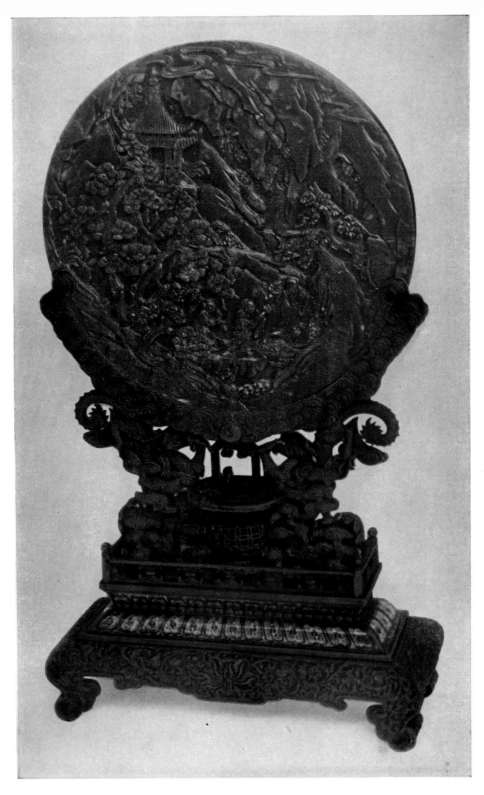

A CIRCULAR CARVED TRANSLUCENT NEPHRITE SCREEN ON
CONTEMPORARY METAL GILT AND CLOISONNE STAND

The carving represents *Shou-Lao* holding *Ju-i* symbol attended by his two
associates *T'ien-Kwan Sze-Fuh* and *Luh-Shen*, in the gardens of Hsi-wang-mu
(The Western Royal Mother). The reverse of the screen is carved with spiral cloud
pattern and flying bats.

COLOUR : Dark Sage Green. Diam. 22.5 c.m.

Ch'ien Lung Period, A.D. 1736-1795.

(Formerly in the Collection of Sir John Mullens.)

PLATE CXXXI

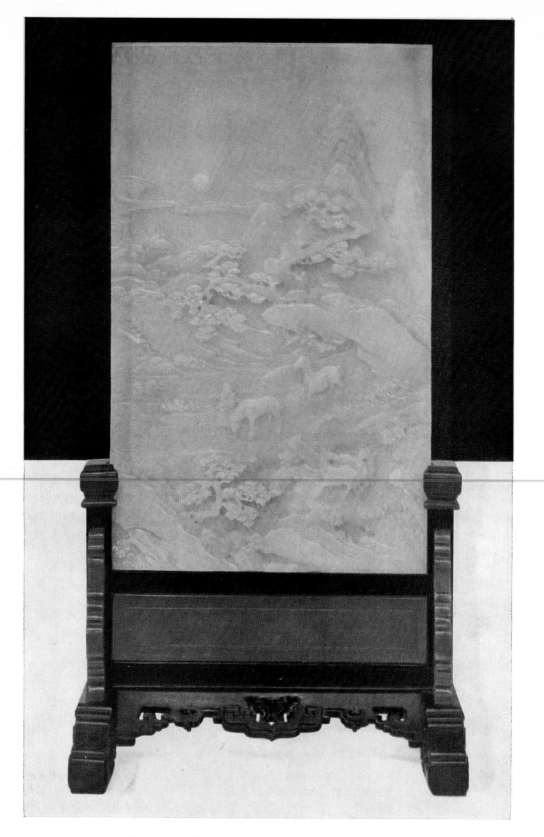

TRANSLUCENT JADEITE PLAQUE OR SCREEN

Carved in bold relief. On one side is represented *Hü Si-Yen* tying needles into the mane of a wild horse, prior to his reputed journey to visit *Sien Ta I Yuan-chün*; on the reverse side a portrayal of Wan-tze K'iao (Prince T'sin, the son of Ling Wang) (571-544 B.C.), riding on an ox playing a flute (*Ti*) in the How-she mountains, believed to have been his abode for over 30 years.

COLOUR: White. H. 26 c.m. W. 15.8 c.m. Thickness 1.3 c.m.

Ch'ien Lung Period, A.D. 1736-1795.

(*In the Collection of Dr. J. W. Fisher.*)

CHAPTER XVIII

DIVINITIES AND OTHER CELESTIAL FORMS CARVED IN JADE.

THE EIGHT TAOIST GENII OR IMMORTALS.

THE emblems of the Eight Taoist Immortals[1] are favourite decorations upon jade carvings, especially during the Ming and Ch'ing Dynasties, but are rarely found prior to those periods. The figures comprise :

(1) The Fan (*Shan*), carried by Chung-li Ch'üan, with which it is believed he revives the souls of the dead. This symbol is sometimes replaced by the fly whisk (*ying shua*).

(2) The Sword (*Chien*), possessing supernatural power, used by Lü Tung-pin.

(3) The Pilgrim's Gourd (*Hu-lu*), belonging to Li T'ieh-kuai, the source of magical appearances. This emblem is nearly always accompanied by the crooked iron staff (*kun*) of the lame beggar.

(4) The Castanets (*Pan*), attributed to Ts'ao Kuo-ch'iu, who is rarely portrayed without a pair in his hand.

(5) The Basket of Flowers (*Hua Lan*), carried by Lan Ts'ai-ho. This emblem is usually associated with the spade (*chan*) of the florist.

(6) The Bamboo Tube and Rods (*Yu Ku*), a type of drum carried by Chang Kuo.

(7) The Flute (*Ti*), played by Han Hsiang Tzu.

(8) The Lotus Flower (*Lien Hua*) possessed by the virgin damsel, Ho Hsien Ku.

During the Ming period certain jade craftsmen made statuettes of these Immortals in nephrite, and this practice continued, more or less, through the K'ang Hsi and Ch'ien Lung periods. Up to the latter date the carvers displayed great ability in the portrayal of their subjects, and some extremely fine specimens have come down to us. Towards the close of the 19th century, however, the figures bore evidence of haste in their execution and finish, the former qualities of symmetry and artistry being replaced by a severe and stolid type of creation.

The material used for modern specimens is still of excellent quality, though the designs lack the innate artistry of the older specimens and are unsatisfying to the connoisseur.

The usual attributes of these Immortals in jade carvings (FIG. 73) are as follows :[2]

Chung-li Ch'uan—generally portrayed bearded, corpulent and half naked. Always holding a fan and peach, or fungus.

[1] Kidd, *China*, p. 288.

[2] For fuller details, the reader is referred to Dr. Yetts' important book, *The Eight Immortals*; to Dr. Bushell's *Oriental Ceramic Art*, p. 579; and to Mayers, *Chinese Readers Manual*, Pt. 11, No. 251.

Li T'ieh-kuai—the Immortal Beggar, using a heavy type of crutch on account of his infirmity, and carrying a gourd shaped vase.

Ts'ao Kuo-chin—a bearded old man wearing a cap, and carrying a pair of clappers. He is sometimes portrayed wearing beautiful draperies, or robes, with a head-covering of an official type (cocked hat), but always carries a pair of castanets.

Lan Ts'ai-ho—portrayed equally as a youth, an aged man, and a girl, usually resting one foot on a spade and carrying a basket of flowers.

Chang Kuo-Lao—variously portrayed with script or castanets, and usually with a "*pao per*" or fish-drum, composed of a cylinder, over which is stretched snake or fish skin. He rides a donkey.

Han Hsiang-Tzu, the Immortal Musician—portrayed with symbolical instruments, and in the act of playing on a flute.

Ho Hsien-Ku—the only female Immortal, generally holding a ladle in the shape of a lotus flower, and abundantly draped with well-designed robes.

Lu Tung-pin—is of warrior type, with sword. The Patriarch of the Hsien, he is represented as an elderly man dressed in scholar's robes. His emblem is a two-edged magic sword. He is the patron saint of jugglers, magicians and barbers.

PLATE CXXXV shows an Altar Screen which formed part of the private individual's altar shrine adornments, and is carved with representations of the Eight Immortals.

OTHER TAOISTIC DIVINITIES.

Lao Tze (whose symbol is the Prunus) the founder of Taoism in China, was first represented as a Deity in jade carvings about the beginning of the 17th century. From that time to the present he has been the subject of many charming works, in which he generally appears seated on an ox.[1] Sometimes, however, he appears riding on a horse, stag, deer or mule. He is perhaps more readily recognised as Shou Lao, the God of Longevity. Three characteristic and distinct types of this divinity are found in jade, in them all Lao Tze takes the form of an elderly man, with an elongated, or protuberant type of head, sometimes having a long drooping moustache, but more often represented with a beard ; he is rarely without a pronged staff, and holds in one hand the symbolical peach fruit (PLATE CXXXVIII). Other carvings portray him mounted on a deer, or an ox, and in landscapes the carver rarely omits this deity whom he represents enshrined, or roaming in the Symbolical Hills of Longevity, with his two associates, Fu-Hsing and Luh-Hsing[2] (PLATE CXXXVI).

Before passing on, the appended brief summary and table of the five characters—Happiness, Honours, Longevity, Joy and Wealth—with

[1] Giles, *Biographical Dictionary*, pp. 416-417.
[2] Mayers, p. 150.

148

PLATE CXXXII

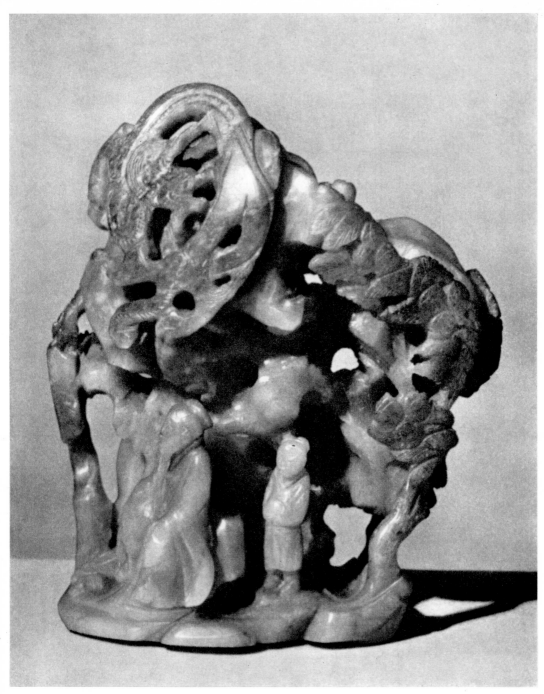

A NEPHRITE CARVING OF THE " ROCKY ISLES OF THE BLEST "

A fearsome representation of the Dragon in the brown colouring of the stone overshadows the entire work
COLOUR : Brown and Green.　　　Mid Ming Period, *circa* A.D. 1500.　　　H. 14 c.m.　W. 12 c.m.
(In the Collection of H. P. Clausen, Esq., U.S.A.)

PLATE CXXXIII

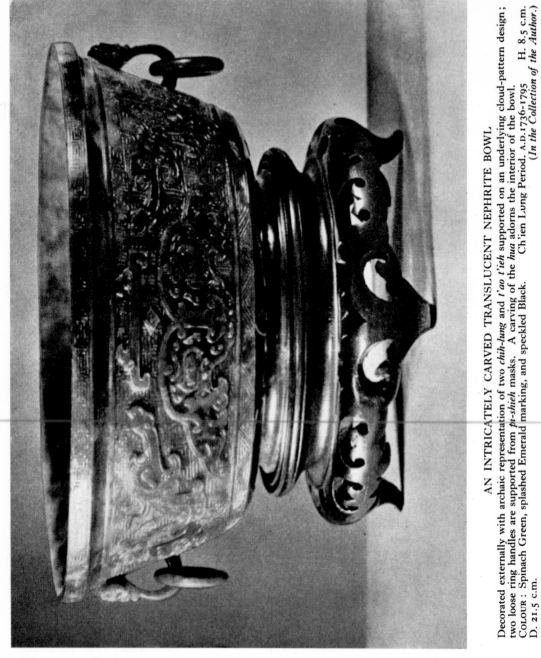

AN INTRICATELY CARVED TRANSLUCENT NEPHRITE BOWL

Decorated externally with archaic representation of two *chih-lung* and *t'ao t'ieh* supported on an underlying cloud-pattern design; two loose ring handles are supported from *pi-shieh* masks. A carving of the *hua* adorns the interior of the bowl.
COLOUR : Spinach Green, splashed Emerald marking, and speckled Black. Ch'ien Lung Period. A.D.1736-1795 H. 8.5 c.m.
D. 21.5 c.m.
(*In the Collection of the Author.*)

PLATE CXXXIV

A COLOUR REPRODUCTION OF THE BOWL SHOWN ON PLATE CXXXIII.

Showing the translucency of the Nephrite carving of this type.

the names of the Taoist Deities which they symbolise, may prove instructive.

Happiness	Fu (福)	Fu-Hsing (天官賜福) Ruler of Heaven.
Rank or Honours	Lu (祿)	Luh-Hsing (祿神) God of honours and dignities.
Longevity	Shou (壽)	Shou-Hsing or Shou Lao (壽星).
Joy	Hsi (喜)	Hsi-Shen or Pu Ti (喜神).
Wealth	Ts'ai (財)	Ts'ai-shen or Husen-t'an p'u-sah (財神).

The symbolical union[1] of these five felicities is usually a group of five bats.[2] This form, however, was not used by the jade carver earlier than the T'ang period.

T'ien-Kwan Sze-Fuh, the God of Happiness, is sometimes represented as an elderly man of military type, with mandarin cloak adorned with the archaic Dragon and Bat design. The literal translation of his name signifies " Heavenly Mandarin, who confers happiness." This Deity is also represented riding on a crane, and may easily be confused with Wang Tsze-ch'iao,[3] holding a flute (ti) and also riding on a crane.

Luh-Hsing, the God of Honours and Dignities, and official emoluments, is usually represented in jade, mounted on a mule, carrying scrolls. The mule, however, is sometimes replaced by a stag which bears the same symbolical interpretation.

The Deity Pu-Ti has been a frequent subject of the jade carver. He has also been portrayed in Chinese paintings and porcelain decoration. The same applies to Ts'ai-shen,[4] the God of Wealth, who is usually figured seated on a tiger, with uplifted arm supporting a knotted wand. Few carvings of the Taoist genii, in European hands, date earlier than the beginning of the 14th century.

Before leaving the circle of Shou-Lao (longevity) it may prove of interest to explain why certain animals always appear in jade in the same grouping.

The Manchurian Crane, accredited with an almost unending life, becomes the emblem of Longevity. Could there be a more fitting group than Shou-Lao and the crane (Sien-Hoh)? According to Chinese legend this bird is nearly as much esteemed as the Fêng Huang; it is considered the usual means of transport for the Immortals.[5]

The Tiger (Hu) and the Dragon (Lung) usually appear in carvings representing the God of Wealth (Ts'ai shen), owing to the belief that these two beasts could effectively guard any, or all of his treasures.

Similarly, we find Hsi-Wang-Mu, the Taoist Queen of the Western Fairyland, associated by the jade artist with Tung-fang So.[6] The

[1] On account of the similarity of the sound of the two words.
[2] Williams, *Dictionary of the Chinese Language*. Compare Doré: *Chinese Superstitions*, Vol. III, p. 254.
[3] Prince T'sin the son of Ling Wang (571-544 B.C.).
[4] Plopper, *Chinese Religion seen through the proverb*, pp. 173-174.
[5] Mayers, *Chinese Readers Manual*, p. 52.
[6] Supposed to have been one of the advisers of Wu Ti. Mayers, *Chinese Readers Manual*, p. 224.

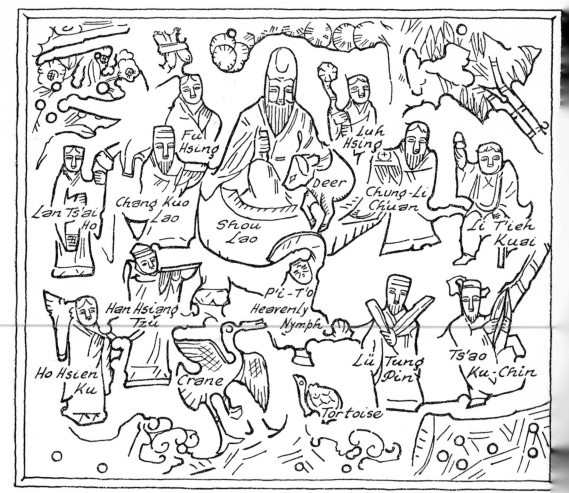

FIG. 73

Vide PLATE CXXXV.

PLATE CXXXV

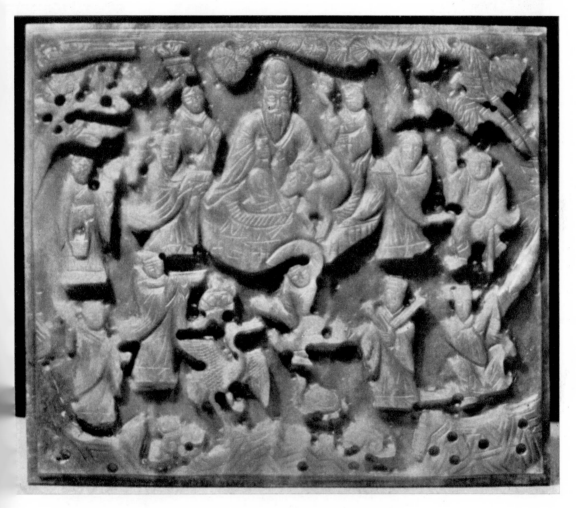

A TRANSLUCENT JADE ALTAR SCREEN

Depicting *Shou Lao* and his two attendants, the Eight Immortals and heavenly nymph accompanied by
Deer, Stag, and Tortoise.

Colour : Mottled Sea Green with Grey White, Brown and Fawn markings. H. 17.8 c.m. W. 20.4 c.m.
Late Ming Period, circa A.D. 1600.

(In the Collection of the Author.)

PLATE CXXXVI

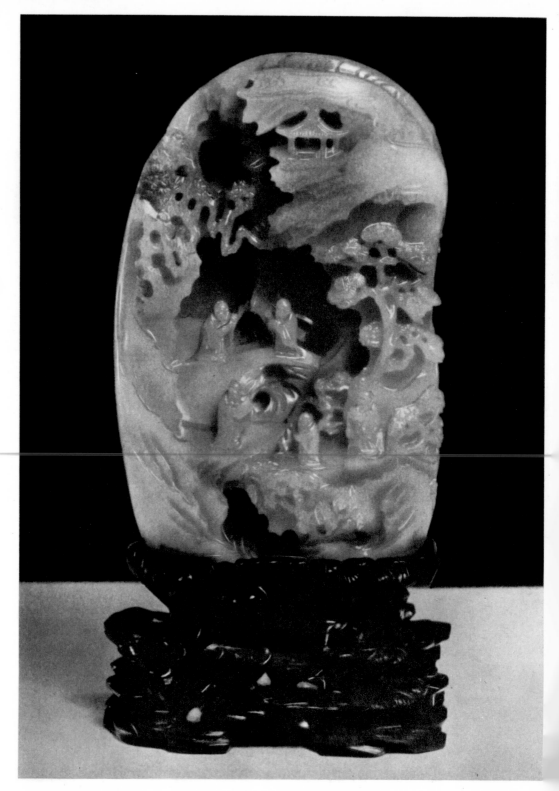

A TRANSLUCENT JADE REPRESENTATION OF " THE ROCKY ISLES OF THE BLEST "

Shou Lao and another Deity represented roaming in the Symbolical Hills of Longevity.

Colour : White. K'ang Hsi Period, A.D. 1662-1722. H. 15.5 c.m.

(The Property of a Private Collector.)

PLATE CXXXVII

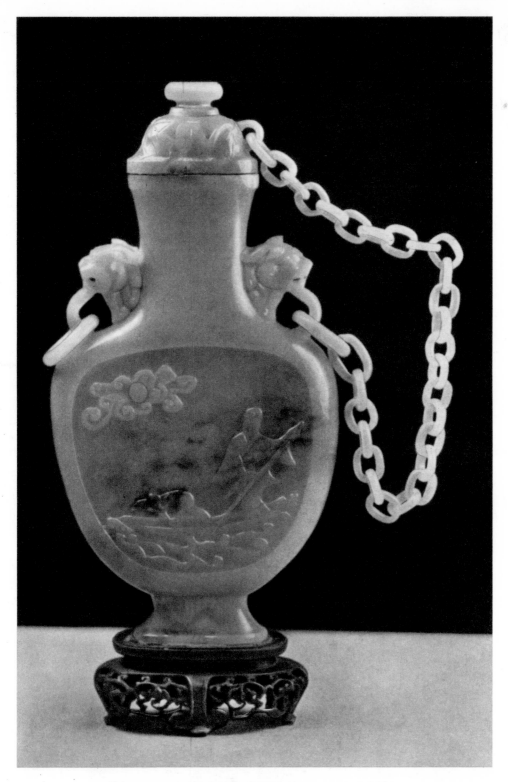

A TRANSLUCENT NEPHRITE VASE AND COVER
The whole carved from a single piece of rock.
COLOUR : Apple Green, splashed emerald shadings. Ch'ien Lung Period, A.D. 1736-1795.
H. 13.5 c.m. Length of Chain, 24.5 c.m.
(*In the Collection of Major R. W. Cooper.*)

PLATE CXXXVIII

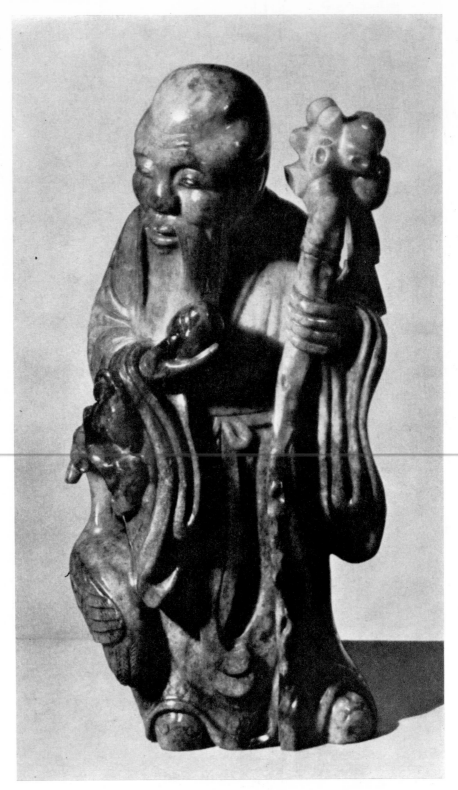

A JADE CARVING OF *SHOU LAO* (GOD OF LONGEVITY)

With Phœnix, Peach and Staff.

COLOUR : Grey Green. Mid Ming Period, *circa* A.D. 1500. H. 27.9 c.m.

(In the Collection of Oscar Raphael, Esq.)

PLATE CXXXIX

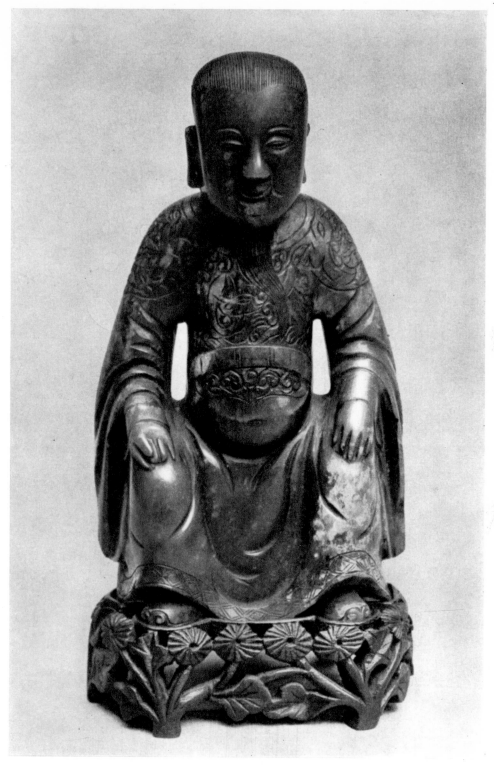

A REPRESENTATION IN JADE OF *T'IEN-KWAN SZE-FUH* (RULER OF HEAVEN)

COLOUR : Opaque mottled Grey Green, flecked Russet markings. H. 18.7 c.m.

Sung Dynasty A.D. 960-1279.

(*The Property of a private Collector.*)

PLATE CXL

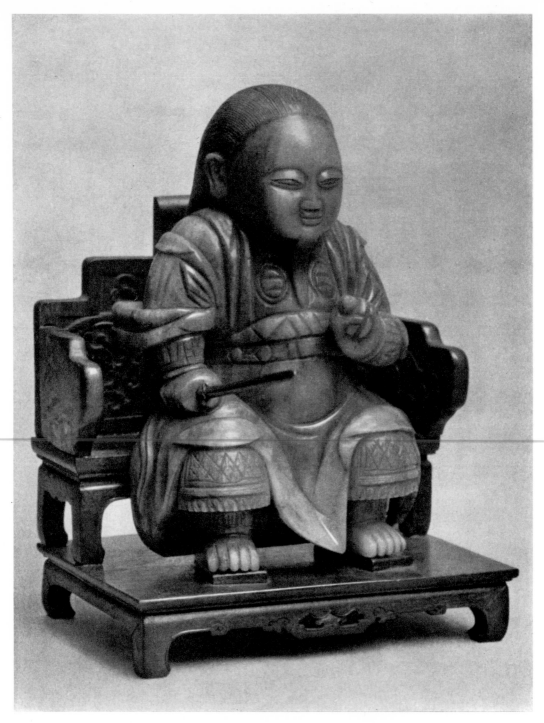

A JADE REPRESENTATION OF *HUAN-TI*

COLOUR : Opaque Green, splashed Grey, Brown and Black. T'ang Dynasty, A.D. 618-906. H. 23.4 c.m.
(*The Property of a private Collector.*)

ensuing is a legend of these personages, who appear in so many land-scape carvings from the Early Ming period to the present time :

Hsi-Wang Mu,[1] the possessor of one of *the Gardens of Paradise*, believed to exist in the Kun Lun Mountains, had evolved special trees and cultivated rare fruits. It is recorded that in her garden grew the peach tree whose peaches ripened once in 3,000 years, and to eat which conferred immortality. Tung-fang So[2] learned of these wondrous fruits and their reputed gift of eternal life and determined to taste the flavour of them. He therefore travelled into the Mountains, to these gardens and, discovering the peach-tree, stole as much of the fruit as he could carry away. The peach-tree being the Tree of Longevity, Tung-fang So thus secured immortality.

This legend explains why Tung-fang So is usually represented as an old man, with a long beard, carrying in his hand a peach or broken sprig of peach tree. He is often confused with Shou Lao.

Hsi-Wang Mu,[3] who was a traveller among the gods, is charac-teristically portrayed in the form of a beautifully draped female figure carried on the back of a *Sien-Hoh* or *Fêng Huang*, or seated in the rugged surroundings of the Islands of the Blessed,[4] from whence emanate all the Taoist fauna and flora.

Other deities frequently portrayed by the jade artist during the 17th and later centuries are :

Hou I, or Liu Hai—usually associated with a three-legged toad, and a resident of the moon.[5]

Ts'ai Shen, the God of Wealth—usually represented standing on a tortoise, or accompanied by a dragon or tiger. This god is probably the most popular of modern China, and is worshipped both in the morning and evening of each day.[6]

Wen-ch'ang, the God of Literature—according to a record in stone, in the Tsing-Hsi temple in Szech'wan, lived during the T'ang Dynasty (A.D. 620-907). He is accredited with living in the Plough, and in the *Wen-ti Annals* he is described as having visited the earth on seventeen different occasions.[7]

Wen-ch'ang appears in earlier Ming jade carvings seated on a mule, or riding a horse, his arms usually folded. In group form he is usually attended by a male and female servant, Hsuen-t'ung-tze and Ti-mu, better known as T'ien lung and Ti-ya.

[1] For account of *Hsi Wang Mu* see Giles, *Adversaria Sinica*, and Doré, Vol. II, p. 258 ; also *General Manual of the Immortals*, Shen-sien t'ung-kien, Chap. I, art. 1.

[2] Edmunds, *Chinese and Japanese Art*, p. 197.

[3] Mayers, *Chinese Readers Manual*. *Hsi Wang Mu* (the Western Royal Mother, p. 178).

[4] " The Islands of the Blessed," i.e. *Ying Chou*, another of the Taoist Paradises, " situated in the Eastern Sea . . . 70,000 miles distant from the land." See Mayers, *Chinese Readers Manual*, p. 298.

[5] Husband of Ch'ang Ngo, who stole from him the drug of Immortality and fled to the moon, where she is said to have been transformed into a frog. Plopper, *Chinese Religion seen through the Proverb*, pp. 48-49.

[6] Doolittle, *Social Life of the Chinese*, Vol. II, pp. 155-156 : Plopper, *Chinese Religion seen through the Proverb*, pp. 172-175.

[7] *Les recherches sur les superstitions en Chine*, also Plopper, p. 170, and Doré, Vol. VI, pp. 41-42, note 3.

PLATE CXLI

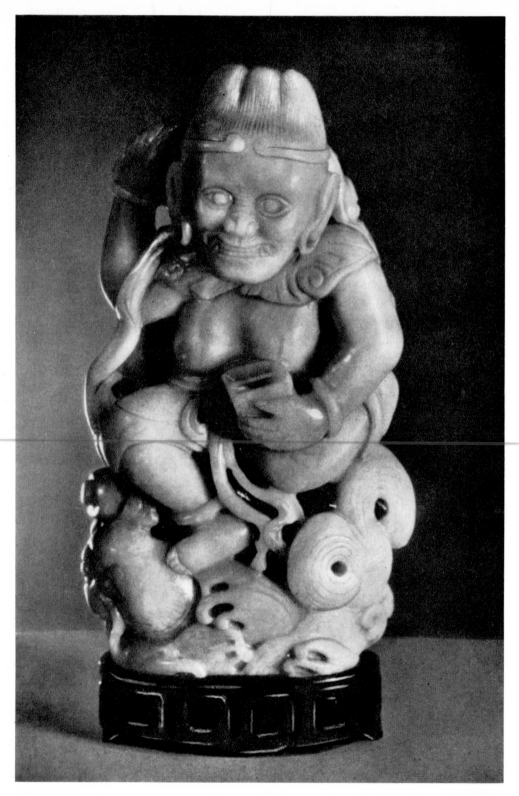

A JADE CARVING OF *K'WEI HSING* STANDING ON MYTHICAL DRAGON FISH

COLOUR : Grey White.　　　Late Ming Period, *circa* A.D. 1600　　H. 26.6 c.m.　W. 15 c.m.
(Formerly in the Collection of Major Morrison.)

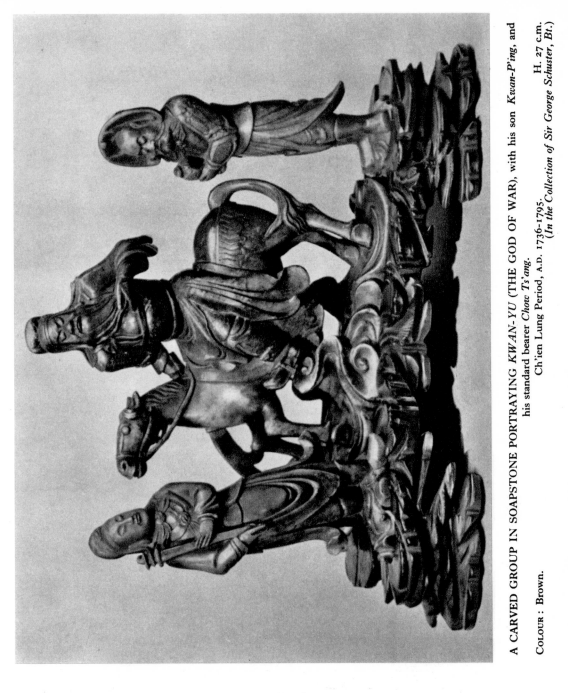

A CARVED GROUP IN SOAPSTONE PORTRAYING *KWAN-YU* (THE GOD OF WAR), with his son *Kwan-P'ing*, and his standard bearer *Chow Ts'ang.*

Ch'ien Lung Period, A.D. 1736-1795. H. 27 c.m.

(In the Collection of Sir George Schuster, Bt.)

COLOUR: Brown.

K'uei Hsing, or the " literary aspirant."[1] Edkin describes this god as a secondary or associate god of Literature. An excellent jade carving, portraying him being conveyed to heaven on a fish-dragon, a fabulous sea-monster (*Ngao*), is here illustrated in PLATE CXLI. This god is recognisable from the ugliness of his features, which was the cause of his rejection from the fabulous literary abode which the Chinese believed to be dedicated to worthy scholars in the Plough. This led him to attempt suicide, from which he was prevented by the monster on which he usually appears, standing with one foot on its head.[2]

Kwan-Yü, the God of War. His first appearance in history was during the period A.D. 221-265, when he became famous for his deeds of daring in the many wars of the time.[3] During the 12th century he was referred to as a personage of high rank, having the status of a Duke. In the period A.D. 1125-1130, he was described as a Prince and, finally, during the reign of Wan Li, A.D. 1595, he was deified, thus attaining the final reward of all mythological heroes.

Kwan-Yü appears to have been favoured with many names, and to enable the jade collector to identify him from the descriptions variously bestowed on him in the Catalogues of Collections, the following table of his names will be found useful :—

Kwan-yü	family name.
Kwan-kung	Kwan, the Duke. Kwan Lao-yeh.
Kwan-ti	God—" The Universal."
Wu-ti	his name, among warriors as the God of War.
Kwan-fu tze	a recent title—God of War (bestowed A.D. 1856).
Kwan Ch'ang-sheng, Kwan Yun-ch'ang and Kwan Show-ch'ang	titles describing him in relation to Birth and Longevity.
H'sieh-t'ien ta-ti	he is referred to by this name in certain mythological writings.
Kwan-sheng-ti-kun	the name by which he is known to the present generation.

Kwan-Yü is variously portrayed in jade carvings, the most usual form being that in which he is shown seated on a horse, holding the tip of his well-groomed beard, or grasping a spear, and accompanied by two other figures, his son, Kwan-p'ing, and his standard-bearer, Chow-ts'ang, PLATE CXLII. In some carvings he appears as a Man of Letters seated, holding in his right hand " The Spring and Autumn Classic." Representations of this god in jade are not of earlier origin than the latter part of the Ming Dynasty, and care should be taken in distinguish-

[1] Edkin, *Religion in China*, pp. 107-108.
[2] A similar god in Taoistic beliefs is Kw'ɛi-sing, a stellar god, residing first in Andromeda and later in Ursa Major.
[3] When he was associated with Generals Liu-pei and Chang-pei. He was finally put to death by General Suen-K'uen A.D. 240.

ing Kwan Ti from a kindred martial figure, Huan Ti, statuettes of whom were made during the time of the " Three Kingdoms " (A.D. 220-280).

Kuan-Yin : The Goddess of Mercy. The origin of this deity is wrapped in the mists of remote antiquity. In early Chinese script she is usually described and depicted as of Indian origin and form. It has been suggested (without proof) that Kuan-Yin was actually the Chinese Princess, Miao-shen,[1] who lived 2587 B.C. or 696 B.C., and some Chinese scholars regard her as a manifestation of the Indo-Tibetan divinity, Avalokitesvara.[2]

There is an interesting theory that the Chinese, at the time of the introduction of Buddhism, were divided among themselves, some classes favouring continuance of the worship of a female divinity, presumably the traditional Princess Miao-shen, or perhaps the mythological Mountain and Dawn Goddess, Chun-t'i,[3] others favouring the Buddhistic Avalokitesvara and that eventually, from these three deities, was evolved, in the person of Kuan-Yin, a goddess satisfying the aspirations of all parties, the form and type of whom, as represented in glyptic art from the Sung Dynasty to the present day, is familiar to all students of Chinese art.

There are extant jade carvings of this deity which are definitely of the late Sung period. Dr. Laufer says that[4] " The artist's sentiment and the expression of his impressions has become the leading motive of art ever since the days of the Sung period."

Representations of this goddess, idealised as a woman, are rarely to be found before the Early Ming period.

It will be interesting to review the styles in which this goddess is represented in jade throughout the ages.

Pre-Sung : definitely Indian in character and difficult to recognise as the Kuan-Yin of later carvers, in fact, more easily recognised as a male form.[5]

During the Yüan period a Buddhistic type is prominent and the characteristic attributes of the goddess, a vase and roll of script in her hands, and birds about her, first appear, though Indian influence is still apparent.

By Mid-Ming we find carvings of mythological objects obviously borrowed from the early attributes of Miao-shen,[6] and cleverly embodied in the creation by the skilled workmen of this era.

Towards the close of this Dynasty we seldom find jade carvings of this Goddess, and during the Ch'ing Dynasty, the Emperor K'ang hsi

[1] Getty, *Gods of Northern Buddhism*, p. 73 ; and Eitel, *Sanscrit-Chinese Dictionary*, p. 18.
[2] Eitel, *Sanscrit-Chinese Dictionary*, p. 18, Getty, *The Gods of Northern Buddhism*, p. 55, and Beal, " probably he is a relic or revival of the old worship of the Hill Gods."
[3] Eitel, p. 75 ; Getty, p. 117-118 ; Johnston, *Buddhist China*, p. 278 ; Beal, *A Catena of Buddhist Scriptures from the Chinese*, p. 412.
[4] In his Book on *Jade*, p. 248.
[5] Cf. Fenollosa, *Epochs of Chinese and Japanese Art*, p. 96 ; and Johnston, *Buddhist China*, pp. 270 and 275.
[6] The two acolytes, Shen-ts'ai and Lung-mu : *Chinese Superstitions*, Vol. VI, pp. 167-168 and 196.

PLATE CXLIII

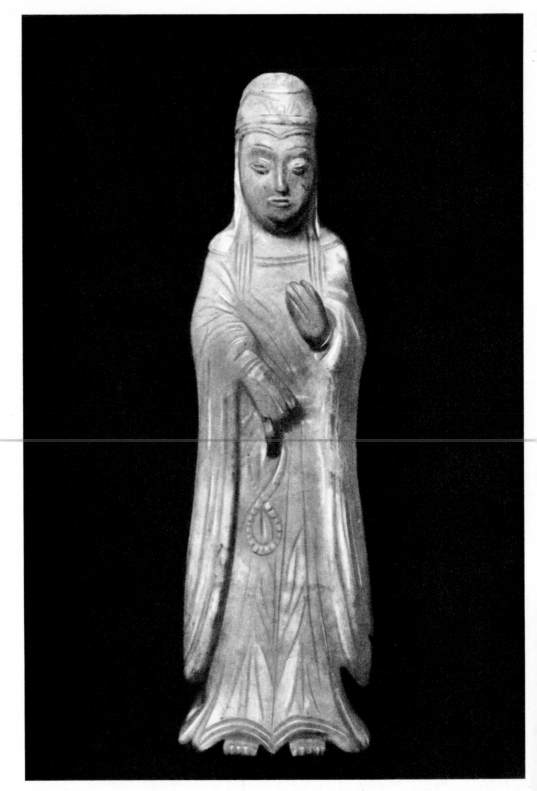

AN EARLY NEPHRITE FIGURE OF *KUAN YIN*

Colour : Grey White. Southern Sung Dynasty, A.D. 1127-1279. H. 17.5 c.m.

(*In the Collection of the Author.*)

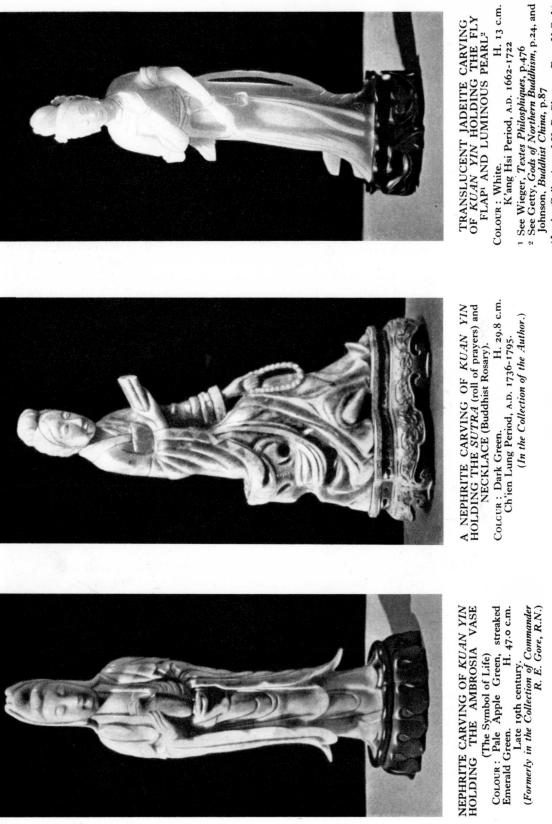

NEPHRITE CARVING OF *KUAN YIN*
HOLDING THE AMBROSIA VASE
(The Symbol of Life)

COLOUR: Pale Apple Green, streaked
Emerald Green. H. 47.0 c.m.
Late 19th century.
(*Formerly in the Collection of Commander
R. E. Gore, R.N.*)

A NEPHRITE CARVING OF *KUAN YIN*
HOLDING THE *SUTRA* (roll of prayers) and
NECKLACE (Buddhist Rosary).

COLOUR: Dark Green. H. 29.8 c.m.
Ch'ien Lung Period, A.D. 1736-1795.
(*In the Collection of the Author.*)

TRANSLUCENT JADEITE CARVING
OF *KUAN YIN* HOLDING THE FLY
FLAP[1] AND LUMINOUS PEARL[2]

COLOUR: White. H. 13 c.m.
K'ang Hsi Period, A.D. 1662-1722

[1] See Wieger, *Textes Philosphiques*, p.476
[2] See Getty, *Gods of Northern Buddhism*, p.24, and
Johnson, *Buddhist China*, p.87
(*In the Collection of H. P. Clausen, Esq., U.S.A.*)

had actually to import an image of this goddess from Tibet, to be placed in the P'u't'o shrine.[1]

During the Ch'ien Lung period, however, we again find the jade carvers busily executing statuettes of this goddess, and carved groups in which she figures, and it is to this period that we owe some of the finest carvings of Kuan-Yin ever executed.

The following is an explanation of the styles in which this goddess is usually portrayed :—

(1) Holding a child in her arms, as the Divine Giver of Children. It is significant that some of the early missionaries regarded these figures as indications of previous contact between the Chinese and Christian peoples.

(2) Standing upon a lotus leaf, originating from the legend that the goddess crossed the sea, seated upon one of these leaves.

(3) With an eye carved in the palm of her hand, derived from beliefs associated with Avalokitesvara, symbolising her ability to see everywhere, and thereby perceive and relieve suffering.

(4) With a Vase, long-necked in form, symbolising Life. Shown in the earliest carvings as a round bowl-form derived from the Indian *Kalasa* ;[2] and in later examples as bottle-shaped and carried by the neck. During the Ch'ing Dynasty it was a beaker vase sometimes adorned with the sacred fungus.

(5) With a Bird, sometimes resembling a Parrot (*Peh-Ying wu*)[3] Cockatoo, or Dove.[4] The Stork or Phœnix which are also used may suggest Hsi Wang Mu.

(6) Wearing a necklace or rosary ; said by some[5] to be an attribute of the fabulous Bodhisattva Akehayamati, and by others[6] to be a representation of a Buddhist rosary (*Fuh-chu*).

(7) With a roll of prayers in her hand, an attitude derived from the mythical goddess Miao-shen and representing the Sutra.[7]

(8) With the Luminous pearl ; another attribute borrowed from the Goddess Miao-shen. It is borne by Kuan-Yin, when represented without her child, and by Lung-nü when Kuan-Yin is carrying the child.[8]

The early jade carvers occasionally portrayed Kuan-Yin holding a lotus flower, but during the Ch'ing Dynasty this flower was sometimes replaced by a branch of willow, a sign of companionship.

The human figures associated with this goddess are Shen-ts'ai and Lung-mu, the damsel and youthful attendant, usually assigned to the mythological Princess Miao-shen. PLATE CXLVI portrays " The White-robed Kuan-Yin (*Peh-i Kuan-Yin*),[9] which form originated about

[1] Edkins, *Chinese Buddhism*, p. 261.
[2] Getty, *Gods of Northern Buddhism*, p. 59.
[3] Williams, *Dictionary of the Chinese Language*,
[4] Getty, *The Gods of Northern Buddhism*, p. 71.
[5] Beal, *A Catena of Buddhist Scriptures from the Chinese*, p. 393.
[6] Doré, Vol. V, pp. 526-528.
[7] *Ibid*, Vol. VI, pp. 147, 161, 165, 229.
[8] Johnston, *Buddhist China*, p. 87 ; and Getty, *Gods of Northern Buddhism*, p. 74.
[9] Getty, *The Gods of Northern Buddhism*, pp. 73 and 87.

A.D. 907-960, when a statue of Kuan-Yin was removed from the monastery of Yin Chow by the order of the Emperor T'ai-tsu, and was re-erected on the Hill, Muh Yeh-shan. The attendant figure would therefore appear to represent p'i-t'o (the Heavenly Nymph) rather than the mythical attendant of Miao-shen (Lung Mü) ; but Eitel[1] tells us that the " white-robed Kuan-Yin " holds a child on her arm, and I think it may safely be assumed that the carver is actually rendering a combination of Kuan-Yin and Miao-shen, a not unusual practice of the carvers of the Ch'ing Dynasty.

THE THREE PURE ONES.
(SAN-TS'ING).

The Taoist Trinity, or " Three Pure Ones "[2] comprises Yuh-Hwang (" The Pearly Emperor " and chief god of the Taoist Pantheon), Tao-kun, and Lao-tze.

According to Chinese belief, Tao-kun dwells beyond the North Pole, where he has existed since the beginning of the world. He assists in arranging the various principles of life and time and is said to control the interaction of the *Yin* and *Yang* principles of Nature.[3] Lao-tze, the expounder of the doctrines derived from the works of Tao-kun, typifies instruction and benevolent influence for the good of Humanity.

A representation of the three deities can be seen in the Taoist temple of the Pearly Emperor, at Ju-kao.

THE EIGHTEEN LOHANS.

The eighteen *Lohans* or *Arhats* are Saints of varying degrees of attainment in the sphere of ascetic life. They took the place of the *Chen-jen*, who were regarded by the Chinese as the highest type of holy man. Geden tells us that the Lohans are essentially connected with the Hinayana phase of Buddhism.[4] It would seem, however, that only sixteen are in reality of Hindoo origin, the other two having been introduced by the Chinese.[5]

In the Temple at Wumei-chou in Nganhwi the Eighteen[6] are described as follows :—

1. The Nesting Monk (Wu-k'o shen-shi).[7]
2. Isvara (Tze-tsai shen-shi).[8]
3. Tao-t'ung shen-shi, who lived on the Purple Jade mountain.
4. The Tiger Tamer (Fung-kan shen-shi).[9] (See PLATE CXLVII).
5. The Founder of the " Lotus School " (Hwei-yuen shen-shi).[10]

[1] *Sanscrit Chinese Dictionary*, p. 18.
[2] Edkins, *Religion in China*, pp. 112 and 113.
[3] Doré, *Chinese Superstitions*, Vol. VI, p. 12.
[4] Geden, *Studies of the Religions of the East*, p. 577, note 1.
[5] *Journal Asiatique*, Sept.-Oct. 1916, p. 286.
[6] Illustrations with descriptions are given in Doré's *Researches into Chinese Superstitions*, pp. 355-383.
[7] *General Mirror of Gods and Immortals* (Shen-Sien T'ung-Kien), Book III, Chap. 4.
[8] *Ibid*, Book XXI, Art. 8.
[9] *Ibid*, Book XVII, Art. 4.
[10] *Ibid*, Book XII, Art. 3, 4, 8.

6. The Foundling (Sheh-teh tze).
7. Han-shan-tze, who lived in a cold cave.
8. A Native of I-chow (Hwei-tsang shen-shi).
9. Gunamati, a Buddhist monk (Kü-ti hwo-shang).
10. Tao-yueh shen-shi, who lived in the Golden Island.
11. Singhalaputra (Shi-tze-pi-k'iu tsun-cheh).
12. A Native of Ts-ing-chow (Tsung-shen shen-shi, who lived at Chao Chow).
13. Rahalata (Lo-heu-lo-to tsun-cheh).
14. The Lazy glutton (Shen-tsan shen-shi, who lived at T'ai-hsing).
15. Kumarajiva (Kiu-mo-lo-to tsun-cheh).
16. Maha Kasyapa. See PLATE CXLVIII (Mo-ho-k'ia-yeh tsun-cheh).
17. Asvaghosha (Ma-ming tsun-cheh).
18. The Monk with the Calico Bag (Pu-tai hwo-shang).

The foregoing Lohans are of special interest to the Jade Collector as some of them are portrayed in the carvings of the Sung and Ming periods. From the Ch'ien Lung period onwards these Holy men would appear to accord with the Tibetan List,[1] as revised by the Emperor Ch'ien Lung, which is at the present time[2] generally accepted in China and is as follows :

1. Alms Receiver (Pindola-Bharadvaja).
2. Golden Calf, a disciple of Buddha (Kanaka-Vatsa).
3. Kanaka-Bharadvaja (Subhinda).
4. The Inseparable (Abhida).
5. Nakula.
6. The Noble (Bhadra).
7. The Timely (Kalika).
8. The Son of the Thunderbolt (Vajraputra).
9. The Protector (Gopaka).
10. Maha-Panthaka.
11. Rahula holding a crown.
12. Nagasena.
13. Anjida (Ingada).
14. Vanavasa.
15. The Unconquered (Ajita).
16. Cuda-Panthaka.
17. Dharmatrata.
18. Hva-shan.

[1] Williams, *Outlines of Chinese Symbolism*, pp. 161-166.
[2] Watters, *The 18 Lohan of Chinese Buddhist Temples*, p. 6 ; and Getty, *The Gods of Northern Buddhism*, p. 156.

PLATE CXLV

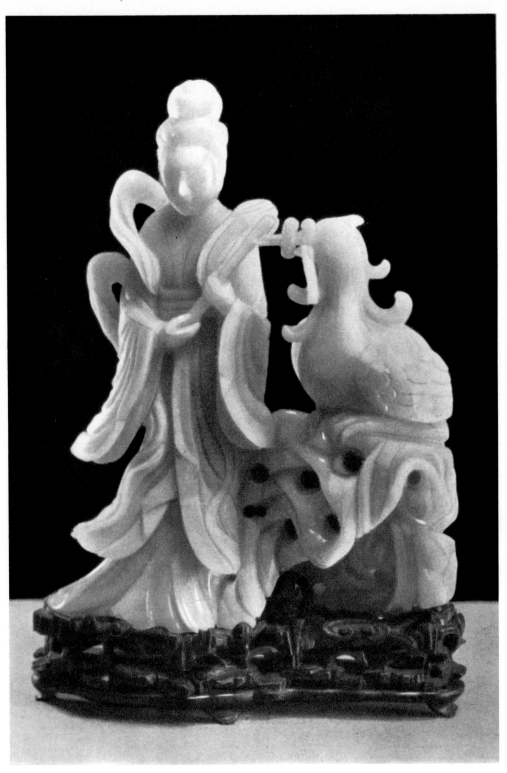

A JADE GROUP CARVING OF *MIAO-SHEN,* or possibly *HSI WANG MU* WITH *FÊNG HUANG*

COLOUR : White. Ch'ien Lung Period, A.D. 1736-1795. H. 25 c.m

The Property of S. Bulgari, Esq., Italy.)

PLATE CXLVI

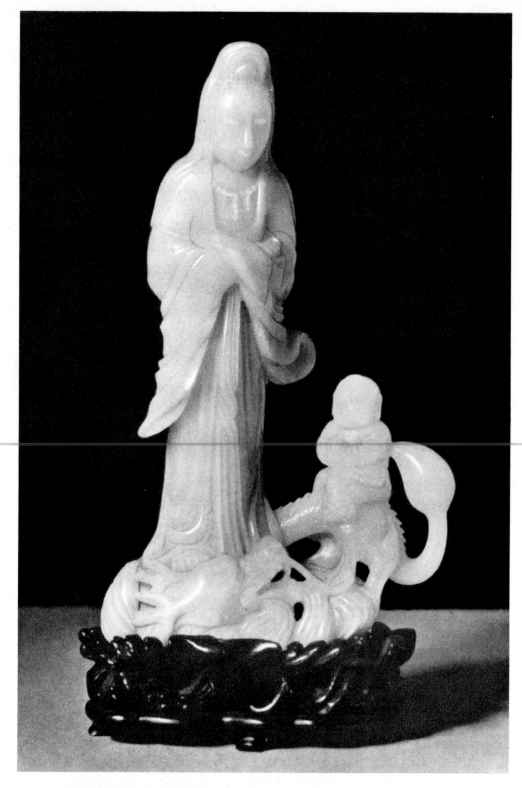

A TRANSLUCENT JADEITE CARVING OF *KUAN-YIN* WITH *LUNG-MU*
STANDING ON A DRAGON

COLOUR : White. Yung Chêng Period, A.D. 1723-1735. H. 22.5 c.m.
(*In the Collection of the Author.*)

PLATE CXLVII

A JADE CARVING OF *HIAN TSI* WITH
THE COCKEREL.

COLOUR: Pale Celadon Green with dark Reddish
Brown markings. H. 10.2 c.m. W. 8.2 c.m.
Late Ming, circa A.D. 1600.
(*Formerly in a Private Chinese Collection.*)

A TRANSLUCENT JADE CARVING OF *FUNG-KAN*
Who lived during the 8th century.

COLOUR: White, with Brown markings. H. 12.2 c.m. W. 9.8 c.m.
Late Ming Period, circa A.D. 1600.
(*Formerly in the Collection of W. G. Wrigley, Esq.*)

A TRANSLUCENT JADE CARVING OF *KUAN YIN*
Seated on a Tiger, with Lotus base.

COLOUR: Sage Green. H. 12.6 c.m. W. 10 c.m.
Late Ming Period, circa A.D. 1600.
(*In the Collection of the Author.*)

PLATE CXLVIII

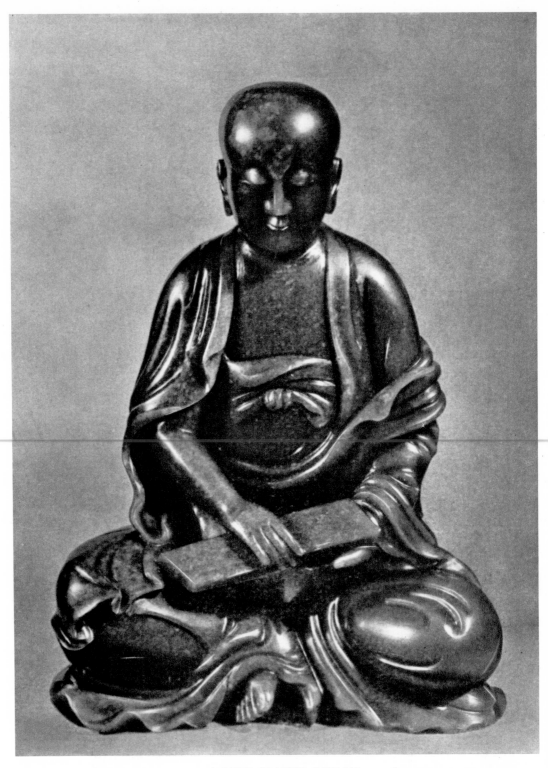

A JADE SEATED *LOHAN*

COLOUR : Green. Mid-Ming Dynasty, *circa* A.D. 1500. H. 24 c.m.
 (*In the Collection of Mr. and Mrs. Edward Sonnenschein.*)

APPENDIX I

MINERALOGICAL METHODS USED IN DETERMINING HARD STONES.

In determining the stone used for a carved object, the mineralogist is severely handicapped by the owner's natural reluctance to permit the removal of any but the most minute filing or chip ; and even this must be taken from an inconspicuous part of the design.

In spite of this difficulty, however, the material can often be identified with certainty. In the first place, the density can be determined by weighing the object, first in air and then immersed in water ; this procedure is, however, rather tedious and the result not always decisive, for the densities of some hard stones are not very widely separated.

Of late years the density test has largely been superseded or supplemented by optical tests. Minute chips or filings are immersed in an oil of suitable refractive index and examined under the microscope. Like Mr. H. G. Wells's " Invisible Man," the chips practically disappear when they are immersed in a liquid of their own average refractive index ; by trial with a series of prepared liquids the index can thus be very quickly ascertained, and its value is characteristic of many varieties of hard stone. Actually the optical tests are rendered more complicated and also more distinctive because the minerals usually vary in refractive index according to the direction in which the light is vibrating ; from this arise several ancillary tests which aid in characterising each variety.

The same filings often exhibit the characteristic texture or interweaving of the component crystals, to which the tenacity of jade is largely due. Nephrite is usually composed of long thin fibres minutely felted, while jadeite is splintery, showing the flat cleavage faces of the broken crystal grains. Ordinary jades are colourless in small fragments, but the darker varieties sometimes yield brilliant green chips. Other stones have their own distinctive characters, such as the granular texture of quartzite or the parallel felting of chalcedony.

Natural jade grades into other types of rock by the admixture of inferior minerals such as felspar. Most worked jades are, however, of fairly pure material ; and this is due, firstly to the destruction of the softer boulders by attrition in the river bed, and secondly to careful choice by merchants and craftsmen. Nevertheless certain objects, especially in early times, were made of less pure jade.

Even the general appearance, with a hardness test, will generally serve to distinguish jade from other stones, but in certain varieties the latter may simulate jade so closely that a test with the microscope becomes essential. Other stones which closely resemble jade in appearance include the following :

Smaragdite, a hard emerald-green stone, distinguished by its dense green colour, opacity, and the presence of white irregular clouds or veins.

Quartzite, which sometimes resembles the yellow and brown jades but is usually saccharoidal in texture.

Serpentine, which attains hardness 5 in the variety bowenite.

Steatite and *Pyrophyllite*, distinguished by their softness.

Chalcedony, nearly always showing some trace of agate or onyx banding or ." moss " structure.

157

MINERALOGICAL METHODS USED IN DETERMINING
HARD STONES—*continued.*

Chrysoprase, having a uniform light apple-green colour.

Jasper, of a darker green and colour more opaque in appearance than jade, and *Indian Avanturine*, distinguished by the " flash " of minute mica flakes.

Finally, it should be borne in mind that certain jade objects may exhibit patches of inferior hardness, whether due to natural alteration in the original rock or to the action of fire or, as some hold, to prolonged burial. They may also develop brown colouring and opacity; very often a part of the stone has remained in the normal condition, and the characteristic felted or crystalline texture can be seen to persist throughout.

APPENDIX II

A SHORT GLOSSARY OF SOME OF THE CHINESE WORDS USED IN THE BOOK

Chan 簠 a vessel made of bamboo like *Li* 筥 used in the service of *Tsin* (薦)

Chan 瓉 a wine cup made of jade

Chan 瑳 white jade

Ch'an Ch'u 仙 猴 the monkey

Chang 璋 an ancient stone or jade ornament used in state ceremonies

Chang Kuo-Lao 張 果 老

Ch'ang O 嫦 娥 the Queen of Luminary

Chao 殼 a pair of gems

Chao yao ching 照 妖 鐘 a charm worn by brides

Chen Kuei 仙 龜 symbolical carving

Chêng 琤 the tinkling sound of gems

Chi 戚 an axe ; a hatchet

Ch'i 琪 a variety of jade

Chiao 珓 an instrument composed in its earliest form of two bars of jade later of two pieces of bamboo, used for consulting the oracle

Chieh 玠 a small tablet made of jade

Chieh-hu 蠍 虎 the lizard

Chieh Lin 結 璘 God of Marriage

Ch'ih muh 尺 木 the fleshy horn of the *Ch'i-lin*

Chi-Hsa 酢 尸 a certain service of a large sacrifice held in the Spring and Winter

Ch'i-lin 麒 麟 the unicorn

Chin-Mao 清 廟 name of a poem composed during the Chou Dynasty embodying congratulations to Chou-Kung

Chios 球 fine gem

Chiu 玖 a black stone resembling jade

Chiung 璚 cinnabar red jade

Ch'iung 瓊 red jade ; chrysophrase

Chou Chu 蟾 諸 three-legged toad

Chou-kung 周 公 name of an Emperor

Chu 猪 the pig : hog

Chu 珠 a jewel, " a pearl "

Chü 琚 pendant ornaments composed of gems

Ch'üan 犬 or 犮 dog

Chüeh 玦 girdle-ring ; chatelaine

Chu'eh 角 a cup used for sacrificial purposes

Chüeh 巌 a cup similar in form to the *Tsan* 俎 and *Huan* 桓, in fact another name given to these vessels during the Hsia Dynasty 夏

Ch'üeh Ch'üeh 猴 the monkey

Chuh 竹 bamboo

Ch'un 春 Spring

Ch'un-niu 春 牛 Spring ox

Fei-shih 飛 獅 the flying lion

Fei-shu 飛 鼠 the flying mouse

Fei-Ts'ui 翡 翠 a variety of jade

Fêng Huang 鳳 凰 the Phœnix

Fo Shou 佛 手 Buddha's Hand

Fu 福 happiness

Fu 玞 a semi-precious stone inferior to jade

Fu 富 wealth

Fuh-ling 茯 苓 " China root ", pine-tree root growth

Fu-i 附 翼 bat and happiness

Fung 鳳 phœnix

— 像 形 fire

Hai shou 海 獸 sea monster

Han Chung-li 漢 鍾 離

Han Hsiang-Tzŭ 韓 湘 子

Han Yü 漢 玉 jade used during the Han Dynasty

Heng 珩 the top gem of the girdle-pendant

Heu 猴 monkey

Ho Hsien-ku 何 仙 姑

Hou 犰 mythological animal

Hsi 犧 a special kind of " Tsun "

Hsi ma p'u t'ao 海 馬 負 圖 sea horse and grapes, a type of decoration

Hsi Wang Mu 西 王 母 mythical Chinese empress (" The Royal Mother ")

Hsiang 象 a type of " Tsun "

Hsiang 香 incense

Hsiang 象 name of a poem, the same as *Hsiang-Wu* 象 武

159

Hsiang-t'an 香罈 an incense burner or basin

Hsieh 㻽 black jade

Hsiu 琇 a coarse jade

Hsuan, 璿 a valuable jade

H'suen-t'an p'u-san 仙壇菩薩 the Tacist God of Wealth

Hsün 珣 a species of gem; ear ornament

Hu 胡 fox changed into a man

Hu 虎 the tiger

Hu 琥 a piece of jade shaped like a tiger

Hua-jin 花紋 diaper patterns

Huan 桓 a vessel similar to the *Tsan* 俎 known by this name during the San Dynasty 商

Huang 璜 a gem ornament of semicircular shape hung from the girdle

Hui Hui Wên 面面文 lotus scroll design

Huo 火 fire symbolical decoration

Hwa-pin 花瓶 vases

Hwang 黃 " yellow "

Hwang Mu 黃目 a certain kind of Tsun, only used for sacrifice in the spring and winter season

Hwuh 笏 Imperial writing-tablet

Ja 加 the second service of Chi-Hsa

Jao p'ing 寶瓶 rare vase or medicine bottle

Jen 任 name of music of the Southern savages

Jên 璽 clear jade

Ji 碧 dark green jade

Ji 璀 indigo jade

Jih 赤 the sun symbolical decoration

J'ih-Kuai Li 鐵拐李

Jon 千 lance, spear, javelin

Ju 珇 kingfisher blue jade

Ju-i 如意 one of the Saptnaratna or seven Precious Things, sceptre 璋

Ju-i 翠雀 kingfisher

Kan 玵 yellow jade

Kan 玕 inferior gem; fine stone

Ki 雞 cock

Kiang-li 康寧 health

Kiao Ch'ih 蚪龍 a young dragon whose horns have not yet grown

Kia-t'ang 家堂 domestic altar

K'iu-Lung 蚪龍 hornless dragon

K'o 珂 an inferior jade

Kou-tzu 犬 dog

Kuan Yin 觀音 Chinese goddess

K'uei 夔 decorative motive in the form of the archaic dragon

K'üen 犬 dog

K'uh-yuen 屈原 privy councillor to Prince Hwai-wang

K'un 琨 a fine jade

K'un lun 崑崙 Chinese mountains

Kung-ki 公雞 the cock

Ku yu t'u K'ao 古玉圖考 a Chinese writing, see Appendix, page 169

Kwang 管 flute; fife

Kwan-tze 罐子 a jar or pitcher without a spout

Kwei 貴 honourable

Kwei 龜 tortoise

Lang 琅 name of a type of jade

Lan-kiao 三教 " Three Religions " of China

Lan Ts'ai-ho 藍采和

Lea-jin 雷紋 thunder pattern

Li 鯉 carp

Li ch'un 立春 a solar period

Lien-hua 蓮花 lotus-flower

Lin 麟 unicorn

Lin 琳 a valuable jade

Li-sao 離騷 a Book of Chinese poems

Liu Hai 畜海

Liu-shu 柳樹 willow

Liu-ying 劉寅 younger brother of the Emperor Ming-ti

Li-yu 鯉魚 the carp

Loh-shu 六畜 six domestic animals

Lu 璐 a beautiful gem

Luh 祿 honours

Luh 鹿 the stag

Lui-jin 鱗紋 fish-scale pattern

Lung 龍 the dragon

Lung ma 龍馬 dragon horse

Lung Mên 龍門 a Chinese rapids

Lü Tun-yang 呂純陽

Ma 馬 the horse

Mao 猫 the cat

Mao 卯 spring

Mea 冕 a crown

Mei 昧 name of music of the Eastern savages

Mei 珥 sceptre

Mên 璊 blood-red jade, a gem of reddish colour

Men-tan-hwa 牡丹花 the peony

Mih-lo 泊羅 Chinese river

Min 珉 stone resembling jade

Ming 玟 a fine type of jade stone
Ming Shih 明兔兔 the hare
Muh 木 wood
Mu-yu 木魚 a wooden fish
Nan Chi Lao Jên 南極老人 spirit of the south Pole
Niu 牛 ox or cow
— 玉兔 moon hare
Pa Chi Hsiang 八仙姓 the eight Buddhist omens
Pa-kua 八卦 eight diagrams
Pai-mu 白牡 a certain kind of white male animal not unlike a sheep. These animals were used only for sacrifices in the Shang Dynasty
Pao-t'ao 蟠桃 fabulous peach
Patra 鉢多羅 begging bowl
Pei 析 a cup or drinking vessel
P'ei Yu Yu 璧魷魚 fish in jade
Pi 璧 a jade ring or disc employed as a ritual symbol
Pi-Chueh 璧角 Chüeh decorated with jade
Pien-fuh 蝙蝠 the bat
Pien Ch'ing 編磬 stone chime
Pi-hsi 蚪龍 hornless dragon
Pi-pien 皮弁 a conical cap made of fur, worn by the Emperor in Chou Dynasty
Pi-san 璧散 San decorated with jade
Pi yu 碧玉 jade
Po 玻 gem
P'o 珀 amber
P'o 璞 jade in the rock
Quo-jin 古文 Cloud ? (archaic form, see " Shuo Wên ")
Quong 灌 a sacrificial service during which offerings are made to the ancestors and gods
San 散 a sacrificial cup
Semi 蟬 the cicada
Sha 蛇 snake
Sha ch'ung 螳螂 praying-mantis
Shan 山 mountains
Shang-hung 上花 method of carving jade
Shan-lei 山罍 a type of *Tsun* used during the Hsia Dynasty
Shea 石 stone
Shêh 蛇 serpent
Shen 神 a spirit
Sheng-t'ien-chi-lung 升天之龍 the celestial dragon

Shen kuei 仙龜 divine tortoise
Shen-lung 神龍 the spiritual dragon
Shi 獅 the lion
Shieh 星 stars
Shieh-yueh 水牛 water buffalo
Shih-liu 石榴 the pomegranate
Shih Tao-yen 許道宜 an early Chinese painter
Shih tzu kou 石獅狗 lion dog
Shih tzu kou 獅狗 the lion-dog
Shii 鼠 the rat
Shi tze 獅子 the lion or dog of *Fo*
Shou 壽 the emblem of longevity
Shuang Hsien 雙仙 the twin genii of Union and Harmony
Shuo Wên 說文 Chinese dictionary. First published A.D. 100, it contains 540 radicals
Sien-chu 仙鼠 fairy rat
Sien-hoh 仙鶴 the Manchurian crane
Sien-jen 仙人 the Immortals
Si-t'ien 西天 the Western Paradise
Sun 牲 animals were killed for sacrifice
Sung Shu 松鼠 pine rat
Sung Shu 松樹 pine tree
Ta-Hsia 大夏 name of music in Hsia Dynasty
Ta Kuei 大圭 symbolical imperial carving
Ta Kung 打孔 method of cutting jade
Ta-mo 打磨 method of polishing jade
Ta-qua 大圭 a large jade
Tan 蟬 Cicada
T'an = *T'ao t'ieh* 貪
T'ao 仙果 fabulous peach
T'ao 桃 peach
T'ao-shu 桃樹 the peach
T'ao-t'ieh 饕餮 ogre mask
Ta-mu 大武 name of music in Chou, Wu-Wang period
Ta-yen 打眼 method of drilling jade
T'ê ch'ing 特磬 sonorous stone
T'iao-ki 條儿 a long narrow table
T'ien 填 name of a type of jade
T'ien Ma 天馬 heavenly horse
T'ien Shu 天鼠 heavenly rat
T'ing 珽 a gem sceptre
Ts'ai 黃河 Yellow River
Tsan 俎 a cauldron similar to the *Tou* 豆
Tsan 瑒 the name of a cup in the Hsia Dynasty

Tsan 瓚 libation cup

Tsan-chou-hsan 三 脚 善 the toad

Ts'ang-Lung 藏 龍 the dragon of Hidden Treasures

Tsao Fu 巢 父 name of a person

Ts'ao Kuo-chiu 曹 國 舅

Tsin 薦 a certain service during which is offered wine and female plants of hemp

Ts'ing-lung 青 龍 Azure Dragon, Eastern quadrant

T'so 瑳 a gem of brilliant white colour

Tsun 尊 general term for vessels used for containing wines

Ts'ung 琮 an octagonal-shaped jade with a round hole in its centre

Tsung Yi 鐘 彝 temple vessel

T'u 兎 hare

T'u-Lung 土 龍 the earthly dragon ; denoting the four quadrants

Tze 子 kernel or stone

Tz'ŭ 孫 offspring or prodigy

Tzŭ 玼 the lustre of a gem

Wan Szu 萬 字 swastika

Wei 瑋 name of a type of jade

Wei-hu 狐 狸 fox

Woh-chang 臥 蠶 recumbent silkworm

Wu-fu 五 蝠 five bats

Wu-Mên 吳 門 a Chinese cataract

Wu-san 五 牲 five sacrificial animals

Wu Ta Ch'eng 吳 大 澂 a Chinese writer on jade

Wu ya 烏 鵶 crow

Yao 珧 a species of gem

Yao 瑤 a precious jade

Yu 璵 the same as *Pan* 璠

Yang 羊 sheep

Yao p'ing 藥 瓶 medicine bottle

Yeh Yen 夜 燕 night swallow

Yeh Yen 日 影 night swallow

Yin and *Yang* 陰 陽 symbolical symbols

Ying 鷹 the eagle

Yin Wêng 銀 a silver wine jar

Yin Yu Fu 銀 魚 a silver fish

Yiu 酉 a Radical denoting vessels used for distilling spirits

Yüan 猿 monkey

Yuan 瑗 a large ring of fine jade

Yuan 琬 a sceptre or baton with a round top

Yu-chang 玉 杖 jade sceptre

Yueh 月 the moon

Yueh 鬱 a certain kind of wine used for sacrifice

Yuen-jin 魚 紋 fish pattern

Yü Huang 玉 皇 the " Pearly Emperor "

Yü kang 玉 缸 fish bowls

Yü ku kuan 玉 骨 灌 fishbone jars

Yu Tou 玉 豆 a vessel in the form of a cauldron

Yu-tsan 玉 瑳 " Tsan " made of jade

Yu-tsan 玉 瓚 a bowl made of jade

Yü 瑜 a beautiful jade

Yü 玉 jade ; gem ; jewel

Yü 玕 jade of stone appearance

Yü 餘 abundance, superfluity

Yü 魚 fish

Yung 雲 cloud

Yung-chiung 迎 春 ceremony " Welcome the Spring "

Yu-yi 玉 液 wine of immortality (jade essence) [無 死 之 藥]

APPENDIX III

THE FIVE SACRED MOUNTAINS OF CHINA 五嶽

Jade carvers throughout the ages have depicted in various ways semblances of the five Sacred Mountains whereon, mythology tells us, the ancient emperors worshipped Heaven and Earth. These mountains, which are frequently referred to in ancient Chinese literature, are generally named by the legend writers as follows :—

1. *T'ai-shan* 泰 山 the principal of the Sacred Mountains ; situated north of T'ai-ngan fu, in Shantung : height 4,500 feet.

2. *Heng-Shan* 衡 山 the Southern Sacred peak ; situated west of the Siang River in Hunan : height 4,000 feet.

3. *Sung-Shan* 嵩 山 the Central Sacred peak ; situated between the Yellow and the Han Rivers in Honan ; height 5,000 feet approximately

4. *Hwa-shan* 華 山 the Western Sacred peak ; situated south of Singan fu in Shensi : height 3,800 feet approximately.

5. *Hang-shan* 恒 山 the Northern Sacred peak ; situated near Ta-t'ung fu in Shansi : height 3,600 feet.

APPENDIX IV

PRINCIPAL RELIGIOUS CHINESE FESTIVALS

1st day of the 1st month. The Taoist Sacrifice to Heaven 天 臘 之 辰.

10th day of the 1st Month. In Southern China celebration of the birthday of the God of the Soil 地 公 生 日.

13th day of the 1st Month. Official offerings in honour of the God of War 關 羽.

29th day of the 1st Month. Sacrifice to the God of Agriculture and Medicine, *Shen-nung* 神 農.

5th day of the 4th Month. Sacrifice in the Temples of Yao 堯 and Yü 禹.

5th day of the 5th Month. The Dragon Boat festival 端 陽 競 渡.

7th Month devoted to sacrifices to the ancestors.

1st day of the 10th Month. Annual sacrifice of the people. 民 歲 臘 之 辰.

8th day of the 12th Month. Annual sacrifice offered by Feudal Princes and Dukes 王 侯 臘 之 辰.

163

APPENDIX V
THE REIGNING CHINESE DYNASTIES

THE legendary period of Chinese history (as distinct from the purely mythical ages which preceded, and which, according to the more extravagant chronologers of the country, reach back some two or three millions of years to the creation of the world) begins with *Fu-hi*, the reputed founder of the monarchy, the first year of whose reign is placed in 2852 B.C. He is the first of the *Wu Ti*, or Five Rulers, who are succeeded by the Emperors *Yao* (2356 B.C.) and *Shun* (2255 B.C.), with whose reigns the *Shoo King*, or " Historical Classic ", opens. *Fuh-hi's* immediate successors were *Shên-nung*, the Divine Husbandman (2737 B.C.) ; *Huang-ti*, the Yellow Emperor (2697 B.C.) ; *Shao-hao* (2597 B.C.) ; and *Chuan Hsü* (2513 B.C.). The Emperor *Shun* was succeeded by the Great *Yü* (2205 B.C.), the founder of the first of the twenty-four dynasties which have ruled the empire in succession down to the advent of the reigning Manchu dynasty in A.D. 1644.

TABLE OF SUCCESSION OF THE CHINESE DYNASTIES

				BEGAN	
1.	Hsia	夏	B.C.	2205	⎫
2.	Shang*	商		1766	⎬ The three Ancient Dynasties.
3.	Chou	周		1122	⎭
4.	Ch'in	秦		255	

 * In 1401 B.C. the title of this dynasty was changed from *Shang* to *Yin*.

				BEGAN	
5.	Han	漢		206	⎫ The usurper *Wang Mang* occu-
6.	Eastern Han	東漢	A.D.	25	⎭ pied the throne A.D. 9–23.

7.	After Han	後漢	221	Three Kingdoms, 三國, divided China, the 漢 Han 魏 Wei, and 吳 Wu.
8.	Chin	晉	265	
9.	Eastern Chin	東晉	317	

10.	Sung	宋	420	This period is known by the collective name of *Nan Pei Ch'ao*, Northern and Southern Dynasties, as the 魏 Wei ruled the north from 420 to 550.
11.	Ch'i	齊	479	
12.	Liang	梁	502	
13.	Ch'ên	陳	557	

14.	Sui	隋	589	
15.	T'ang	唐	618	
16.	After Liang	後梁	907	These short-lived dynasties are known collectively as the 五代 *Wu Tai*, Five Dynasties.
17.	After T'ang	後唐	923	
18.	After Chin	後晉	936	
19.	After Han	後漢	947	
20.	After Chou	後周	951	
21.	Sung	宋	960	

BEGAN

22.	Southern Sung 南宋	1127	The Niu-chih Tartars occupied North China (1115–1234) as the *Chin* dynasty 金朝.
23.	Yüan 元	1280	Mongolian dynasty founded by *Kublai Khan*.
24.	Ming 明	1368	
25.	Ch'ing 清	1644	The *Manchu* dynasty.
26.	Republic 中華民國	1912	

TABLE OF REIGNS OF THE LAST TWO DYNASTIES

EMPERORS OF THE 明 MING DYNASTY

DYNASTIC TITLE OR MIAO HAO.		TITLE OF REIGN OR NIEO HAO.		DATE OF ACCESSION.
太祖	T'ai Tsu	洪武	Hung-wu	1368
惠帝	Hui Ti	建文	Chien-wên	1399
成祖	Ch'êng Tsu	永樂	Yung-lo	1403
仁宗	Jên Tsung	洪熙	Hung-hsi	1425
宣宗	Hsüan Tsung	宣德	Hsüan-tê	1426
英宗	Ying Tsung	正統	Chêng-t'ung	1436
景帝	Ching Ti	景泰	Ching-t'ai	1450
英宗	Ying Tsung	天順	T'ien-shun	1457
	(resumed government)			
憲宗	Hsien Tsung	成化	Ch'êng-hua	1465
孝宗	Hsiao Tsung	宏治	Hung-chih	1488
武宗	Wu Tsung	正德	Chêng-tê	1506
世宗	Shih Tsung	嘉靖	Chia-ching	1522
穆宗	Mu Tsung	隆慶	Lung-ch'ing	1567
神宗	Shên Tsung	萬歷	Wan-li	1573
光宗	Kuang Tsung	泰昌	T'ai-ch'ang	1620
熹宗	Hsi Tsung	天啓	T'ien-ch'i	1621
莊烈帝	Chuang Lieh Ti	崇禎	Ch'ung-chên	1628

EMPERORS OF THE 大清, THE GREAT CH'ING DYNASTY

世祖	Chih Tsu	順治	Shun-chih	1644
聖祖	Shêng Tsu	康熙	K'ang-hsi	1662
世宗	Shih Tsung	雍正	Yung-chêng	1723
高宗	Kao Tsung	乾隆	Ch'ien-lung	1736
仁宗	Jên Tsung	嘉慶	Chia-ch'ing	1796
宣宗	Hsüan Tsung	道光	Tao-kuang	1821
文宗	Wên Tsung	咸豐	Hsien-fêng	1851
穆宗	Mu Tsung	同治	T'ung-chih	1862
		光緒	Kuang-hsü	1875
		製統	Hsüan T'ung	1909
		中華民國	Republic T'ung	1912

APPENDIX VI

A LIST OF CHINESE WRITINGS REFERRED TO IN THE TEXT OF THIS BOOK

(ARRANGED IN APPROXIMATE CHRONOLOGICAL ORDER, WITH BRIEF NOTES)

Yi-King 易 經. The Classic of Changes, one of the most ancient of the Chinese Classics. Comprising several parts, including : (*a*) The sixty-four lineal figures written by Wen-Wang ; (*b*) a treatise on divination and an explanation of part (*a*) (B.C. 1143) ; (*c*) A collection of maxims and a revision of the previous writings by Chou-Kung (B.C. 1108) ; (*d*) A Collection of ten appendices written some considerable time after the original text. These portray the changed ideas of philosophy ; the whole work forms an interesting study of comparison of evolutionary thought.

Ch'un-ts'iu 春 秋. An amplification of the " Spring and Autumn Annals " (History of the State of Lu from 722–484 B.C., written by Confucius). Revised by Tso K'iu-ming 左 邱 明 and called *Tso-chwan* 左 傳.

Chuh-Shu-Ki 竹 書 紀, *Annals of the Bamboo Books*. A collection of ancient documents found A.D. 279 in the tomb of Siang-wang, who died 295 B.C. There are about twenty different documents, one of which contains the annals from Hwang-ti to the last of the Chou rulers, 298 B.C. This compilation is a collection of the Tsin records immortalizing the early Emperors. According to Legge, *Prolegomena to the She King*, Chap. IV, pp. 105–7, the Annals are " filled with ridiculous legends, extravagant statements and many absurdities about the ancient worthies."

Lü-shi ch'un-ts'iu 呂 氏 春 秋, by Lü Peh-wei 呂 不 韋, 3rd century B.C. Historical facts of early China in twenty-six books.

Lun-Heng 論 衡, *Critical Disquisitions*. A publication in thirty books by Wang ch'ung (A.D. 19–90). This writing is an attack on the superstitious notions of the early Chinese and was upheld by the Emperor Ch'ien Lung as a work of merit. (Mayers, *Chinese Reader's Manual*, p. 239.)

Peh-hu t'ung 白 虎 通, Annals of the White Tiger, by Pan Ku, *circa* A.D. 80. An unfinished treatise of Chinese history.

Shuo Wên 說 文, the first lexicon of the Chinese language by Hsien-ti, *circa* A.D. 100.

Eul-Ya 爾 雅. A dictionary of terms used in classical and other writings. It is divided into nineteen sections. Part is reputed to have been compiled in the early Chou period, 1122 B.C. It was revised by Kwoh-P'oh (A.D. 276–324).

Shan-hai-king 山 悔 經, *The Classic of Hills and Rivers*, by Hwoh-P'oh, published *circa* A.D. 300. A geographical survey of the Chou Dynasty (12th century B.C.) dealing with the many mythological, zoological, and botanical wonders of ancient China.

Si-Yiu-Ki 西 遊 記. A biographical account of the travels of Yuen-chwang, 元 莊 a Buddhistic monk who resided in India for seventeen years during the seventh century A.D., and compiled 657 volumes containing pictures and images relating to Buddhism.

166

Li-fang T'ai-p'ing Kwang-ki 李 防 太 平 廣 記. An encyclopædia composed by Li fang A.D. 977, containing useful information regarding Chinese superstitions and folk lore.

K'ao ku t'ou 考 古 圖. Illustrated treatise on things antique, by Lü Ta-liu. Published A.D. 1092 in ten parts, this writing forms a valuable guide to the student desirous of detecting the forms and designs which have obviously been obtained from the bronze worker by the jade carver, part 8 being of interest on account of its record of jade forms. This writing is usually printed together with

Hsüan ho Po Ku t'ou lu 宣 和 博 古 圖 錄, *Illustrated Description of Antiquities*, by Wang fu, published *circa* A.D. 1310, in thirty books. This writing and the *K'ao ku t'ou* are probably the most important of old books on ancient bronzes obtainable to-day, and are invaluable to those students who wish to obtain an authentic rendering of the meaning and symbolism of ancient Chinese ornamentation. Book XII, part II gives descriptions of jades, etc., worn on different occasions as tokens of rank.

Ku yü t'ou p'u 古 玉 圖 譜 by Lung Ta-yüan, A.D. 1176. In 100 books, 700 full-page illustrations. First printed edition A.D. 1779. This latter edition seems to be a collection of lapidaries' patterns, but few ancient jades of exactly the same form are in European collections.

Liang-k'i-man-chi 梁 谿 漫 志, written by Fei-kwun 費 滾, published at the close of the 12th century A.D. It contains 10 books, and is a series of notes on antiquities of the Court of China and miscellaneous topics. (Referred to by Wylie, p. 165.)

Li Ki 禮 記, or *Book of Rites* (Yuan Edition, A.D. 1322). The original writing is attributed to Chou Kung, brother of Wu Wang, and is one of the principal sources bearing on religious cult and an invaluable aid in determining the ceremonial usage of Jade in prehistoric China.

Ku Yu T'ou 古 玉 圖, "Illustrations of Ancient Jade," by Chu Ta-jun. In two volumes, published A.D. 1341. Revised by order of the Emperor Ch'ien Lung, A.D. 1751, and included in a work comprising 42 volumes, 14 volumes of which are known as *Hsi ch'ing hsü chien* 西 清 續 鑑, which is really a supplement and an interesting catalogue of the imperial Collections at Peking illustrated with well-defined woodcuts. The dates ascribed to several specimens seem doubtful, but the original writing forms an excellent guide to forms existing during the period of the compilation of the work.

The Ko-Ku-Yao-Lun 格 古 要 論 by Ts'ao Chao. Published A.D. 1387, revised A.D. 1459. Discussions of the various antiquities of Criteria, in thirteen books. An enlarged and revised edition by Wang Tso, A.D. 1459, has been used for reference in the preparation of my book. Book VI, which deals with precious stones, including jade, agate, crystal, amber, horn, and ivory, sacred figures in stone carvings, and a treatise on distinguishing between the fake and real antique will be found most helpful to all students of jade carvings. Book IX deals generally with objects used in the study and library, etc. Book XI, part I, has an excellent treatise on jade seals.

Wen-hsien t'ung-K'ao 文 獻 通 考, in 348 books compiled by Mu Twan-Lin *circa* A.D. 1300. An encyclopædia of general information extremely useful for the student of mythology and early Chinese ritual. Supplemented and revised in A.D. 1586 and 1772.

Chinese Materia Medica, by Li Shih-chèn. Published A.D. 1578.

Ch'ing-fi-ts'ang 清 秘 藏 by Chang Yiu-wèn. China, A.D. 1595. Various descriptions of rare objects of Ancient China.

P'ing shih 瓶 史 "History of Vases," by YUAN HUNG-TAO, *circa* A.D. 1600.

Po-wu-yao-Lan 博 物 要 覽 by KU YING T'AI. China, A.D. 1621–7. A general treatise on objects of Vertu.

T'ien Kung K'ai wu 天 工 開 悟 by SUNG YING-SHÊNG. Published A.D. 1637 in three books. Book III describes among several other minerals, etc., jade, agate, and rock crystal.

Shen-sien kung-kien 神 仙 通 鑑. *The General Mirror of Gods and Immortals*, first published A.D. 1640 by a Taoist Monk. It contains a selection of about 800 Taoist saints, sages, and divinities fully described. Second edition published A.D. 1700 in 22 books, and a third and revised edition published 1787 in 39 books. Wylie refers to this work in *Notes on Chinese Literature*, p. 223.

Tze-chi-t'ung-kien Kang-muh 資 治 通 鎌 綱 目, " The Elucidation of Historic Annals," by CH'EN JEN-SHIH 陳 仁 錫. First published at the end of the Ming Dynasty, *circa* A.D. 1640, and revised in a new edition, 1708, in 91 books.

Ki-yuen Ki-so-ki 寄 園 寄 所 寄, " Select Extracts." A compilation in 12 books, doctrinal, historical, and literary, of selections from preceding works. Much of the contents is devoted to matters of antiquity, and the rest deals with the Ming Dynasty. Published about A.D. 1660.

Ku-chin-t'u-shu 古 今 圖 書. K'ang Hsi's Encyclopædia, published A.D. 1662–1722. Sections dealing with pottery and sculpture have been referred to during the compilation of this book.

Jeh-chi-luh 日 知 錄, " Daily Jottings ". A collection of notes on a variety of subjects, including Imperial antiques, sacrifices to ancestors, etc., by KU YEN-WU 顧 炎 武, 32 books, published A.D. 1673.

Chieh Tzu Yuan Hua Chuan 芥 子 園 畫 傳. " The Drawing Book of the Mustard seed garden," written by LI LI-WENG, and published during the reign of Khang Hsi. It is considered probable that many of the landscapes and ornamentations carved on Jade Boulders, during the Ch'ien Lung period, owe their inspiration to this Picture Book. (See F. Perzynski, *The Burlington Magazine*, vol. xviii, p. 170). The first five volumes, published 1678, have illustrations engraved by Wang An-tsie 王 安 節. The following seven volumes published in A.D. 1679, all illustrated by engravings done by Wang an-tsie, Pi-tsao, and Sï-tsao. The next four volumes, published 1809, are augmented with colour illustrations. The entire work was translated into French in 1914, by R. Petrucci.

Süen-tseh t'ung-shu 選 擇 通 書. A guide to divination, published A.D. 1683 by the Board of Rites. Revised under Imperial patronage in 1741 in 36 books and considered essential for the efficiency of State worship. (Wylie, *Notes on Chinese Literature*, p. 132.)

Ku Chin T'u Shu Chi Ch'êng 古 今 圖 書 集 成. Published in A.D. 1726 in 10,000 books, arranged in 6,109 categories. A general work of reference (in the British Museum).

San-ts'ai k'u hwui 三 方 圖 會. A cyclopædia of arts and sciences in 106 books. With a number of illustrations. By CH'EN YUEN-TUNG. Published A.D. 1735.

Koh-Chi King-Yuenn 格 致 鏡 原. A cyclopædia in 100 books, compiled by Ch'en Yuen-lung 陳 元 龍, and published in A.D. 1735. It contains the origin and history of various subjects. Many of its quotations from literature are incorrect. (Wylie, *Notes on Chinese Literature*, p. 188.)

T'ao Shuo 陶說 by CHU YEN. Published in 6 vols., A.D. 1774. Book IV dealing with Ritual Vessels and general descriptions. Part I (*a*) objects of the T'ang and Yü (third millennium B.C.) referred to in ancient text ; (*b*) objects of the Chou dynasty ; (*c*) objects of the Han Dynasty are of particular interest.

Hsi Yü Wên Chien Lu. Published in A.D. 1777, by a Manchu author, an excellent treatise on Chinese Turkestan and the working of the jade quarries. (An extract from this excellent writing will be found in Bushell, *Chinese Art*, vol. I, p. 129, and Pope-Hennessy, *Jade*, p. 7.)

Wên fang ssǔ K'ao 文房肆考 by T'ANG PING-CHÜN in 8 books. Published A.D. 1782.

Book IV deals with ancient bronzes, ancient and modern jade, its history and characteristics, with copious notes depicting those minerals which bear similar characteristics. This book is worthy of study as it contains information of a technical character which should prove both helpful and instructive for those interested in the early Chinese mineralogical research.

Ku yü t'u k'ao 古玉圖考. Investigations into ancient Jades, by WU TA-CH'ÊNG (A.D. 1889). An exceptionally helpful book based on extant specimens.

Sin-cheng ch'u t'u Ku ch'i t'u chi, by LI JU-KIEN. 3 volumes, A.D. 1923. This writing, dealing primarily with the excavations at Sin-cheng, mentions certain specimens of jade found during these excavations.

Chung Kuo mei shu, 中國美術 *The Fine Arts of China*, by TAI YÜ. Shanghai, A.D. 1923.

Chung-tseng san-kiao Yuen-liu sheng-ti Foh-shi shen-shen-ki 重增三教源流聖帝佛師搜神記. General history of the three religions of Early China. (Undated.)

Ta-Luh-fen-sin-Yuan 大六壬尋原. A treatise on divination of prehistoric times. (Undated.)

Tseng-fu-fi chwan wan-foh-kwei tsung 增補秘傳萬法歸宗 a treatise on talismans and charms of the early Chinese. (Undated.)

Ts'ien-Han-shu 前漢書 " Chronicles of the former Han," by CHANG K'ANG CHWAN. (Undated.)

APPENDIX VII.

BIBLIOGRAPHY CHIEFLY OF EUROPEAN AND AMERICAN WORKS RELATING TO CHINA AND ITS ARTS, MANY OF WHICH HAVE BEEN CONSULTED IN THE PREPARATION OF THIS BOOK.

Augmented by the names of Catalogues and Collections reviewed. Certain of the books tabulated here are of a general character but, nevertheless, they will be found of great value to the student of Jade.

Aalst, J. A. Van. *China, Imperial Maritime Customs.* II.—Special Series, No. 6. *Chinese Music.* Shanghai, 1884.

Anderson, William. *Catalogue of a Collection of Japanese and Chinese Paintings* in the British Museum. London, 1886.

Andersson, J. G. *Preliminary Report on Archæological Research in Kansu.* *Bulletin Geological Survey*, No. 5. Peking, 1923.

Ashton, Leigh, and Basil Gray. *Chinese Art.* London, 1935.

Ashton, Leigh. *Introduction to the study of Chinese Sculpture.* London, 1924.

Bahr, A. W. *Old Chinese Porcelain and Works of Art in China.* London, 1911. Collection of Archaic Chinese Jade at present in England.

Ball, J. Dyer. *Things Chinese.* New York, 1912.

Ball, K. M. *Decorative Motives of Oriental Art.* London and New York, 1927.

Bauer, Dr. Max, and L. J. Spencer, M.A. *Precious Stones, their character and occurrence.* London, 1904.

Beal, S. *Buddhism in China.* London, 1884.
Buddhist Records of the Western World. Translated from the book by Hsiuen Tsiang. London, 1884 and 1906.

Binyon, L. *The Flight of the Dragon.* London, 1911.
Guide to an Exhibition of Chinese and Japanese Paintings. British Museum. London, 1910.

Biot, Edouard. *Le Tcheou-li, ou Rites des Tcheou.* 2 vols., and *Table analytique.* Paris, 1851.

Bishop, H. R. *Investigations and Studies in Jade.* New York, 1906. 2 vols. Privately printed, only two copies known to exist in England, at the British Museum and the Victoria and Albert Museum.

Bishop, H. R. *Collection of Jade and Other Hardstones.* Metropolitan Museum of Art, The. *Handbook*, No. 10. New York.

Blondel, S. *Le Jade, Étude historique, archéologique et littéraire sur la pierre appelée Yü par les Chinois.* Paris, 1875.

Bosch-Reitz, S. C. *Early Chinese Pottery and Sculpture.* Metropolitan Museum. New York, 1916.

Brinkley, Frank. *China; its History, Art, and Literature.* Boston, U.S.A., 1901.

Burlington Fine Arts Club Catalogue of Chinese Art. London, 1915.

Bushell, S. W. *Oriental Ceramic Art Collection of W. T. Walters.* 5 portfolios and a separate volume of text. New York, 1897.

Bushell, S. W. *Description of Chinese Pottery and Porcelain, being a translation of the T'ao shuo.* Oxford, 1910.

Bushell, S. W. *Chinese Art.* 2 vols. London, 1904. Chapter VII. Carving in Jade, etc.

Bushell, S. W. *Chinese Porcelain by Hsiang Yuan Pien.* 1908.
Buttin, C. *Les Anneaux-disques préhistoriques et les tehakras de l'Inde.* Annecy, 1903.

Chamot, Auguste F., Collection. New York, 1907.
Chavannes, Édouard. *Les Sculptures sur pierre en Chine au temps des deux dynasties Han.* Paris, 1893.
Chavannes, Édouard. *Les Mémoires Historiques de Se-ma Ts'ien.* 5 vols. Paris, 1895-1905.
Chavannes, Édouard. *Le T'ai Chan.* Paris, 1910.
Chavannes, Édouard. *Explorations of Northern China.* Paris, 1902.
Cheng, F. T., Lectures by. " Civilization and Art of China." London, 1936.
Chiang. Yee. *The Chinese Eye.* London, 1935.
Chinese Art. *Burlington Magazine Monograph.* Batsford, 1925.
Chinese Art. B. T. Batsford Ltd. 1935.
Chinese Art. International Exhibition of Royal Academy of Arts, London, 1935-6. *Official Catalogue.*
Chinese Exhibits at the Louisiana Purchase Exposition. St. Louis, U.S.A., 1904.
Chinese Recorder, The. Shanghai.
Chinese Review, The. Hongkong.
Chinesische Kunst—*Chinese Exhibition, Catalogue of.* Berlin, 1929.
Collier, V. W. F. *Dogs of China and Japan in Nature and in Art.* New York, circa 1910.
Couling, S. *Encyclopædia Sinica : Jade.* 1917.
Couvreur, S. *Chou King Ho Kien Fou* (China). 1897.
Couvreur, S. *Li Ki.* 2 vols. *Ho kien fou,* 1899 and 1913.
Cox, Charles. *The Pictorial Museum of Animated Nature.* 2 vols. London, undated. Containing an exhaustive treatise on Animals throughout the world, illustrated with 5,000 woodcuts.
Cranmer-Byng, L. *A Lute of Jade.* London, 1912.
Crow, *Handbook for China,* fourth edition. Section on Art and Industries. New York, 1921.

Davis, Frank. *Chinese Jade.* Privately published by the Author. London, 1935.
Davis, Sir J. F. *The Chinese.* London, 1836.
Dennys, N. B. *The Folk Lore of China.* London, 1876.
De Groot, J. J. M. *The Religious System of China.* Vols. I-VI. Leyden, 1892-1910.
De Morant, G. Soulie. *A History of Chinese Art.* London, 1931.
De Tizac, H. *Animals in Chinese Art.* London, 1923.
De Tizac, H. *L'Art Classique Chinois* (Chou and Han Periods). Paris, 1926.
Doolittle, J. *Social Life of the Chinese.* New York, 1876. 2 vols.
Doré, Henry, S. J. *Researches into Chinese Superstitions.* Vols. I-VIII. Shanghai, 1918.

Easter, S. E. " Jade." *The National Geographic Magazine,* Vol. XIX. Washington, 1903.
Edkins, J. *Chinese Buddhism.* London, 1880, revised 1893.
Edkins, J. *Chinese Architecture.* London, 1890.
Edkins, J. *Religion in China.* London, 1893.
Edkins, J. *Ancient Symbolism among the Chinese.* London, 1899.

BIBLIOGRAPHY OF EUROPEAN AND OTHER WORKS—*continued.*

Edmunds, W. H. *Pointers and Clues to the subjects of Chinese and Japanese Art.* London, 1934.

Eitel, E. J. *Handbook of Chinese Buddhism.* Hong-Kong, 1884.

Farrington, O. C. *Gems and Gem Minerals.* Chicago, 1903.

Fenellosa. *Epochs of Chinese and Japanese Art.* 2 vols. 1912.

Ferguson, J. C. *Outlines of Chinese Art.* Chicago, 1919.

Fischer, Heinrich. *Nephrit und Jadeit.* Second edition. Stuttgart, 1880.

Fiske, John. *Myths and Myth-makers : Old Tales and Superstitions Interpreted by Comparative Mythology.* Boston and New York, 1900.

Ferguson, J. C. *Outlines of Chinese Art.* Chicago, 1919.

Getty, A. *The Gods of Northern Buddhism.* Oxford, 1914.

Gieseler, Dr. *Études d'Archéologie Chinoise.* See *Revue Archeologique*, 1917, 1918, 1919.

Giles, H. A. *Chinese-English Dictionary.*

Giles, H. A. *An introduction to the History of Chinese Pictorial Art.* Shanghai, 1905 ; London, 1918.

Giles, H. A. *The Civilization of China.* London, 1911.

Giles, H. A. *Jade, Nineteenth Century.* 1904.

Giles, H. A. *Jade Adversaria Sinica.* No. 9. Shanghai, 1911.

Giles, H. A. *A Chinese Biographical Dictionary.* London, 1898.

Gorer, E., and J. F. Blacker. *Old Chinese Porcelain and Hard Stones* ; particularly Vol. II, Group XII. 2 vols. London, 1911.

Gould, Charles. *Mythical Monsters.* London, 1886.

Griffiths, Rev. W. E. *China's Story in Myth and Legend, Art and Annals.* Boston and New York, 1911.

Hentz, C. *Chinese Tomb Figures.* London, 1928.

Hetherington, A. L. *The Early Ceramic Wares of China.* London, 1922.

Hirth, F. *Chinesische Studien.* München, 1890.

Hirth, F. *The Ancient History of China to the end of the Chou Dynasty.* New York, 1908.

Hobson, R. L. *Chinese Pottery and Porcelain.* 2 vols. London, 1915.

Hobson, R. L. *The Later Ceramic Wares of China.* London, 1922.

Hobson, R. L. *The Wares of the Ming Dynasty.* London, 1923.

Hobson, R. L. *Catalogue of the George Eumorfopoulos Collection of Chinese, Corean and Persian Pottery and Porcelain.* 6 vols. London, 1925.

Hobson, R. L. *Chinese Porcelain and Wedgwood Pottery.* Lady Lever Art Gallery Collection, Part II, Chap. 12. London (Batsford), 1928.

Hobson, R. L. *Catalogue of the Leonard Gow Collection of Chinese Porcelain.* London, 1931.

Hobson, R. L. *Catalogues of Chinese Pottery and Porcelain in the Collection of Sir Percival David, Bt.* London, 1934.

Hobson and Hetherington. *The Art of the Chinese Potter.* London, 1923.

Honey, W. B. *Chinese Porcelain.* London, 1927.

Hopkins, L. C. *The Honan Relics.* R.A.S.J. 1921.

Johnston, R. F. *The Lion and Dragon in Northern China.* New York, 1910.

Journal of the Society of Arts. " Chinese Imitation of Hardstones." London, 1906.

Kay, Charles de. *Bird Gods*. New York, 1898.
Koop, A. J. *Early Chinese Bronzes*. London, 1924.

Laufer, Berthold. *Chinese Pottery of the Han Dynasty*. Leyden, 1909.
Laufer, Berthold. *Chinese Grave Sculptures of the Han Period*. Paris, 1911.
Laufer, Berthold. *Catalogue of a Selection of Art Objects from the Freer Collection*. U.S. Nat. Mus. Washington, 1912.
Laufer, Berthold. *Jade : A Study of Chinese Archæology and Religion*. Chicago. 1912.
Laufer, Berthold. *Le Jade dans le culte et les rites funéraires en Chine sous les dynasties Tcheou et Han*. (Gieseler, G.) *Revue Archéologique*, 5S., IV, p. 61. 1916.
Laufer, Berthold. *Archaic Chinese Jades in the Bahr Collection*. New York, 1927.
Legge, James. *The Chinese Classics*. Second edition. 7 vols. Oxford, 1893.
Legge, James. *The Sacred Books of China ; The Li Ki*. Oxford, 1885.
Legge, James, *Li Ki*, Book XLV. Section 13.
Legge, J. *The She King or Book of Poetry*.
Little, A. J. *Gleanings of Fifty Years in China*. London, 1886.
Loo, C. T. and P. Pelliot. *Les Jades Archaiques de la Chine*. Paris, 1926.

Mangin, A. *Earth and its Treasures ; A description of the Metallic and Mineral Wealth of Nature*. London, 1875.
Maxwell, J. B. " Chinese Jade." *Burlington Magazine*, No. 137.
Mayers, W. F. *The Chinese Reader's Manual*, Part 1, pp. 303-304. Shanghai, 1874.
McGowan, J. *Chinese Folk Lore* and *Sidelights on Chinese Life*. 1907.
Mackenzie, D. A. *Myths of China and Japan*. London, 1923.
Milloue, L. de. *Musée Guimet Catalogue*. Paris, 1910.
Müller, F. Max. *Sacred Books of the East*. Oxford, 1879-97.
Müller, F. Max. *Comparative Mythology*. London, 1909.
Münsterberg, Oskar. *Chinesische Kunstgeschichte*. 2 vols. Esslingen, 1910.

Nott, Charles, Ltd. *Catalogues of Chinese Hardstone Carvings*, 1931, 1932, 1933, 1934, 1935. London.

Old, W. G. *The Shu King*. London, 1904.

Paléologue, G. M. *L'Art Chinois*. Paris, 1887.
Parker, E. H. *China and Religion*. New York, 1910.
Parker, E. H. *Ancient China Simplified*. London, 1908.
Pope-Hennessy, Dame Una. *Early Chinese Jades*. 1923.

Raphael, Oscar. " Jade." *The Journal of the Royal Society of Arts*, No. 4342, Vol. LXXXIV. Royal Academy lectures on Chinese Art.
Rawlinson, G. *The Religions of the Ancient World*. London, 1882.

Schlegel, G. *Uranographie Chinoise*. 2 vols. Leyden, 1875.
Silcock, Arnold. *Introduction to Chinese Art and History*. London, 1936.
Siren, O. *Chinese Sculpture from the Fifth to the Fourteenth Century*. London, 1924.
Smith, F. P. *Contributions towards the Materia Medica and Natural History of China :* Shanghai, 1871. *Jade*, p. 124.

Smith, Sir William. *Smaller Classical Dictionary of Biography and Mythology.* London, 1880.

Smithsonian Institution, Annual Report of. 1876. Pp. 402-418.

Soothill, W. E. *The Three Religions of China.* London and New York, 1913.

Stein, Aurel. *Sand-Buried Ruins of Khotan.* London, 1904.

Sumitomo, K., Baron. *Sen-oku Sei-sho.* (The collection of old bronzes of Baron S.) Part 1—Bronze Vases, etc. Explanatory notes by K. Hamada. Illustrated 1921. Part 2—Ancient Mirrors by K. Hamada. English version by M. Toyoda. Illustrated 1921. Special volume—Ten Chinese bells. Explanatory notes by K. Hamada. Illustrated 1923. Additional volumes : Part 1—Vases, Images, etc. Text by K. Hamada (in Japanese. List of plates also in English), 1926. Part 2—Ancient Mirrors. Text by S. Umchara and K. Hamada (in Japanese. List of plates also in English) 1921-1926(?).

Takeuchi, K. " The Chinese Appreciation of Jade." *Burlington Magazine*, No. 123.

Thoms, P. P. *A Dissertation on the Ancient Chinese Vases of the Shang Dynasty.* London, 1851.

Thorpe, W. A. The Rutherston Collection of Jades at South Kensington. *Burlington Magazine*, Vol. LV, No. CCCXX.

Tredwell. *Chinese Art Motives Interpreted.* London, 1915.

Watters, T. *The Eighteen Lohan of the Chinese.* Shanghai, 1899.

Williams, C. A. S. *Outlines of Chinese Symbolism and Art Motives.* Shanghai, 1932. *Jade*, pp. 232-235.

Wilke, G. *Südwesteurofäische Megalithkultur*, 1912, pp. 96-99.

Wong, K. C. *Chinese Jade and its Antiquity* (excerpt), 1925.

Wylie, A. *Notes on Chinese Literature.* Shanghai, 1902.

Wu, Henry H. *Ancient Chinese Jade.* Explanatory notes on T. C. Liu's Collection. Shanghai, 1933.

Yamanaka and Co. Illustrated Catalogues describing Jades ; especially those produced during 1927, 1930, 1933 and 1935.

Yetts, W. Perceval. *Catalogue of the Chinese and Korean Bronzes, Sculptures, Jades, etc., in the George Eumorfopoulos Collection.* London, 1929 and 1930. A very valuable and comprehensive catalogue which every student should consult.

Yetts, W. Perceval. *Symbolism in Chinese Art.* Leyden, 1912.

Yetts, W. Perceval. *The Eight Immortals.* (Journal of the Royal Asiatic Society, 1916 and 1922).

Yule, Sir H. *The Book of Marco Polo.* London, 1903.

APPENDIX VIII
MARKS, DEVICES, AND MAP.

DATE MARKS.

Dates may be indicated either by the reign-title or by cyclical characters or by a combination of both. The following marks, found chiefly on porcelain, show reign-titles.

This is an example of a six-character mark. It is read from above downwards and from right to left. The first two characters are TA MING, the name of the dynasty; the second two are HSÜAN TÊ, the reign period; and the last two are NIEN CHIH, meaning "period made." A version in archaic "seal" characters is shown on the right.

大明宣
德年製

MING DYNASTY.

Below are some of the commoner date marks of the Ming dynasty. The six-character marks are followed by some four-character marks in which the name of the dynasty is omitted. It is the custom to refer to Emperors by the names of their reign-periods.

大明成化年製	大明弘治年製	大明正德年製	大明嘉娟年製	大明隆慶年製
CH'ÊNG HUA (1465–1487)	HUNG CHIH (1488–1505)	CHÊNG TÊ (1506–1521)	CHIA CHING (1522–1566)	LUNG CH'ING (1567–1572)

大明萬曆年製	大明天啟年製	洪武年製	永樂年製	崇挽年製
WAN LI (1573–1619)	T'IEN CH'I (1621–1627)	HUNG WU (1368–1388)	YUNG LO (1403–1424)	CH'UNG CHÊN (1628–1643)

MANCHU OR CH'ING DYNASTY.

大清順治年製		大清康熙年製		大清雍正年製	
SHUN CHIH (1644–1661)		K'ANG HSI (1662–1722)		YUNG CHÊNG (1723–1735)	

175

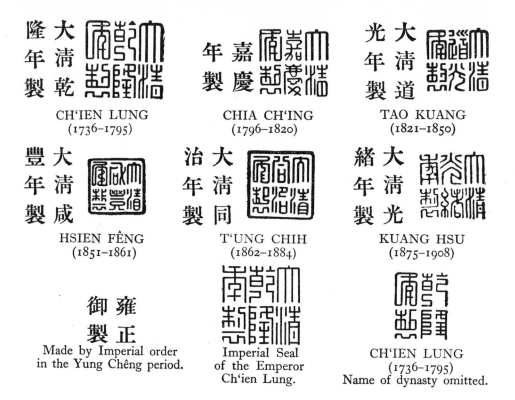

CH'IEN LUNG
(1736–1795)

CHIA CH'ING
(1796–1820)

TAO KUANG
(1821–1850)

HSIEN FÊNG
(1851–1861)

T'UNG CHIH
(1862–1884)

KUANG HSU
(1875–1908)

御雍
製正

Made by Imperial order
in the Yung Chêng period.

Imperial Seal
of the Emperor
Ch'ien Lung.

CH'IEN LUNG
(1736–1795)
Name of dynasty omitted.

CYCLICAL DATE MARKS.

The Chinese cycle is a period of 60 years, and each year is indicated by combining two characters, the first being one of the Ten Celestial Stems and the second one of the Twelve Earthly Branches.

元大
年明
乙成
西化

Cyclical year *i-yu* (1465) of
the Ming reign-period Ch'êng Hua.

又
年辛
製丑

Made in the cyclical year *hsin ch'ou* re-
curring (1721), indicating the recurrence
of this date under K'ang Hsi, who reigned
for over sixty years.

年丙
製戌

Made in the cyclical year *ping
hsü* (1766 ?), indication of which
cycle is here omitted.

同
治
十
癸二
西年

Cyclical year *kuei yu* (1873),
being the 12th of the T'ung
Chih period.

In the following table the first horizontal line of characters represents the Ten Stems. If the eye is carried vertically downwards from the Stem which occurs in an inscription until the Branch character is recognized, the date is found by taking the number printed here against the Branch to represent the year calculated from the beginning of the particular cycle concerned. From the end of the Yüan period onwards the cycles began in 1324, 1384, 1444, 1504: 1564, 1624, 1684, 1744, 1804, 1864, and 1924 A.D.

甲 chia	乙 i	丙 ping	丁 ting	戊 mou	己 chi	庚 keng	辛 hsin	壬 jên	癸 kuei
子[1] tzŭ	丑[2] ch'ou	寅[3] yin	卯[4] mao	辰[5] ch'ên	巳[6] szŭ	午[7] wu	未[8] wei	申[9] shên	酉[10] yu
戌[11] hsu	亥[12] hai	子[13]	丑[14]	寅[15]	卯[16]	辰[17]	巳[18]	午[19]	未[20]
申[21]	酉[22]	戌[23]	亥[24]	子[25]	丑[26]	寅[27]	卯[28]	辰[29]	巳[30]
午[31]	未[32]	申[33]	酉[34]	戌[35]	亥[36]	子[37]	丑[38]	寅[39]	卯[40]
辰[41]	巳[42]	午[43]	未[44]	申[45]	酉[46]	戌[47]	亥[48]	子[49]	丑[50]
寅[51]	卯[52]	辰[53]	巳[54]	午[55]	未[56]	申[57]	酉[58]	戌[59]	亥[60]

177

TA CHI.
" Great Good-luck."

WAN SHOU WU CHIANG.
" A myriad ages never
ending."

FU LU SHOU.
" Happiness, Rank, and
Longevity."

**YUNG CH'ING
CH'ANG CH'UN.**
" Eternal Prosperity and
enduring Spring."

**CH'ANG MING FU
KUEI.**
" Long Life, Riches,
and Honour."

**FU KUEI CH'ANG
CH'UN.**
" Riches, Honour, and
enduring Spring."

WÊN CHANG SHAN TOU.
" Scholarship high as the
mountains and the Great Bear."

CH'ING.
" Congratulations."

SHOU.
" Longevity." Known in
Holland as the Spider mark.

CHI HSIANG JU I.
" Good fortune and
fulfilment of wishes."

TE HUA CH'ANG CH'UN.
" Virtue, Culture, and
enduring Spring."
WAN LI NIEN TSAO
" Made in the Wan Li
period."

CHIH.
" By Imperial order."

SHUANG HSI.
" Double, or wedded, Joy."
Inscribed on bridal presents.

BARAGON TUMED.
" For the Princess of the west wing
of the Tumed Mongolian Banners."

MARKS IN PRAISE OF THE PIECES INSCRIBED.

玉 古 文 珍

YÜ. "Jade." KU. "Ancient." WÊN. "Artistic." CHÊN.
"Precious, a Gem."

鼎奇
臭 之玉 玩 雅
玉 珍寶 玉 玩

CHÊN YU. CH'I YÜ PAO TING WAN YÜ. YA WAN.
"True Jade." CHIH CHÊN. "Trinket Jade." "Artistic Trinket."
 "A Gem among precious
 vessels of rare Jade."

鼎奇
之石 珍 如奇 知在
珍寶 玩 玉珍 樂川

CH'I SHIH PAO CHÊN WAN. CH'I CHÊN JU YÜ. TSAI CH'UAN
TING CHIH CHÊN. "Precious "Rare and precious CHIH LO.
"A Gem among precious Trinket." as Jade." "I know that they
vessels of rare Stone." [fishes] rejoice in
 water."

SYMBOLIC MARKS.

THE EIGHT TRIGRAMS (*pa kua*), in the centre of which
is a symbol for the Two Regulating Powers (*yin* and *yang*).

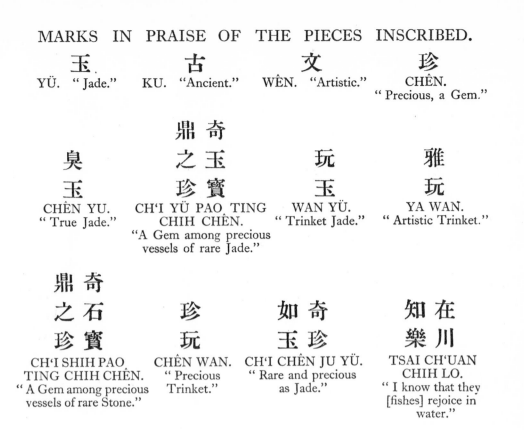

MAP OF CHINA SHOWING CHIEF CENTRES OF
ARTISTIC ACTIVITY

180

INDEX

The Roman numerals refer to the Plates.

INDEX

INDEX

INDEX

INDEX

INDEX